Activist Film Festivals

Activist Film Festivals
Towards a Political Subject

Sonia Tascón and Tyson Wils

intellect Bristol, UK / Chicago, USA

First published in the UK in 2017 by
Intellect, The Mill, Parnall Road, Fishponds, Bristol, BS16 3JG, UK

First published in the USA in 2017 by
Intellect, The University of Chicago Press, 1427 E. 60th Street,
Chicago, IL 60637, USA

A catalogue record for this book is available from the
British Library.

Cover designer: Holly Rose
Copy-editor: MPS Technologies
Production manager: Katie Evans
Typesetting: Contentra Technologies

Print ISBN: 978-1-78320-634-6
ePDF ISBN: 978-1-78320-635-3
ePUB ISBN: 978-1-78320-636-0

Printed and bound by CPI Antony Rowe, UK

This is a peer-reviewed publication.

Contents

Introduction

Sonia Tascón and Tyson Wils

Opening thoughts (Sonia Tascón)

This book was born of the hypothesis that different platforms for political activism may produce different audiences and that film festivals explicitly intended to help further social change, or those defined as having an activist orientation, need to be considered more closely as they "envelop" a spectator differently. The difference mentioned has to do with much of the ways that the scholarship surrounding activism and visual media has configured an ethical and political spectator as a problematic figure whose embodiment of geopolitical power disparities infect the viewing to such a degree that they (we) cannot help but reinforce these inequalities. These disseminations often also take into account the visual media involved and how their very production is implicated in the disparities, but then go on to make generalizations about the spectator who views others' suffering as always already invested in a system of viewing deeply riven with power (Sontag 2003; Hesford 2011; Chouliaraki 2006, 2012; Torchin 2012a; Boltanski 1999). This power makes of some people objects (victims) and others vested with (fuller) human agency, the latter manifesting in the impulse to "save" the victims. In this current work, we have asked contributors to consider more closely the idea that the site where the activism takes place makes a difference to the ways in which the individuals are engaging with this system of power. That is, the context of the consumption of the filmic image may be conducive to a deeper/reduced engagement with the questions of power and the relationships of power inherent in the production of images, their exhibition and their spectators. In this regard, this book wants to explore the idea that the context of the exhibition of films has something significant to say to that relationship of power in which the filmic images, its producers, its exhibitors and its spectators are inextricably entwined.

Films and film festivals have been some of the oldest of the modern forms of visual activism (de Valck 2007), and yet activist film festivals have received little attention in the academic literature. In Latin America, the birth-home of one of the editors, film festivals were being used in the 1960s and 1970s to disseminate revolutionary ideas both for converting the social world, and for the production of new types of films that would encourage participation in that transformation (Solanas 1969). Some work has begun to appear that considers the role of film festivals in activism, particularly a 2012 text, edited by Dina Iordanova and Leshu Torchin entitled *Film Festival Yearbook 4: Film Festivals and Activism*. Much of the work of that book considers the specific ways in which activist film festivals create a distinct network of flows, and some attention is given to their audiences,

although to a much lesser extent. Some mention is made of "the testimonial encounter" (Torchin 2012: 2), and that the intended aim of these sorts of festivals is to mobilize audiences towards creating social change (Iordanova 2012; Blaževič 2012). In this current edited volume, we sought to expand on this work and asked our contributors to consider this scholarship, but also others who have engaged more precisely with visual activism and spectatorship. Contributors have participated in this volume from a wide variety of backgrounds, some of which we will describe more closely below. But at this point it may be worthwhile to disseminate the visual activism and spectatorship field more widely, beginning with a discussion of what is meant by visual activism and activist spectatorship. It will necessarily be a brief dissemination as it is intended to only give a broad overview of the field within which this book is situated.

Visual activism and activist spectators

In bringing the field of visual activism and spectatorship together, we cannot escape the fact that of all the terms used to describe the relationship between the image and a spectator whose viewing is intended to produce heightened awareness and eventual activity for social change, that of "witnessing" "suffering strangers" are the most common. Luc Boltanski's 1999 seminal text *Distant Suffering* is possibly the most indicative of this trend in considering these images as constructed for, and appealing to, a particular audience. Susan Sontag's 2004 treatise on war photography, entitled *Regarding the Pain of Others*, continues in this trend. Both of these texts remain two of the most influential, conceptually, in the reading of humanitarian visual texts. But many others have followed in this discursive fashion (Chouliaraki 2006, 2012; Torchin 2012; Bornstein 2009; Hesford 2011; Tascón 2012). In all of these analyses, a particular spectatorial position is assumed: that the viewing stance of those who are given access to the troubled situations of others must necessarily be unequal, more privileged in some way, from those who are the film subjects; and that often the inequality is reinforced through such viewing and the eventual actions they motivate in the viewer. These analyses correctly assume that watching others' troubles is not a neutral activity; it is subsumed within an economy of local and global power that can construct bodies as having agency or as failing to have it – whether this is manifest in the image or in the daily lives of people. But this is heightened in the case of images, as these have the capacity for transgressing communication borders and cultural filters by flowing with ready ease via films, videos and now the Internet. The Joseph Kony campaign of 2012, its success and subsequent critiques show this well.

Current conceptualizations of humanitarian "ways of seeing" (Gaines 1986) are largely critiques of well-meaning naivety at best, or as the justification for military interventions at worst. In recent research conducted by one of the editors (Tascón 2015), studying human rights film festivals, I developed the idea of "the humanitarian gaze" to attempt to capture some of the geopolitical dimensions with which the above scholars have been grappling, but

also consider that many of their explanations arose from spectatorship of a particular kind, largely that which takes place in the watching of television news. Some of that discussion takes place in my own chapter in this tome. Much of the criticism of the Kony phenomenon featured elements of the politics of viewing with which those scholars have grappled. A question that emerges from these critiques, however, is whether these analyses, or critiques, end up reproducing the political and cultural economies from whence these images emerge because, in seeking to overturn these relationships the analyses themselves continue to stamp their power by failing to see other possibilities. That is, by continually reifying the relationship of image consumption from an assumed binary of power – victim/saviour for example – even while attempting to interrupt and make salient its features, it continues to assume and support "the logic of a global morality market that privileges Westerners as world citizens" (Chouliaraki 2012: 9). For the purposes of this book, we can change "citizens" for "spectator" and the argument remains the same. In this book, we wished to begin from those debates, which although not strictly about "visual activism", but more strictly "visual humanitarianism", in the senses I will define below, they have been extremely influential. We want to begin and tease apart the idea that consuming images to motivate people to help change the troubled lives of others can be viewed differently if we begin from the idea that, in certain contexts, there may be an enhancement of a type of viewing that can encourage nuances outside the victim-saviour mentality. In some contexts, we can be encouraged to step away from the notion that seeing others' troubles, while mediated, can be less "distant", if we are enabled to understand that we are not watching "suffering" but a specific moment of [an]other's need in which we become, within the privilege of the access to the images, implicated. This is to imagine that the image, within certain parameters and contexts, can help produce an encounter with aspects of [an]other's life that can lead to a nuanced awareness. This is neither to romanticize this process, nor to negate the very complex and problematic features of the scholars' debates mentioned above, in which images of others' troubles, for the powerful Western spectator, often "cannot help but nourish belief in the inevitability of tragedy in the benighted or backward – that is, poor – parts of the world" (Sontag 2004: 64). Leshu Torchin, discussing Meg McLagan's study of Tibetan activism, makes a similar comment more directly aimed at "the activist spectacle", in which "the mobilization of essentialized images of otherness [...] [occurs] in order to outline the more complicated practices of meaning-making and – remaking for purposes of engaging audiences in social justice movements" (2012: 15). In an earlier paper I also raise similar disquiets (Tascón 2012) in relation to the care needed in programming for human rights film festivals.

What this book seeks to do is to facilitate discussions that may consider other possibilities. Meg McLagan and Yates McKee offer some of these alternatives as they open their 2012 book *Sensible Politics*. Part of their interest centres on placing emphasis on the different platforms and networks as the image becomes part of "the public" and "makes thing public" (10). As they note "[a] photograph displayed in a newspaper is not the same object when it is displayed in an art gallery" (10):

[a]ttending to political aesthetics means attending not to a disembodied image that travels under the concept of art or visual culture or to a preformed domain of the political that seeks subsequent expression in media form. It demands not just an examination of the visual forms that comment upon and constitute politics, but analysis of the networks of circulation whereby images exist in the world and the platforms by which they come into public prominence.

(10)

For us this has meant re-considering the "differing epistemologies and infrastructures" (10) that attend the film festival, as it becomes a platform specifically of and for activism. Before turning to a description of the ways in which contributors consider these issues, I want to turn to a brief discussion of the difference between "activism" and "humanitarianism". Although the two terms are often used interchangeably, and is a distinction whose full deliberation cannot be covered here, it is nevertheless important to make it because they are each grounded in different histories and processes. We wish to highlight in this volume some of the ways in which activist film festivals attempt to transform spectatorship from mere "ironic" or "detached knowingness" (Chouliaraki 2012: 2) towards actively engaged citizen for social change (Iordanova 2012; Blažević 2012).

Humanitarianism and activism

Perhaps the clearest way to characterize humanitarianism is to begin from the definition provided by Wiktor Osiatyński (2009). He describes humanitarianism as an activity that "implies a passive victim who needs to be protected and assisted" (61). The passivity of the victim is often because "humanitarian" action centres on people who have experienced severe and tragic events of significant magnitude leading to major displacement or disruption, such as war. As I explain elsewhere:

> Humanitarianism as an institutionalised undertaking has a lengthy history, but it has mostly been associated with aid in times of crises as a result of natural disasters, or "man made" violence such as civil unrest, genocide, war, famine, etc.
>
> (Barnett 2013)

Activism, on the other hand, is an explicitly political action, which attempts to reach to the "heart" of the relations of power that contribute to the problem, and attempts to change the conditions of its creation. This definition of activism as opposed to humanitarianism is important to make as it relates to the use of visual material. Visual texts, like other texts, make, manifest and reproduce these relations of power because they are an integral part of the ways in which these relations are expressed and constructed, but through a specific type of language, the visual. Visual texts do not simply filter or mediate the world passively; they

are in direct and active relation to the ways in which these relations are constructed, just as written and spoken language is. Activism is, in our understanding of it, hence much more closely related to Jacques Rancière's notion of "politics" as he relates it to the aesthetic, which, for him "revolves around what is seen and what can be said about it, around who has the ability to see and the talent to speak, around the properties of space and the possibilities of time" (Rancière 2004: 13). In this way visual creations such as films are not simply "tools" of or for activism, but active creators and reproducers of relations of power in and of themselves. They are of and return to the world of social human being, but also exist to construct their own meanings. We are interested in exploring how the activist film festival is a site that helps this reconfiguration in particular ways. Further, that these festivals may not altogether rely on notions of watching distant and suffering others, but on notions of more intimate solidarity with others, to do so. The contributors that follow develop this variously.

Structure of the book (Tyson Wils)

To date, little regard has been given to the ways in which the gaze of a spectator who chooses to view images of others' troubles may be configured differently through the context of consumption. The Internet is, for example, producing patterns of production and consumption of information that can reinforce geopolitical relations in the politics of viewing others' troubles, but also provide platforms for a much more porous, wider and faster dissemination and critical examination of the same than ever before. These differing contexts produce different spectatorial effects, and this is what this book is attempting to begin to consider in relation to film festivals. What we have asked contributors to consider is that activist film festivals bring together the ideals of activism in the definition given above, of the festival or the festive and the screening of films for a set of spectators for whom the communal space becomes as important as the festival-ness and the films screened themselves. Specific elements are at play in this space. In what follows, Tyson Wils outlines for the reader, chapter by chapter, the ways by which various contributors engage with this field and the question that guides them: "How do activist film festivals help to promote a politically active spectator?"

Section 1 begins with Sonia Tascón's work on activist film festivals. Tascón argues that through the way that space is organized at such festivals – particularly in terms of how events such as post-screening discussions are run – distant spectatorship, unidimensional experiences of suffering and other features of what she refers to as the "humanitarian gaze" can be challenged. Drawing on her experience of the 2011 Human Rights Watch International Film Festival, held in New York, as well as on other accounts of activist film festival spectatorship, Tascón suggests that activist film festivals can create "responsible historical subjects through a process that is similar to that described by Third Cinema's 'the film act'". While acknowledging that at such festivals there are many extra-cinematic activities that guide spectators towards a life "beyond the frame", she focuses on post-screening

discussions because she believes these are particularly reflective of Third Cinema's "film act". Drawing on the work of Dina Iordanova, as well as Ezra Winton and Svetla Turnin's chapter from this book, Tascón says that, compared to post-screening discussions that happen in other festivals, activist film festivals allow more complex sessions to evolve that emphasize the screened film's relationship with the social world and encourage audiences to become active participants in debate. As such, Tascón argues that post-screening discussions make "activist film festivals a place where a particular type of spectator is facilitated, one that may be less detached and prone to the expectation of seeing tragic victims".

While focusing more specifically on documentary films at activist or human rights film festivals, Lyell Davies explores the role of extra-cinematic, or what he prefers to call "off-screen", events and activities, which complements Tascón's "film act" inspired approach to post-screening discussion at activist film festivals. For Davies, it is important to question the assumption that political or activist documentaries will galvanize public action when audiences at particular festival sessions view them as stand-alone films. He argues that "we must also rigorously evaluate the ways that we, as viewers, receive documentary films or draw pleasure from them". He suggests that this is particularly important because the language and aesthetic form of documentary has gravitated towards emphasizing "individual subject experience at the expense of a deeper analysis of the economic or political forces that define our lives". Davies is also conscious of the need to evaluate the impact of political and activist documentaries with more nuance than simply looking for examples of direct political action that stem out of audience viewings of films. He says, for example, that screenings of documentaries can play complex roles "in sustaining the commitment of those who are already involved in activist work, or provide a forum for constituents to come together to contemporise interpersonal relations" (6); that is to say, come together to share, as well as potentially discuss, ways of seeing the world.

In his chapter, Davies shows that while film exhibition spaces at activist film festivals "can serve as a potentially rich location for the production of political knowledge", such spaces do not necessarily produce an "ideal" political subject – "individuals who, once they are provided with information about a particular injustice, possess both the political competency needed to take action on the issue and access to the channels they will need for the action to be effective". Rather, within such spaces, different frames or shared ways of seeing the world can be established. Similar to Tascón, Davies explains how "off-screen" activities at activist film festivals, such as post-screening discussions, are intended to be spaces where audiences are positioned to be witnesses who are able to not only respond to what they have seen in a film but also become more aware. The intention is not only to make such audience members aware of the social and political issues raised in a film, but also how to take action to address such issues. However, he adds an important point to Tascón's insights into the post-screening discussions at activist film festivals; namely, that different kinds of audience identification are possible within such "off-screen" activities, including the fact that different subject-positions can be affirmed by audience members and different pleasures had by them (this relates to the construction of an "ideal" political subject that Davies questions – see above).

Drawing on Dina Iordanova's model of activist film festivals, as well as the New Latin American Cinema Movement of the 1960s and 1970s, Tomás F. Crowder-Taraborrelli and Kristi Wilson investigate whether the festival partnership between Independent Television Service's (ITVS) Community Cinema (CC) documentary film festival and colleges such as Soka University of America can be considered activist. CC is part of ITVS's outreach programme, which "aims at fostering active community engagement, debate around public issues, and political activism with respect to a range of human rights, social and environmental issues". While working within similar terrain to Davies and, in particular, Tascón – specifically in regard to drawing on the screening and distribution tactics employed by members of the Latin American cinema movement, which is where the concept of "the film act" stems from – the authors add another dimension to the notion that extra-cinematic, or "off-screen" space, can be utilized to transform the subjective position of spectators. Situating pre- and post-screening activities beyond the four walls of the exhibition space, Crowder-Taraborrelli and Wilson consider the relationship that CC has with different education and community-based organizations as well as ITVS's weekly television show *Independent Lens*, which is screened on the public television station PBS. In order to ascertain in what way, and to what degree, CC can be considered activist, the authors focus on the CC screenings that were held at Soka University for six years.

Section 2 begins with Ezra Winton and Svetla Turnin's piece on documentary film festivals; in particular, International Documentary Film Festival Amsterdam and Sheffield Doc/Fest. Like Davies, Winton and Turnin focus specifically on documentaries and on documentaries in relation to politically engaged sites such as the spaces created at activist film festivals. However, they also consider documentaries in relation to broader institutional and social forces that currently define and shape activist practices. Like all the authors in Section 1, Winton and Turnin are interested in questions to do with what makes activist film festivals different from other kinds of festivals, particularly in regard to modes of spectatorship. However, they explore such questions through a different lens to the other three authors. They employ three "interlocking concepts" to study the relationship between political activism and festival space. The first concept is "affective architecture" which has to do with what happens when individuals come together in space to form an audience at an activist film festival. On the basis of the immediate experience that individuals have of being part of such an audience, where dialogue and participation are facilitated, members may become part of an informed and politically committed collective at the festival. The second concept is "the politics of presence" which, as the authors explain, has to do with "the transformative potential of social spaces where diverse inclusion has presumably been achieved". As suggested by this quote, for political festivals, "the politics of presence" has to do with not only recognizing the importance of, but also encouraging, diverse experiences of festival screenings and events so that difference is seen as a "productive and legitimate aspect of documentary spectatorship". The third concept is Jacques Ranciére's notion of "dissensus", which one of the co-editors of the book, Tyson Wils, also draws on for his chapter in this section of the book. The authors discuss how "dissensus" represents a disruption

to "consensus" or what Ranciére refers to as mode of "policing" that normalizes political and social action. Winton and Turnin argue that Ranciére's concept of "dissensus" can be used to conceive of film festivals as spaces that can facilitate genuine political and cultural pluralism where it is possible to question the accepted frameworks of social experience that exist within western, liberal-democratic capitalism.

Matthea de Jong and Daan Bronkhorst then switch our attention to human rights film festivals. De Jong and Bronkhorst, like all the authors in this book, are interested in discussing audience experiences at political festivals, in their case specifically human rights festivals. While focusing particularly on what moves spectators or makes them inspired politically, they also acknowledge, as Davies does in Chapter 2, the different subject-positions that spectators may occupy at such festivals as well as the different kinds of pleasures they might have. They encompass all these different possible audience reactions under the umbrella term "moral imagination". Drawing on their experience working in NGO's and film festivals – Bronkhorst is a staff writer at the Dutch section of Amnesty International, and has been involved in festivals such as the Amnesty International Film Festival, while de Jong is a programmer at the Movies that Matter Festival – the authors suggest ways to organize a human rights festival, including key questions to consider. Two questions in particular are important to them: "fascination", which involves asking how festival attendees will "be moved, touched and inspired", and "mobilization", which involves asking what social and/ or political changes can result from festival film screenings and events. Utilizing Marie-Bénédicte Dembour's four schools of human rights model, the authors suggest that there are four types of human rights festival. They propose that each type can, in its own way, socially and/or politically mobilize audiences and make them fascinated in the manner discussed above.

In the last chapter of Section 2, Tyson Wils applies Jacques Ranciére's notion of "dissensus" to the Human Rights Arts and Film Festival (HRAFF), which is based in Melbourne, Australia. Wils discusses how HRAFF's curatorial address to spectators draws on the language and practices of institutional human rights discourse. He argues that in order to try to attract different audience types to the festival, staff at HRAFF mobilize certain terms and phrases in festival materials that reflect the dominant language of western human rights discourse. He also suggests that they make film selections and put on film events that reflect broader discursive practices associated with this new human rights regime. However, drawing on the concept of "dissensus", he shows that HRAFF's connection to western human rights discourse also represents a particular mode of politico-aesthetic activity. He explains that, for French philosopher Ranciére, human rights, today, represent the rights of all kinds of people, regardless of their class position, geographic location or cultural upbringing. This produces a situation of "dissensus" because "when those who have been traditionally excluded from being full citizens or playing legitimate political roles within the state can enact human rights claims, dispute is created about what human rights are exactly and whom they are applicable to". Wils suggests that, through film selections and events, and festival messages and statements, HRAFF "is able to interact

with its attendees in a manner that engenders dispute about what human rights is, exactly, and who, or to what situations, it is applicable". Wils' chapter can be situated in terms of de Jong and Bronkhorst's discussion of human rights film festivals, as well as Winton and Turnin's use of "dissensus" in relation to political film spaces and their interest in broader institutional and social forces that currently define and shape activist practices.

Section 3 begins with David Owen's work on the Bristol Palestine Film Festival. Owen, who established the festival in 2011, reflects on what motivated him to want to use film "to provide a forum for artistic and cultural exchange, whilst focusing on bringing the complex humanitarian situation in Palestine to a public forum". He discusses two approaches he has used to attract broader audiences to the festival, including non-activists. The first approach involves the use of "audience segmentation", which, he explains, "is a method of dividing the public into subgroups". He explains how he used this model to identify the different audience types that the festival wanted to attract and "to develop methods for marketing the festival to them". The second approach involves the use of "systems thinking", which, he says, provided him with tools to create a festival that would not only attract people with shared political attitudes and values, but also a diverse range of people who could engage with the festival as consumers, activists and/or learners. He says that: "In order to engage the wider public in meaningful conversation about the Palestine experience of the conflict with Israel, I was deeply connected with the idea that the festival would need to commit to being as pluralistic as it could". To this end, he informs us, he programmed films that could provide deep "insights into the Palestinian narrative", rather than simply films which emphasize suffering or victimhood. Owen's work relates not only to Tascón's critique of spectatorship models that reduce the "other" on-screen to a suffering or tragic figure, but also Winton and Turnin's endorsement of pluralism and difference within activist film festival spaces. Owen's work also provides a specific example of how to develop an activist film festival once it is has been created, which complements de Jong and Bronkhorst's more general consideration of key issues to think about when establishing or developing a human rights film festival. Finally, Owen's discussion of how he targeted diverse audiences for the festival can be connected to the strategies employed by the HRAFF to broaden its demographic reach, which Wils discusses in Chapter 6.

The next chapter in Section 3 is Shweta Kishore's. Kishore, who is a documentary film-maker as well as a former features film programmer with HRAFF in Australia, discusses the fieldwork she has undertaken in Uttar Pradesh, northern India. Drawing on Marijke de Valck's use of Bruno Latour's Actor Network Theory, Kishore discusses the Cinema of Resistance (COR) film festivals, a series of festivals organized by Jan Sanskriti Manch (People's Cultural Forum), an organization "founded by progressive artists and cultural activists". Kishore explains that one of the advantages of using Latour's Actor Network Theory to examine film festivals is that "it includes both human and non-human actors as objects of study", meaning that processes and forces that shape the structural foundation of a festival can be examined alongside various human actors, including those who are part of the periphery that makes up the total film festival event. Using this approach, Kishore

argues that, against the "masses" and "classes" approach to audiences that characterizes the mainstream, commercial Bollywood system, COR is able to offer "the possibility of alternate forms of social subjectification". She says that a number of attendees at the COR festivals have "cultural desires to connect with representations of lived realities [that] exceed the mass cinema experience", and that those involved in running the festivals respond to this desire in a number of ways, including by collaborating with "local cultural actors to co-produce creative aspects such as festival theme, curation and operational elements". Unlike the production, distribution and exhibition practices that characterize the commercial film culture of the dominant Bollywood industry, the COR festivals are able to "address cinematic desires anchored in the subjective knowledge contexts and experiences" of local and regional audiences. Like Winton and Turnin, and Wils, Kishore situates the festival she looks at in terms of broader social factors; however, her focus is on industrial issues to do with the circulation of film culture as well as how this dissemination is tied to place. In this latter respect, Kishore is the first author in the book to provide a national and regional focus to viewing practices, highlighting the role that place plays in determining the relationship between festivals and audiences. Moreover, while, like all the authors in this book, she is interested in the question of how political agency demonstrates itself in connection with the desires and subjectivity of audience members, her analysis offers an important example of how a "participatory public culture" can be created through film, and how agency can belong to audiences in a way that involves direct engagement with the festival.

Like Kishore, Alexandra Crosby also provides a national and regional focus to activist film festival activities. She discusses various organizations and festivals in Indonesia and Malaysia that she has worked at, including the Australian NGO EngageMedia, which is based in Jakarta, South to South Film Festival, which is also based in Jakarta, and Freedom Film Festival (FFF), which is based in Kuala Lumpur. For Crosby, activist film festivals in Indonesia and Malaysia "provide opportunities for audiences to participate beyond spectatorship"; this is in the sense that that the spaces at such festivals are "sites of friction, where activists, films and the networks that connect them operate at multiple scales". Drawing on the work of Anna Tsing, Crosby says that the metaphor of "friction" is used to explore how the local and global, in the sense of both local and global space and local and global imaginaries, interact in complex, nuanced ways. "Scale" refers to the spatial dimension of a project and the breadth and depth with which such a project can be viewed. She says of the FFF, for instance, that it "is a travelling festival that takes place in multiple locations where Malay is a common language: Malaysia, Singapore and Indonesia". She also says that it puts on regional events, such as when it is partnered with EngageMedia in 2014 "to organize a special screening of Freedom Film Festival films in Jakarta, with a programme of films from Cambodia". Crosby explains that the aim of such festivals is to provide "screening spaces for diverse content, opportunities for data to be exchanged (films are often shared on discs or uploaded to hard drives) and social spaces for film-makers and organizers who work together primarily online to meet face to face". Moreover, collaborations with organizations

like EngageMedia can bring "audiences together that were not previously connected, and in doing so, open up discussions about regional solidarity", even if such discussions happen online – through social media or via the "publishing portal at engagemedia.org, which provides festival organizers with free access to a diverse range of open licensed video content" – as much as through face-to-face communication. The FFF not only shows how festivals can work at "multiple scales of activism", but also how a "regional humanitarian imaginary" can be created which "makes audiences imagine different types of locality". Like Crowder-Taraborrelli and Wilson and Kishore, Crosby shows how extra-cinematic activities or what Davies refers to as "off-screen space" – terms that are connected to "the film act" insofar as they are used to express what happens around and outside of activist film screenings – can provide an example of collaboration and participation that extends beyond the exhibition space of the festival. Like Kishore, Crosby also considers the role that local and regional identities, or collective imaginaries, play in activist film festival activities.

Section 4 of the book begins with Davinia Thornley's chapter on imagineNative Film + Media Arts Festival, held annually in Toronto. Thornley says that this festival "celebrates the latest film and media works by Indigenous peoples" and "is regarded as one of the world's most important Indigenous film festivals". She says that the goal of the festival is "not simply to encourage a cross-cultural encounter between Indigenous and non-Indigenous ways of knowing, but also to ask non-Indigenous people to practice self-reflectivity in terms of the *limits* of their understanding of what they watch". While, like authors such as Tascón and Davies, Thornley focuses on events such as post-screening discussions in order to show how different festival practices produce activist spaces, she elaborates upon the Third Cinema model introduced by Tascón, and picked up by other authors in this book, such as Crowder-Taraborrelli and Wilson. Thornley discusses the notion of Fourth Cinema, which she says "designates a separate designation for films made by and addressing Indigenous peoples and their concerns". Such a specific position for Indigenous film-making and theory also recognizes that "Indigenous networks operate outside national boundaries", a point that offers a different angle from which to approach the question of how extra-cinematic activities make spaces political at activist film festivals, as well as how such activities can involve networks of communication that expand a given festival's reach and influence. Thornley draws on the concept of Fourth Cinema to discuss how the imagineNative Film + Media Arts Festival facilitates collaborative criticism and curation in order to force spectators "to not only confront the differences between themselves and others but [also] acknowledge and live with those differences" and perhaps even begin "to question their own position and value systems so that the work of watching alters the critic/viewer as well". Here we see an affirmation of difference and diversity that resonates with what Winton and Turnin and Owen say in their respective chapters about pluralism. The latter's desire to find a way to help spectators see the world outside of stereotypes and binary distinctions, a desire also reflected in Tascón's work, particularly resonates with Thornely's contention that the models of Fourth Cinema and collaborative criticism can be used to encourage audiences to recognize that, in order to understand the Indigenous stories and experiences they see

on-screen, they have to be willing to explore the limits of their own knowledge whilst at the same time enter into dialogue with the "other".

The next chapter in Section 4 is Ana Gilbert's who looks at Brazil's International Disability Film Festival *Assim Vivemos* (*The Way We Live*). Gilbert draws on French philosopher Michel Foucault's notions of "heterotopia" and "governmentality" in order to examine the festival's perspective on disability as well as the influence this perspective exerts on audiences. "Heterotopia" refers to a real space that is discordant, dynamic and non-normative, a space "outside of all spaces", that is to say, different from all other spaces in a certain culture. Such a space has mirror-like qualities insofar as it can reflect, contest, distort or invert other spaces that are external to it; in this sense, a heterotopic space is a counter-site. Broadly speaking, "governmentality" has to do with (i) the techniques and tools that one group may use to govern the actions or modes of thought of another group or individual and (ii) the tools and techniques that an individual may use upon him or herself to structure and shape the field of their possible thoughts and actions. It is important to note that these two aspects of governmentality can involve power relations that are based on "empowering" groups or individual subjects rather than removing liberties – for Foucault, governmental power has to do with the way groups and individuals are guided towards certain actions or with having certain ideas, which includes the work that goes into identity-construction and self-exploration.

Utilizing these two concepts Gilbert argues that, on the one hand, *Assim Vivemos* creates a space that employs "persuasive discursive strategies" to orientate spectators towards alternative ways of thinking about the human body. She says that the festival aims to be "an other space which can be defined as heterotopic" to the extent that it "exhibits different realities about individuals with disabilities". One way that it exhibits such diversity is through its international selection of films, which enables the festival to represent disability within different social contexts. On the other hand, Gilbert says that the festival "implicitly reinforces what it intends to question by making use of narratives of overcoming". Such heroic narratives emphasize the commonalities that "typical" and "atypical" bodies have; namely, abstract human qualities such as individual identity and conscious freedom. Gilbert says that such narratives can render invisible the unique, and legitimate, life-world experiences that people with a disability have: "the materiality of the body remains in the background and the tendency is to minimise biological differences, experiences of embodiment and particular needs". In order to demonstrate how the festival constructs disability in relation to what is normal and non-normative, Gilbert provides a discourse analysis of the history of disability narratives. In this sense her work can be linked with other chapters in this book that consider the ways activist film festivals are interconnected with broader social, political and/or industrial factors, such as Winton and Turnin who consider documentary film festivals in relation to broader institutional and social forces that currently define and shape activist practices, and Wils who contextualizes the way the Human Rights Arts and Film Festival (HRAFF) engages with its attendees in terms of the language and practices of institutional human rights discourse.

The final chapter in the book is Stuart Richard's piece on queer film festival audiences. Echoing Davies, Bronkhorst and de Jong and, in particular, Owen's respective interests in the different kinds of subject-positions available to audience members at activist film festivals, Richards highlights "the potential for contemporary queer audiences to be both consumers and be spectators of ideologically progressive films". Richards discusses the kinds of images of homosexuality in popular queer films programmed on the festival circuit. He argues that, on the one hand, festivals such as the San Francisco International LGBTQ Film Festival – Frameline show films that reproduce the ideology of homonormativity. Richards explains that homonormativity refers to the construction of an "ideal" homosexual subject, an identity based on middle-class consumption and domesticity. In some ways functioning similar to the way narratives of overcoming in Assim Vivemos displace the singularity and material of disability experience, by emphasizing how able and disabled people are similar rather than different, homonormativity values dominate mainstream heterosexual culture. The result of homonormativity for homosexual identity is de-politicization, because a norm is established that imitates "heteronormative archetypes" at the expense of recognizing and affirming difference. On the other hand, Richards says that the same festivals can also programme films that "distinctly challenge" homonormativity. For example, Frameline 35 in 2011 "opened with a film that explores the relationship between a young transgender woman and her father" while, in 2012, the Melbourne Queer Film Festival opened with a "road movie with Olympia Dukakis and Brenda Fricker as an elderly lesbian couple travelling to Canada to get married". Such films, Richards claims, "challenge pre-existing dominant norms" and provide "voices for identities traditionally marginalised in the gay mainstream media". Adopting the perspective that the films screened at a festival need to be looked at as key elements of the festival apparatus that can influence the collective identity of audiences, Richards suggests that "Queer film festival programs offer a complex interplay between conventional media practices and attempts to rupture dominant norms". It is in this sense that he believes that an individual attendee at a given festival can be "both a customer and a politically active subject".

Closing thoughts

We do not wish to suggest that the relations of power are not ever present in the relationship between powerful viewer and producer of images, and the subject of the images, in activist film festivals. And we cannot discount the ever-present possibility that these relations of power continue to produce this "other" as able to be represented as suffering victim in order to engender pity rather than solidarity; along with the fact that this unequal relationship forms part of a much more expansive matrix of global power. We only wish to pose the possibility that some contexts of viewing interrupt the closure of this impulse.

Activist film festivals appeal to their audiences for different reasons than those that cohere non-activist film festivals, and it is for this reason that this book came into being. We hope that the reader of this book will begin to consider more closely that what we have

posed does not negate either those scholars interested in humanitarian viewing, nor those concerned with film festivals more widely. What we are hoping to begin to open up is the idea that film festivals that are of an activist hue – that is, those that are not simply appealing to a "humanitarian gaze" that is ultimately about ourselves – pose for both festival studies and visual humanitarian studies a set of questions that are more productive both politically and ethically. It may be that film festivals, even within their use of newer online platforms, still retain some of the older discourses of being disruptive of an order, and in activist film festivals, this is ever more important. It is certain that what goes into, and what goes on, in activist film festivals, towards orienting audiences differently, needs some further study. It is the ultimate hope that this book will engender the debates that will lead to that.

References

Barnett, M. (2013), *Empire of Humanity: A History of Humanitarianism*, Ithaca, NY: Cornell University Press.

Bazin, A. (1955/2009), "The festival viewed as a religious order", in R. Porton (ed.), *Dekalog 3: On Film Festivals*, London and New York: Wallflower, pp. 13–19. (Originally in *Cahiers du Cinema*, June 1955 [trans. Emilie Bickerton].)

Blažević, I. (2012), "Film festivals as a human rights awareness tool: Experiences of the Prague One World Festival", in D. Iordanova and L. Torchin (eds), *Film Festivals Yearbook 4: Film Festivals and Activism*, St Andrews: St. Andrews Film Studies, pp. 109–120.

Boltanski, L. (1999), *Distant Suffering: Morality, Media, and Politics*, Cambridge: Cambridge University Press.

Bornstein, E. (2009), "Spaces of empathy: Humanitarianism and the activist imaginary", http://www4.uwm.edu/c21/pdfs/fellowship_project_summaries/Bornstein.pdf. Accessed 22 June 2015.

Chouliaraki, L. (2006), *The Spectatorship of Suffering*, London: Sage

—— (2013), *The Ironic Spectator: Solidarity in the Age of Post-Humanitarianism*, Cambridge and Malden: Polity Press.

Czach, L. (2004), "Film festivals, programming, and the building of a national cinema", *The Moving Image*, 4:1, pp. 76–88.

—— (2010), "Cinephilia, stars, and film festivals", *Cinema Journal*, 49:2, pp. 139–45.

Gaines, J. (1986), "White privilege and looking relations: Race and gender in feminist film theory", *Cultural Critique*, 4, pp. 59–79.

Hesford, W. S. (2011), *Spectacular Rhetorics: Human Rights Visions, Recognitions, Feminisms*, Durham, NC: Duke University Press.

Iordanova, D. (2012), "Film festivals and dissent: Can film change the world?", in D. Iordanova and L. Torchin (eds), *Film Festival Yearbook 4: Film Festivals and Activism*, St Andrews: St. Andrews Film Studies, pp. 13–30.

Iordanova, D. and Torchin, L. (2012), *Film Festival Yearbook 4: Film Festivals and Activism*, St Andrews: St. Andrews Film Studies.

McLagan, M. and McKee, Y. (eds) (2012), *Sensible Politics: The Visual Culture of Nongovernmental Activism*, New York: Zone Books.

—— (2012), "Introduction", in M. McLagan and Y. McKee (eds), *Sensible Politics: The Visual Culture of Nongovernmental Activism,* New York: Zone Books.

Osiatyński, W. (2009), *Human Rights and their Limits*, New York: Cambridge University Press.

Rancière, J. (2004), *The Politics of Aesthetics* (trans. G. Rockhill), New York and London: Continuum.

Sobchack, V. (1999), "Towards a phenomenology of nonfictional film experience", in J. M. Gaines and M. Renov (eds), *Collecting Visible Evidence*, Minneapolis and London: University of Minnesota Press, pp. 241–254.

Solanas, F. and Getino, O. (1969), "Towards a third cinema", *Documentary is Never Neutral*, http://www.documentaryisneverneutral.com/words/camasgun.html. Accessed 18 February 2015.

Sontag, S. (2004), *Regarding the Pain of Others*, London: Penguin.

Tascón, S. M. (2012), "Considering human rights films, representation, and ethics: Whose face?", *Human Rights Quarterly,* 34:3, pp. 864–883.

—— (2015), *Human Rights Film Festivals: Activism in Context,* Basingstoke: Palgrave Macmillan.

Torchin, L. (2012), "Networked for advocacy: Film festivals and activism", in D. Iordanova and L. Torchin (eds), *Film Festival Yearbook 4: Film Festivals and Activism.*

—— (2012a) *Creating the Witness: Documenting Genocide on Film, Video, and the Internet,* Minneapolis: University of Minnesota Press.

de Valck, M. (2007), *Film Festivals: From European Geopolitics to Global Cinephilia,* Amsterdam: Amsterdam University Press.

Wong, C. H. W. (2011), *Film Festivals: Culture, People, and Power on the Global Screen,* New Brunswick and London: Rutgers University Press.

Zielinski, G. (2012), "On the production of heterotopia, and other spaces, in and around lesbian and gay film festivals", *Jump Cut: A Review of Contemporary Media,* 54, http://www.ejumpcut.org/currentissue/gerZelinskiFestivals/index.html. Accessed 13 October 2015.

Section 1

Film Festivals as Platform

Chapter 1

Watching Others' Troubles: Revisiting "The Film Act" and Spectatorship in Activist Film Festivals

Sonia Tascón

[…] this is not just a film showing, nor is it a show; rather, it is, above all A MEETING!
(Solanas and Getino 1969)

Activist film festivals, films and their audiences come together within a communal space to fulfil a particular contract, one that centres on the broad aim of social change (Iordanova 2012; Torchin 2012). These spaces, it is hoped, will aid in "transforming spectators into responsible historical subjects" (Brenez 2012). This is achieved, or, rather, enhanced, I argue, through a negotiation of the three elements – films, film festival and spectators – into a set of relationships that bind them differently were their activities not "activist". In this chapter, I focus on each element in different measure, mostly because I am primarily interested in refuting a long-standing acceptance in the literature dealing with spectatorship of the sorts of images screened in these festivals, as one that promotes a relationship of "distance". Furthermore, much of this is premised on the idea that these images represent a uni-dimensionalized "suffering", which demands of the powerful spectator a response that can ultimately lead to aversion and apathy. The discourse of "distant suffering" (Boltanski 1999; Sontag 2003) emerges, I argue, from a history of gazing at humanitarian images in the powerful west from a particular context and frame; I have called this "the humanitarian gaze" (Tascón 2015). In this chapter, I propose that activist film festivals, particularly, enhance the possibility of creating "responsible historical subjects" through a process that is similar to that described by Third Cinema's "the film act" (Getino and Solanas 1969). This attempts to position spectators in a relationship with films that is intended to close the distance with the film subject, but also to construct a more equal relationship, one where complexity may emerge more readily.

In this chapter, I outline how the types of films screened, and the activist festival as a space of disruption and irruption, enhance proximity between spectator and film subject, mostly by enabling complexity to emerge, a necessary condition to fostering solidarity and a stronger commitment to social change. This relationship is mirrored in Third Cinema's manifesto, in which the relationship between film and spectator is named "the film act". It is a relationship that attempts to recover a political project distinct from that described by "distant suffering", one that requires a:

> […] paradigm shift, an epistemological break, so to speak, that recovers the dialogical nature of the gaze, in which the camera is an actor and reality is the coauthor […] [and]

is born in the act of viewing itself, in the special moments when the passive spectator becomes an active viewer, filled with empathy for the ghostly figures on the screen.

(Chanan 2010: 52–3)

The shift Chanan expresses is, I suggest, aided by what goes on in activist film festivals, and the gaze he refers to is a historically composed and dominant one. I have called it "the humanitarian gaze", and, although others have used the term (Mostafanezhad 2015), I use it here in a quite distinct way to not only capture the "distant suffering" that is a central discursive feature, but also that this gaze has the seeds of its own undoing. Although I do not have the sufficient space to outline fully what I mean by this term, its development and its deconstructive dimensions, I provide some of its historical context and developments here, in order to move onto describe how "the film act" (film element) and activist film festivals (film festival element) pose, and enact, the actual shift proposed by Chanan. In this way, activist film festivals work towards activating and constructing another relationship between the distant spectator and the film (the audience element), one that, at times, relies on the dominant gaze in order to undo it.

Beginning with humanitarian spectatorship: The humanitarian gaze

The humanitarian gaze is a term I use to refer to a set of features that characterize humanitarian spectatorship. I call it a gaze because it is a powerful filter for watching others experiencing troubles, a set of pre-existing "relations of looking" that position those who watch (and produce) the images as having greater authority (validity, agency, influence, so on) than those whose lives are portrayed on the screen. This authority emanates from the very nature of watching, of being *able* to watch others (and usually only certain others), and given entry into their moments of vulnerability; indeed, that these images are produced from an attitude of mendicancy. This position bestows upon the spectator of these images the possibility of remaining distant and detached while watching others' suffering. This translates into the description of a spectator of extreme sensitivity and yet with a salacious appetite for and rapaciously consuming of others' suffering, as long as the suffering can be decisively "incisioned" to occur elsewhere. So, Susan Sontag, for example, discusses in her book *Considering the Pain of Others* (2003) that the exhibition of war photographs in the powerful west permits depictions of extreme brutality and death if these representations further a belief of the "inevitability of tragedy in the benighted or backward – that is, poor parts of the world" (64). The demand that suffering remains elsewhere and that the spectator remains removed from the actual site and causes of suffering are themes continued by other scholars. In these accounts, the spectator is drawn to the suffering of others (Boltanski 1999), may even need to be cajoled to assist through appeals to negative emotions like shame (Kennan 2004), yet remain uncommitted (or "ironic" as per Lilie Chouliaraki 2006 and 2012), but only to the point where their sensibilities are not

overwhelmed or "fatigued" (Moeller 1999; Chouliaraki 2006), at which point they may easily withdraw (Hesford 2011).

In the case of human rights, a specific discourse for activism, the relations of looking in their corresponding film festivals can go one step further, where "watching" is equated with monitoring as opposed to simply looking (Tascón 2015). The added dimension of such a specific discourse for activism positions the powerful spectator differently, already in a fractionally more active and committed pose as monitors of a universalist vision of human subjectivity, albeit retaining the inequality of the relationship between the spectator and film subjects by the persistent uni-directionality of the gaze. This distinction is important for my argument, although the specifics of the "human rights gaze" versus "the humanitarian gaze" are not my focus here. The distinction begins to point to a plethora of spectatorial positions possible within the entire realm of visual activism. It is to a diversity of "looking relations" in the realm of humanitarian visual activism to which I want to turn the reader's attention because, as I argue below, there are others being made manifest that are not characterized by "distant suffering". Distinctions that need drawing more closely have to do with viewing contexts as well as the nature of the images themselves. For example, Luc Boltanski, credited with coining the phrase "distant suffering" in his 1999 book *Distant Suffering: Media, Morality and Politics* prepares his analysis from news items about humanitarian tragedies. The humanitarian project itself grew out of, and was fed by, news agencies reporting on tragic events.

Humanitarianism is a powerful discursive regime (Foucault 1972, 1979) and practice of intervention in others' troubles, informed by an unequal power relationship between giver and receiver, based on both economic and political factors, and premised on a form of relief that emerges from "suffering" in conditions of immediacy and emergency (Middleton and O'Keefe 2007; Lischer 2005). Humanitarianism as an institutionalized undertaking has a lengthy history, but it has mostly been associated with aid in times of crises as a result of natural disasters, or "man-made" violence such as civil unrest, genocide, war, famine and so on (Barnett 2013). These are abrupt events that result in catastrophic dislocations, violence, conflict and immense suffering. Most of these troubles have historically arrived firstly as news items for the powerful spectator of the West. Michael Barnett, tracing the history of humanitarianism, draws the direct connection between the growth in humanitarianism as a profession, and news. These images are distributed

> [...] by twenty-four hour news agencies, the world could now watch the horrific spectacles of state failure and civil war, ethnic cleansing and genocide, the use of children as soldiers capable of committing war crimes, and the flight of people from all forms of violence, only to find "safety" in city-sized refugee camps without adequate food, shelter or medical care.
>
> (Barnett 2013: 2)

The stock trade of humanitarian images is of people from the non-affluent world experiencing persistent and consistent violence or disaster; emergencies or catastrophic situations of

deprivation and displacement; war, unrest and genocide, but also longer-standing social evils such as sex trafficking (Brown et al. 2010). While some, such as sex trafficking, represent a set of social ills that are not immediate emergencies, the moral panic with which it is often greeted adds it to the list of "horrific" spectacles. I do not want to suggest that sex trafficking or other abuses are any less morally offensive because of the way in which the affluent western spectator responds. I am here wishing to focus on the modality and intensity of the reaction, which, in my estimation, enables an unequal relationship to be maintained. The "benighted" are frozen in their despondency, and the viewer of such tragedy is invited to intervene at any point because the need will always be *there*; *there* being always somewhere else, and always present and ready for intervention. Although with the advent of the Internet and social media, these sites of dissemination of humanitarian images have changed, the construction of the humanitarian gaze can still be said to have originated under these conditions.

The permission some have to gaze at others' troubles or vulnerabilities, which accompanies the unequal relationship of the humanitarian gaze, and to intervene in their lives as part of the broader humanitarian project is, in part, possible from the construction of this ongoing state of immediacy and urgency. That is the power of the humanitarian gaze, which emerges from, reflects and reproduces geopolitical power, as much as shapes the spectator of visual activist material. This stance is powerfully dominant and important to understand because it is where many audience members begin as they enter an activist film festival. In my own research, looking at programming in human rights film festivals (Tascón 2015), I did not consider specifically issues of spectatorship. From programming decisions and audience reactions, and from the scholars' discussion above, however, I conceptualized that this gaze had distinct features, one of the most significant being the ways in which it organizes the spectator's viewing. The spectator filtering through the humanitarian gaze tracks across the story-arc of the films for a couple of well-developed tropes, and is unsettled when it does not find them. (Here I can only provide a short glean of my findings as this is not the focus of this chapter.) One of those is the overwhelmed, passive victim: of powerful forces beyond their control, such as "modernization", or "environmental crises". The point to this figure is not that they experience troubles, but that they are "passive" and disabled from acting in the face of their troubles. This figure enables the "saviour-spectator". The other figure is of the active freedom fighter, working to become more "like us". With this figure, the spectator is not so much concerned that the film subjects are seeking their liberation, but that their political project coincides with ours in some way. That is, that "their" project is emulating "our" social, political or economic models, for example, seeking democracy, or western-style education. With this figure, the spectator identifies or becomes the "facilitator-spectator". Both of these figures embody for the powerful spectator an affirmation of something about themselves rather than a disinterested concern for the welfare/struggle of another. There is a third figure although it is usually reserved for "one of us", where strength, resilience, agency and flawed, complexity are more apparent in the figures on the screen. We usually see these figures when using films to portray activism by one of "our own". As powerful as

the humanitarian gaze is, it also contains the seeds of its own destruction. By this I mean that embedded in its registers is a clear binary between "us" and "them", which can easily begin to break down when the binary cannot be sustained (e.g. when the "them" becomes one of "us", or the border is no longer clear between the two). It can also occur when the assumed mendicancy in the story-arc is not that at all, but a story intended to enhance a more equal relationship; and passivity perhaps only a mask or performance to "hook" the powerful humanitarian spectator. The best example of this was in the screening of Tanaz Eshaghian's 2011 documentary in the 2011 Human Rights Watch International Film Festival, which I describe in more detail below.

Love Crimes of Kabul

Prior to the screening of *Love Crimes of Kabul*, the festival posted a description that enticed audiences to a film that seemed to fulfil familiar themes related to the "Muslim woman". This was the festival's description of the film:

> Jailed for running away from home to escape abuse, for allegations of adultery, and other "moral crimes," the women of Afghanistan's Badum Bagh prison band together to fight for their freedom. The film follows three young prisoners as they go to trial, revealing the pressures and paradoxes that women in Afghanistan face today, and the dangerous consequences of refusing to fit into society's norms. Their defiant actions come to be seen as threats to the very fabric of society, and their acts of self-determination as illegal.
>
> (Human Rights Watch International Film Festival 2011)

Already the description is filtering the subjects of the film for the potential audience, making them palatable. This description uses elements of the first two figures described above: as victims of a set of moral codes that are oppressive of women; and as defiant freedom fighters whose struggles have to do with opposing oppressive social norms and working towards self-fulfilment. In fact, none of these things actually take place in the film, the women were neither "banded together" nor fighting for a generalized cause, although they were shown as having high levels of *determination* and cunning. The film is a snapshot in the daily lives of three women in Badum Bagh Women's Prison as they await judicial decisions, all of them jailed for transgressing moral codes of conduct: Kareema, for extramarital sex; Aleema for running away from home (which, one of the guards in the film says, is akin to fornication) and Sabereh who was denounced by her father after he caught her having anal sex with a boy (although this fact only emerges later in the film). The film gives us a clue as to its intentions to transgress the clear binary of the humanitarian gaze from the beginning credits, to turn it on its head as it were, when the title is shown in English and is then gradually written in Dari in the direction in which Dari is written, what to European languages would be "backwards". This already signals that the film will not be fulfilling

familiar expectations. And this is exactly what unfolds as Eshaghian skilfully shows the women's stories in the earlier parts to be what the audience expects: victims for falling in love and expressing it; then slowly unravelling a far more complex situation. Kareema is initially shown as unfairly jailed merely for having had sex with Firuz, the boy she loves. Aleema is first portrayed as having been jailed solely for running away from a violent household and ending up in her aunt's house. Sabereh is described as having been arrested while having dinner with her boyfriend for "intending to have sex", while making much of the fact that she is still a virgin. As the film progresses, however, a much more nuanced situation is exposed and Kareema is shown to be extremely cunning and devious, using her pregnancy to denounce her and Firuz in order to force him to marry her. She says at one point "I think by doing this I get the man I love". Aleema is shown to be equally self-serving in her decision not to marry her aunt's son when that would ensure their release, because she knows that the terms of marriage are her only weapon for the future. Sabereh, we subsequently discover, had been caught by her father in the act of anal sex with the boy in question and that her father denounced her in order to teach her a lesson, an action he subsequently regretted. Kareema and Aleema are subsequently released. Firuz was forced, by the courts and social custom, to marry Kareema, and Aleema was released and chose to return to her family. Not only are the women shown to be deceitful, cunning and strategic, their original actions were also taken knowingly. None suffered ill-effects other than Sabereh who ends up serving a jail sentence, but whose father bitterly regrets being the agent who brought this about. Kareema is, indeed, shown to be actively and assertively directing her new husband and his family, even before her release.

The reaction of audiences at the festival was bewilderment. One of the audience members asked the film-maker in a Q&A after the screening whether she had intended to portray the women as devious in love. The question betrayed an idealization of love that is culturally specific (and which the women in the film also shared as they initially characterized their situation in these idealized terms), as much as the fact that the romanticization is, in part, necessary to fulfil the contract of the figure of victim/fighter. When the characters in the film stepped outside the idealized version necessary to enthral them in the roles of victim/fighters (for the cause of individually choosing love), there was discontent in the audience. Love, in the context of this film, and the context of its screening – an activist space contending with issues that need addressing – becomes the focal point for the filtering of the pre-existing demands of the humanitarian gaze. Victim means helpless and passive in the face of injustice; fighter means self-sacrifice for a higher cause (in this case the audience recognizes love as the higher cause, and so the women are understood to be fighting for "our" understanding of it). Deviousness and artfulness are not part of the equation because love is to be understood "our way" – a romantic ideal that individuals feel, not a social phenomenon with cultural specificities through which a network of responsibilities and obligations is met, as well as having political dimensions. Eshaghian replied that it was naïve to expect love to be pure and selfless. In this answer she was asserting a double fact: that, in fact, romantic love is never

devoid of power, the power invested in the productive/reproductive union; and that to expect this in others is to continue to paralyse them in our need to have this fulfilled, even if this is constantly being questioned on the screen about "our" subjects (one only has to think of the popularity and plethora of films, and television programmes, centred on "dysfunctional" families in the Anglophone world). In effect, it is a desire to "other" the power dimension of love when it has been impossible, and even harmful (I'm thinking of the Brady Bunch phenomenon as I write this), to fulfil romantic love's idealized promise to ourselves. The simplification of the "ideal" of love, the seeking of a film subject whose suffering revolves around a simplified version of that, while not demanding that of ourselves, uni-dimensionalizes that film subject in order that we may consume them; in this case, in order that we may be justified to continue intervening in their lives. Eshaghian presented us with a more complex subject, one that more closely approximates our own messy existences with romantic love, and for that she was seriously questioned. But that these sorts of uneasy films can be exhibited, that these questions can be raised to increase complexity; these are the topics I turn to next. Because, I argue, activist film festivals are propositioned from within the very heart of their histories, to unsettle the dominant order. This becomes a discursive demand for the spectator to engage actively with the images. Hence, festivals are a space where the humanitarian gaze can be unravelled. Due to its disruptiveness, the activities and films selected in activist film festivals often position spectators in a different sort of relationship with the images; that relationship is akin to the one proposed by Third Cinema (TC) and "the film act", and I turn to an exploration of this next.

Activist film festivals and Third Cinema

The possibility of the subversion of the humanitarian gaze is heightened, I suggest, in a film festival because of a number of factors, the most significant of which is the disruptive discursive framework within which film festivals operate. Film festivals, as all festivals, have within their origins a disruptive element, similar to Bakhtin's "carnival" (Bakhtin 1984). Film festivals emerged out of a European history to curtail the power of Hollywood and subversively encourage national cinemas (Czach 2004). They continued this tradition as they began to fragment into specialized exhibition spaces (de Valck 2007), from whence activist film festivals emerged, largely through a stance of oppositional "unruliness" (Zielinski 2012). Third Cinema, similarly, was born of a motivation to provide alternatives to First Cinema (Hollywood, primarily) and Second Cinema (avant-garde cinema of Europe primarily). Third Cinema was, instead, to foster the production of local stories and the films were to be structured in such a manner that they would encourage discussion; there was to be no easy and ready consumption of the images. The new relationship was termed "the film act", which involved both the purposeful production of films to engage discussion, and that they be relevant to "the protagonist of life" beyond the film. Films were to be the *catalysts* for

audience discussions by having direct relevance to its viewers and their communities. So, before I turn to activist film festivals' potentials for configuring a responsible spectator/ subject, I want to turn to this idea of "the film act".

The film act: The protagonist of life

Third Cinema (TC) was a political project as much as a cinematic one. In order to understand "the film act" as an aspect of TC, it is important to cover a little background and the aims of that brand of cinema. Although scholars often mention the significance of earlier Latin American film scholars/film-makers to the development of TC (Guneratne 2003), here I attribute much of the actual name for this movement and its specific aims to the 1969 essay by Fernando (Pino) Solanas and Octavio Getino *Towards a Third Cinema*. It is to this essay that I address the following comments, acknowledging that many other scholars have followed and developed TC further since that time. It was also in that essay where the term "film act" or "film action" was used.

By way of a brief background, *Towards a Third Cinema* emerged out of political struggles in Latin America in the 1960s and 1970s, during which time films were used for social commentary regularly. As Anthony Guteratne (2003) points out, cinema had been imbricated in liberation struggles and decolonization movements during the 1960s in Cuba, Brazil and Bolivia, and film scholars from these nations produced essays on the subject prior to, alongside and after the work by Solanas and Getino. For example, Glauber Rocha's *An Aesthetic of Hunger* (1965; from Brazil); Julio García Espinosa's *For an Imperfect Cinema* (1979; from Cuba); Jorge Sanjinés' *Problems of Form and Content in Revolutionary Cinema* (1979; from Bolivia). The number of film-makers who are said to have been involved in "liberation cinema", or "militant cinema", a term used by Solanas and Getino for TC, is even wider, including Argentina's Fernando Birri, Humberto Ríos, Raymundo Gleyzer, as well as Cuba's Santiago Alvarez, to name a few. Michael Chanan has listed the impact TC had on diverse activist cinema in other parts of Latin America, namely in Mexico, Uruguay, Colombia and Chile, but also outside the continent in Africa, the Middle East and Asia (Chanan 1997). Third Cinema had been conceptualized primarily as a reaction to what Getino and Solanas termed First Cinema (Hollywood) and Second Cinema (auteur), as these were films that represented the "entertainment" and "art" impulses, respectively, and were said to be alienated, and reproduced alienation, from the sociopolitical life-world.

In this regard, TC makes direct political claims to films' deep and direct implicated-ness in the world of social living, the life-world according to Vivien Sobchack (1999), when she is discussing the relationship of that world to documentaries; as being of that world rather than reified, or abstracted, from it. As Mike Wayne remarks, TC "is a cinema primarily defined by its socialist politics", which places it up against a lived world in which cinema is used to "address unequal access to and distribution of material and cultural

resources, and the hierarchies of legitimacy and status accorded to those differentials". Third Cinema is, therefore, a film practice that was always intended to be in a direct and ongoing relationship with the life-world its cinema represented, and could not be divorced from those material realities.

The "film act" fits in the wider context of TC as a mechanism by which film and its spectators become one in a broader political field, one which demands involvement in the film, and by the film in the world beyond. Films are therefore not closed circuits but "open-ended", organic and living texts that form part of life as lived "by the principal protagonists of life" (Solanas and Getino 1969). In their 1969 essay, Solanas and Getino sought for films to be produced so as to promote "the active involvement and subsequent political participation of the viewer" (Chanan 2011). Films and their viewers were to be indispensable to each other, bonded through a mutual need: social change. Films, while having a life of their own are, ultimately, to be produced in the service of "the protagonist of life"; indeed, Solanas and Getino go further, suggesting that films' life is *for* the "protagonist of life", and its subsumption to that liberates the form from meaninglessness (Solanas and Getino 1969).

Essentially, films produced within the scope of Third Cinema's visions promote an active and interactive relationship between life-world, film, and spectator. In this way, film and film watching become more than "spectating" – premised as this term is on the notion of spectacle, in which the screen is mere performance that exceeds the spectator and his/her world. Film and its viewer open each to the other; film is a "detonator, or pretext" (Solanas and Getino 1969) to bring together the world of lived experience, the spectator as protagonist and actor, and film; finally, instigating action that includes the film in the act but goes beyond the film (Iordanova 2012) but is in need of it. Film is a pretext for that coming together, yet not a pre-text, alone and before the others in the relational network. This positions the spectator as actor in the act of viewing, and as an ethico-political participant in the life of which she/he is protagonist as well. The active engagement between films and their viewers place them in a commensurate, engaged encounter, unlike the powerful spectator of the west of which Lilie Chouliaraki writes, whose shift away from "common humanity" has led to "a disposition of detached knowingness" (Chouliaraki 2013: 2). The encounter of film with spectator is, then, a beginning not an end, a re-opening out to the world in a different note:

> This is why the film stops here; it opens out to you so that you can continue it. The film act means an open-ended film; it is essentially a way of learning.
>
> (Getino and Solanas 1969)

The relationship that is sought in TC between film and its spectators is deep and engaged.

It is important to point out that film festivals were integral to the development, dissemination and propagation of TC throughout Latin America to begin with (Mestman 2013-2014: 18–79), and then worldwide.

Activist film festivals: Life "beyond the film"

I think the whole point of having this type of film festival is the transfer that takes place from the screen to the audience. This transfer hopefully inspires some form of action.

(Farnel cited in Fischer 2012: 227)

The networks in which the image circulates and the platforms by which it is manifest rest upon differing epistemologies and infrastructures. These different modes of circulation address distinct publics and make possible varying forms of political action, enabling particular claims to be made while foreclosing others.

(McLagan and McKee 2012: 10)

I want to propose that activist film festivals enhance the possibility of an engaged and questioning spectator, even one invested in the humanitarian gaze, because such festivals "embrace" spectators differently. In an activist film festival, the viewing of films is but one part of the usual fare; film screenings are part of a network of activities within the festival and beyond, so that spectators are guided towards a life "beyond the film". In a similar manner to Third Cinema's positing of the viewing of films as an "act" (Solanas and Getino 1969; Mestman 2003) rather than disconnected consumption, these settings position films and spectators as part of an intimately connected community. Along with the use of documentaries that results in a closer identification with the screen subjects, the pre- and post-screening activities add to the possibility of an active, engaged spectator that is further removed from the detached, ironic spectator that Chouliaraki (2013) mentions in her conception of the humanitarian imaginary in *The Ironic Spectator*. I am deeply indebted to Lilie's work in this area as it influenced directly my notion of the humanitarian gaze. I could not give sufficient acknowledgement to her here, but do so in my 2014 *Human Rights Film Festivals* book (see References). In what follows I focus primarily on the post-screening discussion in activist film festivals, as they have the greatest intersections with TC's "the film act" and hence increasing the potential for enhancing the responsible historical subject mentioned by Brenez, above.

Film festivals, as Ger Zielinski (2012: online) points out, are organized by "the possibility of social unruliness and limited rebellion". As he elaborates, festivals are, at least in their inception, a contained space for the celebration of "otherness" and deviance, but always within boundaries that are authorized by the communities and discourse(s) within which they perform that social unruliness. So, for example, human rights film festivals are authorized to act within the discursive bounds of "human rights", and function to celebrate the "otherness" of marginalized groups whose rights have been compromised. Activist film festivals perform that unruliness further through the encouragement of an active, critical viewer, who disrupts the social order through "the question". The act of a question is a disruption and a trigger to interrupt an established order. In the question is the seed of an opening; a door to avenues unexplored or unnamed. When the audience member

asked the film-maker of *Love Crimes of Kabul*, Tanaz Eshaghian, what she had intended, the question revealed elements of a gaze unnamed until then (within that film screening, at least). Eshaghian's film upset that order, deviated from the norm, and the programmers included such a film for its subversive characteristics. But the audience question opened up the film's full disruptive potential.

Post-screening discussions are not only usual in activist film festivals; they are also essential features that often encompass lengthy and complex debates. Ezra Winton and Svetla Turnin, in this volume, consider the ways that panel discussions in activist film festivals are more than a staple feature; they are usually an integral part of a film screening. Furthermore, in differentiation to other film festivals where post-screening panel discussions take place, in activist film festivals they are lengthier, more complex discussions that expand on the film beyond its immediate narrative or aesthetic/production elements. These discussions are usually intended to make the connection to the social world in ways that other panel discussions in other film festivals do not.

Dina Iordanova makes specific mention of the post-screening discussions and "outreach and community building" dimensions of activist film festivals, as elements that not only distinguish them from other film festivals, but also encourage an active participant:

> The topical debates are probably the single most important feature that makes a festival activist: it is in the context of these discussions that a more complete understanding of a film can crystallise and a call to action can take place. In fact [...] the discussion is as important as the film screening and undoubtedly constitutes an inherent part of the festival structure. In this respect, discussions at activist film festivals differ from the Q&A sessions at mainstream festivals: the goal is not to receive insight and information about the film's making and message, but to go beyond the film and address the issues that the film is concerned with, as well as to influence the thinking of the audience. Thus, audience engagement is of prime importance.
>
> (Iordanova 2012: 15–16)

Films are located within these festivals in a relationship with their audiences that closely resembles the "film act" of TC. In the phrase "beyond the film", Iordanova points to the function of films as primers of the action in which Third Cinema's "the protagonist of life" (Solanas and Getino 1969) is encouraged to be involved; one element in a community of events, symbols, artefacts and people whose role is to view life differently and then act to change the life conditions for another. Whether these audiences enter these spaces to see "suffering", or to join in a "common humanity", in solidarity with others, is almost irrelevant; the discussions have the potential to excavate meanings and dimensions of that relationship not available through the individual consumption of images. It is the collection of all of these things in one space, a space that is then transformed for collecting and unearthing new meanings, that makes activist film festivals a place where a particular type of spectator is facilitated, one that may be less detached and prone to the expectation of seeing tragic victims.

Hamid Naficy (2003) calls the sort of spectatorship in an activist film festival a "hailing and haggling". The term emerges from his experiences of running a festival of Iranian films at UCLA (University of California, Los Angeles). In his words, "film festivals are prime sites for intensified national and transnational translations and mistranslations, as well as hailing and haggling over acts of representation" (Naficy 2003: 197); spaces for collecting competing interests and visions, and negotiating. Of course, the negotiations are never absolutely equal, as film festival scholars have pointed out (Stringer 2001; de Valck 2007). But they also provide spaces for the haggling of which Hamid speaks, and to that extent hail spectators to haggle. For me, this has been a constant source of inspiration, as occurred in the discussions that took place after the screening of *Love Crimes of Kabul* in the New York festival. The possibility for the audience to haggle was also evident in the Buenos Aires Human Rights Arts and Film Festival (HRAFF) of my recent research, where there were interjections (particularly by the women in the audience) during and after film screenings, and the impassioned discussions after the screenings, a phenomenon mirrored in Davinia Thornley's chapter in this volume. These experiences bore a close resemblance to Naficy's descriptions of his childhood viewing of films in Iran, where the experience was a noisy, odorous, engaged activity. Teshome Gabriel describes something similar when contrasting spectatorship among African and US audiences:

> The Western experience of film viewing – dominance of the big screen and the sitting situation – has naturalized a spectator conditioning so that any communication of a film plays on such values of exhibition and reception. The Third World experience of film viewing and exhibition suggests an altogether different route and different value system. For instance, Americans and Europeans hate seeing a film on African screens, because everybody talks during the showings; similarly, African viewers of film in America complain about the very strict code of silence and the solemn atmosphere of the American movie theatres.
>
> (Gabriel 2014)

These experiences, of a collectively shared form of viewing, while potentially merely illustrating a different cultural style of watching films, are also an alternative epistemic possibility for understanding spectatorship. In this description is an ontological relationship with film that invites films to be part of an everyday existence. This does not mean that films need to be about "our" experiences, but that they are regarded as part of that life, which includes extending our experience of the world, seeing others and other places otherwise inaccessible, and in that viewing reside political and ethical implications. The kind of viewing Gabriel and Naficy describe, and that TC directed its viewers to have, is not characterized by "distance" between spectator and film (subject), but rather a close, intimate bond that forecloses distance. Seeing other people's troubles on the screen, therefore, becomes not always and everywhere a burden, but an extension of ourselves into another universe, implicating us deeply.

Closing thoughts

Teshome Gabriel, following Solanas and Getino, asks that films "develop a new film language" (1982: 3) in order to enable them to act as motivators, and for the spectator to become actor. I suggest that activist film festivals perform some of that function although by positioning films differently, rather than by demanding them to be produced within a specific regime. In these spaces films come to be part of an entire package and in relationship with many other parts: the physical space, the organizers and programmers, the audiences, the film-makers and the life-world outside it. This is in some measure achieved by the sorts of films selected, largely documentary films, but mostly because they immerse their audiences in a communal experience (Bazin [1955] 2009; Torchin 2012) that encourages participation. The significant role that post-screening discussions can play in the total experience, leading to participation and possible action, should not be understated. Through the encouragement of active engagement and active participation, other spectating positions than that suggested by Chouliaraki's detached ironic spectator, are made possible. However, I also do not want to overstate the role of post-screening discussions in generating the possibility of an active spectator. What will ultimately motivate an affluent, powerful spectator of films watching others' troubles on a screen is far more complex than this paper could cover. What I did want to suggest, however, is that there are alternative spectating positions, some of which Sobchack, Naficy, Gabriel and Chanan, but also Getino and Solanas in 1969 with their "film act", have made available to us. I wanted to focus on the possibilities, from those who do think that an epistemic shift can take place, and how, to produce that responsible subject of Brenez's, and the empathic active spectator of Chanan's. But above all I want to highlight that the activist film festival is, indeed, a "space for togetherness and inspiring one another" Blažević 2012: 120), and "places for renewal of commitment, where one sheds the yoke of cynicism by watching empowering stories and mingling with equally committed people". And so in that togetherness is already an action that collects the space for the beginning of the road to a citizen-spectator.

References

Barnett, M. (2013), *Empire of Humanity: A History of Humanitarianism*, New York: Cornell University Press.

Bakhtin, M. (1984), *Rabelais and His World*, Bloomington: Indiana University Press.

Bazin, A. ([1955] 2009), "The festival viewed as a religious order", in P. Richard (ed.), *Dekalog 3: On Film Festivals*, London and New York: Wallflower, pp. 13–19. (Originally published in *Cahiers du Cinema*, June 1955 [trans. Emilie Bickerton].)

Blažević, I. (2012), "Film festivals as a human rights awareness building tool: Experiences of the Prague One World Festival", in D. Iordanova and L. Torchin (eds), *Film Festival Yearbook 4: Film Festivals and Activism*, St. Andrews: St. Andrews Film Studies, pp. 109–120.

Boltanski, L. (1999), *Distant Suffering: Morality, Media, and Politics*, Cambridge: Cambridge University Press.

Brenez, N. (2012), *Sight and Sound*, http://www.bfi.org.uk/news-opinion/sight-sound-magazine/features/greatest-films-all-time-essays/light-my-fire-hour-furnaces. Accessed 13 October 2013.

Brown, W., Iordanova, D., Torchin, L. (2010) *Moving People, Moving Images: Cinema and Trafficking in the New Europe*. St. Andrews: St. Andrews Film Studies with College Gate Press.

Chanan, M. (1997), "The changing geography of third cinema", in *Screen*, special Latin American edition, 38:4, http://www.mchanan.com/wp-content/uploads/2013/12/third-cinema.pdf. Accessed 28 November 2015.

—— (2010), "Going south: On documentary as a form of cognitive geography", *Cinema Journal*, 50:1, pp. 147–154.

Czach, L. (2004), "Film festivals, programming, and the building of a national cinema", *The Moving Image*, 4:1, pp. 76–88.

Chouliaraki, L. (2006), *The Spectatorship of Suffering*, London: Sage.

—— (2012), *The Ironic Spectator: Solidarity in the Age of Post-Humanitarianism*, Cambridge: Polity Press.

Espinosa, J. G. ([1979] 2005), "For an imperfect cinema", *Jump Cut: A Review of Contemporary Media*, http://www.ejumpcut.org/archive/onlinessays/JC20folder/ImperfectCinema.html. Accessed 28 November 2015.

Fisher, A. (2012), "Hot docs: a prescription for reality: An interview with Sean Farnel, former director of programming at Hot Docs Canadian International Documentary Festival", in D. Iordanova and L. Torchin (eds), *Film Festival Yearbook 4: Film Festivals and Activism*, St. Andrews: St. Andrews Film Studies, pp. 225–234.

Foucault, M. (1972), *The Archaeology of Knowledge*, London: Tavistock Publications.

—— (1979), *Discipline and Punish: The Birth of the Prison*, Harmondworth, England: Peregrine.

Gabriel, T. (1982), *Third Cinema in the Third World: The Aesthetics of Revolution*, Ann Arbor: UMI Research Press.

—— (2014), *Towards a Critical Theory of "Third World" Films*, http://teshomegabriel.net/towards-a-critical-theory-of-third-world-films. Accessed 13 January 2014.

Guneratne, A. R. (2003), "Introduction", in A. R. Guneratne and W. Dissanayake (eds), *Rethinking Third Cinema*, London: Routledge.

Hesford, W. (2011), *Spectacular Rhetorics: Human Rights Visions, Recognitions, Feminisms*, Durham and London: Duke University Press.

Human Rights Watch International Film Festival (2011), *Love Crimes of Kabul*, http://ff.hrw.org/past-festivals/2012. Accessed 11 June 2013.

Iordanova, D. (2012), "Film festivals and dissent: Can film change the world", in D. Iordanova and L. Torchin (eds), *Film Festival Yearbook 4: Film Festivals and Activism*, St. Andrews: St. Andrews Film Studies, pp. 13–30.

Kennan, T. (2004), "Mobilizing shame", *South Atlantic Quarterly*, 103:2&3, pp. 435–449.

Lischer, S. K. (2005), *Dangerous Sanctuaries: Refugee Camps, Civil War, and the Dilemmas of Humanitarian Aid*, New York: Cornell University Press.

McLagan, M. and McKee, Y. (2012), "Introduction", in M. McLagan and Y. McKee (eds), *Sensible Politics: The Visual Culture of Nongovernmental Activism*, New York: Zone Books, p. 10.

Mestman, M. (2003), "La hora de los hornos" ("The hour of the furnaces"), in A. Elena and M. Díaz López (eds), *The Cinema of Latin America*, London and New York: Wallflower Press, pp. 119–130.

Mestman, M. (2013–2014), "Estados Generales del Tercer Cine. Los Documentos de Montreal, 1974", *Rehime número 3 (Cuaderno de la Red de Historia de los Medios)*, Buenos Aires: Verano, pp. 18–79.

Middleton, N. and O'Keefe, N. (2007), *Disaster and Development: The Politics of Humanitarian Aid*, London: Pluto Press.

Moeller, S. (1999), *Compassion Fatigue: How the Media Sell Disease, Famine, War, and Death*, New York and London: Routledge.

Mostafanezhad, M. (2014), "Volunteer tourism and the popular humanitarian gaze", *Geoforum*, 54, pp. 111–118.

—— (2015), *Volunteer Tourism: Popular Humanitarianism in Neoliberal Times*, Burlington, VT: Ashgate Publishing Company.

Naficy, H. (2003), "Theorizing 'third world' film spectatorship", in A. R. Guneratne and W. Dissayanake (eds), *Rethinking Third Cinema*, New York and London: Routledge, pp. 183–201.

Rocha, G. (1965), "Aesthetic of hunger", *Diagonal Thoughts*, http://www.diagonalthoughts.com/?p=1708. Accessed 28 November 2015.

Sanjinés, J. ([1979] 1997), "Problems of form and content in revolutionary cinema", in M. T. Martin (ed.), *New Latin American Cinema: Volume One, Theory, Practices and Transcontinental Articulations*, Detroit: Wayne State University Press.

Sobchack, V. (1999), "Towards a phenomenology of nonfictional film experience", in J. M. Gaines and M. Renov (eds), *Collecting Visible Evidence*, Minneapolis and London: University of Minnesota Press, pp. 241–254.

Solanas, F. E. and Getino, O. (1969), *Towards a Third Cinema*, http://www.documentaryisneverneutral.com/words/camasgun.html. Accessed 18 February 2013.

Sontag, S. (2003), *Regarding the Pain of Others*, Penguin Books.

Stringer, J. (2001), "Global cities and the international film festival economy", in E. Shiel and T. Fitzmaurice (eds), *Cinema and the City: Film and Urban Societies in a Global Context*, Oxford: Blackwell Publishers, pp. 134–144.

Tascón, S. M. (2015), *Human Rights Film Festivals: Activism in Context*, Basingstoke, UK: Palgrave Macmillan.

Torchin, L. (2012), "Networked for advocacy: Film festivals and activism", in D. Iordanova and L. Torchin (eds), *Film Festival Yearbook 4: Film Festivals and Activism*, St. Andrews: St. Andrews Film Studies, pp. 1–12.

de Valck, M. (2007), Film Festivals: From European Geopolitics to Global Cinephilia, Amsterdam: Amsterdam University Press.

Wayne, M. (2001), *Political Film: Dialectics of Third Cinema*, London: Pluto Press.

Zielinski, G. (2012), "On the production of heterotopia, and other spaces, in and around lesbian and gay film festivals", *Jump Cut: A Review of Contemporary Media*, 54, http://www.ejumpcut.org/archive/jc54.2012/gerZelinskiFestivals/. Accessed 28 November 2015.

Chapter 2

Off-Screen Activism and the Documentary Film Screening

Lyell Davies

Behind the launch of all activist film festivals is a belief that the exhibition of film can contribute to the advancement of social, political or developmental change. For many of the activists or political entrepreneurs who organize these festivals or select the films to exhibit at them, documentary film is seen as a genre that is particularly well suited to this purpose. For this reason, the exhibition programme at film festivals linked to human rights, environmental issues, animal rights, world hunger, global inequality or similar themes tends to be dominated by documentary films. This is not a new or unexpected role for the documentary. For much of its history there has been the expectation that documentary film can play a role in changing how people think or act, thereby, ultimately, playing a role in shaping the nature of society. Whether utilized to advance mild social reform as intended by the genre's early champion John Grierson (Grierson 1966; Winston 1995), incarnated as the radical left-wing committed documentary (Waugh 1984) or pressed into service as a tool of state propaganda or reform, the documentary is thought to possess an instrumental ability to shape real conditions that is not commonly expected of other genres of film.

It is strange then that despite a healthy array of scholarship on the documentary (Barnouw 1974; Cowie 2011; Bruzzi 2000; Nichols 1991; Renov 2004; Winston 1995), there is a relative paucity of studies on the impact of the documentary on actual audiences, including little research exploring documentary viewership in specific local contexts, such as at film festivals, at activist screenings, on community television channels or in other settings where it is circulated with the express purpose of social activism. While there is reliable evidence as well as anecdotal accounts that indicate that the circulation of documentary film can be an important way for activists, human rights campaigns or social movements to advance their agendas (Alexander 1981; Gregory et al. 2005; Harding 1997; Juhasz 1995; Nichols 1980; Waugh, Baker and Winton 2010), the processes by which this actually occurs have yet to be adequately theorized. To counter this absence, in this chapter I explore the knowledge production that occurs "off-screen" among audiences at activist film festivals or screenings.

In her work on film festivals in general, Vanessa R. Schwartz argues that "extra-cinematic" and "para-cinematic" events, such as receptions, red-carpet entrances, press conferences, award ceremonies and after-screening parties, are important aspects of most film festivals (2007: 72). Film scholar Liz Czach adds that for festival attendees these events are as important as the films themselves (2010). In place of the terms "extra-cinematic" or "para-cinematic", I prefer using the more colloquial term "off-screen" to describe these events, since it is a more accessible term for use outside the academy and by those who engage day-to-day in the work of organizing film festivals or screenings. At a human rights

or activist film festival, the off-screen events on offer may include social gatherings, staged publicity-seeking events or features of celebrity culture similar to those seen at other types of film festivals. But in addition they are likely to include workshops, organizing sessions or round-table discussions where opportunities exist for information exchange about political campaign or social movement work. In tandem with planned, formal off-screen activities such as these, film festivals also generate opportunities for unplanned, informal off-screen experiences. These include chance networking opportunities among festivalgoers in the spaces of public assembly created by a film festival, such as on ticket lines or in cinema lobbies before or after screenings.

In this chapter, I draw on documentary film theory (Gaines 1999; Nichols 1980, 1984, 1991; Winston 1996), studies of film festivals (Blažević 2009; Czach 2010; Tascón 2012; Torchin 2012; Wong 2011) and sociology-based research on the operation of social movements (Groch 2001; Jasper 1999; Snow and Benford 1992; Tarrow 1994), to outline a framework with which we can explore activism in the off-screen of a documentary film festival or screening. Underlying my study is a belief that we must be critical of the ability of stand-alone documentary films to mobilize people to action as well as suspicious of the pleasures that a passive experience of documentary viewing can bring to audiences, even in settings where activism or an engagement with pressing social or political issues is the stated purpose. As Helena Zajícová, programme director of the Czech One World Human Rights Film Festival, observes when organizing a film festival, "[p]aying attention to the organization of debates and invitations of guest speakers is [...] crucial; otherwise the screenings might miss the point" (2009: 36). Indeed, although usually not recognized as such, the act of attending a documentary film festival is epistemologically strange, with festivalgoers sitting in darkened, sometimes richly accoutremented theatres to watch a parade of on-screen elsewheres, whether these be depictions of dramatic conflicts, poverty or injustice, or simply the everyday dramas or traumas of some distant person's life. At a documentary film festival, the commonly unequal relations between who is seen on-screen and who is seated in the audience is evident in a variety of ways, including a discrepancy in wealth, race, education or position in the Global North or Global South. This aspect of attending a documentary film festival usually passes unacknowledged, when it should invite all in attendance to ask, "What are we doing here?" Responding to this question, in this chapter I argue that in addition to critically examining the veracity, political intent or syntax and artistry of the documentaries that are put before us under the guise of activism, we must also rigorously evaluate the ways that we, as viewers, receive documentary films or draw pleasure from them. We must, in other words, explore ways to radicalize the experience of documentary film viewership.

It is all the more pressing that this occurs because the documentary genre is in transformation: documentary films are commonly received and valued as a "discourse of sobriety" (Nichols 1991) linked to social progress, education and scientific practices of observation and evidence gathering within civil society and the nation state. But with the recent proliferation of new and hybrid forms of documentary and other forms

of reality-based TV and media (some of which bear significant textual similarity to the documentary), as well as a restructuring of the relations between the individual, state and political life within neo-liberal globalization, the documentary's claim of the real and its civic mission of reportage and justice-advancing education within the nation state are in question (Harvey 2005).[1] In what John Corner has termed our "post documentary" age (2002: 255–269), many new forms of reality-based media have coalesced around a regime of truth that foregrounds an individual subjective experience at the expense of more general truth claims or a deeper analysis of the economic or political forces that define our lives. In media of this kind, first person narrative has been raised to the status of sole truth and "notions of community, polity and public space are distant background to the revels of a subjectivity that is its own reward and kingdom" (Brenton and Cohen 2003: 31). While most documentary makers would resist comparing their work to reality TV or other sensation-driven, drama-laden forms of non-fiction media, the form, syntax and histories of the documentary and these new or hybrid non-fiction forms are intertwined. Thus we must consider the role the documentary is playing in what Lilie Chouliaraki has termed the age of "the ironic spectator" (2013); a period where the nature of solidarity between self and others has been restructured by the ascent of a neo-liberal subjectivity that values personal gratification, and "doing good to others is about 'how I feel'" (Chouliaraki 2013: 3).

What happens off-screen is as important as what happens on-screen

An obvious but limited way to evaluate the political impact of documentary film is to seek out clear-cut cases where the exhibition of a particular film led those who saw it to take some form of direct, measurable action – one that in all likelihood they would not otherwise have taken. One illustration of this occurring is offered by the response by a group of individuals in Ireland when they viewed *In Cold Blood: The Massacre of East Timor* (Gordon 1992) during a broadcast on the British television station ITV. Spurred on by what they saw, the group formed the East Timor Ireland Solidarity Campaign, an organization that subsequently significantly contributed to raising the Irish public's awareness of the Indonesian military occupation of East Timor, eventually driving major Irish political parties to publicly state their opposition to the occupation and thereby contributing to the tide of Timorese and international opposition that eventually forced Indonesia's withdrawal from that country.[2] Examples such as this illustrate that the exhibition of documentary film can have a recordable political effect, moving individuals who were previously passive bystanders (individuals holding no views on a particular subject) or political adherents (individuals holding particular views but who have yet to act on them) to take action as fully engaged constituents within a campaign or social movement for change.

But evaluating the impact of documentary film in this way has major weaknesses. If our only way of considering the success or failure of political documentary film-making (or the screenings where films of this type are exhibited) is to look for dramatic cases like this one,

we will likely be disappointed by the performance of the documentary overall – since such cases are not the norm. Employing an evaluation method of this kind, documentary film scholar Jane Gaines reports that when she polled a group of cinema scholars and individuals involved in the distribution of political documentaries about the impact of documentary film on political conditions, the outcome was disappointing since, while the group "could list documentary films that moved them personally, they could not be certain that these films had actually changed anything for anyone" (1999: 85). The problem with this approach is that it seeks to uncover only a direct, instrumental effect for the documentary, in the process ignoring the role that documentaries or film screening events play in the day-to-day cultural life of campaigns or movements for change. It overlooks how films or film screenings can play a role in sustaining the commitment of those who are already involved in activist work, or provide a forum for constituents to come together to contemporize interpersonal relationships, which may, in turn, sustain an individual's "embeddedness" within a movement and thereby serve as "an antidote to leaving, and as a support to continued participation" (Della Porta and Diani 2006: 118).

Thus, a weakness of this method of study, as is illustrated by Gaines' poll, is that it seeks to identify films that have changed the world in broad and expansive ways – something that even mass social movements are often unable to do – while not paying adequate attention to the complex ways that individuals are drawn to political action, or sustain their involvement over time. More than exhibiting individual films that propel audiences towards singular, immediate political action, film festivals can be sites where campaigns or movements are constructed or renewed as those in attendance come together as a public and collectively develop or advance a shared way of seeing the world. These processes are no less important for ongoing activist or political organizing work than are dramatic events that appear to change the world. To borrow three terms employed by William Alexander to describe the work of 1930s American workers' movement film-maker Harry Alan Potamkin: committed films can "expose" social or political conditions in need of redress or "impel" people to take action on these conditions, and they can also "sustain" the work of constituent activists who, or organizations that, are already converted to a cause (1981: 23).

Furthermore, a narrow instrumental analysis of the immediate effect of a documentary on its viewers, such as I have described, assumes the presence of an audience of fully formed, politically savvy citizen-viewers – individuals who, once they are provided with information about a particular injustice, possess both the political competency needed to take action on the issue and access to the channels they will need for their action to be effective. The presumption of the pre-existence of this ideal viewer ignores deeper questions about the processes by which people become active constituents within campaigns or social movements; how the political knowledge and motivation needed to participate in these activities are generated; as well as how those who engage in political work access the prerequisite resources and networks needed to be effective. Implicitly, by assuming that an idealized, politically fully competent documentary viewer is present from the outset, this way of thinking also fails to consider that a viewer's response to a film may be dramatically different to the one intended

by the film's maker. For example, the viewing of a film depicting oppression or injustice can, irrespective of its maker's intent, simply foster compassion fatigue or a politics of despair among viewers if they are not provided with both an understanding that change can occur, and knowledge about how it can occur (Chouliaraki 2013; Moeller 1999).

In a similar fashion, this way of thinking also ignores that there may be other less laudatory pleasures that attract viewers to documentary films, ranging from voyeurism and the pleasure of seeing how others live or how they suffer, to an affirmation of the self or one's own culture through the viewing of others who are seen as ethically, culturally or economically backward (Boltanski 1999; Sontag 2002; Chouliaraki 2013). Indeed, a feature of the way that the history of documentary film-making has been recorded in cinema history is a downplaying of the presence of a prolific history of "shockumentary", exploitation and sexploitation documentary film-making, including films that propagate colonial worldviews and orientalism. These films are the "unwelcome documentaries" of documentary film history, and their existence is typically only noted in passing.[3] A minimizing of the history of documentary making of this kind conceals the fact that audiences seeking to engage in voyeurism, the arousing scopophilic pleasures associated with viewing sex acts, or fantasies of superiority and/or the domination of others have been drawn to documentaries since the birth of the genre. With these pleasures as an established, if largely unacknowledged, feature of documentary viewership, we cannot assume that they are not also present in the reception of films that are intended to advance humanistic ideals. As Sonia Tascón argues, films depicting backward-region-centred narratives may enable festival audiences to hold those they see on-screen "in a position of eternal suffering" for the benefit of the more powerful in the relationship, the film-festival-attending western viewer who draws from the experience the satisfaction of affirmed feelings of superiority (2012: 872). Thus, even in settings where the advance of high-minded ideals may be the stated purpose, audiences may be drawing other pleasures from their viewing experience, including those that are rooted in the reaffirmation and maintenance of unequal power relations between themselves and those who are seen on-screen.

Off-screen knowledge production

Rejecting the notion that the value of documentary film as a tool for change should be measured only by looking for dramatic instances such as the Irish example I have described, it is productive to examine the ways that the film exhibition site can serve as a potentially rich location for the production of political knowledge. Illustrating how the off-screen can operate in this manner is the example of a video screening I attended at Charas/El Bohio Community Center in New York City's Lower East Side in April 2001. On exhibition at this community screening were roughly edited videotapes that had been recorded a few days earlier by protestors at the anti-corporate/globalization convergence in Quebec City, Canada, during the Summit of the Americas – where the Free Trade Area of the Americas

was being negotiated. Videotaped by the protestors themselves, the videos that were screened depicted street performances and puppetry; chanting and singing; the tearing down of the security fence erected to prevent protesters from entering the centre of the city where the summit was held and violent clashes between police and a small group of militant protesters. During the screening, those in attendance, most of whom seemed to have been in Quebec City during the convergence, cheered the actions of those seen on-screen, booed when the police appeared, and, when someone who was personally known to the group or present in person at the screening appeared, shouted encouragement or criticism. At no point during the evening was there any discussion of the success or failure of the protest or any attempt to explore or explain the role that the protest played in advancing the goals of the anti-corporate movement. Overall, the evening was not an activity of soberly viewing documentary footage for the purpose of learning about issues, campaign goals or successes. Instead, a very different form of engagement with the media that was screened took place – one where, within an environment where political positions were performatively displayed by those present, a reaffirmation and solidifying of individual and group identities was at the fore. In contrast to the case of the Irish activists and their subsequent campaign work – which seems to illustrate the recruitment of new movement constituents through the broadcast of media to anonymous viewers – this screening illustrates the circulation of media to an audience composed almost entirely of individuals who were already social movement constituents. While the loud exchanges witnessed on this occasion are more dramatic than the exchanges we would expect to see and hear in other more formal settings such as at most film festivals, they highlight how film exhibition sites can serve as a place where, through the actions of those present, positions are taken, identities are claimed, correct viewing postures vis-à-vis the themes of the media exhibited are established and social movement participation is sustained.

The position taking and identity claiming on display on this occasion included a strong sense of self-efficacy on the part of protesters, as those in attendance loudly responded to the on-screen visual evidence that during the convergence they had been undeterred in their commitment to press for the goals of the movement to which they belong, despite facing resistance from a massive policing operation. But more than this occurred in the screening room. As the evening unfolded, a small subgroup of those in attendance grew increasingly aggressive in their response to the images presented on-screen, growing loudly assertive regarding the dramatic role they had personally played at the convergence or would play at the next one, particularly in regard to the confrontations they had had or intended to have with police. In response, other members of the audience began to caution these individuals, calling them by name and charging that they were "losing it" or "getting out of hand". When the aggressive behaviour of the rebel subgroup continued, the criticisms levelled against them by others in the audience escalated and, forcefully admonished, the subgroup was instructed to quieten down and conduct themselves in a manner more acceptable to the larger group.

Unifying the constituents of a social movement is a shared way of looking at the world, a "collective action frame" (Snow and Benford 1992). This provides movement constituents

with a shared diagnosis that there are social or political conditions in need of redress; a prognosis of the kind of action that needs to occur to redress these conditions; and both a belief that the actions of a movement can be successful, and a motivation to act. The verbal exchanges that took place between the rebel subgroup and the others present at this screening illustrate the negotiation of the collective action frame of this group of protestors. The subgroup was criticized for focusing on only what its members had personally done at the convergence or would do at the next; a stance that was opposed by others in attendance who sought to frame the protest as a collective achievement and did not want to frame it in such individualistic terms. At the same time, the stance of the rebel subgroup, with its stated plan to engage in violent action against police in the future, ran contrary to the non-violent stance of most of those present. Indeed, the posturing by these individuals likely seemed to some in the audience as illustrative of the kind of aggressive, masculinist behaviour that anti-corporate activists ascribe to state and corporate entities, and not to themselves. Through the exchanges that took place, the collective action frame of the majority present was both stated and reaffirmed, with its boundaries policed. In this way, the interactions occurring off-screen were a form of knowledge production where consensually developed protest tactics (an adherence, by and large, to non-violent tactics) as well as the movement's fundamental philosophy of non-hierarchical participatory action were affirmed.

At this screening, the isolation that can be a characteristic feature of film viewership was shattered, as the off-screen physical space of the screening hall became an active site for those in attendance to take and negotiate political positions within the context of the public sphere that had temporarily formed at the event. All film festivals serve as a site of knowledge production of this kind (Wong 2011: 13–15), since they facilitate the formation of "a public" where people "discuss political, social and cultural ideas through the medium of cinema" (Wong 2011: 163). At this screening, the performative actions of those present meant that audience position taking and a reaffirmation of the group's shared collective action frame occurred as the videos were being projected on-screen, rather than before or after a screening as might more typically occur during pre- or post-film exchanges at a more orthodox screening setting. Nonetheless, there are parallels between what happened at this screening and the kind of productive exchanges that can be generated in both the planned and impromptu off-screen settings of a film festival.

Creating conditions for off-screen activism

Many scholars note that face-to-face encounters and the presence of sites that invite physical encounters of this kind can be integral to the launch and maintenance of activist or social movement work (Della Porta and Diani 2006; Klandermans and De Weerd 2000; Stryker 2000). In research on the disability rights movement, Sharon Groch proposes that for an oppositional movement to emerge, "oppressed groups usually need physical space in which

to communicate and share perceptions of their experiences with relatively little interference from or control by the dominant group" (Groch 2001: 65). She describes these spaces as "free spaces", adding that oppositional movements will develop in different ways depending on the kinds of free spaces to which they have access. Indeed, she proposes, that without access to free spaces even groups of individuals with latent sympathies towards a particular set of political goals may not be able to develop into a unified movement (Groch 2001: 65).

The history of politically committed documentary making by left-wing film-makers, as well as film-making by those who seek to advance more modest liberal agendas, contains examples of projects that have recognized the utility of using the exhibition site in a manner that mirrors Groch's proposition. In America, the left-wing film-making group Newsreel, launched in 1967, ascertained early in its work that there was little to be gained from distributing their catalogue of films to anonymous audiences in the way that commercial films are distributed. Instead, Newsreel proposed that the film screening must be a place of active off-screen engagement between a film's themes and the audience in attendance. To foster the type of active movement-mobilizing dialogue they sought, the group formed a speaker's bureau to lead pre- and post-film discussions. Within the screening format developed by Newsreel, the "film should never stand alone and [...] the structure of the screening had as much priority as the structure of the film" (Nichols 1984: 138). This exhibition model was influenced by strategies employed by Third Cinema film-makers in Latin America in the 1960s and early 1970s, such as by the Argentina-based film-maker and theorist Octavio Getino who uses the term "decentralized parallel circuits" to describe the distribution of film at unannounced guerrilla-style, community screenings, where a portable film projector and generator are used (1986: 103). During these screenings, the film was stopped at crucial moments so that audience members could engage in dialogue about the issues raised by what they were seeing on-screen. Bolivian film director Jorge Sanjinés, of the radical film production group Ukamau, reports that strategies of this kind liberated film from the "static movie houses devoted to sterile pleasure" (1997: 70). In this distribution model, the goal is to establish dialogue and solidarity among those present, not to deliver a purely aesthetic experience or foster adulation for the work of a particular film auteur. In a similar fashion, many participatory media-making projects around the world today employ moderator-led, facilitated screening/discussion sessions as a part of their practice, in an effort to use video making as a tool in the advancement of community building and economic development (White 2003).

Indeed, returning for a moment to the instance of the Irish activists who contributed to the liberation of East Timor, here too, under closer examination, we can see that this group's ability to organize their campaign work was linked to the presence of conditions that have features in common with the free space described by Groch. Previously, I presented this case as an example of how a group of anonymous bystander viewers became active movement constituents after viewing a single documentary film. But this is not the full story. The founding members of East Timor Ireland Solidarity Campaign all lived close to each other in the closely knit working-class neighbourhood of Ballyfermot, to the west

of Dublin's city centre, and most among the initial group of participants were members of Ireland's long-term unemployed. Recalling the evening when they watched *In Cold Blood: The Massacre of East Timor*, the group's leader Tom Hyland reports,

> One of the neighbours called to the house and said, "There's a documentary programme on tonight that I think you would be interested in." I think like most people, we have a switch-on/switch-off kind of situation, [but] for some reason we switched on that night. We sat through an hour and we were disturbed by what we saw and what we heard. I think everybody that saw the programme felt challenged as human beings, [we had] to look into this situation.

(Hyland 1993)

Hyland's description suggests that the shared experience of watching the documentary, as well as the close interpersonal ties that existed between those in attendance, contributed to the launch of the organizing work conducted by the group. Hyland also reports that when the group began their work they drew on their knowledge of Irish history to draw parallels between the domination of East Timor by its larger neighbour, Indonesia, and the domination of Ireland by Britain.[4] In this case, pre-existing connections between those who watched the broadcast, as well as a shared understanding of colonialism, provided the group with a framework with which to launch their political work. In addition, because most in the group were unemployed, they had the time they needed to do their work. Thus, even in this instance, where the documentary in question appears to have sparked the group's organizing work, this work was made possible, and its political thrust was framed, by off-screen conditions.

A goal of all film festivals is providing for its audience an experience that is larger than simply viewing a film or films. Festival ticket-buyers must not only decide to watch a film, but "also choose to experience that film as part of the festival screening process" (de Valck 2007: 19). Thus, in a fundamental way, all film festivals are concerned with delivering an off-screen experience for those in attendance. At the major multi-genre film festivals, the off-screen experience promised includes the spectacle of red carpet events or access to star directors and actors; a purer experience of cinephilia or, simply, the shared excitement and buzz of festival ticket-holders' lines and crowded auditoriums. At documentary film festivals, the off-screen experience promised is in some ways similar to other film festivals, and celebrity director-driven spectacle and cinephilia may be present. But these features are of less importance at festivals of this kind since attendees are also likely to be seeking an experience where the artistry of the documentary, a sense of civic engagement or informed citizenship, and a heightened experience of epistephilia are at the fore. Activist film festivals are different again: while elements of spectacle may still be present in the promise that celebrity activists, public intellectuals or noted film-makers will be in attendance, the overall experience is intended to be one of a "testimonial encounter" where the audience is positioned as witnesses "who take responsibility for what they have seen and become

ready to respond" (Torchin 2012: 2–3). Igor Blažević of the One World Human Rights Film Festival argues that while the films exhibited at human rights film festivals often appear at other kinds of festivals, human rights festivals are distinguished by their focus "on information and testimony rather than art and entertainment; their aim is awareness-building and education" (2009: 15).

Linked to this aim, at activist and human rights festivals, off-screen events serve as sites where those in attendance can be provided with additional information about political themes, or can be connected with activist networks. Mariagiulia Grassilli, of Bologna's Human Rights Nights festival, reports that this festival, beyond simply screening films, creates a "site for encounters and dialogue among activists, film-makers and the community" (2012: 40). At this festival and others like it, through forums such as Q&A sessions and round-table discussions, "speakers, such as community organizers and experts can provide basic information as well as social, historical, political and practical information for taking action" (Torchin 2012: 8). In the book *Setting Up a Human Rights Film Festival: A Handbook for Festival Organizers Including Case Studies of Prominent Human Rights Events*, published by People in Need, the sponsoring organization behind the One World Human Rights Film Festival, Zajícová argues, "when scheduling the films, allow enough time for debates and Q&As" (2009: 36). Although, of the 240 pages that compose this how-to manual, detailing all aspects of festival organizing from the programming of films to the hosting of guest film-makers, Zajícova's comments on how to correctly orchestrate Q&A sessions – which end with the argument that a discussion facilitator should be on hand "to direct the debate and help the audience to digest their impressions from the films" – occupy less than half of one page (2009: 36).

With all film festivals seeking to offer audiences an off-screen experience, the presence of Q&A sessions or other public forums at a particular festival does not indicate whether this festival seeks to foster, or is effective in fostering, activist work on the part of those present. In point of illustration are the Q&A sessions at one of the world's leading documentary film festivals, Hot Docs Canadian International Documentary Festival, hosted annually in Toronto. While not claiming to be an activist festival per se, Hot Docs has cultivated the image that it is a festival that engages with pressing social and political issues, and included in its film programme each year are documentaries that also screen at activist or human rights film festivals (Fischer 2012: 228). From observing the way that Q&A sessions are orchestrated at this festival, it is clear that while they do provide festivalgoers with some additional information about the films exhibited, the themes depicted in them or about the ongoing lives of the film subjects featured, they are limited with regard to the kind of dialogue they support. Of the Q&A sessions I observed while conducting fieldwork at the festival between 2011 and 2014, the overwhelming majority were ten to twenty minutes in length, thereby only allowing audience members to direct a handful of questions to the film directors or subjects present at the screening.[5] Follow-up questions were also uncommon, curtailing the clarification of any points that were raised or a digging deeper into the issues at hand.

Managed in this way, the structure of the Q&A sessions at this festival ensures that any issues introduced, as well as the intent of the film-makers or the nature of the films exhibited, will not be scrutinized in any depth. Describing Hot Docs' Q&A sessions, Ezra Winton of Canada's Cinema Politica screening network argues, "too many times there is only enough time for a few questions or comments [...] because the room needs to be cleared for the next projection" (2013). He proposes that this could be resolved by building "[a] slower festival, or at the very least, a festival not so focused on constant growth, [which] could mean more time for meaningful post-screening dialogues and debates" (Winton 2013). The way the Q&A sessions at Hot Docs are orchestrated indicates that they are included in the programme primarily to draw audiences with the promise of an engaging and entertaining festival-based experience, rather than to deliver access to a robust dialogue about the issues raised by a film or bring people together for future activism. Film festivals, and the off-screen events within them, are a form of public "occasion", possessing a "distinctive ethos, an emotional structure, that must be properly created" (Goffman 1963: 19). For festivalgoers, the experience of attending a film festival is defined by how a festival and the events falling under its umbrella are structured. Film festivals that seek to promote activism or advance human rights must structure the experience on offer in such a way that it promotes these goals. If not, they may simply deliver a template film festival experience; one where the structure and timing of screenings, Q&As, and other activities create for festivalgoers an experience that is no different from the one available at festivals where launching or sustaining activism is not the central purpose.

Conclusion

When considering the effect of documentary film on its audiences, there is no reason to reject the idea that individual films, when they are presented to anonymous audiences during broadcast or by other means, can play a role in moving people to take action. Many social movement theorists argue that the more common way for social movements to grow or renew their constituent base is through the recruitment of "intimates" – such as co-workers, friends or those already involved in related campaign efforts; nonetheless the recruitment of "strangers" through the transmission of "anonymous media" is still important to most contemporary social movements (Jasper 1999: 65). But there is a need to think about the role of documentary film in other, less anonymous settings, such as when films are exhibited at activist screenings or human rights film festivals of the kind I have described. Campaigns or social movement are not only moved forward by high-profile events, such as the passing of legislation or the launch of public protest activities. They are moved forward by people showing up and sharing a physical space, exchanging and refining ideas, collectively developing and adopting shared bodies of knowledge and committing to continue to show up again and again until collectively defined outcomes are attained. To this end, just as pickets, protests or strikes are standard modular strategies that can be used by a

range of campaigns or social movements as they seek to advance their agendas (Tarrow 1994), documentary film-making, the hosting of film screenings and the organizing of film festivals are modular activities that have been adopted by many movements or campaigns. But we must critically assess whether this mobilization is occurring as hoped at these events: as Tascón observes, activist and human rights film festivals must be watchful of what they are doing since there is the ever-present danger that under the guise of alleviating the injustice or oppression faced by those seen on-screen, they serve only to gratify the pleasures and needs of those in attendance (2012: 882). By better understanding what can occur off-screen at a festival or film screening, and how the off-screen can serve as a productive space where knowledge production, organizing and movement building can take place, we may be able to assure that this does not occur.

References

Alexander, W. (1981), *Film on the Left: American Documentary Film from 1931–1942*, Princeton: Princeton University Press.

Barnouw, E. (1974), *Documentary: A History of the Non-Fiction Film*, New York and Oxford: Oxford University Press.

Blažević, I. (2009), "How to start", in T. Porybná (ed.), *Setting Up a Human Rights Film Festival: A Handbook for Festival Organizers Including Case Studies of Prominent Human Rights Events*, Parague: People in Need, pp. 14–25, http://www.oneworld.cz/2012/userfiles/file/OW-cookbook_web.pdf. Accessed 1 March 2015.

Boltanski, L. (1999), *Distant Suffering: Morality, Media and Politics*, Cambridge: Cambridge University Press.

Brenton, S. and Cohen, R. (2003), *Shooting People: Adventures in Reality TV*, London and New York: Verso.

Bruzzi, S. (2000), *New Documentary: A Critical Introduction*, London and New York: Routledge.

Cavara, P., Jacopetti, G. and Prosperi, F. (1961), *Mondo Cane*, Italy: Mondo Cane Filmes.

Chouliaraki, L. (2013), *The Ironic Spectator: Solidarity in the Age of Post-Humanitarianism*, Cambridge and Malden: Polity Press.

Corner, J. (2002), "Performing the real: Documentary diversions", *Television and New Media*, 3:3, pp. 255–269.

Cowie, E. (2011), *Recording Reality, Desiring the Real*, Minneapolis and London: University of Minnesota Press.

Czach, L. (2010), "Cinephilia, stars, and film festivals", *Cinema Journal: The Journal of the Society for Cinema & Media Studies*, 49:2, pp. 139–145.

Della Porta, D. and Diani, M. (2006), *Social Movements: An Introduction*, Oxford: Blackwell Publishing.

Ellis, J. C. and McLane, B. A. (2005), *A New History of Documentary Film*, New York and London: Continuum.

Eyerman, R. and Jamison, A. (1998), *Music and Social Movements: Mobilizing Traditions in the Twentieth Century*, Cambridge: Cambridge University Press.

Fadiman, D. and Levelle, T. (2008), *Producing With Passion: Making Films That Change the World*, Culver City: Michael Wiese Productions.

Fischer, A. (2012), "Hot docs: A prescription for reality: An interview with Sean Farnel, former director of programming at Hot Docs Canadian International Documentary Festival", in D. Iordanova and L. Torchin (eds), *Film Festival Yearbook 4: Film Festivals and Activism*, St. Andrews: St Andrews Film Studies, pp. 225–234.

Gaines, J. M. (1999), "Political mimesis", in J. M. Gaines and M. Renov (eds), *Collecting Visible Evidence*, Minneapolis and London: University of Minnesota Press, pp. 84–102.

Getino, O. (1986), "Some notes on the concept of a 'Third Cinema'", in T. Barnard (ed.), *Argentine Cinema*, Toronto: Nightwood Editions, pp. 99–108.

Goffman, E. (1963), *Behavior in Public Places: Notes on the Social Organization of Gatherings*, New York: The Free Press.

Gordon, P. A. (1992), *In Cold Blood: The Massacre of East Timor*, UK: Yorkshire Television.

Grassilli, M. (2012), "Human rights film festivals: Global/Local networks for advocacy", in D. Iordanova and L. Torchin (eds), *Film Festival Yearbook 4: Film Festivals and Activism*, St. Andrews: St Andrews Film Studies, pp. 31–48.

Gregory, S., Caldwell, G., Avni, R. and Harding, T. (eds) (2005), *Video For Change: A Guide For Advocacy*, London and Ann Arbor: Pluto Press.

Grierson, J. (1966), "First principles of documentary", in H. Forsyth (ed.), *Grierson on Documentary*, New York and Washington: Praeger Publishers, pp. 145–156.

Groch, S. (2001), "Free spaces: Creating oppositional consciousness in the disability rights movement", in J. Mansbridge and A. Morris (eds), *Oppositional Consciousness: The Subjective Roots of Social Protest*, Chicago and London: The University of Chicago Press, pp. 65–98.

Harding, T. (1997), *The Video Activist Handbook*, London and Chicago: Pluto Press.

Harvey, D. (2005), *A Brief History of Neoliberalism*, Oxford: Oxford University Press.

Hyland, T. (1993), personal communication, 6th July.

Jasper, J. M. (1999), "Recruiting intimates, recruiting strangers: Building the contemporary animal rights movement", in J. Freeman and V. Johnson (eds), *Waves of Protest: Social Movements Since the Sixties*, Lanham, Boulder, New York and Oxford: Rowman and Littlefield Publishers, Inc. pp. 65–84.

Johnson, M. E. and Johnson, O. (1932), *Congorilla*, USA: Fox Film Corporation.

—— (1937), *Borneo Land of the Devil Beast*, USA: Twentieth Century Fox Film Corporation.

Juhasz, A. (1995), *AIDS TV: Identity, Community, and Alternative Video*, Duke University Press: Durham and London.

Klandermans, B. and de Weerd, M. (2000), "Group identification and political protest", in S. Stryker, T. J. Owens and R. W. White (eds), *Self, Identity, and Social Movements*, Minneapolis and London: University of Minnesota Press, pp. 68–90.

Lesser, J. (1951), *Jungle Headhunters*, USA: Thalia Productions Inc.

Marcelline, R. (1966), *Macabro*, Italy: Royal Film.

Miller, L. and Waugh, T. (2014), "The process of place: Grassroots documentary screenings", in S. Turnin and E. Winton (eds), *Screening Truth to Power: A Reader on Documentary Activism*, Montreal: Cinema Politica, pp. 35–44.

Moeller, S. D. (1999), *Compassion Fatigue: How the Media Sell Disease, Famine, War and Death*, New York and London: Routledge.

Nichols, B. (1980), *Newsreel: Documentary Filmmaking on the American Left*, New York: Arno Press.

—— (1984), "Newsreel, 1967–1972: Film and revolution", in T. Waugh (ed.), *Show Us Life: Towards a History and Aesthetics of the Committed Documentary*, Metuchen and London: The Scarecrow Press, Inc., pp. 135–153.

—— (1991), *Representing Reality: Issues and Concepts in Documentary*, Bloomington and Indianapolis: Indiana University Press.

Olsen, R. (1974), *Shocking Asia*, West Germany: First Film Organization.

Paget, D. (1998), *No Other Way to Tell It: Dramadoc/Docudrama on Television*, Manchester and New York: Manchester University Press.

Renov, M. (2004), *The Subject of Documentary*, Minneapolis and London: University of Minnesota Press.

Sanjinés, J. (1997), "Problems of form and content in revolutionary cinema", in M. T. Martin (ed.), *New Latin American Cinema: Volume One. Theory, Practices, and Transcontinental Articulations*, Detroit: Wayne State University Press, pp. 62–70.

Schwartz, V. R. (2007), *It's So French! Hollywood, Paris, and the Making of Cosmopolitan French Film Culture*, Chicago: University of Chicago Press.

Snow, D. A. and Benford, R. D. (1992), 'Master frames and cycles of protest', in A. D. Morris and C. McLurg Mueller (eds), *Frontiers of Social Movement Theory*, New Haven and London: Yale University Press, pp. 133–155.

Sontag, S. (2002), *Regarding the Pain of Others*, New York: Farra, Straus & Giroux.

Stryker, S. (2000), "Identity competition: Key to differential social movement participation?" in S. Stryker, T. J. Owens and R. W. White (eds), *Self, Identity, and Social Movements*, Minneapolis and London: University of Minnesota Press, pp. 21–40.

Tarrow, S. (1994), *Power in Movement: Social Movements, Collective Action and Politics*, Cambridge: Cambridge University Press.

Tascón, S. (2012), "Considering human rights films, representation, and ethics: Whose face?", *Human Rights Quarterly*, 34:3, pp. 864–883.

Torchin, L. (2012), "Networked for advocacy: Film festivals and activism", in D. Iordanova and L. Torchin (eds), *Film Festival Yearbook 4: Film Festivals and Activism*, St. Andrews: St Andrews Film Studies, pp. 1–12.

University of Limerick (2003), https://www2.ul.ie/web/WWW/Administration/Ceremonies/Honorary_Conferrings/Honoured_by_UL/Recipients/Thomas%20Hyland. Accessed 6 July 2014.

de Valck, M. (2007), Film Festivals: From European Geopolitics to Global Cinephilia, Amsterdam: Amsterdam University Press.

Waugh, T. (ed.) (1984), *Show Us Life: Towards a History and Aesthetics of the Committed Documentary*, Metuchen and London: The Scarecrow Press, Inc.

Waugh, T., Baker, M. B. and Winton, E. (ed.) (2010), *Challenge For Change: Activist Documentary at the National Film Board of Canada*, Montreal and Kingston: McGill-Queen's University Press.

White, S. A. (ed.) (2003), *Participatory Video: Images that Transform and Empower*, New Delhi, Thousand Oaks and London: Sage Publications.

Winston, B. (1995), *Claiming the Real: The Documentary Film Revisited*, London: British Film Institute.

Winton, E. (2013), "Hot docs turns twenty", *Art Threat*, 24 April, http://artthreat.net/2013/04/hot-docs-2013/. Accessed 1 March 2015.

Wong, C. H. Y. (2011), *Film Festivals: Culture, People, and Power on the Global Screen*, New Brunswick and London: Rutgers University Press.

Zajícová, H. (2009), "Programming human rights film festivals", in T Porybná (ed.), *Setting Up a Human Rights Film Festival: A Handbook for Festival Organizers Including Case Studies of Prominent Human Rights Events*, Prague: People in Need, pp. 26–41, http://www.oneworld.cz/2012/userfiles/file/OW-cookbook_web.pdf. Accessed 1 March 2015.

Notes

1 Harvey argues that neo-liberal ideology has proved effective at co-opting long-standing concepts of human dignity and individual freedom, separating them from notions of collective consciousness or the formation of social solidarities. He writes, "[n]eoliberal rhetoric, with its foundational emphasis upon individual freedoms, has the power to split off libertarianism, identity politics, multiculturalism and eventually narcissistic consumerism from the social forces ranged in pursuit of social justice through the conquest of state power" (2005: 41). In light of the ascendancy of neo-liberal market-driven ideology and a rewiring of what individual freedom means, we can ask: first, how the ascent of a neo-liberal "common sense" is shaping how viewers interpret and respond to the documentary films they watch? And second, how is the documentary itself being employed to advance neo-liberal ideology? This second question is of key importance since, as Harvey argues, neo-liberal thought has now made a long march through "the corporations, the media, and the numerous institutions that constitute civil society – such as the universities, schools, churches, and professional institutions" (2005: 40). Therefore, irrespective of the aura of independence adopted by many documentary film-makers, it is sensible to investigate the ways in which individual documentary film-makers, or sections of the genre as a whole, may be operating deliberately or de facto in the service of neo-liberal ideology.

2 On the occasion of the conferring of an honorary Doctor of Laws on East Timor Ireland Solidarity Campaign founder Tom Hyland, the University of Limerick recorded that Hyland

> [...] worked ceaselessly to achieve his prime objective of bringing the horror of East Timor, initially to the conscience of the Irish people, and ultimately to the consciousness of the

international community. He passionately lobbied, inter alia, Prime Minister Keating of Australia and senior members of the Irish government. In this context, he persuaded David Andrews, the then Minister for Foreign Affairs, to accompany him to East Timor. This visit played a very significant part in subsequent events there. These included the establishment of a United Nations peacekeeping force, which included an Irish contingent and a Transitional Administration for East Timor (UNTAET). Internationally supervised elections were also introduced with significant Irish participation. Following the successful elections in September 2001, East Timor is now in the process of evolving as a democratic state with full independence for its people. The presidential election on 14th Apr, 2002 was an important milestone and East Timor has become the most recent member of the United Nations. Tom's efforts, and those of his fellow workers both within and outside East Timor, have had a major influence on all of these events.

(University of Limerick 2003)

3 A survey of the leading studies of documentary film history reveals that a selective canon of films and film-makers is typically in place. In Erik Barnouw's *Documentary: A History of the Non-Fiction Film* (1974), the author notes the existence of exploitative travelogue documentaries such as *Congorilla* (Johnson and Johnson 1932), shockumentaries such as *Mondo Cane* (Cavara, Jacopetti and Prosperi 1961), and other politically or ethically questionable forms of documentary making. But Barnouw devotes only a few pages to films such as these, focusing instead on a canon of films stretching from the work of Dziga Vertov, Robert Flaherty, John Grierson, Walter Ruttmann and others, to the present. This trend is replicated in other documentary histories such as Jack C. Ellis and Betsy A. McLane's *A New History of Documentary Film* (2005), in which the authors note in passing the existence of exploitation documentaries, but do not situate them as a significant presence within the documentary's history. By minimizing how widespread films such as these have been in documentary film history, a perception that the documentary genre has largely been a serious and high-minded art form linked to social improvement, education and other worthy goals has been maintained. Another history, largely unrecorded, is visible in a sampling of films such as *Borneo Land of the Devil Beast* (Johnson and Johnson 1937), promoted with the tagline "[s]avage, unbelievable, and absolutely authentic"; *Jungle Headhunters* (Lesser 1951), promoted as a film that will allow audiences to "[s] ee human heads shrunk to the size of an orange!" and "[t]en-times-ten other thrills and terrors"; *Macabro* (Marcelline 1966), promoted with the tagline "[h]ave you the courage to see the world in the raw?"; or *Shocking Asia* (Olsen 1974), a mondo-style Orientalist travelogue. A survey of the how-to books available to individuals who seek to learn how to make documentary films replicates this trend, and in titles such as Dorothy Fadiman and Tony Levelle's *Producing With Passion: Making Films That Change the World* (2008), an entirely positivist understanding of the documentary's history and the uses it has been put to is presented. To explore this topic further, see Stella Bruzzi for a critique of how the theoretical templates generated by film scholar Bill Nichols to describe the documentary's "modes" may be complicit in maintaining a narrow canon of documentaries in the academy (2000).

4 Hyland reports:

> [In Ireland] there's a sympathy for smaller countries that come through the hands of suffering from larger countries. It probably fits into our own historical background, where our own country had a lot of tragic things happening to it at the hands of our large neighbour. That's probably buried in the psyche of some people.
>
> (Hyland 1993)

5 In a broad sense, the very notion that a film-maker should be on hand to answer the audience's questions during Q&A sessions is rooted in an auteurist approach to film-making, one that foregrounds the art of documentary making – including assigning to individual, entrepreneurial film-makers the status of expert, as well as some measure of celebrity – at least as much as the issue at hand.

Chapter 3

ITVS (Independent Television Service) Community Cinema: State-Sponsored Documentary Film Festivals, Community Engagement and Pedagogy

Tomás F. Crowder-Taraborrelli and Kristi Wilson

Introduction

In an age where states like California have seen their once cutting-edge public university systems falter under the weight of a financial crisis, corporate corruption and fiscal mismanagement, smaller private institutions have seen admission application numbers rise (Pérez-Peña 2013). Individuals who opt to attend small private institutions run the risk of feeling isolated and removed from the type of civic dynamism and engagement that larger public institutions offer, or, as Henry A. Giroux suggests, that they once offered (2012: 1–13). Giroux claims that higher education at all levels, in one way or another, has been negatively impacted by the rhetoric of austerity. Accordingly, a corporate optic of measurability (in terms of both measuring out cuts to the infrastructures of public universities and ushering in corporate-style "quantifiable" forms of assessment) has replaced an emphasis on teacher and student autonomy, critical thinking and civic participation among students – long-standing characteristics of the higher education experience. If we accept Giroux's proposal that higher education is becoming increasingly anti-democratic, one could expect to feel the impact of the loss of political engagement at a small private university perhaps more severely than at some of the larger universities where debates between faculty unions and administrations still rage on. Piya Chatterjee and Sunaina Maira argue that private liberal arts colleges are important players in the "corporate logics of the 'global marketplace'", and that the same type of neo-liberal restructuring that Giroux finds at work in public US universities is also at work on private liberal arts campuses (2014: 10).

One also feels a parallel anti-democratic, corporate strain in the distressing state of media consumption and television reporting in the United States. Although many people have Internet connections and the possibility of accessing independent news organizations, it is clear from the Wikileaks, Aaron Swartz, Bradley Manning and Edward Snowden cases that the flow of information from corporate and military sources to the public is limited and closely policed. Individuals who have challenged such locks on information have been harshly punished. As if the threat of incarceration was not enough to ensure a generally compliant US public, Glenn Greenwald suggests that the existence of a mass surveillance operation is sufficient (in and of itself) to stifle the type of dissent associated with a healthy democratic culture (2014: 3). Matthew P. McAllister underscores the dangers of what he argues is a blurring of the lines between privacy, surveillance, personal and political agency, among other phenomena associated with new media consumption in the millennial era (Papathanassopoulos 2011: 1). Gabriela Palavicini goes so far as to suggest that mass media

is so influential politically that it substitutes for collective political decision-making in some parts of the world without having to be a political player (2011: 237).

This chapter evaluates Independent Television Service's (ITVS) Community Cinema (CC)[1] documentary film festival in its claims to promote the type of collective responsibility deemed "a central preoccupation of a vibrant democratic culture and society" (Giroux 2012: 11). Giroux and other scholars like James Loewen have noted the propagation in American high schools of uninformed citizens that embody the ideals of what they refer to as limited citizenship. Where higher education is concerned, student engagement in social movements and causes, such as access to free public education (as in student activism in Chile and El Salvador, for example), should be reference points by which we judge the level of involvement in key issues (student loan debt, rising tuition fees, exorbitant dropout rates among Latino students, etc.). Any lack of engagement can been considered an end result of the politics of deregulation and privatization realized in today's neo-liberal university (Giroux 2012; Loewen 2000; Chatterjee and Maira 2014), as well as significant changes in the way in which individuals consume audio-visual materials in "complex multimedia environments" (Papathanassopoulos 2011: 1).

Given the current climate of limited citizenship, the unique position of a documentary film television series that brings forth stories not told on most channels, on a network available for free in most homes (Public Broadcast Service [PBS]), should not be underestimated, even as ITVS has come under fire for promising funding and then pulling the plug for certain films, such as Carl Deal and Tia Lessin's *Citizen Koch* (2013), a documentary critical of the advocacy group founded by PBS patron, climate change denier and oil tycoon David Koch. For college campuses across the country, the CC festival offers an important, if controversial, venue in which to access information about some of the most important political, social and economic developments in the United States and across the world. This chapter considers a six-year partnership between the CC festival (during which period over 40 documentaries were screened) and Soka University of America (SUA), a small private liberal arts college in South Orange County, California. We question whether this particular model for a film festival can be characterized as "activist", according to Dina Iordanova's model (discussed below) and whether it has the potential to contribute to a fuller form of citizenship on university campuses in an age of diminishing forums for public engagement between local communities and student organizations and leaders.

We draw certain structural parallels between the Community Cinema (CC) festival (for which, one of the authors is a producing partner) and the New Latin American Cinema movement of the 1960s and 1970s with respect to their film screening and distribution strategies, the political nature of their films and their respective responses to the pressures of increasingly anti-democratic media landscapes. For example, the CC festival structure shares many key characteristics with the New Latin American Cinema movement: there are open discussions after screenings; films tend to be about pressing social issues and certain tools of engagement are provided for the spectators; spectators are encouraged to become active participants in social change, as the film topics tend to encompass current issues and/or past

political struggles; there are efforts to distribute the films among different social classes, and panellists, intellectual and/or community leaders are invited to view the films and participate in post-screening debates; and special efforts are made to recruit young audiences in order to create consciousness about the possibility of social change and documentary film's central role in counter-discourses.

The differences between the New Latin American Cinema movement and CC, besides historical changes in technology and the political context of dictatorship, lie in opposing methods of production. While CC is centralized by Independent Television Service (ITVS), and the films conform to the institutional mandates of a large production house, New Latin American film-makers worked independently or in a collective and, in most cases, simultaneously participated in grass-roots political struggles. The production values of their films were shaped by the immediate objectives and input of a variety of political and social organizations. For example, during the filming of Fernando Solanas and Octavio Getino's film *The Hour of the Furnaces* (1968), the directors screened portions of their unfinished film, stopping to solicit the participation of working-class audiences as to their opinions and suggestions. Audiences were encouraged to debate the film and offer ideas for its conclusion (Stam 1990: 254). Thus, the films tended to be radical in structure compared to Hollywood counterparts, as they were ideologically shaped rather than influenced by corporate concerns.

ITVS builds local community for its documentary programme through a combination of individual and institutional outreach. Participating institutions like ours (SUA) sign a contract that emphasizes, among other things, that CC's pairing of films with community organizations and leaders engaged in the topics represented by the films is a model for civic engagement. SUA offers an advantageous academic setting for community engagement on a local and a global scale, with its high concentration of international students, mandatory study-abroad requirement for all students and diverse array of courses taught on campus and other courses taught in various parts of the world. Underscoring the university's mission and liberal arts curriculum is its founder's work on pedagogy. In the foreword to *Soka Education*, SUA founder, Daisaku Ikeda warns against reducing education to "a mere mechanism that serves nationalistic objectives, be they political, military, economic or ideological" (Ikeda 2010: vii).[2] For Dr Ikeda, the purpose of education consists in developing "[t]he compassion to maintain an imaginative empathy that reaches beyond one's immediate surroundings and extends to those suffering in distant places" (Ikeda 2010: vii).

Independent documentary films have often engaged in imaginative empathy for sufferers in presenting varied, and at times unconventional, perspectives on industrial development, environmental degradation, racial discrimination, poverty, government policies, and – in the past two decades – on the increasing corporate control of media outlets, among other issues. In the 1960s and 1970s film-makers from the New Latin American Cinema tradition had the same general set of preoccupations. Some, like Fernando Birri, were influenced by educational theorists like Paulo Freire, especially regarding ideas about the development of critical consciousness (Freire 1974). Others were influenced by Italian neo-realism and the

Centro Sperimentale di Cinematografia (the Experimental Center of Cinematography) in Rome and the Cuban Revolution (Ruberto and Wilson 2007; Greenfield 1973).

In the politically polarized US media market, certain independent documentary films with progressive political agendas have occupied a condemnatory fringe, much as fake news shows such as *The Daily Show* and *The Colbert Report* have done on cable networks. According to Henry Jenkins, the fact that *The Daily Show*, whose viewers are among the most highly educated in the nation, has no pretence of being "objective" allows it to facilitate a healthy level of scepticism among its viewers (Jenkins 2006: 234–238). For Jenkins, however, the simple consumption of independent documentaries and/or fake news shows is problematic. He suggests that "[…] a politics based on consumption *can* represent a dead end when consumerism substitutes for citizenship […] but it *may* represent a powerful force when striking back economically at core institutions and can directly impact their power and influence" (Jenkins 2006: 222, original emphasis).

ITVS's outreach programme, Community Cinema (CC), aims at fostering active community engagement and debating around public issues and political activism with respect to a range of human rights, social and environmental issues. The CC programme is the largest publically funded programme of its type in US television, and its unique relationship to college campuses across the United States lends its film festival an activist edge.[3] Dina Iordanova argues that, as pedagogy and activism are so closely correlated, a "special feature of activist film festivals is their frequent involvement with educational institutions, which also function as implied stakeholders in the project to mobilize public opinion and nurture committed cultural citizens" (Iordanova 2000: 14). Ideally, this person would manifest the ability to think outside of her/his social class and advance progressive political agendas – with respect to issues of censorship, environmentalism, the LGBTQ community, indigenous communities, general human rights, etc. – building solidarity across social classes and national boundaries. The cultured space the CC programmes bid to occupy, at universities and art institutions that support noncommercial media, is precisely the one that Patricia Zimmerman suggests has been weakened since the 1990s by US religious right and conservative policy groups such as the Christian Coalition, Accuracy in Media, the American Family Association, the Christian Action Network, the Heritage Foundation and the Center for the Study of Popular Culture (Zimmerman 2000: 3). Not surprisingly, PBS and ITVS share a spot on what Zimmerman calls the "enemies list" that such conservative groups routinely target for embracing what Cornel West calls "a cultural politics of difference" (cited in Zimmerman 2000: 5). Frank Webster identifies a general "siege" on public service institutions like PBS and an analogous weakening of democracy over the last generation (in Papathanassopoulos 2011: 22). However, more recently, Eugenia Williamson suggests that the battle for representation of cultural difference now exists inside the PBS/ITVS organizational structure (2014). We see analogous battles for representation occurring on college campuses across the United States. Julia C. Oparah points out that "as higher education has become increasingly corporatized, scholars have noted the consolidation of an academic-military-industrial complex, an interdependent

and mutually constitutive alliance whereby corporate priorities and cultures [...] increasingly shape the face of academia" (in Chatterjee and Maira 2014: 101).

To what extent can CC offer an alternative space for and promote democratic participation in the historically politically conservative "exopolis" of Orange County (Soja 1992)? Might documentary film and transmedia projects like CC provide models for shaping and changing the politics of viewing and the exercise of civic engagement? Can they produce "witnessing publics [or] subject positions" that imply taking action and responsibility for others (Torchin 2012: 3)? These are some of the questions we engage in this chapter.

ITVS Community Cinema – The history and development of a "film festival in your living room"

Self-styled as "public media's independent voice", the Independent Television Service (ITVS) was launched in 1991 as a result of a congressional mandate to champion independently produced broadcast programmes that " [...] take creative risks, advance issues and represent points of view not usually seen on public or commercial television" (ITVS Funding 2008; McChesney 2004). The Corporation for Public Broadcasting – ITVS's main funding source – presents and promotes documentaries and dramas on public and cable television, and new media projects online. ITVS produces three series: *Independent Lens*, *Global Voices* and *True Stories: Life in the USA*.

Community Cinema (CC) is a monthly screening festival, which highlights select films that will air, shortly thereafter, on *Independent Lens*. CC hosts programmes in 65 markets, produces over 550 events in partnership with 700 community-based organization partners. Managed by nine ITVS Regional Outreach Coordinators, these efforts draw in around 35,000 spectators to view an array of award-winning documentaries (About The Corporation for Public Broadcasting). ITVS mails DVD copies of the films to associate producers for screening at the CC festival before the films are officially released. Pre-screenings function as a lure for prospective viewers of public television by placing them in a privileged position. Each season, a well-known actor introduces the films. The 2014 series features Stanley Tucci, who welcomes audiences and highlights their exclusivity as spectators, encouraging them to continue a dialogue after the screening. ITVS associate producers invite local audiences, through campus events calendars and regional newspapers, to attend the free screenings. Social media functions as an additional way to spread the word among the students on campus. Pre-screening ITVS films at universities addresses the problem of public television's greying spectatorship by promoting the ITVS brand among younger viewers. CC provides additional online pedagogical and activist resources to accompany each film. Spectators are invited to learn more about the film-makers and producers through easily accessible bio statements and press kits. The press kits facilitate easy promotion of the festival on university and community websites, and can be used to spotlight connections between brands, such as universities, ITVS, and local PBS stations. The "Engagement Resources" tab on the ITVS website allows one to download

a wide range of pedagogical materials for educational use, such as discussion questions, detailed biographies about some or all of the films' protagonists, action guides for schools and after-school programmes and mentorship guidelines to facilitate and promote youth leaders.[4]

The particular combination of provocative films, invited speakers, pedagogical support and live Q&A sessions after each screening is a standard fare for the activist film festival (Iordanova 2012: 15). And yet, although ITVS is "committed to programming that addresses the needs of underserved and underrepresented audiences" (Ellis and McLane 2009: 297) and to an expanded notion of civic participation, Lilie Chouliaraki casts a shadow of a doubt onto the efficacy of a western media outlet, such as CC, to effect real change for distant, or even nearby, sufferers (2013). Chouliaraki suggests that audiences in the west often participate in a media culture that positions them as "ironic spectator[s] of vulnerable others", reproducing what she refers to as a neo-liberal lifestyle – one that replaces political narratives of common humanity with "feel good altruism" (Chouliaraki 2013: 2). "Feel good altruism" drives the compulsion to act on strangers without the expectation, or even desire, for reciprocation and does little or nothing to change the relationship of inequality upon which a neo-liberal economic paradigm depends. Chouliaraki argues that "feel good altruism" actually contributes to and perpetuates relations of inequality.

Documentary film-makers from the New Latin American Cinema tradition of the late 1960s–early 1970s, such as Raymundo Gleyzer, Fernando Birri, Fernando Solanas, Octavio Getino and Patricio Guzmán, criticized the encroachment of free-market capitalism in the global South along similar lines at its inception and in its most repressive form: military dictatorship. At a moment when film-making technology was becoming more readily available, lighter weight and easier to use, these film-makers understood film as a central weapon in the fight against social inequality and the battle for public opinion. They wanted simultaneously to provide venues for media action and to cultivate a base of activists; literally a base of people who would join their struggles against dictatorships, US imperialism and global capitalism. A moral imperative to act can be associated with many of the CC films, as well. However, given the sociocultural disconnect between most ITVS audiences and the subjects of the documentaries, this moral imperative might just as easily fall upon deaf ears as prompt action. Or, if it does prompt action, the actions might ultimately contribute to the "inhuman conditions" of humanitarianism by reproducing western entrepreneurship, now in the form of economic aid. Sheryl WuDunn and Nicholas D. Kristof's series for ITVS, *Half the Sky: Turning Oppression into Opportunity for Women Worldwide* (adapted from the book of the same name), for example, comprise just a few examples of documentary films that could be seen to form part of what Chouliaraki calls the "humanitarian imaginary". The humanitarian imaginary is a set of practices organized around the spectacle of distant sufferers that include features such as professional witnessing, benefit concerts, celebrity involvement and film festivals, and that result in an ambiguous form of solidarity (2013: 20–22). Sonia Tascón refines this idea to consider the particularly scopic, unequal relations

of power between "giver and receiver" where film and media are concerned with her notion of the "humanitarian gaze":

> The humanitarian gaze [...] organizes what we may expect to see when viewing others' troubles [...] I call it a gaze because it is constitutive of a way of looking, of expecting to see, as well as being reproduce-able [...] This gaze has a well-established and assumed relationship between who will watch and who will be watched, and within this who is the assumed helper and helped.
>
> (2015: 35)

Tascón suggests that, while the humanitarian gaze is often used to draw in audiences for film festivals, festival organizers have the ability to undo it (2015: 35); an important caveat that resonates with the role of the producing partner in the CC programme.

CC's ethos is founded upon an idea that attending a series of live screenings in an academic and/or community setting like Soka University of America (SUA) – and forming part of an audience Q&A – fosters a different type of spectator culture in the digital age that involves interactive "relationships between specialized institutions and opinion and citizen activity", resulting in active citizenship in a "participatory culture" (Almond and Verba in Mellado and Lagos 2013: 13).

Screenings at Soka University of America

The Community Cinema (CC) film festival series is organized in a ritualistic manner in which certain films correspond to annual cultural heritage celebrations. For example, Llewellyn M. Smith's film *American Denial* (2015) was screened on our campus during black history month in 2015. Previous films about black history that formed part of the festival on our campus include: Taylor Hamilton and Christine Khalafian's *The Powerbroker: Whitney Young's Fight for Civil Rights* (2014), Bill Siegel's *The Trials of Mohammed Ali* (2013), Sharon La Cruise's *Daisy Bates: First Lady of Little Rock* (2012) and Shukree Hassan Tilghman's *More Than a Month* (2012). Films were also grouped according to subtler, less-visible sides of current controversial political topics. For example, the 2013–2014 festival seasons included documentaries that featured the everyday struggles of Latinos and immigrants such as Bernardo Ruiz's *Los Graduados/The Graduates* (2013), *State of Arizona* (2014) and *Las Marthas* (2014), as well as those of returning soldiers suffering from PTSD (in Danfung Dennis's *Hell and Back Again* [2011]). These films, in particular, address aspects of life that normally remain underrepresented in US corporate media outlets, such as the fear of deportation, anguish over not being able to access higher education (due to financial or legal status concerns), unemployment and teen pregnancy. Additional themes addressed in the film series include environmental degradation, women leaders and social change, Native American history, poverty and grass-roots movements in underdeveloped countries, war and the military, among others.

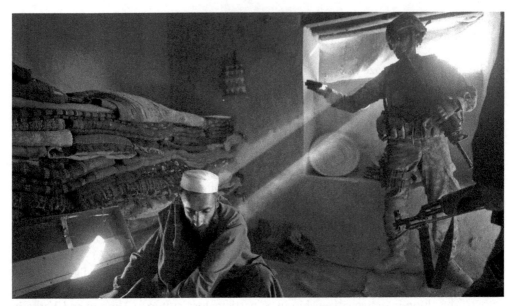

Figure 1: A scene from *Hell and Back Again* (2011). Photo courtesy of Danfung Dennis and Indie Lens Pop-Up.

In Spring 2013, Kirby Dick's film *The Invisible War* (2012), nominated for best documentary at the 2013 Academy Awards and winner of the 2012 Sundance Film Festival audience award, was selected by the SUA CC associate producer for a special screening.[5] *The Invisible War* documents the history of rape and sexual abuse in the US military and raises critical questions about military tribunals as an appropriate form of justice for such crimes. The film is noteworthy not only for giving voice to a few of the thousands of women assaulted by officers of the US army every year (an estimated 26,000 members of the armed forces were sexually assaulted in 2012), but because it unveils the nepotism of an institution that has managed to maintain a system of sexual exploitation and injustice (Wheaton 2013). The film also points an accusing finger at Washington and certain political elites who continue to partner with the military in the ill treatment of soldiers, in stations, on the battlefield and upon their return home. *The Invisible War* received critical attention by film reviewers, talk show hosts (like Bill Maher) and the Hollywood industry, but the system of injustice it exposes posed a particular challenge for our local community of viewers. While the film and post-screening engagement with invited panellists left many of our audience members feeling that the alliance between the government, the military and the arms industry is perhaps too powerful to confront, the film's link to an activist website and the producing partner's selection of Q&A panellists facilitated a "witnessing public", in the sense that previously unknown crimes were "rendered recognizable and actionable" through the festival's participatory structure (Torchin 2012: 3).

Figure 2: Lieutenant Elle Helmer at the Vietnam War Memorial. Photo courtesy of Cinedigm/Docudrama Films and Indie Lens Pop-Up.

SUA professor Ryan Caldwell, guest panellist and author of *Fall Girls: Gender and the Framing of Torture at Abu Ghraib* (2012), spoke at length about the conspiracy of silence of military authorities in regards to sexual abuse cases at our screening of the film. Caldwell explained that the military command tends to ignore these types of cases because in the US military "the individual is not as important as the whole" (Caldwell 2013). A second panellist for the film screening, who was an active member of the US air force reserve unit, echoed Caldwell's analysis of power relations in the US army and offered detailed testimony of her own sexual abuse. She explained that every officer she turned to for help refused to incriminate a fellow officer before military authorities. Of her abuser she had this to say to the audience: "I feel haunted by him […]. He was always around and everyone knew what he was doing but he could do whatever he pleased […] He always chose me, above anyone else to work beside him, in private and at public events, and was very explicit about all the things he wanted to do to me".[6] The Air Force reserves member described the harassment she endured in detail, which validated the stories of victims in the film and offered an opportunity for audience members to understand the complicity of perpetrators of sexual abuse in the army.

The film featured a website (www.notinvisible.org), displayed at length after the credits, which suggested at least three ways in which one could get involved: sign a petition, support legislation to investigate and prosecute perpetrators, donate money or time to support a programme to assist soldiers suffering from PTSD. This website address was visible during the post-screening panel discussion. The Q&A for this film prompted complex discussions of issues that had yet to play out in official policy at the national level, and an exploration of the invisible complexities of the topics (that might never rise to the surface in mainstream media coverage). For example, one of the questions that came up interrogated the separate systems of justice depicted in the film (military tribunals and civil courts) and their relationship to the notion of civil rights. Drawing upon her sociological work as a co-expert witness and researcher, Caldwell shared information about her experiences attending the Abu Ghraib trials (Iraq); The Canal Killings defence trial of Michael Leahy (Iraq); as well as the Murder "Kill Team" defence trial of Jeremy Morlock (Afghanistan). Caldwell reiterated that it is very difficult for soldiers to prosecute their offenders because their cadres make up the very members of the military tribunals. In this instance, the festival did not stop short at "feel good" altruism. Rather, it left audiences considering the problematic grey zones of military power relations and with a set of actions they could take to help curb the epidemic of rape in the military.

A good number of Community Cinema (CC) festival films are affiliated with NGOs, which are often prominently featured in the promotional materials provided by ITVS. In its ambitious project to sell itself as a multimedia campaign to expose the under-documented and tragedy of missing women around the world, *Half the Sky: Turning Oppression Into Opportunity for Women Worldwide*, strives to make transnational connections between NGOs and potential activists concrete. The Independent Television Service (ITVS) provides information connecting viewers to the *Half the Sky Movement* website, which contains links to relevant issues, NGO partners, participating celebrities, resources and more (http://www.halftheskymovement.org/pages/smartgirls). Our SUA students have been more willing to attend a screening if they anticipate learning a thing or two about how a particular NGO works to affect change in the social situation depicted by the film. Additionally, many SUA students apply for internships during the summer, so the relationship between CC and NGOs is of particular interest to them.

Of all the film events we have hosted as part of the CC festival, the screening of *Los Graduados/The Graduates* most closely approximated a spectator experience at an activist film festival as outlined by Iordanova:

Alongside educational links, outreach and community building are equally important for the activist film festival; they allow it to build awareness and trust, as well as to enlist support and mobilize for the specific cause that the festival and the respective backing organization(s) stand for. These are achieved by a combination of extras that enhance the screening of films, such as discussions and Q&A sessions, but also the production of supporting information and website campaigns.

(2012: 15)

The Graduates is a two-part documentary film that features the life stories of six young Latino/a students as they struggle to graduate from high school. The two-part film is divided into gendered sections. We decided to screen the section devoted to girls' experiences, because of the high number of Latina pregnancies in high schools and the added expectation for childcare and extended family care placed on female students. Before the screening, SUA collaborated with a nearby high school (in Santa Ana) with a large Latino/a population. Around 50 students took a field trip to SUA for the screening (their school provided transportation). Three panellists participated in the post-screening discussion: SUA professor of American History James Spady and two Chicana/Latina activists Carolyn Torres and Jesus Cortez. During the Q&A, students expressed that they enjoyed seeing their own and their friends' stories reflected on the screen. However, all three panellists were disappointed with the episode because, while it tracked the students' progress towards their goals of obtaining a high school degree, it failed to engage with the structural problems of inequality that have historically led to economic and sociocultural discrimination for the Latino/a community.

The Graduates: Girls Hour focuses upon case studies of Latino/a students who are the first in their families to graduate from high school. All three profiles in the girls' hour of the series are success stories, in the sense that the girls graduate from high school, against serious odds. The film highlights the concern among young people about competition in the labour

Figure 3: Chastity grew up in the Bronx and almost dropped out of high school when her family became homeless. Photo courtesy of Indie Lens Pop-Up.

market, and underscores the belief that without an education young people can't make it in the global economy. Maria Teresa Kumar, Founding President and CEO of Voto Latino and contributor to MSNBC, is one of the prominent Latino/a public figures that appear briefly in the documentary. Kumar argues that students often want to quit school because they feel the pressure to work in order to help the household. She also recognizes that Latino students are held to a lower standard of expectations to attend four-year colleges than their white counterparts. Kumar learned techniques for getting into and paying for a four-year university from a white friend who was applying to law school. This brief allusion to the strategies of the white upper-middle classes to prepare and send their children to college is one of the few sections of the documentary in which structural issues are suggested. For the most part, Kumar seemed to pass up several opportunities to discuss social change through political participation in the film.

In another telling scene, Stephanie Alvarado, a student who confronts gang violence on a daily basis and for whom school feels like a prison (due to metal detectors and the presence of private security services), is shown engaging in a lot of activities that she claims are "character-building". She volunteers to address a union rally of Chicago teachers on strike. However, we do not hear Stephanie explain the political reasons for her support of her teachers' strike and her union activism in general. The film ends on a positive note, as Stephanie receives a grant to travel to Senegal to build schools and makes plans to go to college. Following the screening, panellists critiqued the fact that this episode only featured success stories. There was an interesting, heated debate between Soka University of America students, the high school students and community members about the impediments to civic engagement. Many students expressed the opinion that without immigration reform, their parents and other family members would not be able to participate in politics. Chouliaraki suggests that films like these *alone* (products of the humanitarian imaginary) inevitably fail to promote a base of meaningful action: "it is this repertoire of staged images and stories about distant suffering that comes to legitimize the imperative to act on vulnerable others as the moral order of modernity. [...] as its 'humanitarian imaginary'" (2013: 28). While, *The Graduates: Girls Hour* does not depict a pathway to active citizenship, this lacuna sparked an important Q&A discussion about the failure of this particular documentary to portray a sense of solidarity among potential activists.

While some of the goals of the CC festival fall in line with certain New Latin American cinema traditions, the issue of how to mobilize a base of action, a central concern for New Latin American cinema film-makers, is still a problem for the festival. As contemporary film scholars Maximiliano Ignacio de la Puente and Pablo Mariano Russo suggest, New Latin American cinema film-makers understood the role of a film screening as "a moment of reflection and memory construction about social movements and struggles in order to reach out and captivate the working class" (de la Puente and Russo 2007: 69–70). Following a Brechtian model for active spectatorship in theatre, New Latin American cinema film-makers were acutely interested in revolutionizing the relationship between the spectator and their explicitly political films. Fernando Birri understood the motivation for and

consequence of the social documentary to be analogous to what Brecht thought the theatre should be, namely, the "change from sub-life to life" (in Martin 1997: 208). Birri thought this could be achieved through film-making with a "popular optic", one that actively avoids being an accomplice with the very power structures that support underdevelopment.

As we have pointed out, Community Cinema (CC) utilizes strategies in post-production that resemble the types of connections between New Latin American film-makers and their bases of activists such as reaching out to spectators and the local communities, engagement in dialogue on social issues, invitations to action through links to grass-roots organizations, offering free screenings and circulation through educational institutions. We argue, however, following a Brechtian model, that the seeds for radical change should be part of ITVS's pre-production as well as post-production. Activist film is not only about watching the film and then being prompted to action, but actively participating in the construction of the narrative. This might be a way out of the "feel good altruistic" trap the Chouliaraki refers to. Antonio Traverso and Tomás Crowder-Taraborrelli discuss the nuances in the craft of Latin American film-makers (in particular film-makers from the Southern Cone) during this prosperous period, suggesting that not only did they use "[...] a varied range of innovative distancing and self-referential cinematic techniques, including intertitles, collage, archival and found footage, hand-made film, animation, vox/pop, in/situ interviews, in/camera film viewing and debate and experimental montage. [...]" but they also dedicated themselves to the analysis and the theorizing of their approaches (Traverso and Crowder-Taraborrelli 2013: 6). The CC festival is progressive on many levels but falls short in accomplishing a consistent base of activists due to the fact that it is in lockstep competition with, and ironically, complicit in the conservative formal structures of network broadcasting platforms. As Jorge Sanjinés has proclaimed "a participating spectator cannot be a consumer, and the person who becomes a participant abandons being a spectator in order to become part of the living, work of art-audience dialectical process" (Sanjinés and Grupo Ukamau 1979: 89). And the words of Julio García Espinosa have never been more relevant:

> The development of science, of technology, of the most advanced social theory and practice, has made possible as never before the active presence of the masses in social life [...] there are more spectators now than at any other moment in history [...] The task currently hand is to find out if the conditions which will enable spectators to transform themselves into agents – not merely more active spectators, but genuine co-authors – are beginning to exist.
>
> (Espinosa 1997: 75)

Thus, Stanley Tucci's invitation to be part of a CC dialogue leaves open the comforting possibility that one might just as easily stay a passive consumer of media than opt into a dialogue or even a movement. That said, this somewhat ambiguous view of the potential of the CC film festival, especially in light of the regressive politics of some of the PBS-funding

sources, is mitigated by the important role of the academic/community venue in which the films are shown. Tascón suggests that:

> Activism, distinct from humanitarianism, is a sustained activity the aim of which is social change of a longer-term nature, and often entails a politicization of activities that aim to disrupt, subvert, and transform social structures rather than simply alleviate suffering.
>
> (2015: 41)

Thus, in its programming, but also in its ongoing relationships with producing partners and invited panellists, many of whom characterize themselves as activists, the CC programme creates a socially transformative climate in which activist spectatorship can grow over time. However, as McChesney points out, a truly transformative climate in which activism could be promoted would entail "rethinking the organizational structure of public broadcasting", and abolishing its connections to commercialism altogether. Only then, would such a programme be capable of "generating a democratic relationship with the audience that is not mediated by advertisers or determined by the need for profit maximization" (2004: 249). While the recent appointment of David Koch to the PBS board casts a shadow over this possibility, we concur with McChesney that festivals like CC, because of the quality of their non-commercial films and the important role of the producing partner, have been "jewels" in their otherwise bleak local media environments (2004: 248). The burden falls upon producing partners in local communities to demand that ITVS democratize its internal organization and renew its mandate to take creative risks and represent communities and perspectives that are otherwise censored or marginalized in commercial media.

References

Baughman, D. and O'Hara, J. (2010), *Bhutto*, San Francisco: Yellow Pad Productions.

Bernardo, R. (2013), *Los Graduados/The Graduates*, San Francisco: Quiet Pictures.

Boswell, B. (2014), *The Powerbroker*, San Francisco: ITVS.

Caldwell, R. (2012), *Fallgirls: Gender and the Framing of Torture at Abu Ghraib*, Surrey, England and Burlington, Vermont: Ashgate Publishing.

Chatterjee, P. and Maira, S. (eds) (2014), *The Imperial University: Academic Repression and Scholarly Dissent*, Minneapolis and London: University of Minnesota Press.

Chermayeff, M. (2012), *Half the Sky*, San Francisco: ITVS.

Chouliaraki, L. (2013), *The Ironic Spectator: Solidarity in the Age of Post-Humanitarianism*, Cambridge: Polity Press.

Corporation for Public Broadcasting (2014), "About the corporation for public broadcasting", http://www.cpb.org/aboutcpb/reports/itvs/10itvs.pdf. Accessed 15 June 2015.

Danfung, D. (2011), *Hell and Back Again*, San Francisco: Roast Beef Productions/Docuramafilms.

Deal, C. and Lessin, T. (2013), *Citizen Koch*.

Dick, K. (2012), *The Invisible War*, San Francisco: Cinedigm Entertainment Group/ Docuramafilms.

Ellis, J. C. and McLane, B. A. (eds) (2012), *A New History of Documentary Film* (2nd ed.), New York: Continuum International Publishing Group.

Espinosa, G. J. (1997), "For an imperfect cinema", in M. T. Martin (ed.), *New Latin American Cinema, Volume One: Theory, Practices, and Transcontinental Articulations*, Detroit: Wayne State University Press.

Freire, P. (1974), *Education for Critical Consciousness*, London and New York: Bloomsbury Revelations.

Gaines, J. M. and Renov, M. (eds) (1999), *Collecting Visible Evidence*, Minneapolis: University of Minnesota Press.

Giroux, H. (2012), *Education and the Crisis of Public Values*, New York: Peter Lang Publishers.

Greenfield, C. C. (1973), "New South American cinema: From neo-realism to expressive realism", *Latin American Literary Review*, 1:2, pp. 111–123.

Greenwald, G. (2014), *No Place to Hide: Edward Snowden, the NSA, and the U.S. Surveillance State*, New York: Metropolitan Books.

Ibarra, C. (2014), *Las Marthas*, San Francisco: Undocumented Films.

Ikeda, D. (2010), *Soka Education: For the Happiness of the Individual* (2nd ed.), Santa Monica: Middleway Press.

Iordanova, D (2012), "Film festivals and dissent: Can film change the world?" in D. Iordanova and L. Torchin (eds), *Film Festival Yearbook 4: Film Festivals and Activism*, St. Andrews: St. Andrews Film Studies, pp. 13–25.

Independent Television Service (ITVS) (2013), "The graduates youth action guide", http://cdn. itvs.org/TheGraduatesYouthAction-Guide.pdf. Accessed 15 June 2015.

Jenkins, H. (2006), *Convergence Culture: Where Old and New Media Collide*, New York and London: New York University Press.

La Cruise, S. (2010), *Daisy Bates: First Lady of Little Rock*, San Francisco: ITVS.

Loewen, J. W. (2000), "The Vietnam War in high school American history", in L. Hein and M. Selden (eds), *Censoring History: Citizenship and Memory in Japan, Germany, and the United States*, New York and London: East Gate.

Martin, M. T. (ed.) (1997), *New Latin American Cinema, Volume One: Theory, Practices, and Transcontinental Articulations*, Detroit: Wayne State University Press.

McAllister, M. P. (2011), "Consumer culture and new media: Commodity fetishism in the digital era", in S. Papathanassopoulos (ed.), *Media Perspectives for the 21st Century*, New York: Routledge, pp. 149–165.

McChesney, R. D. (2004), *The Problem of the Media: US Communication Politics in the Twenty-First Century*, New York: NYU Press.

Meek, M. (2008), "ITVS: Has this key funding partner lost its way?", *Independent Magazine*, http://www.independent-magazine.org/magazine/2008/12/itvs. Accessed 15 June 2015.

Mellado, C. and Lagos, C. (2013), "Redefining comparative analyses of media systems from the perspective of new democracies", *Communication & Society*, 26:4, pp. 1–24.

Oparah, J. C. (2014), "Challenging complicity: The neoliberal university and the prison-industrial complex", in P. Chatterjee and S. Maira (eds), *The Imperial University: Academic Repression and Scholarly Dissent*, Minneapolis and London: University of Minnesota Press, pp. 99–122.

Palanivicini, G. (2011), "Mass media's influence on the transformation of the Mexican political regime", *Latin American Policy*, 2:2, pp. 234–246.

Papathanassopoulos, S. (ed.) (2011), *Media Perspectives for the 21ˢᵗ Century*, New York: Routledge.

Pérez-Peña, R. (2014), "Best, brightest and rejected: Elite colleges turn away up to 95%", *New York Times*, Education Section, 8 April.

de la Puente, I. and Russo, P. M. (2007), "La exhibición como instancia de reflexión y construcción de las memorias de las luchas de los movimientos sociales", in J. Campo and C. Dodaro (eds), *Cine Documental, memoria y derechos humanos*, Buenos Aires: Nuestra America Editorial.

Renov, M. (1993), *Theorizing Documentary*, New York and London: Routledge.

Ruberto, L. E. and Wilson, K. M. (eds) (2007), *Italian Neorealism and Global Cinema*, Detroit: Wayne State University Press.

Sandoval, C. and Tambini, C. (2014), *The State of Arizona*, San Francisco: Camino Bluff Productions.

Sanjinés, J. and Grupo, U. (1979), *Teoría y práctica de un cine junto al pueblo*, Mexico: Siglo Veintiuno Editores.

Siegel, B. (2013), *The Trials of Mohammed Ali*, San Francisco: Kartemquin Films.

Smith, L. (2015), *American Denial*, Brighton: Vital Pictures.

Soja, E. (1992), "Inside exopolis: Scenes from orange county", in M. Sorkin (ed.), *Variations on a Theme Park: The New American City and the End of Public Space*, New York: Hill and Wang, pp. 94–122.

Stam, R. (1990), "The hour of the furnaces and the two avant-gardes", in J. Burton (ed.), *The Social Documentary in Latin America*, Pittsburgh: The University of Pittsburgh Press, pp. 251–266.

Tascón, S. M. (2015), *Human Rights Film Festivals: Activism in Context*, New York: Palgrave Macmillan.

Tilghman, S. H. (2012), *More Than a Month*, San Francisco: Intelligence Pictures.

Torchin, L. (2012), *Creating the Witness: Documenting Genocide on Film, Video and the Internet*, Minneapolis: University of Minnesota Press.

Traverso, A. and Crowder-Taraborrelli, T. (2013), "Political documentary film and video in the southern cone", *Latin American Perspectives*, 188, 1:1, pp. 5–22.

Webster, F. (2011), "Information and democracy: The weakening of social democracy", in S. Papathanassopoulos (ed.), *Media Perspectives for the 21ˢᵗ Century*, New York: Routledge, pp. 21–40.

Wheaton, S. (2013), "Sexual assaults in military raise alarm in Washington", *The New York Times*, http://www.nytimes.com/2013/05/08/us/politics/pentagon-study-sees-sharp-rise-in-sexual-assaults.html?_r=0. Accessed 3 June 2015.

Wilson, K. M. and Crowder-Taraborrelli, T. (eds) (2012), *Film and Genocide*, London and Madison: University of Wisconsin Press.

Williamson, E. (2014), "PBS self-destructs and what it means for viewers like you", *Harper's Magazine*, April.

Zimmerman, P. (2000), *States of Emergency: Documentaries, Wars, Democracies*, Minnesota: University of Minnesota Press.

Notes

1 The ITVS Community Cinema series programme changed its name to Indie Lens Pop-Up in 2015. As the films discussed in this essay were screened during the Community Cinema period, we will refer to the series by its former name.

2 Daisaku Ikeda is the founder of Soka University of America and Soka University of Japan, its sister university in Tokyo.

3 ITVS described as the "holy grail" of independent film-making. In 2010, IVTS funding from the CPB was just under 14 million dollars. Since its inception: CPB annual funding agreements for ITVS from its initial year (1990) through FY10 total $199,530,241. http://www.independent-magazine.org/magazine/2008/12/itvs. See also Jack, C. E. and Betsy, A. M., *A New History of Documentary Film*, pp. 297–301, and Michael, R., *Theorizing Documentary*, pp. 20–22.

4 For example, see the "Youth Action Guide" developed to accompany the film *Los Graduados/The Graduates* at http://cdn.itvs.org/TheGraduatesYouthActionGuide.pdf. These pedagogical materials provide useful short cuts for teaching, often serving as lures for professors campus-wide to refer to the films in their classrooms.

5 *The Invisible War* was not part of the Community Cinema festival line-up in 2013, but it is an ITVS documentary film that aired on Independent Lens. The Soka University associate producer requested a special screening of this film, as part of SUA's festival, due to its immediate social relevance and potential to denounce serious crimes and human rights abuses. The fact that ITVS granted SUA special rights to screen the film speaks to its commitment to social justice.

6 Community Cinema post-screening discussion of *The Invisible War* (25 April 2013).

Section 2

Contextual and Institutional Forces

Chapter 4

The Revolution Will Not Be Festivalized: Documentary Film Festivals and Activism

Ezra Winton and Svetla Turnin

Existing studies on the relations between media and democracy – with their focus on policy, texts or ownership and control – present valuable but incomplete arguments, as they largely neglect the audience dimension.

(Harindranath 2009: 24)

Yet it seems important to […] admit that most of the writing on festivals by mainstream critics is inordinately celebratory.

(Porton 2009)

Regarding documentary activism

In this chapter, we seek to depart from the bulk of festival studies and associated scholarship by considering the audience as an integral part of our analysis, while also providing a critical lens from which to view festivals and their relationship with documentary and activism. As Thomas Waugh in his influential 1984 volume *Show Us Life* indicates, documentary cinema has a long and rich history of encounters with activism. When politically committed film-makers like Anand Patwardhan or Alanis Obomsawin spend decades working with subjects and communities, then make available their finished films to those same communities as tools and platforms in the service of both short- and long-term social change, empowering audiences to be part of the process along the way, we call this "documentary activism" (Turnin and Winton 2014: 20). We are interested in how documentary film-makers and institutions interpret such creative-community work (specifically, how it is interpreted by and incorporated in the programme of documentary festivals), and what kinds of consequences these interpretive frameworks have on both works aimed at social change and their attendant audiences. These are concerns that inspire the discussion that follows.

Documentary films interface with activism in several ways: as vehicles for learning about and engaging with communities, as well as building communities themselves; as methods of empowering various constituencies; as instruments for political campaigns or content for social movement media; as collaborative, creative projects involving skill-sharing with communities or as participatory video projects; as agit-prop interventions in the public sphere; as NGO-driven visual culture oriented towards the dissemination of "sensible politics" (McLagan and McKee 2012); as educational public service; as personal statements

and testimonies that take on status quo discourses and dominant narratives; as critiques of dominant media representations; and as artful invectives against dominant, mainstream culture and commercially situated media.[1]

In this chapter, we are interested in a kind of documentary that "functions as a zone of conscience and consciousness" (Zimmermann 2000: 11), while intervening in systems that perpetuate injustice and oppression. Our research privileges non-fiction films that "shine light on the dark recesses of power" (Downing 2014: 14) and whose makers remain indelibly committed (Waugh 1984) to the slow and uphill struggle of social justice and resistance movements and campaigns. In short, we are interested in activist documentaries, and whether you call them political docs, social justice non-fiction films or alternative media, their commonality is located in the objectives and intent of their makers (to effect progressive and radical social change), the life and struggles of their subjects (as compelling representatives of actuality) and the stories they explore (as affective narratives), and the consequences of their diffusion (as campaigns or awareness-building tools, change-agents, platforms for political performance and discourse and so on). In short, they are the creative hubs for communities and publics engaged in and dedicated to documentary activism.

We also recognize that some political documentaries are not interested in advancing progressive social change, such as recent examples that fan the flames of racism and xenophobia in the name of anti-terrorism.[2] Still others seek to contribute to modes of social action largely circumscribed by liberal and instrumental frameworks of reform, rather than radical and structural transformation.[3] While our interest in the relationship between social justice and media includes considerations of all activist documentaries, with regards to festivals we focus on those works that advance social change agendas and act as calls-to-action, whether they champion a *progressive radical* political framework, or a *liberal consensus* one. We also explore the relationship of such documentaries to institutional forces currently defining and disseminating the activist sub-genre. Through an investigation into the ways in which influential non-fiction film festivals approach documentary and activism, we hope to advance not only a greater understanding of the intersection of documentary, festivals and activism, but also to elevate progressive/radical political documentaries, their makers and the communities they forge and serve.

Regarding film festivals

Film festivals are a relatively new sociocultural phenomenon, having gained prominence only after the Second World War. Whereas the first festivals were created out of the clay of cultural nationalism (de Valck 2007: 14), a core European festival network rapidly inspired global fragmentation of both purpose and form: as the nationalisms of the 1970s gave way to waves of globalism (Czach 2004: 86–87), a bloom in identity-oriented festivals (those

focused on sexuality, gender, ethnicity, etc.) registered promising differentiation in the festival corpus, further spawning specialty platforms for cinephiles seeking specific issue and niche programming (such as LGBTQ, anti-corporate, silent film, Soviet cinema, labour documentary, crime dramas and much more).[4] This evolution of splintering has given us our current festival-abundant epoch where literally thousands of festivals of all shapes and sizes now dot the global mediascape. Among the more recent descendants of the original core-European festival family (Berlin, Locarno and Cannes) are those focused solely on or prominently featuring documentary film and video. In their ranks are the environmental and human rights festivals, which have multiplied exponentially in the last 20 years, partly as a response to and embodiment of the processes of globalization (and its attendant globalizing "scapes", to conjure Arjun Appadurai),[5] and partly as an expression of the rise of organized civil society – a historical development perhaps best characterized by burgeoning social movements (Carroll and Hackett 2006) and the "NGOization" of culture and politics and activist discourse (Choudry and Kapoor 2013). As festival audiences' experience, knowledge and subjectivities are indelibly linked to historical conditions (Harindranath 2009), it is instructive to consider the productive and problematic entanglement that has characterized NGO and civil society activism with documentary.[6] And while some scholarly attention has focused on these elements at the site of festivals, including the recently published *Film Festivals and Activism* (Iordanova and Torchin 2012), we find a lacuna persists in the research whereby "festival activism" is seldom approached from a critical, especially anti-capitalist, perspective, and where spectatorship is rarely problematized as a mode of consumption.

To address this gap, we look critically at International Documentary Film Festival Amsterdam (IDFA) and Sheffield, two film events and institutions that showcase some activist/political documentaries and promote to varying degrees different levels of audience engagement around these works through their screenings, Q&As, panel discussions and other auxiliary events. We selectively engage with these doc-fest giants because of their relevance and influence, as well as their familiarity to us, both as festival attendees and participants.[7] Through our analysis of the intersection of documentary, activism and festivals, we seek to address two important questions for activists, documentarians and scholars (especially those interested in the relationship between social justice and media): how do festivals interpret and incorporate activism, oppositional discourse and critical engagement with film beyond cinephilia, and what are some theoretical and praxis-oriented consequences to the ways in which festivals structure and imagine audiences along the consumer-citizen-activist spectrum?[8] To explore these issues we propose a theoretical framework that considers documentary's association with activism along with the film festival's linkage with consumption by bringing together concepts of alternative media, affective space and Jacques Rancière's dialectic of *consensus* and *dissensus*. Throughout our discussion we remain invested in the transformative power of documentary as catalyst for audiences and communities engaged in progressive social change efforts.

Doing research as documentary activists

We share this affinity for documentary activism as advocates of political cinema and long-serving organizers of activist documentary screenings.[9] Inspired by critical media, cultural and feminist studies, we reject conventional notions of objectivity, opting instead for an interrogation of festival/documentary spaces that is underscored by our own subjective experience so that we may yield a "synthetic cultural account" informed by a "contextual and interpersonal" approach to knowledge (Stacey 1988: 21–27). There is precedent for the conspicuous positioning of the researcher's subjective voice in documentary, and on this count we are indebted to the work of Gaines (1996) and Waugh (2011), respectively. Our subjective experiences as festivalgoers as well as programmers and campus/community event organizers with our organization Cinema Politica inflect our research, and we identify as documentary activists interested in anti-oppression, anti-capitalist and social justice causes and campaigns. Over the years we have experienced first-hand the transformative power of documentary, expressed to us by various modes of spectatorship activation, from audiences who join (or launch) related campaigns, to actions born out of specific screenings, to those who become involved in progressive activist organizations and to activists who use our screening spaces as platforms for radical political communication. Looking beyond our own activities, we find this kind of activist screening space increasingly bracketed out at the site of our not-so-distant cousin, the mainstream documentary film festival.[10] This observation, situated in relation to our own concerns around documentary and activism, has led us to the relatively nascent scholarly field of festival studies.

Towards a critical festival studies

The scholarship on film festivals is rich with description of the inner workings of *film fetes*, including festival film exhibition and dissemination, the mechanisms of the "festival circuit" and commentary on the ways in which festivals foment community, circulate culture, forge economy and, historically, perform politics on the geopolitical stage. More recent singular academic efforts have zeroed in on specific festivals, such as those by Zielinski (2008), SooJeong (2012) and Winton (2013), where a particular site acts as a synecdoche for diffuse trends, conventions and practices in festival culture and commerce. Reading through the diverse and sometimes fervent festival scholarship it is, with few exceptions, difficult to locate any pronounced critical impulse, at least with regards to activism as it intersects with concerns around film festivals and spectatorship.

Similarly, it is difficult to locate critical theoretical concerns, placed in dialogue with methodology and rich description, in the bulk of literature on film festivals.[11] There are examples of scholars deploying sound theoretical frameworks, such as de Valck's hoisting of Actor Network Theory in her reading of the development of the European film circuit (de Valck 2007), and Stringer's use of Foucault to analyse festival space as heterotopic (Stringer

2003). Further, much festival theory is in conversation (intentionally or otherwise) with Anderson's conceptualization of "imagined community" (Anderson 1991) and its notion of the psychic corralling of populations through media across temporal and spatial landscapes, whereby one accounts for membership despite geographic or temporal barriers.

We realize this chapter cannot address all of the aforementioned issues, and in turn we orient our discussion to three underdeveloped aspects of festival scholarship. Specifically, our study moves to (1) focus on political activism and its relationship to festival space; (2) contribute new (and renewed) concepts to a diminutive body of festival theory and (3) advance a formulation of the subject that could be called *critical festival studies*.[12] We humbly acknowledge our indebtedness to the work of pioneers in the field like Nichols (1994: 68–85), whose analyses have provided a much-needed critical entry point for the work that followed, and is yet to come.[13] We therefore turn to an outline of our embryonic theoretical framework, built on three interlocking concepts: affective architecture, the politics of presence and Rancière's notion of dissensus. Each concept is meant as a compendious point of departure for continued critical discussions focused on activism and film festivals (as opposed to a foreclosed framework).

Building an affective space

Film scholars and documentary activists Liz Miller and Thomas Waugh argue that, "mobilizing affect is the currency of documentary and a critical first step in raising awareness of political realities, but screening a political doc is not enough" (Miller and Waugh 2014: 41). When a moving documentary produces affect,[14] that force of transformation can subside to the realm of inaction and pity if it is "not accompanied by some kind of deeper reflection" (Miller and Waugh 2014: 41). Miller and Waugh point out that transforming "affect to critical self-reflection" requires much more than a truncated Q&A session: "[a] first step is creating an environment where questions are encouraged, and where debates are exciting and are led by unconventional 'experts'" (Miller and Waugh 2014: 41). Fostering critical and engaged spectatorship could be the purview of festivals, and at least one scholar has described festivals as an affective space,[15] but even then we see the potential of affect – to move impacted bodies into action – as shirked opportunities. In these festival environments, myriad cultural symbols and messages converge on screens and in social spaces, shaping how festivalgoers experience, feel about and respond to the festival and its offerings, both individually and collectively. This sensorial configuration connects with Raymond Williams's concept "structure of feeling", which is the differential quality of experience at a given time and place, especially as it relates to the interaction between art, culture and institutions, and is actuated by Williams as a way to account for the lived experience of ideology (Williams 1961: 146). This often-cited theory ushers our notion of the affective space of festivals, where, as is argued in relation to groundbreaking LGTBQ festivals:

A space [is formed] where a group of individuals could *meet* and create a community. As such they were counter-public spheres, where the films were as important as the staging of the *event*. Thus, the functions of queer film festivals were, and still are, to represent the community cogently in its diversity [...] and to constitute their respective counter-publics.

(Loist and Zielinski 2012: 50, emphasis added)

With regards to documentary, activist and human rights film festivals, the coming together of community for a shared experience approximates what we describe as an *affective architecture*. The *architecture* of this space echoes Williams's structural consideration of feeling (or a felt reality) and the ways in which social structural elements (like institutions, social mores, conventions and codes) embody and shape our cultural and ideological differences.[16] The architecture is *affective* because it is a space oriented towards impassioned projections that summon a "prepersonal intensity corresponding to the passage from one experiential state of the body to another and implying augmentation or diminution in that body's capacity to *act*" (Massumi 1987: 17, emphasis added). It is a cultural space where bodies come together (as an audience and as a *body politic*[17]) and have the potential to translate personal experiential impact to social impact. The ways in which this affective architecture is controlled, subverted or put to use are varied, yet often the transformative potential is directed towards status-quo cultural and political regimes (whether that is western human rights discourse, neo-liberalism, consumerism or capitalism), rather than antipodal, alternative or dissenting reflexive and interpretive spaces.

At most mainstream festivals, the affective architecture is shaped in part by management and grant-funding or sponsoring institutions (a framework of corporate, non-governmental and state interests) and less so by participating artists, publics and audiences. It is often structured to bracket out (or contain) critical discourse, with truncated Q&As lasting ten to fifteen minutes at most, instead of lengthy, introspective discussions that allow for an emotive and collectively reflexive response from audiences. Audiences moved by a screening of *Blackfish* (Cowperthwaite 2013) at Hot Docs in 2013 came up against such imposed limitations when after a short Q&A someone in the audience yelled "But what can *we* do?" Despite the existence of a local tie-in campaign to close down Ontario's Marineland, there was no opportunity created to discuss localized action or share information from community activists. This structure of enclosure, shaped by the laws of efficiency and accumulation (of audiences, tickets, etc.), severely limits a film's potential to incite divergent expression, dialogue and political participation by foreclosing on local political action. In this regard we believe that an *effective cinema of action* will only flourish within an *affective screening space of political possibility*.

Festival spaces are structured contact zones[18] that facilitate experience, feeling and expression among and between attendees, and can be designed to nurture some forms of communication and social action while discouraging others. Speaking more broadly, Laura Podalsky writes on emotion and affect as it relates to cinema:

[Deleuze] encourages us to understand the cinema (and the subject) not in terms of scopic action(s), but rather multisensorial processes [...] Instead of examining how films organize or fix the spectator's visual apprehension of the profilmic space or how they deploy moral distinctions to align us with particular characters rather than others, we need to acknowledge and account for the myriad touch-points through which films and situated audiences encounter each other.

(Podalsky 2011: 13–14)

Podalsky's analysis of a "cinematic aesthetics of sensation" foregrounds affect as a distinct sensorial response to film, different from the socially constituted emotional response, where "affect is embodied intensity" and emotion is "the socio-linguistic fixing of the quality of an experience which is from that point on defined as personal" (Podalsky 2011: 12–14). Powerful documentaries that reveal gross human rights abuses or injustices are uniquely situated to evoke an embodied response from audiences while combining both the emotional pull of cinematic technique and the knowledge push of rational discourse. This potent combination can create an affective space where the embodiment of injustice is translated into empathy, anger and inter-bodily dialogic and expressive encounters.[19]

At commercially driven festivals the affective architecture is designed to contain a consumer response to cinema (privatized, sensible, individual), while determining that the various *touch-points* and encounters that hash out the entanglement of politics and aesthetics are relegated to the social space outside the festival, whence they came. This is why at mainstream festivals audience members will neither find activists tabling and handing out flyers, nor will they encounter lengthy post-screening discussions, but will instead find ubiquitous marketing campaigns for corporate sponsors and privatized spaces that combine industry, market and NGO interests with the pursuit of capital (such as micro-meetings and pass-holder cocktail receptions). On this topic, activist film-maker Anand Patwardhan laments:

Sadly, documentary festivals, especially the well-known ones, are victims of their own success. In the early days, before docu-filmmaking became high-budget and lucrative, festivals provided a much-needed space for filmmakers and film lovers to meet and discuss their concerns, which had less to do with money and more to do with content and form. Slowly the market entered the picture and initially filmmakers welcomed the fact that they could make distribution connections this way.

(personal communication)

In contrast to market-oriented festivals, at anti-capitalist, radical and anarchist screening spaces the affective architecture nurtures and encourages diverse responses to films, time for reflection and introspection and ways to transfer disembodied (projected) injustice into bodily (individual *and* collective) action.[20] These spaces, in which documentaries are viscerally *felt*, as they "make their appeal through the senses to the senses" (Gaines 1999: 92)[21]

amount to messy arenas for politics and culture that recall Chantal Mouffe's notion of agonistic pluralism (Mouffe 2000). Such spaces, by the very nature of their diverse, non-commercial inputs, are geared towards social transformation that shifts action and discourse away from oppressive socio-economic structures. Furthermore, they do not conform to the perceived liberal consensus of political expression and action that comprise many festival spaces, where embodied affect is mutated into disembodied "impact" (the buzzword of so many "social action entertainment" surveys and assessments).[22]

Politics of presence and dissensus

If the affective architecture points to a structure of feeling that helps give shape to a festival "body politic" (Loots 2001: 9–14), then the politics of presence and dissensus signal an attributive quality between the structure and the moving parts, where the former suggests aspects of personal embodiment and, the latter, interpersonal politics. We see a politics of presence as the spatial, affective and politicized festival articulation of Stuart Hall's notion of "the politics of representation" – Hall's theoretical lens for viewing media and culture, which involves decoupling images from their supposedly fixed meanings (Hall 1988: 442–451). For Hall, representation is both reflexive and constitutive, and in this framework mainstream festivals can be seen both to be in conversation with the dominant social order and count themselves as among its working parts. We are interested in Hall's interrogations into the who, what and how of audio-visual information encountered at screenings, and in the less investigated *participant-reception* context of the film text – the ways in which the collective audience experience can both displace notions of *consumer-reception* and challenge current assumptions about media practices as they relate to activism.[23]

The term *politics of presence* was used in relation to the civil, women's and labour rights movements of the 1960s and later as a lens in the 1990s to critique a persisting lack of political inclusion and equality, where it was deployed as both academic criticism and a way to imagine improvements of representational deficiency in the material sphere of social life. Anne Phillips, who devoted her 1996 volume to an interrogation of the concept *Politics of Presence*, writes: "Radical democrats, particularly those of more utopian bent, have continued to explore alternative avenues of 'typical' or 'mirror' or 'random' representations, which they have seen as [...] a more satisfactory way of ensuring that all interests are adequately addressed" (Phillips 1995: 2). Its progressive conclusion is the notion of a utopic space of diversity and difference, where productive debate, justice-oriented discourse and egalitarianism can exist in the public sphere. We are updating the phrase to apply it to the transformative potential of social spaces where diverse inclusion has presumably been achieved, such as those found at documentary-oriented festivals.

A politics of presence that welcomes disagreement and difference, as opposed to deliberative dialogue's onus on the manufacturing of consent, fosters a multiplicity of frameworks and approaches to the injustices and crimes encountered on-screen and then

discussed. Following Mouffe, this kind of politics of presence contributes to democratic values that include, rather than overlook or bracket out, radical perspectives:

> One of the shortcomings of the deliberative approach is that, by postulating the availability of a public sphere where power would have been eliminated and where a rational consensus could be realized, this model of democratic politics is unable to acknowledge the dimension of antagonism that the pluralism of values entails and its ineradicable character.
>
> (Mouffe 2000: 13)

If consensus, vis-à-vis deliberative democracy or otherwise, is a liberal fantasy that signals an end to a politics of difference and where elite interests (or more crudely, the loudest and most privileged voices) set the agenda (Rancière 2010: 42), then a reinvigorated politics of presence is needed at festivals to encourage a diversification of what we see as *normative festival spaces*, where antagonism and pluralism would be recognized and encouraged as productive and legitimate aspects of documentary spectatorship. This is a kind of presence articulated through political action and discourse (imagine a screening that leads into a political rally). Indeed, as Geiger notes: "documentary has long produced a kind of imagined space – and 'real place' – for social engagement" (Geiger 2011: 144–149), and as such festivals featuring documentary work are not only spaces of circulation, but also where aspects of politics and aesthetics manifest as on-the-ground culture and community.

This brings us to our final, and most abbreviated, theoretical marker *dissensus*, which is Rancière's antithetical political-aesthetic configuration to consensus. His theoretical framework connects with Mouffe's notion of agonistic pluralism and, more generally, with radical political action and discourse by way of his fierce opposition to any authoritative presence in social spaces shaped by the engagement of politics and art. In his eminent "Ten Theses" he argues:

> The police is that which says that here, on this street, there's nothing to see and so nothing to do but move along. It asserts that the space of circulating is nothing other than the space of circulation. Politics, in contrast, consists in transforming this space of "moving-along" into a space for the appearance of a subject: i.e., the people, the workers, the citizens: It consists in refiguring the space, of what there is to do there, what is to be seen or named therein. It is the established litigation of the perceptible.
>
> (Rancière 2010: 37)

Just as "the police" exert authority (Rancière 2011: 3), festival management has the power to shape the festival space as either one of circulation within an accepted capitalist framework, or a reconfigured space of documentary activism in a dissenting and (politically) polyvalent framework. Rancière's notion of dissensus allows us to disrupt the idea that festivals must be distributive nodes of "the sensible" and instead conceive of festivals as facilitating a cultural

politics of the *unsensible* (including radical politics, anarchism and anti-capitalist expression and action). In his introduction to *Dissensus: On Politics and Aesthetics*, Steven Corcoran sums up Rancière's philosophy on these two modal points of mainstream and alternative social organization:

> Consensus, as Rancière understands it, is defined by "the idea of the proper" and the distribution of places of the proper and improper it implies. This logic is, in his view, the spontaneous logic underlying every hierarchy: "it is the very idea of the difference between the proper and the improper that serves to separate out the political from the social, art from culture, culture from commerce" and that defines hierarchal distributions where everyone's speech is determined in terms of their proper place and their activity in terms of its proper function, without remainder.
>
> (Corcoran 2010: 2)

Conversely, dissensus is the logic of disruption of the above ordering. For Rancière, dissensus "consists of a certain *impropriety* which disrupts the identity and reveals the gap between *poeisis* and *aisthesis*" (Corcoran 2010: 2, original emphasis).[24] If film festivals have become showcases for both "innovative cinema and corporate entities" (Porton 2009: 1–9), and destinations for high-profile NGOs (Iordanova 2012: 1–12), then the logic of consensus would seem to consist of matching a proper *poeisis* of pacified spectator space (this in no way implies a passive audience), coupled with privatized reform actions (undergone outside of the circulation space of the festival), with an *aisthesis* of comfort, pleasure and the familiar. In other words, if documentary festivals that trade on controversial and provocative social justice narratives are corralling consensus, and in doing so simply providing slightly differentiated spaces of consumption and emotion similar to those found in the gathering spaces of the commercial multiplex and corporate conference, then an activated logic of dissensus – of rupture between sensible politics (reception-consumption) and pretty images (social action entertainment and other iterations of liberal consensus documentary) – could shake the foundations among festivals enough to let in some oppositional and antagonistic forces (within mainstream festivals and as alternative spaces elsewhere).

It is our contention that mainstream commercial festivals police (in the Rancière sense) discursive platforms, truth modes and channels of circulation to fit within the established practice of approaching social justice from a neo-liberal capitalist framework, where consumption and privatization, not to mention financialization, are points of contention of the image complex. By maintaining a liberal activism that is tied to modes of operation that uphold the status quo of reformist instrumental intervention (small individual acts), state and NGO-led solutions, and knowledge-through-entertainment, mainstream festivals do little more than acknowledge injustice, while inadvertently promoting (in)action and (in)equity. Folding in the "whole community", as Rancière suggests, prefigures a space of action that includes oppositional and uncomfortable views and perspectives. Where this

occurs, the festival space resembles less a commercial space of consumption and more an affective architecture that breeds dissent, confrontation and radical political action.

In an effort to leverage these theoretical impulses, the section that follows describes encounters with two documentary festivals that engage in various levels of juggling consent and dissent, affect and effect, *doing* and *knowing*.

Festival encounters: Sheffield Doc/Fest

In the introduction to *Film Festivals and Activism*, Torchin writes that "[one] could find a component of activism in many festivals, and not simply those explicitly identified as activist, as these are spaces that enhance the testimonial encounter between viewer and screen witness through discussions, activities, and links to action" (Torchin 2012: 10). A festival that successfully brings together industry, cinephiles, activists, academics and civil society groups and organizations is the UK-based Sheffield Doc/Fest. Arguably one of the ten most prominent documentary festivals in the world, Sheffield has managed to sustain a unique and seemingly independent programming identity, an independence reflected in its brand identity and inclusive spirit as well. Unlike most festivals that receive government and industry funding for their operation, Sheffield refrains from imposing a conspicuous corporate presence on its events, and its approach to sponsor recognition is quite subtle.

We attended the festival in 2012, on the heels of Occupy Wall Street and the Arab Spring.[25] In a timely and politically responsive manner, the festival had programmed a number of auxiliary events connected with the Occupy movement, exhibiting an acute awareness and sensibility to the pressing and transformative nature of the movement. All events offered relevant sources, activist sign-up sheets and plug-in opportunities for audiences to connect with organizations and groups working on the ground (linking efforts missing from many commercial documentary festivals). Screen slides featured relevant hashtags and important Twitter accounts to engage with during and after the events, encouraging the audience to continue the polyvalent discussions.

A panel entitled "Occupy Documentary: Can Filmmakers Be Activists?" and featuring film-makers Emily James (*Just Do It: A Tale of Modern-Day Outlaws* 2011), Brian Knappenberger (*We are Legion: The Story of the Hacktivists* 2012), Daniel Garvin (*We're not Broke* 2012) and journalist, rabble-rouser and film-maker Leah Borromeo explored the relationship between documentary film-making and activism. The discussion focused on the transformative power of documentary, its role in social movements and the challenges doc-making activists face in the production and distribution of their work, as well as the discursive space in which such work exists. In an environment reminiscent of an activist film festival, the film-makers discussed their motivation to inspire audiences towards critical inquiry and actions for social change. They reflected on their practice, art and direct involvement with the issues and subjects represented in their work, as well as the ways in which their lives and work interlocked with various degrees of activist practices. The

absence of "experts" or institutional representatives participating on this panel meant the focus of the discussion remained in the purview of the film-makers, who reflected on their art practice and direct personal involvement with the issues and subjects represented in their work.[26]

The panel exemplified the potential of documentary festivals to nurture a documentary activism in which radical cultural practitioners and makers can frame the discussion and explore topics on subversive film-making and activist practices. In line with Torchin's observation that the "activism of a festival is [located] [...] in its sites for discussion, exchange, networking [...] and promotion of the work being done" (Torchin 2012: 99) one could say that Sheffield Doc/Fest offers a fertile space for critical discourse where activist *modes of doing* – such as hacktivism, direct action, climate camps and anti-Olympics organizing – are legitimized and make up the radical subject matter of artistic production and audience outreach.[27] Auxiliary events like these give shape to the affective architecture of the film programme, and can draw on the affective power of the films and media presented at the festival to transform contact zones into spaces of action.

Also featured at Sheffield Doc/Fest was the Palestinian-Israeli documentary *5 Broken Cameras*, directed by Emad Burnat and Guy Davidi. Few films we have seen screened have generated such a strong, palpable response from audiences. Combining the dynamic qualities of powerful and personal storytelling with the conflict-transcending collaboration of a Palestinian and Israeli film-maker, the film manifests the hopeful notion of collaborative resistance. Sheffield programmed the documentary despite already having a surplus of content on the topic, and allowed for an extended hour-long discussion after the screening, arranging to have both the Palestinian director-subject and the Israeli co-director in attendance. The resulting discussion with the audience was vibrant, diverse, lengthy and emotional, and certainly conducive to "renewing social commitment [...] and exciting others into the possibilities of political engagement" (Blaževič 2012: 110).

The space allowed Burnat's experiences to be crystallized in an affective architecture in which the politics of presence involved not only the audience and artist, but the protagonist as well. Just as the "transformative power of testimony [...] is enabled through situated activities" (Torchin 2012: 3), the extra-screening testimonials of the film-maker-subject allowed for not only an affective spectator experience, but also the possibility for audience activation. A semblance of a community took shape during the discussion – a body politic of informed and committed audience members (perhaps the beginnings of Rancière's "whole community") – allowing for a collective transference of the sensory experience from screen to body, and of compassion and commitment to solution-based calls to action. It was, in effect, an affective space in which the emotional and corporeal response swept through the audience and instilled a communicative and affective politics of both inclusion and dissent.

Sheffield Doc/Fest ensured that both film-makers attended the festival and presented their work in an equitable, inclusive setting,[28] reflecting a "representational intervention" approach (Torchin 2012: 4). Burnat's brave and humanitarian responsibility to document was juxtaposed with Davidi's role as an outsider-witness to the violence exacted on Burnat's

small community, and both film-maker-activists spoke of the collaboration as an equitable relationship, which Burnat claimed was not based on politics but rather artistic appreciation (he had seen Davidi's work in Bil'in), as well as a humanism that transcended the politics of the region.[29]

Following Raymond Williams, works of art require "active readings" in order to become "present" in one's life, and "the making of art [...] is always a formative process, within a specific present" (Williams 1977: 129). Extended artist-audience discussions involve a process of collective active "reading" of a film in a shared material space that enables a sensorial transference from screen to body, through spoken and embodied language, or the articulation of feelings in a collective space. According to Davidi (speaking at Sheffield Doc/Fest 2012), 5 Broken Cameras was meant to build "relations and connections" that would continue beyond the context of the festival for members of the festival audience. Indeed, the screening of the film established a bond of trust and empathy between the viewers and the subjects in the film. As one audience member exclaimed, the film came across as an "incredibly subversive weapon for truth", alluding to the affective power of documentary and the capacity of film festivals to build "interpretive contexts" in which to "raise public awareness and advocate for social change" (Blažević 2012: 112). In his discussion of a "horizon of expectations" germane to documentary audiences, Harindranath posits: "The crucial aspect of the documentary interpretation is, obviously, our assumption that the text relates directly with the outside world" (2009: 130). Rigorous, contemplative audience discussions and other auxiliary discourse-focused events common at Sheffield Doc/Fest steer spectator expectations towards the outside world first encountered on-screen, then beyond.

Festival encounters: IDFA

The International Documentary Festival Amsterdam, or IDFA, is by most accounts the biggest and most influential documentary festival in the world.[30] The Dutch event, held each November, features numerous extended Q&As, talks and panel discussions alongside social issue documentaries. These are often moderated by local experts, film critics, journalists and media makers, and reflect the festival's commitment to audience engagement, the power of which can be seen in the swelling ranks of dedicated audiences it attracts and retains during discussions. Blažević claims the difference between festivals usually lies in the way they "understand their core mission, the motivation behind their screenings and what they want to achieve" (Blažević 2012: 111). Similar to activist festivals, IDFA recognizes its tremendous outreach potential, which it skilfully employs to connect audiences to advocacy, capacity and awareness-building, and to create spaces conducive to critical discourse and political activism.

In 2013, IDFA screened *Return to Homs* (Derki 2013), inviting both the producer and director to attend an extensive post-screening discussion. In the words of Higgins, the discussion allowed for the "reconfigur[ation of] power relations and act[ed] as counter

space to often violent political realities" (Higgins 2012: 138) by focusing on the Syrian artists, their experiences and their interpretative approach (as opposed to that of western media, politicians or NGOs) to translate affect into political effect in their war-torn country.

That year, IDFA also partnered with Oxfam Novib, one of the seventeen Oxfam affiliates working on poverty around the world, to present the Oxfam Global Justice Award to a film in the festival programme. Oxfam selected three films: *No Land No Food No Life* (Miller 2013), *The Trouble With Aid* (Pollack 2012) and *Light Fly, Fly High* (Hofseth and Østigaard 2013), all connected to campaigns in the Oxfam roster. Oxfam created a trailer for the award, featuring clips from the three contenders, which was played before every festival screening, industry screenings included, giving the films and the organization tremendous exposure. The award recipient was determined by an audience vote at three special Oxfam-sponsored screenings, held in the main cinema to sold-out audiences of 750. Each of these screenings featured panel discussions with Oxfam, other NGO representatives, and the film-makers. Along with the audience ballot slip, audience members were also given flyers, sign-up sheets, petitions and brochures, which allowed them not only to learn about the issues, but also leave with tangible plug-ins for future involvement. According to Amy Miller, the director of *No Land No Food No Life*, a documentary exploring the effect of agricultural land grabs around the world, Oxfam worked with her from the beginning to invite other participants to the panel, in this case a representative from Friends of the Earth. Miller says that the opportunity to speak alongside organizations already working on the issues featured in her film generated tremendous "capacity to make sure there is engagement with the issue", an observation that resonates with Torchin's claim that partnerships with NGOs "enhance capacity building" (Torchin 2012: 97) at film screenings. A question remains, however, as to how "capacity-building" can help engage audiences in a critical manner, inspire productive empathy and translate affect into direct action and involvement beyond the festival.

Oxfam Novib's partnership with the festival and its impressive physical and mediated presence at the presentation of these films is an example of providing governmental and non-governmental interests a "performative platform" (Torchin 2012: 7). At the *No Land* panel, both NGOs did not miss an opportunity to showcase their impressive roster of campaigns and multi-pronged approaches to tackling the issues, including initiatives focused on lobbying powerful players such as banks, investment funds and corporations to act responsibly. The film-maker, on the other hand, spoke of her experience with groups and organizations such as Via Campesina, which works directly with peasants, and in this way discussed land grabs as extensions of ongoing processes of neo-colonialism, the importance of building solidarity with farmers locally and abroad, and the need to re-evaluate the capitalist system that brought about the injustices in first place. The tension between the liberal discourse imparting trust in "corporate social responsibility" and the somewhat radical critique articulated by the director prompted the Friends of the Earth representative to suggest that one does not need to be anti-capitalist to be against land grabs. Miller's refreshing interventions into what could have been a homogenized, consensus-driven liberal panel generated animated audience response and activated spectatorship. The discussion

was an excellent example of politics of presence, where a basic consensus ("land grabs are bad") did not prevent an articulation of diverging and even oppositional viewpoints, and inspired dissensus, which we consider a positive development for documentary activism at a large festival.[31]

Discussing NGO participation in festivals as complicating, in their own way, a politics of presence implies a targeted, formal presentation or routine that does not extend beyond each organization's institutionally mandated parameters. Given this, how is their inclusion conducive (or not) to documentary activism? Although each of the three IDFA films selected for the Oxfam Global Justice Awards had an impressive five or more screenings, Oxfam Novib's participation did not, ironically, extend beyond the screenings at the main theatre. According to Miller, Oxfam missed a great opportunity to be present at the rest of the screenings of her film, an opportunity seized by Friends of the Earth, who worked closely with Via Campesina, and who distributed materials and provided updates at the Q&As after the film. Friends of the Earth did not limit its outreach efforts to one screening and remained committed to education and community building for the remainder of the film's run and throughout the festival, a sustained effort that affirms Miller's decision to seek out their participation as activist-partners and illustrates how film-makers themselves can effectively foster multi-stakeholder participation at events around their screenings – that is, if the architecture permits.

Conclusion

In preparing this chapter, we were greatly impacted (and affected) by Joshua Oppenheimer's *The Act of Killing*, a documentary that offers a dissenting version of the dominant narrative of the 1965–1966 Indonesian genocide, and that confronts and implicates us in the violence it seeks to understand. We asked Oppenheimer what he had to say about the cultural politics of documentary, festivals and activism, and he offered the following comment:

> The aim of art is to help us gaze unflinchingly at truths we fundamentally already know, but have been too afraid to acknowledge, and perhaps too afraid even to remember. This makes radical activism possible, but it is not the same as either activist journalism or activism itself. By forcing people to contemplate our most painful truths, nonfiction film opens the space for us to address our most frightening problems. Film festivals should focus on works of poetic power that are truly disquieting, and open a space for radical action.
>
> (personal communication)

We agree with Oppenheimer, and have outlined some theoretical points and anecdotes in this chapter in order to offer a critical account of documentary festivals – events that often trade on social justice discourse and political activism. Our intention has not been to paint

a hopeless picture of the potential for radical political encounters at these institutions, but rather to highlight some problematic conventions and tendencies. We hope festivals, including the mainstream commercial variety, find the spirit and fortitude needed to diversify the festival space and experience, and to open the space for radical action. The capitalist-liberal framework has much to offer in terms of coping mechanisms, reform and distraction from real structural solutions and radical change. We believe that documentary festivals have the potential to facilitate ruptures in the status quo, which continues to construct consensus on "activism" around everything from the environment to climate change to human rights. To achieve these radical spaces of action and art, we need a new kind of festival activism, and we need a Critical Festival Studies that examines and theorizes festivals. As Porton reminds us, "In an era where digital technology makes it feasible to design a film festival that will not require any of us to leave the confines of our own homes, the films screened at any one event are almost less significant than the institutional apparatus that promotes them and the media buzz that either enshrines or demonizes them" (2009). We have endeavoured to do our small part in looking at that institutional apparatus, and have attempted to shift a liberal framework to a radical framework through which to experience, interpret and use documentary and activist festival spaces, discourse and texts.

References

Anderson, B. (1991), *Imagined Communities*, New York: Verso.

Bao, H. (2010), "Enlightenment space, affective space: Travelling queer film festivals in China", in M. Iwatake (ed.), *Gender, Mobility and Citizenship in Asia*, Helsinki: University of Helsinki Press, pp. 174–205.

Benzine, A. (2013), "Pivot's Shapiro: We are a general entertainment network", *Realscreen*, http://realscreen.com/2013/03/28/pivots-shapiro-we-are-a-general-entertainment-network/. Accessed 25 May 2014.

Blažević, I. (2012), "Film festivals as a human rights awareness building tool: Experiences of the Prague One World Festival", in D. Iordanova and L. Torchin (eds), *Film Festival Yearbook 4: Film Festivals and Activism*, St. Andrews: St. Andrews Film Studies, pp. 109–120.

Burnat, E. and Davidi, G. (2011), *5 Broken Cameras*, Alegria Productions, Burnat Films Palestine, Guy DVD Films.

Carroll, W. K. and Hackettt, R. A. (2006), "Democratic media activism through the lens of social movement theory", *Media Culture Society*, 28:1, pp. 83–104.

Choudry, A. and Kapoor, D. (eds) (2013), *NGOization: Complicity, Contradictions and Prospects*, London: Zed Books.

Corcoran, S. (2010), Editor's introduction, in S. Corcoran (ed.), *Dissensus: On Politics and Aesthetics*, London and New York: Bloomsbury Academic, pp. 27–44.

Cowperthwaite, G. (2013), *Blackfish*, New York: CNN Films.

Czach, L. (2004), "Film festivals, programming, and the building of a national cinema", *The Moving Image*, 4:1, pp. 76–88.

Deleuze, G. and Guattari, F. (1987), *A Thousand Plateaus: Capitalism and Schizophrenia* (trans. B. Massumi), Minneapolis: University of Minnesota Press.

Derki, T. (2013), *Return to Homs*, Berlin, Damascus and Cairo: Proaction Film.

Downing, J. (2014), "Illuminating the crimes of the powerful: A foreword", in S. Turnin and E. Winton (eds), *Screening Truth to Power: A Reader on Documentary Activism*, Montreal: Cinema Politica, pp. 17–28.

Gaines, J. M. (1996), "The milos in Marxist theory", in D. E. James and R. Berg (eds), *The Hidden Foundation: Cinema and the Question of Class*, Minneapolis: University of Minnesota Press, pp. 56–71.

Gaines, J. M. (1999), "Political mimesis", in J. Gaines and M. Renov (eds), *Collecting Visible Evidence*, Minneapolis: University of Minnesota Press, pp. 84–102.

Geiger, J. (2011), "Documentary: Negotiating the public sphere", *New Formations*, 74, pp. 144–149.

Hall, S. (1988), "New ethnicities", in D. Morley and K.-H. Chen (eds), *Stuart Hall: Critical Dialogues in Cultural Studies*, New York: Routledge, pp. 442–451.

Harindranath, R. (2009), *Audience-Citizens: The Media, Public Knowledge and Interpretive Practices*, New Delhi: Sage Publications India, p. 24.

Higgins, N. (2012), "'Tell our story to the world': The meaning of success for a massacre foretold – A filmmaker reflects", in D. Iordanova and L. Torchin (eds), *Film Festival Yearbook 4: Film Festivals and Activism*, St. Andrews: St. Andrews Film Studies, pp. 133–148.

Hofseth, B. and Østigaard, S. (2013), *Light Fly, Fly High*, Olso: Fri Film.

Iordanova, D. (2012), "Film festivals and dissent: Can film change the world?", in D. Iordanova and L. Torchin (eds), *Film Festival Yearbook 4: Film Festivals and Activism*, St. Andrews: St. Andrews Film Studies, pp. 1–12.

Iordanova, D. and Torchin, L. (eds) (2012), *Film Festival Yearbook 4: Film Festivals and Activism*, St Andrews: St Andrews Film Studies.

Loist, S. and Zielinski, G. (2012), "On the development of queer film festivals and their media activism", in D. Iordanova and L. Torchin (eds), *Film Festival Yearbook 4: Film Festivals and Activism*, St. Andrews: St. Andrews Film Studies, pp. 49–62.

Loots, L. (2001), "Re-situating culture in the body politic", *Agenda: Empowering Women for Gender Equality*, 49, pp. 9–14.

McLagan, M. and McKee, Y. (eds) (2012), *Sensible Politics: The Visual Culture of Nongovernmental Activism*, Brooklyn: Zone Books/MIT Press.

Miller, A. (2013), *No Land No Food No Life*, Montreal: Films de l'Oeil.

Miller, L. and Waugh, T. (2014), "The process of place: Grassroots documentary screenings", in S. Turnin and E. Winton (eds), *Screening Truth to Power: A Reader on Documentary Activism*, Montreal: Cinema Politica, pp. 35–44.

Mouffe, C. (2000), "Deliberative democracy or agonistic pluralism", *Reihe Politikiwissenschaft/Political Science Series*, 72, Vienna: Institute for Advanced Studies, https://www.ihs.ac.at/publications/pol/pw_72.pdf. Accessed 12 June 2014.

Nichols, B. (1994), "Global image consumption in the age of late capitalism", *East-West Film Journal*, 8:1, pp. 68–85.

Ott, B. L. and Mack, R.L. (2010), *Critical Media Studies: An Introduction*, Hoboken: Wiley-Blackwell.

Phillips, A. (1995), *The Politics of Presence*, Michigan: Clarendon Press.

Podalsky, L. (2011), *The Politics of Affect and Emotion in Contemporary Latin American Cinema*, New York: Palgrave Macmillan.

Pollack, R. (2012), *The Trouble with Aid*, London: Wall to Wall.

Porton, R. (2009a), "Introduction", in R. Porton (ed.), *Dekalog 3: On Film Festivals*, London: Wallflower Press, pp. 1–9.

—— (2009b), "The festival whirl: The utopian possibilities–and dystopian realities–of the modern film festival", http://www.movingimagesource.us/articles/the-festival-whirl-20090908. Accessed 3 April 2014.

Pratt, L. (1991), "Arts of the contact zone", *Profession*, 91, pp. 33–40.

Rancière, J. (2010), "Ten theses on politics", in S. Corcoran (ed.), *Dissensus: On Politics and Aesthetics*, London and New York: Bloomsbury Academic, pp. 27–44.

—— (2011), "The thinking of dissensus: Politics and aesthetics", in P. Bowman and R. Stamp (eds), *Reading Rancière*, London and New York: Continuum, pp. 1–17.

SooJeong, J. (2012), *The Pusan International Film Festival, South Korean Cinema and Globalization*, Hong Kong: Hong Kong University Press.

Stacey, J. (1988), "Can there be a feminist ethnography", *Women's Studies International Forum*, 11:1, pp. 21–27.

Stringer, J. (2003), "Regarding film festivals", unpublished Ph.D. thesis, Bloomington: Indiana University.

Torchin, L. (2012a), "Networked for advocacy", in D. Iordanova and L. Torchin (eds), *Film Festival Yearbook 4: Film Festivals and Activism*, St. Andrews: St. Andrews Film Studies, pp. 1–12.

—— (2012b), "Traffic jam revisited: Film festivals, activism and human trafficking", in D. Iordanova and L. Torchin (eds), *Film Festival Yearbook 4: Film Festivals and Activism*, St. Andrews: St. Andrews Film Studies, pp. 95–106.

Turnin, S. and Winton, E. (2014), "Introduction: Encounters with documentary activism", in S. Turnin and E. Winton (eds), *Screening Truth to Power: A Reader on Documentary Activism*, Montreal: Cinema Politica, pp. 17–28.

de Valck, M. (2007), *Film Festivals: From European Geopolitics to Global Cinephilia*, Amsterdam: Amsterdam University Press.

Waugh, T. (ed.) (1984), *Show Us Life: Toward a History and Aesthetics of the Committed Documentary*, Metuchen: The Scarecrow Press.

—— (2011), *The Right to Play Oneself: Looking Back on Documentary Film*, Minnesota: University of Minnesota Press.

Williams, R. (1961), *The Long Revolution*, New York: Columbia University Press.

—— (1977), *Marxism and Literature*, Oxford: Oxford University Press.

Winton, E. (2013), "Good for the heart and soul, good for business: The cultural politics of documentary at the hot docs film festival", unpublished Ph.D. thesis, Ottawa: Carleton University.

Zielinski, G. J. Z. (2008), "Furtive, steady glances: On the emergence and cultural politics of lesbian and gay film festivals", unpublished Ph.D. thesis, Montreal: McGill University.

Zimmermann, P. (2000), *States of Emergency: Documentaries, Wars, Democracies*, Minneapolis: University of Minnesota Press, p. 11.

Notes

1 Of course there are documentaries that seek other paths divergent from those that lead to activism – but we are, for the purpose here, less interested in prosaic wildlife TV series, celebrity exposés and commissioned historical hagiographies.

2 For example, the repulsive 2007 documentary *Obsession: Radical Islam's War with the West* (Raphael Shore and Wayne Kopping 2007).

3 See *POM Wonderful: The Greatest Movie Ever Sold* (Spurlock 2011), *Waiting for "Superman"* (Guggenheim 2010), *No Impact Man* (Gabbert and Schein 2009) or *The Cove* (Psihoyos 2009) for examples.

4 Skadi Loist and Ger Zielinski track some of these developments in their article "On the development of queer film festivals and their media activism", in Iordanova and Torchin (2012).

5 In his influential essay on globalization, "Disjunction and difference in the global cultural economy", Appadurai deploys several imbricated scapes that can be thought of as interlocking components of globalization, including ideascapes and mediascapes. These two scapes resonate with the international development of festivals and their connectivity, as this process has been shaped by and reflects globalizing ideologies (human rights, neo-liberalism and capitalism) and media (from transnational co-productions to the festival circuit).

6 For more on documentary NGOization, see Farnel in Winton (2013: 172).

7 IDFA is largest doc fest in the world; Hot Docs is the largest in North America; and Sheffield is the biggest documentary event in the United Kingdom.

8 Or put differently we could consider the ways in which documentary festivals not only negotiate documentary activism, but also how they conceive of and foment passive to active audiences.

9 With the caveat that we exercise a relatively narrow perspective on global film festival and documentary cultural politics, as a North American-based Bulgarian and Canadian operating in the western sphere, we acknowledge both our position of privilege and of limited scope. As such we have avoided commentary on festivals and documentary politics taking place in other parts of the world and in other cultural and political spheres.

10 The authors fully acknowledge that documentary film festivals aren't "mainstream" in the sense of oppositional poles to alternative media, as situated in most alternative media scholarship and discourse. We use the term throughout this chapter to rather refer to some of the larger, more established and influential, and in some cases, commercial and populist documentary festivals. These are indeed big fish in a small pond, as all niche-festivals (including documentary) operate in the great shadow of their mixed-genre, fiction-oriented counterparts – events that truly champion the convergence of capital, spectacle and consumptive culture. Still, we feel our "mainstream" documentary festivals are, within the marginalized sphere of documentary, less pushed to the edges and more visible than so many other political, activist, anarchist and radical festivals. For those interested in pursuing the more "radical" documentary festivals, we suggest visiting the site of the newly formed Radical Film Network: http://www.radicalfilmnetwork.com/

11 Of course there are exceptions to the rule, such as the 2009 collection *Dekalog 3: On Film Festivals* (ed. R. Porton).

12 We propose a kind of *critical festival studies* and scholarship that would share characteristics and objectives explored in "critical media studies" (Ott and Mack 2009).

13 The invaluable and constantly updated online resource filmfestivalresearch.org offers an introductory list to "Film Festival Theory" that includes essential contributions and many extrinsic or even misplaced works for such a grouping, perhaps proving our point on the critical-theory festival lacuna. More here: http://www.filmfestivalresearch.org/index.php/ffrn-bibliography/1-film-festivals-the-long-view/1-1-film-festival-studies/1-1-a-film-festival-theory/.

14 By "affect" we mean the classic Latin-derived definition of "to act on" or "produce an effect or change in", combined with Deleuze and Guattari's notion of affect as differentiated from feeling or emotion, as a force that compels a body to transformation (and that body, following Deleuze and Guattari, is not only corporeal and individuated, but can also include other bodies such as bodies of thought, institutions, the body politic). The authors distil their approach to understanding affect in the following passages: "For the affect is not a personal feeling, nor is it a characteristic; it is the effectuation of a power of the pack the throws the self into upheaval and makes it real" (Deleuze and Guattari 1980: 262). And: "Affects are becomings. Spinoza asks: What can a body do? We call the *latitude* of a body the affects of which it is capable at a given degree of power, or rather within the limits of that degree. *Latitude is made up of intensive parts falling under a capacity, and longitude of extensive parts falling under a relation*" (279, original emphasis).

15 Hongwei Bao is one of the few scholars emphasizing the coming together of sociopolitical, emotional and affective forces at the site of film festivals (with a focus on queer film events), arguing that "Affect [...] play[s] a very important role in the construction of queer spaces" (Bao 2010: 199).

16 While our use of architecture is largely metaphoric, it is interesting to note that a material structuring of festival space, by architects and planners, impacts bodies that move through those spaces. This is an element of festivals and other public events recently highlighted by individuals in wheelchairs protesting Montreal's Encuentro 2014 lack of accessibility.

17 We are inspired by feminist scholar Davina Cooper's notion of the "progressive body politic" as a collective and active citizenship combined with the building of plurality. For more, see Roseneil, S. (ed.) (2013), *Beyond Citizenship?: Feminism and the Transformation of Belonging*, New York: Palgrave Macmillan, p. 119.

18 For more on the notion of cultural encounters as contact zones see Pratt (1991).

19 It is our assertion that mainstream festivals emphasize the emotional impact in their screening spaces (through programming and Q&As) while deliberately or obtusely bracketing out the corporeal potentiality of affect to move people into action (as opposed to moving emotions). We consider this a disservice to the protagonists of so many of these documentaries, where subjects are literally putting their bodies at risk, or are subjected to bodily violation: as spectators it is our moment to reciprocate productively and respond with our own bodies (in demonstrations, soup kitchens, crisis centres or through the many modes of direct action).

20 Of course we would like to point out that these are not hard-and-fast festival types, but points on a spectrum that varies from a cinema of action to a cinema of consumption with myriad blurred lines and transgressed positions in between (e.g. a commercial festival may be decidedly apolitical and conspicuously corporate but still manages to host lengthy post-screening discussions).

21 In her discussion of the impact of political documentaries as media that potentially move spectators both emotionally and physically (into action), Gaines charts new territory in the field by highlighting the interplay between screened bodies and those of audiences, stating that "Political mimesis begins with the body" (Gaines 1999: 90).

22 For more on "social action entertainment", see Benzine (2013).

23 For example, the concern that *clicktivism* is the new, and entirely disembodied, political activism of the day.

24 For Rancière, *poeisis* involves the complex display of signs and meanings and *aisthesis* the emotional impact or engagement of feelings through which the art is received or felt. Combined, these two qualities coalesce to form his notion of representation, or mimesis. For more on this discussion, see http://www.artandresearch.org.uk/v2n1/ranciere.html.

25 That same year Sheffield Doc/Fest refused to withdraw *Ai Weiwei: Nevery Sorry* (Klayman 2012) and *High Tech, Low Life* (Maing 2012) after a request made by the Chinese embassy in London. The festival cited a refusal to be censored or pressured and exhibited the films, which featured unfavourable representations of the Chinese government. The Chinese delegation subsequently withdrew from attending the festival.

26 Such as so many festival panel discussions on working the market in one's favour and how to make a profit while "changing the world".

27 Other timely panels during the 2012 edition of the festival included "Not much sex so far: Climate change – Doc's greatest challenge" (a panel featuring academics, progressive thinktanks, film-makers and broadcasters) and "Occupy Wall Street livestream this!" (a conversation between Emily Bell, a Columbia University professor of journalism, and Tim Pool, the independent journalist who livestreamed the events in and around Zuccotti Park during the Occupy Wall Street protests).

28 In comparison, Hot Docs chose to bring only the Israeli film-maker, a fact they blamed on lack of sufficient funding, and while Davidi is an articulate and sensitive speaker, the budget-based decision resulted in a lamentable shortfall.

29 The post-screening conversation also revealed that their relationship was not seamless, and it encapsulated some of the tensions inherent in the occupation, particularly in the way Davidi was able to steward questions in English and thus dominated the discussion.

30 http://www.filmfestivaltoday.com/person-of-the-week/the-doyenne-of-documentaries

31 That, however, was not the case at the post-screening panel discussion after *The Trouble with Aid*, where a more consensus-driven exchange took place, dominated as it was by liberal NGO rhetoric.

Chapter 5

Human Rights Film Festivals: Different Approaches to Change the
World

Matthea de Jong and Daan Bronkhorst

Introduction

In recent years, the number of film festivals with a focus on human rights has grown rapidly. This chapter presents a structure that allows an assessment of goals, methods and results. Our theoretical framework starts from authors such as Susan Sontag (2003) and Luc Boltanski (1999) who write on the experience of viewing the suffering of others and what it implies for social conscience and humanitarianism. Yet while linking the distant suffering with "painful, stirring images as the initial spark" (Sontag 2003: 80), we feel a phenomenological analysis of human rights film festivals should take the extra step of including the activism perspective as generated by groups with social change goals. For that purpose, we use a model of human rights "schools" and human rights defence.

"You can ask whatever you want"

On the outskirts of Ouagadougou in Burkina Faso, the film festival Ciné Droit Libre had set up a huge screen for an audience of hundreds, maybe more than a thousand people. Directly in front of the screen were little children playing around. We sat on plastic chairs. Around the chairs was a human hedge of boys and girls on scooters. The full moon gave the spot a magic glow. On the screen, first there were music videos with popular West African musicians and clips of stand-up comedians commenting on freedom of speech to attract an audience. Then, there was a feature-length documentary dealing with land issues in Burkina Faso. While the end credits were running, festival director Abdoulaye Diallo shouted out: "This is Ciné Droit Libre, you can ask whatever you want"![1] And many participated in a fierce discussion.

We attended this festival as part of a group of international film festival staff, with the purpose of sharing knowledge and experiences. "It is all about the popularisation of human rights", said Diallo, "that is the main target".[2] He pressed upon us the message that in his view Ciné Droit Libre is only successful when it helps people realize that they have rights, human rights, and that they can claim these rights. These are different worlds. At the Movies that Matter Festival in the Netherlands, where we work, one hardly feels the urge to make people aware of their own rights – it's more about the rights of *others*, those oppressed and marginalized by repressive regimes, and it is about being critical and knowledgeable about complex issues.

In this chapter, we first sketch the worldwide growth of human rights film festivals and the perspectives and aims of such festivals brought forward by the festivals' organizers. We take the concept of the "moral imagination" as a starting point for positioning the attempts to engage the audience through the screening of human rights films. We then elaborate the core choices and challenges that confront the organizers in aiming at such engagement. The organizers have to address the issues of selection and presentation of films and concomitant debate. Also, they have to consider the engagement that a festival is supposed to produce in the form of fascination (emotional and intellectual involvement) and mobilization (awareness and activism). Having outlined these structural elements of human rights film festivals, we present a set of four "schools" or operative formats that the festivals have adopted, often combining ingredients of more than one school. We offer the typology of these schools in particular reference to human rights defenders, the individuals and groups most closely associated with human rights work. In conclusion, we submit that this paradigm of schools offers important guidance for understanding the various forms of impact that festivals can have on audiences and on the wider public perception of festivals and their human rights message. In our analysis, these festivals are among the most effective means to support human rights as they reflect the wide array of strategies, aims and interpretations that is nowadays associated with the domain of human rights defence.

Growth and aspirations

Despite their often heavy content – "feel-bad movies" we call them jocularly among the festival staff – the sector that focuses on socially engaged films has grown greatly over the past years. In our experience, film-makers are increasingly taking the initiative to be actively involved in the distribution of their films in the country or region where the films' themes are relevant so as to help facilitate social change. We have witnessed a rapid worldwide increase of film festivals that focus on human rights. In 2004, seventeen film festivals founded the Human Rights Film Network. The network has grown every year with new members since then including Papua New Guinea, Ethiopia, Bolivia, Lithuania and many other countries. In 2014, the network comprises 40 member festivals. And many more countries, not yet represented in the network, have film festivals with a focus on human rights, including Colombia, Kyrgyzstan, Niger and Romania. These festivals screen films that portray the many facets of human dignity, including the suffering from violations of freedom of expression and personal integrity, the damages of armed conflict, the pain of deprivation and social injustice.

What do the festivals aspire to? Our partner of the AfricanBamba Human Rights Festival in Thiaroye, Senegal, puts it this way:

The festival is one of the few opportunities for us to communicate to our governors, to our people and to the world what are our dreams, our worries, how we would see a social just and peaceful world. In Thiaroye, AfricanBamba Human Rights Festival is viewed and

lived by the people as a new way for the community to engage, be recognised, and express themselves on urgent social issues.[3]

The festivals basically share the same goal: promotion of the observance of human rights through cinema, as encapsulated in this quote. But that is the objective defined at its widest. To achieve more precise objectives, the ways these festivals position themselves, the criteria for film selection and the manner in which the films are presented vary considerably. At the Movies that Matter Foundation in the Netherlands, we have been in a unique position to witness this growth in diversity. The foundation has supported more than 140 festivals and initiatives worldwide with grants during the past seven years. We also pioneered the Human Rights Film Network.

Moral imagination

The audience comes to watch films, to enjoy cinema and to have an inspiring festival experience. What are their moral considerations in watching human rights films? Susan Sontag explains that "the painful, stirring images supply only the initial spark" in how we relate to the pain of others "beset by war and murderous politics for a consideration of how our privileges are located on the same map as their suffering, and may – in ways that we prefer not to imagine – be linked to their suffering, as the wealth of some may imply the destitution of others" (Sontag 2003: 80).

Cinema is pre-eminently the medium that has the ability to further expand the moral imagination, the ability to imagine ourselves in the situation of others, despite the fact that the other is often far away. The process of being morally imaginative includes disengaging from and becoming aware of one's situation, envisioning moral conflicts and dilemmas and the ability to imagine new possibilities (Johnson 1993: xi–xii). The "gradual expansion of our moral imagination" is paired to "an insistence that there is something irreducible that we all share", as Barack Obama phrased it in his 2009 Nobel speech.

According to Luc Boltanski, the response to distant suffering should be an effective speech (1999: 185–188).[4] However, we are not sure how images influence our ethical responses and moral behaviour, and what would be the most appropriate communication and response related to a film. One and the same film can appeal to different audiences, reach different layers of understanding and evoke different kinds of experiences. For some, it is just a pleasant way of spending a night out. For others, it is an eye-opening film that will alter professional and political decisions. Some will be numbed, or bored and walk away, others will be inspired to doing something. Some close their eyes when the images are too shocking, others feel the need to be shocked so as to understand what's it all about. A film may have the effect of reinforcing the perceived "gap" between the self and the other, or it may create a sense of understanding and contact. For festival organizers, it is of course vital that the audience can relate to what is seen on the screen. But we should heed what

mid-nineteenth century philosopher Søren Kierkegaard remarked in one of his journals: "Whoever wants to grieve that a hundred thousand people die every day, is ridiculous. One must limit one's grief to what is within one's reach" (1928: 112).

A festival's core issues

In planning, organizing and hosting a festival, we distinguish four core issues for the organizers to consider:

1. *Selection* is about the deliberations that confront festivals in choosing films and framing a programme Should the festival focus on the cinematic quality of the films or on their content? Is the human rights film only a piece of art, or should it have a certain effect on the audience? "Should human rights films serve as a tool for something more than just the presentation of a good story or a reality well told?" (Bronkhorst 2004: 7). Dutch film-maker Ilse van Velzen sees her award-winning documentaries (*Fighting the Silence* [2007], *Weapon of War* [2009], *Justice for Sale* [2011]) firstly as documentaries made for an international audience, and secondly as films that can be made into tools for education. After the film is released for an international audience, she and her co-director (and twin sister) Femke bring their films back to the communities in DR Congo where the films dealing with violence against women originated. For this purpose, the films are re-edited to best suit the target groups: the sound (voices) is dubbed, the length is adjusted, swear-words are taken out and consent of the protagonists is sought specifically before distributing the film in their country. The Van Velzens take out parts, after consulting local organizations that evaluate the content of the films, that might entail unwanted discussion. "You don't want people to respond on a side message instead of the main message".[5] On the other side of the spectrum, one finds the argumentation that a film is a work of art that should not be changed or its screening interrupted, irrespective of its audience. The artistic product has, as artists will tend to argue, been carefully composed. To adjust the film would violate its integrity. This line of argumentation underlines that cinematographic qualities are a prime selection criterion for the festival programmer: they greatly enhance the chances for engagement by a large audience. This is also what the Van Velzens sisters agree on: a "message" film is not what most people would want to see. In good films, the line between art and education, form and content, is osmotic.

2. *Presentation* refers to the ways festivals organize their screenings and everything around it, such as debates, public interviews, educational events, a music concert, football play or exhibition next door. Many festivals offer a platform for discussion after a film has been watched, facilitating public debate. When we screened *5 Jahre Leben* (Schaller 2013), a fiction film about Murat Kurnaz who was detained in Guantánamo Bay for over five years, the "real" Murat Kurnaz attended the screenings for a Q&A sessions afterwards. He spoke to a mesmerized audience, freely and without rancor about

what happened to him. When we screened the feature film *Resolution 819* (Battiato 2008) about the massacre in Srebrenica, the discussion afterwards was intense and chaotic. Some Bosnian war survivors who attended the screening walked angrily out of the theatre. They felt personally attacked, though less because of the way the film represented the tragic events than because of the remarks from the audience. Not much later, one of them came back to publicly explain why they had left. Presentation is also about the choice of venue or location. Festivals can screen films in a film theatre, a multiplex cinema, outside on a market square or little villages in remote places.

3. *Fascination* is about audience experience and the way festival organizers reflect on how spectators watch films and are moved, touched and/or inspired by them. Igor Blazevic, founder of the One World Festival in Prague, explains about the kind of films he selected:

> They have been telling stories of ordinary, simple people doing extraordinary things in extreme situations of poverty, wars, injustice. I started to be inspired and encouraged by those films which do not show human beings as defeated, suppressed and humiliated, helpless victims. Rather I look for charismatic, inspiring personalities who have been able to overcome mountainous odds to claim and stand for the human dignity.
>
> (Blazevic 2013)

Maria Carrión is the director of FiSahara, an annual film festival in the refugee camps of Sahrawi people in the Sahara desert. She says, "This audience suffers so much in their daily lives that we don't want to bring more suffering to the screen. So we carefully pick those films that tell stories of empowerment".[6]

4. *Mobilization* covers imputations about the changes that can, or are intended to, result from the films and collateral events. In its most general sense, what organizers of human rights film festivals have in mind is a process of conscientization (Freira 1970, 2005), of raising awareness. Evidently, not all forms of "conscience" gained are what these festival organizers would like to see. Films can foster hate, nationalistic feelings, apathy, fundamentalist views or an anti-fundamentalist philosophy that does not attach any particular real-life significance to a conceptual construct such as that of "human rights".[7] Films can be part of civil as well as *un*civil society. One way to approach the issue of the wished-for change is to distinguish between "types" of conscience, or mental states. After having viewed the same film, one person's mental change may be quite different from another person's. Or the change may be different after a second viewing. Or one person can experience various mental effects, even conflicting ones. We sketch five steps of the moral imagination, or changed mental state, that the spectator can experience after watching a film at a human rights film festival:

Steps of the moral imagination of the spectator at a human rights film festival

- "I'm touched now". The film moved me, changed my mood and made an impression. I can't say whether that will have a more lasting effect on my perception, attitude or actions.

- "I know more now". I have learned things that I did not know before. I have become more aware of the scope, the depth, the character of an issue. This will have an effect on my perception, possibly more.
- "I am more critical now". I not only have learned new things, I also am more able now to analyse. I can see that things are more complex (or more simple) than I thought before. I may feel that the film-maker has made good choices (or that it was mainly an attempt to manipulate me).
- "I feel concerned (responsible, guilty) now". I have become aware that issues portrayed in the film concern me. The distant suffering is something that people like me should do something about. It makes me think about my position in society, about my capabilities.
- "I feel called to action now". I am clearly aware that I should do something about the issues that concerned me in the film. I may change my professional choices, or initiate action, or donate money or join an organization.

Human rights "schools"

All festivals aim towards raising awareness, many even aim at social change. But how do the festival organizers see the position of their festival? How can the festivals increase their impact? How can festivals optimize their role as powerful actors in a civil society? A phenomenological[8] analysis of human rights film festivals should include scrutiny of the activism generated by groups with social change goals. For that purpose, we adapt the model of the four human rights "schools" as developed by Marie-Benedicte Dembour (2010: 1–20). We opt to view this model in the perspective of those whom a UN 1998 Declaration labelled as "human rights defenders".[9] As we will explain later, we feel a film festival is an exceptionally apt tool to address the diversity of frames associated with human rights defenders.

The four human rights schools as proposed by Dembour are:

1. The *natural or principled school* embraces the most common and well-known definition of human rights: rights one possesses simply by being human. The universality of human rights is derived from their natural character. This school has traditionally represented the heart of orthodox human rights defence.
2. The *deliberative school* conceives of human rights as political values that liberal societies choose to adopt. Human rights come into existence through societal agreement – they are elaborated through negotiations. The idea of this school is that one would like to see human rights become universal, but recognizes this will require time. Human rights defenders offer their wisdom and expertise to improve the status of human rights.
3. The *protest school* considers human rights as a platform from which to articulate entitlements demanded by or on behalf of the poor, the unprivileged and the oppressed. Human rights are claims and aspirations. They oblige us to stand up for the humiliated and those in the margins. International treaties and rules can help, but should not get

in the way. Human rights defenders are activists, fighting injustice as injustice and not because a treaty says so.

4. The *discourse school* is characterized by its lack of reverence towards human rights. Human rights exist only because people talk about them. Discourse school adherents are convinced neither that human rights are given nor that they constitute the right answer to the ills of the world. Human rights defenders operate from the premise that the language of human rights, in their various interpretations, has become a powerful tool for expressing social and political claims.

Festivals are virtually always a mixture of these different schools. In response to a questionnaire we developed in preparation for this article, José Miguel Beltán Sánchez from the human rights film festival in San Sebastian in Spain says: "We try to program movies with different goals."[10] Maria Carrión from FiSahara explains that,

> [...] because FiSahara combines two target audiences – one comprised of the local refugee population and the other comprised of international guests – we also aim to combine two strategies. On the one hand, the "principled" approach helps to raise awareness among a wider international audience, and the other, the "protest" approach is a tool for the Sahrawi people to express their cultural identity and use film as a tool for cultural survival and social change.[11]

Uli Stelzner from the festival in Guatemala adds:

> The most important objective is to create a critical youth and civil society, to break the polarisation and monopolisation of private and commercial mainstream media, to enforce human rights and political participation and motivate action for change. In the mixture of the different "types" lies the key of the success of our festival.[12]

With this in mind, let's have a closer look at the festivals.

Principled type

The *principled* type of festival starts from the inherent dignity of the human being and emphasizes a universal humaneness that should appeal to the widest possible audiences. In June 2013, for the very first time, the Human Rights Human Dignity International Film Festival was staged in Yangon, Burma. Afterwards, the festival toured through the country with its award-winning films, reaching large crowds and full houses. The organizers distributed a leaflet with the Universal Declaration of Human Rights to all those in the audience. Festival director Min Htin told us when we met in Amsterdam in November 2013 that their main challenge is the difficulties to get the required permission from local

authorities. That is because they use the term "human rights". However, he feels that he simply "has to use the term in this specific period of time for the sake of their country and for the Lady (Aung San Suu Kyi)".[13] Former political prisoner and human rights defender San Zaw Htwe said he had been struck by the fact that at the Human Rights Human Dignity International Film Festival "audiences seem more interested in venting their anger on rights abuses, rather than developing a better understanding of what exactly their human rights are" (Myat 2013). In Ukraine, a special programme of "Docudays UA" consists of film screenings and discussions in prisons and jails with the objective "to teach people about the concept of human rights, including respect to the rights of prisoners".[14] After the screenings and discussions, human rights experts give free legal advice to prisoners. Other screenings specifically target the staff of penitentiary services. That some festivals feel it is their duty to make people aware of their own rights can often be derived from the very name of the festival: Manya Human Rights International Film Festival in Uganda ("manya" means "get to know"), Derecho a Ver (the right to see) in Colombia, Opin Yu Yi (open your eyes) in Sierra Leone including special sessions called Sabi Yu Rights (know your rights).

Deliberative type

The *deliberative* type is a festival most of all serving as a forum for debate and catering to more specialized audiences, or those more directly involved in human rights. The deliberative type aims to convince the target audience to adopt human rights as political values because human rights are the best possible legal and political standards that can rule a society. Movies that Matter facilitates invitation-only screenings at the Dutch Ministry of Foreign Affairs. On International Human Rights Day (10th December) it also shows screenings at many Dutch embassies worldwide. Each year, One World from Czech Republic hosts a film festival in Brussels targeting policy makers and NGOs connected to the European Parliament. Some screenings take place at the European Parliament, during staff lunch breaks. Festival du Film et Forum International sur les Droits de l'Homme (FFIDH) in Geneva carefully picks the dates for the festival to coincide with the UN Human Rights Council's main session. The film selection is adjusted when expedient to the themes that will be discussed during the council. *No Fire Zone* (Macrae 2013) is an example of a film that was screened during the Council and later on at various national parliaments. This documentary about the armed conflict in Sri Lanka meticulously shows the war crimes and crimes against humanity committed by the government in the course of 2009. The film-makers started a campaign targeting the United Nations and the governments of the Commonwealth. After huge international pressure on the Sri Lankan authorities requesting an independent investigation, that government announced in November 2013 a survey to determine the number of people killed during the country's 26 years of civil war. In this manner festival organizers can foster a debate on topics that they would like to see high on the political agenda. These films offer an audiovisual alternative for the documents and reports that politicians need to go through

before making decisions. They shouldn't be propagandistic. Sonia Tascón rightly commends caution in selecting films as a tool for human rights advocacy purposes (2012: 864–883).

Protest type

The *protest*-type festival is strongly oriented towards social and political life, often springing from a movement that opposes the powers that be, and sees human rights as an instrument for overall change. An example is Cine Amazónico, a travelling film festival in Ecuador focusing on the rights of the inhabitants of the Amazon region. The festival screens films that would otherwise remain unseen, films that stir a debate and sometimes even lead to non-violent protests. The government recently forced the organization's office to shut down, accusing the NGO of interfering in political events and "affecting the public peace" (Global Voices Online 2013). Another example is CineMobile Caucasus. In 2012, the organizers of CinéDoc, the documentary festival in Tbilisi in Georgia, organized this mobile cinema project in the isolated border regions of the southern Caucasus. The aim was to create more mutual understanding and cross-border dialogue between the people living on different sides of the borders in a region torn between conflict and war. To do so, the organizers neglected those films dealing with war, conflict or internally displaced persons. Instead, to garner trust and mutual understanding, they selected those films dealing with daily life. Organizer Artchil Khetagouri explains that

> [...] screening a film from the neighbouring country is already provocative enough. Because of the public pressure and fear of authorities it was sometimes extremely challenging to discuss certain topics. To initiate dialogue and peaceful debates it was vital to be neutral, and not get involved in political discussions.[15]

Side by Side is an LGBTQ festival in St Petersburg in Russia organized by a courageous team of human rights defenders that is confronted with an increasingly repressive climate. Its last edition in 2013 faced five bomb threats and various hostilities from nationalist groups. Theatres terminated their contracts with the festival and foreign guests were scared off from coming to Russia. Towards the end of the festival one of the organizers said, "We're just a festival, but there's the sense we're running a military operation" (Anon 2013).

Like Side by Side, many festivals have to operate with great caution to ensure the safety of their teams and visitors. Festival dates are chosen carefully not to coincide with elections, for instance. Also self-censorship is a recurring issue. Topics that are considered too sensitive are sometimes avoided in order to keep other important topics on the agenda and build support. Invitation-only screenings can be a way to get around censorship boards. For the Indonesian distribution of *The Act of Killing* (Oppenheimer 2012), the film-makers did not choose to present the film in regular Indonesian cinemas, as the censorship board would most probably prohibit the screenings. Instead, they provided DVD copies of the film to NGOs so as to enable them to organize invitation-only screenings. The documentary,

nominated for an Oscar in 2014, has since been screened several thousand times, and has millions of downloads. The film-makers made the film available for free inside Indonesia – another way around the censors. The film has also been seen hundreds of thousands of times on Youtube, where the film is available without English subtitles.

Discourse-steered type

The *discourse-steered* festival has a largely post-modern position: it offers films and debate in great variety and pretends to be no more than a venue where people come to agree or disagree on human rights issues and what they are related to. Nuremberg International Human Rights Film Festival in Germany is such a festival. Festival director Andrea Kuhn states:

> We consider ourselves a film festival that engages audiences in a critical debate about films, media and human rights. We feel that part of any human rights activity should be a conception of an audience as critical individuals that should be respected to make their own informed decisions. We want them to question their perception of the world and we hope that they think the films we present are good films that take them seriously and not just feeding them with a message, but allowed to think themselves.[16]

Isabelle Gattiker, programme director of the International Film Festival and Forum on Human Rights (FIFDH) in Geneva, explains: "We organize high-level debates after the main screenings with international speakers giving different views on the subject. We highly encourage contradictory discussions".[17] One World similarly sees itself mainly as a discourse-steered festival, as it serves as a debate platform for the often highly educated audience, but also has the ultimate goal to inform, encourage and motivate people to change "even small and everyday things around them".[18] Kumjana Novakova, creative director of Pravo Ljudski in Bosnia Herzegovina adds:

> Most important is an open dialogue, not criticism towards a certain group or towards the government. Especially in our country where the past is not so easy. We need to provide safe places for discussion. We simply pose questions, not only to other people but also to ourselves. I think it is most important to provide this kind of space.[19]

These festivals are usually open to everyone, allowing human rights issues to be discussed outside the government buildings, universities or NGO offices. Our colleague from the Karama Human Rights Film Festival in Jordan explains:

> There is currently a debate here as to how democratic the country truly is, and whether it could be more democratic. That debate is primarily taking place amongst academics. A film festival is accessible to everyone, which benefits the discussion.
>
> (Zeehandelaar 2011)

Discourse-type festivals preferentially screen films that raise questions. Sometimes, the very term human rights is not used at all, in order to be more accessible to a broad audience, or to avoid a political connotation. Festivals speak of "socially engaged cinema" (FreeZone, Serbia [Anon] 2014), "films about rights and freedom" (Festival des Libertés, Belgium [Anon] 2014), "films that not only entertain but also seek to broaden our views of the world" (Vermont International Film Festival, USA [Anon]), films that "support innovative ways of creating awareness on social issues" (Addis International Film Festival, Ethiopia [Anon]).

Conclusion: Choices and impact

All four types of festivals as outlined above are valuable and important, each with their specific strengths in engaging the audience's "fascination" and "mobilization". The principled type will often offer films that deal with local issues and opt for open-air screenings at popular places. Deliberative screenings for a specific target audience pick venues that work best for each group. To redress injustice, protest-type festivals may be geared to using their festival as a platform for action, facilitating workshops on film making or non-violent activism, distributing petitions or providing suggestions on how to further promote the observance of human rights. Discourse-steered events will be most effective when opposite views and observations can be tabled.

A festival that limits its concept of human rights to one "school" can easily become a one-sided event. Pressing the message in mass-screenings will not create the intimate setting that allows for free exchange of knowledge and ideas. Film screenings solely for the sake of social and political change can turn a festival into propaganda. Deliberative-type screenings may hinder the popularity of the event for the general audience. Discourse-steered kind of screenings can become non-committal or too intellectual.

Different approaches towards human rights can perfectly exist next to each other within the same festival. Indeed, festivals optimize their impact by shifting between different strategies for different objectives. The mixed bag of views and interpretations makes a film festival a rewarding place for any exposition of human rights defence. For the defenders are a mixed bag too: they include professionals and volunteers, activists and thinkers, officials and rebels, tenacious workers and accidental witnesses. They all have their rightful place-provided they stick to the ethics of their work. A multifaceted festival convincingly portrays the complexity of human rights defence.

Most importantly, human rights film festivals reinforce the moral imagination and so help us to connect with other people and reflect on our own position and behaviour. Sometimes this is accomplished by a festival positioning itself as a cultural event; at other times, it may best be presented in an educational or political setting. In the words of Sridhar Rangayan festival director of Flashpoint: India, "We feel it is crucial to make the festival not highly academic and didactic, but to combine elements of advocacy and entertainment with a judicious mix of documentaries and narrative films".[20]

A situation of political transition or armed conflict or economic crisis, a tense political climate, a lack of financial means or organizing capacity or other specific circumstances of place and time put a significant mark or even compel a festival to a specific approach. But these circumstances do not necessarily force the choice of a particular identity. A human rights film festival can capture worthwhile opportunities for awareness and debate by going beyond the immediate response to the needs and circumstances of the moment.

Acknowledgements

We thank all members of the Human Rights Film Network for inspiration and feedback, in particular Gediminas Andriukaitis, José Miguel Beltán Sánchez, Igor Blazevic, Maria Carrión, Sawsan Darwaza, Abdoulaye Diallo, Isabel Gattiker, Abdoulaye Gaye, Eric van de Giessen, Min Htin, Gennady Kofman, Andrea Kuhn, Humberto Mancilla, Kumjana Novakova, Sridhar Rangayan, Zuzana Raušová, Taco Ruighaver and Uli Stelzner. We also thank courageous film-makers and festival organizers Joke Baert, Manny de Guerre, Artchil Khetagouri, Callum Macrae, Joshua Oppenheimer, Helena Sala, Ilse and Femke van Velzen.

References

Anon, (n.d.) Free Zone, www.freezonebelgrade.org/eng. Accessed 18 June 2014.

Anon, (n.d.) Human Rights Film Network, www.humanrightsfilmnetwork.org. Accessed 18 June 2014.

—— (2013), "The Russian reader", http://therussianreader.wordpress.com/2013/12/14/side-by-side-lomasko/. Accessed 18 June 2014.

Battiato, G. (2008), *Resolution 819*, France, Poland, Italy: Canal +.

Blazevic, I. (2013), *Human Rights Human Dignity International Film Festival Catalogue*, (n.p.), p. 6.

Boltanski, L. (1999), *Distant Suffering: Morality, Media and Politics*, Cambridge: Cambridge University Press, pp. 185–188.

Bronkhorst, D. (2004), "The human rights film: Reflections on its history, principles and practices", p. 7, www.chra.ie/docs/TheHumanRightsFilm.pdf. Accessed 18 June 2014.

Dembour, M. B. (2010), "What are human rights? Four schools of thought", *Human Rights Quarterly*, 32, pp. 1–20.

Freire, P. (1970), *Pedagogy of the Oppressed*, New York: Continuum.

—— (2005), *Education for Critical Consciousness*, New York: Continuum International Publishing Group.

Global Voices Online (2013), http://globalvoicesonline.org/2013/12/06/ecuadorian-government-shuts-down-environmental-ngo-pachamama/. Accessed 18 June 2014.

Johnson, M. (1993), *Moral Imagination*, Chicago: Chicago University Press, pp. xi–xii.

Kierkegaard, S. (1928), *Papirer*, Copenhagen: I A, p. 112 (our translation).

Macrae, C. (2013), *No Fire Zone*, London: Outsider Films.

Myat, M. M. (2013), "Democracy in motion", *Bangkok Post*, 13 October, p. 14.

Obama, B. (2009), "Remarks by the President at the Acceptance of the Nobel Peace Prize", Transcript, The White House, www.whitehouse.gov/the-press-office/remarks-presidentacceptance-nobel-peace-prize. Accessed 18 June 2014.

Oppenheimer, J. (2012), *The Act of Killing*, Denmark, Norway, UK: Final Cut for Real ApS.

Schaller, S. (2013), *5 Jahre Leben*, Germany: TeamWorx Television & Film.

Sontag, S. (2003), *Regarding the Pain of Others*, New York: Farrar, Straus and Giroux, p. 80.

Tascón, S. (2012), "Considering human rights films, representation, and ethics: Whose face?", *Human Rights Quarterly*, 34, pp. 864–883.

van Velzen, I. and van Velzen, F. (2007), *Fighting the Silence*, the Netherlands: If Productions.

—— (2009), *Weapon of War*, the Netherlands: If Productions.

—— (2011), *Justice for Sale*, the Netherlands: If Productions.

Zeehandelaar, M. (2011), "Interview with Ayman Bardawil", in Dutch, *Wordt Vervolgd*, April.

Notes

1 Diallo, A., July 2012 festival screening in Ouagadougou, Burkina Faso.

2 Diallo, A., July 2012 presentation at a workshop programme for festival organisers from the African continent in Ouagadougou, Burkina Faso.

3 Gaye, A. (2014), project proposal for the AfricanBamba Human Rights Film Festival in Senegal.

4 According to Boltanski, to move towards action, the spectator's speech should be intentional. This concerns not only the fact of saying something but also *meaning to say*. Moreover, the expressive conception of the relationship between intention and action is realized above all in the public space. And a particularly appropriate social form for making the intentional, gestural and effective character of speech clear is the *demonstration*.

5 Van Velzen, Ilse, November 2013 presentation at the Mobile Cinema Workshop organized by Movies that Matter in Amsterdam, The Netherlands.

6 Carrión, M., November 2013 presentation at the Mobile Cinema Workshop organized by Movies that Matter in Amsterdam, The Netherlands.

7 The view that the significance of human rights may be coming to an end has been expressed by, among others, Stephen, H. (2013) in *The Endtimes of Human Rights*, Cornell University Press, and Jan, E. and Samuel, M. (2014) in *The Breakthrough: Human Rights in the 1970s*, University of Pennsylvania Press.

8 Phenomenological in the sense that we analyse these festivals not for internal consistency or deontological position, but in terms of how they have become a phenomenon in the present-day worlds of film and human rights. "Phenomenological" as used by Maurice Merleau-Ponty in his *Phenomenology of Percention* (1945) implies that we perceive intersubjectively and intentionally. It's not the logic or reality of a phenomenon, but our perception of it that we analyse.

9 UN Declaration on Human Rights Defenders (2004), General Assembly Resolution A/RES/
 53/144, and explanatory notes in 'Human Rights Defenders: Protecting the Right to Defend
 Human Rights Fact Sheet No. 29', www.ohchr.org/Documents/Publications/FactSheet29en.
 pdf. Accessed 18 June 2014.
10 Beltrán, S., & Jose, M. (2013), in response to a questionnaire we developed in preparation
 for this article and was distributed amongst members of the Human Rights Film Network.
11 Carríon, M. (2013), in response to a questionnaire we developed in preparation for this
 article and was distributed amongst members of the Human Rights Film Network.
12 Stelzner, U. (2013), in response to a questionnaire we developed in preparation for this
 article and was distributed amongst members of the Human Rights Film Network.
13 Htin, M., November 2013 presentation at the Mobile Cinema Workshop organized by
 Movies that Matter in Amsterdam, The Netherlands.
14 Kofman, G. (2013), report about the DocuDays Ua Travelling Film Festival in Ukraine.
15 Khetagouri, A. (November 2013), presentation at the Mobile Cinema Workshop organized
 by Movies that Matter in Amsterdam, The Netherlands.
16 Kuhn, A. (2013), in response to a questionnaire we developed in preparation for this article
 and was distributed amongst members of the Human Rights Film Network.
17 Gattiker, I. (2013), in response to a questionnaire we developed in preparation for this article
 and was distributed amongst members of the Human Rights Film Network.
18 Raušová, Z. (2013), One World International Human Rights Documentary Film Festival, in
 response to a questionnaire we developed in preparation for this article and was distributed
 amongst members of the Human Rights Film Network.
19 Novakova, K. (2013), presentation at the Mobile Cinema Workshop organized by Movies
 that Matter in Amsterdam, The Netherlands.
20 Rangayan, S. (2013), in response to a questionnaire we developed in preparation for this
 article and was distributed amongst members of the Human Rights Film Network.

Chapter 6

Refusal to Know the Place of Human Rights: Dissensus and the Human Rights Arts and Film Festival

Tyson Wils

Introduction

Maria Grassilli (2012: 33), Artistic Director of the Human Rights Nights Festival, has said that most human rights film festivals draw on the definition of human rights expressed in documents such as the Universal Declaration of Human Rights (UDHR), which was proclaimed in 1948 by the United Nations General Assembly. The Human Rights Film Network (HRFN), for example, which is a network comprising 38 independent festivals that "subscribe to the principles and practices as recognized by the Network", has a charter which states that: "The Network strives to promote a broad concept of human rights, on the basis of international standards as embedded in the [UDHR] and other international law." The charter further claims that, as the adjective "universal" suggests, "human rights cannot be annulled or diminished on the basis of 'tradition', 'culture' or any other excuse", for human rights belong to all human beings. On the basis of this understanding of human rights, the charter says that the partnership of film festivals within the Network promotes films that are explicitly or implicitly based on universal, human rights tenets as outlined in documents such as the UDHR.

The Network's charter frames the UDHR in terms of principles of universal applicability and natural law. In conformity with these principles, the universal stands for formal, abstract ideas that refer to essential rights possessed by every human being. According to this doctrine of human rights, the single property "human" designates qualities that are not only naturally shared by every single person on the planet, but which are also unchanging. As Samuel Moyn (2010) has suggested, while contemporary human rights are very much a product of events that have occurred since the end of the Second World War, they do have a connection with the history of beliefs in human universalism and the idea that "humans are all part of the same moral group or – as the 1948 declaration was to put it – the same 'family'" (13). What this means is that articles that make up the UDHR are presumed to represent rights or qualities that are eternally part of the human condition and, therefore, able to be actualized by every individual. On the basis of this interpretation, when such rights or qualities cannot be realized – for whatever political, religious or social reason – it can be said that human rights violations are occurring.

It is not uncommon to frame the Universal Declaration of Human Rights (UDHR) in terms of universal and natural law; however, in what sense the listed rights in the UDHR are or should be universal and natural has been debated and contested. Marie-Bénédicte Dembour (2010), for example, has suggested that there are at least four schools of thought

that conceive of human rights differently: natural school, deliberative school, protest school and discourse school. She says that each school does not approach issues such as human rights law (5–6), or questions such as whether human rights are universal, in the same manner (9). For instance, as opposed to thinkers who belong to the natural school, and who believe that human rights are entitlements that "one possesses simply by being a human being" (2), thinkers who belong to the discourse school tend to believe that while "the language surrounding human rights has become a powerful language with which to express political claims" (4), this does not mean that human rights should be treated as a given. Moreover, natural school thinkers generally believe that human rights has a metaphysical foundation, although there can be disagreement within this school regarding what constitutes this foundation: the "human family", "Human reason", God or Nature. By comparison, discourse school thinkers usually critique the notion that there is a metaphysical foundation to human rights.

As indicated by the fact that natural school thinkers may differ in regards to what they consider to be the metaphysical source of human rights, Dembour stresses the fact that the schools represent "ideal-types rather than fixed categories" (4). In other words, it may be possible for two members of the same school to disagree about certain aspects of human rights; indeed, it might also be possible for a single thinker to be associated with more than one school. Nonetheless, for Dembour, the school-model is still useful for identifying the different orientations and approaches that, broadly speaking, currently make up the human rights conceptual field.

While there is much philosophical and legal debate regarding the nature and application of human rights, the general consensus is that all kinds of rights claims today are articulated through the discourse of human rights. Thinkers as diverse as Michael Ignatieff (2007) (who Dembour locates as belonging to the deliberative school, to the school that accepts "that human rights are the best possible legal and political standard that can rule society" [3] but that the universal adoption of human rights is dependent upon the global development of liberal-democratic governance and law), Wendy Brown (1995) (who Dembour associates with the discourse school), Costas Douzinas (2002) and Jacques Rancière (2004) have all talked about the fact that, today, human rights represents the rights of different individuals and groups. To be sure, neither all of these thinkers use the same language to express what this new rights environment is, nor do they always agree on what its causes and effects are. Nonetheless, on a fundamental level, they all assert that western human rights discourse focuses on individual and group rights and, in particular, on rights related to identity issues.

Writers such as Ignatieff (2007) and Douzinas (2001) have also stressed the fact that it has been international texts such as the UDHR that have played a major role in creating a new kind of political discussion and a new set of political demands based on values of individualism and on cultural minority claims for justice. Ignatieff, for instance, has said that such texts represented a revolutionary moment in political and social thought because they ushered in a new individual and group rights regime; in other words, they introduced a mode or system of rights that now dominates the globe:

From 1948's Universal Declaration of Human Rights onward, the history of the past half-century has been the struggle of colonial peoples for their freedom, the struggle of minorities of colour and women for full civil rights, and the struggle of aboriginal peoples to achieve self-government.

(2007: 3)

The Universal Declaration of Human Rights altered the balance between national sovereignty and individual rights. With the declaration, the rights of individuals were supposed to prevail over the rights of states when those states engaged in abominable practices. This might be the most revolutionary of all the changes that have taken place since the peace of Westphalia established the European order of states in 1648.

(49)

Douzinas (2001) has suggested that the creation of the Universal Declaration of Human Rights (UDHR), along with other "foundational acts" (183) such as the first of the Nuremberg Trials held between November 1945 and October 1946, started a wave of human rights treaties and agreements. He says that such "foundational acts" spawned, in particular, a proliferation of human rights claims based on "civil and political [...] rights associated with liberalism", "economic, social and cultural [...] rights associated with the socialist tradition" and "group and national sovereignty rights associated with the decolonisation process" (183). Even the historian Moyn, who sees the 1940s as only one decade among many that were significant for the development of contemporary human rights, nonetheless accepts that texts such as the UDHR symbolically opened up the space for rights to revolve around individual entitlements.

The focus of this chapter is on how the Human Rights Arts and Film Festival (HRAFF), which is based in Melbourne, Australia, addresses its spectators in relation to institutionalized human rights discourse. HRAFF, which is one of the members of the Human Rights Film Network (HRFN), was first launched in 2007. Like other human rights festivals, HRAFF negotiates a range of discourses, including the human rights discourse (both in its institutional and activist forms) and the film festival circuit discourse. In this respect, HRAFF is like other human rights festivals, such as the Human Rights Watch Film Festival (HRWFF), which is also a member of the HRFN. Since the early 1990s, once the festival became, in the words of former Festival Director Bruni Burres (2012), "a fully-fledged festival" (202), HRWFF has positioned itself in relation to both the film festival discourse and the social education discourse in order to concentrate "on showing great works of cinematic art that (highlight) critical social issues by top veteran artists or excellent emerging artists" (203). At the same time, it has had to work with its parent organization, Human Rights Watch (HRW), one of the world's foremost human rights organizations.

This chapter explores how the Human Rights Arts and Film Festival (HRAFF) functions within the legal and cultural world of the western human rights landscape, particularly in the context of attracting various audiences to the festival. As will be demonstrated, while a number of factors shape the festival's broader decision-making and programming, the festival's attempt to appeal to different audience types is, in large part, shaped by its

relationship to institutional human rights discourse. This relationship informs the festival's curatorial address to spectators; hence, the kind of experience that the festival creates for spectators is characterized by interpretive frames that can be linked to the new human rights environment. As already pointed out, within this environment all kinds of rights claims are enunciated through the discursive structure of conventional human rights language.

Drawing on the work of Rancière, who, as mentioned earlier, is one of the thinkers who believes that human rights, today, represents the rights of different individuals and groups, it will be argued that HRAFF's approach to attracting audiences reflects the new human rights regime where there are multi-various claims for, and expressions of, human rights. Rancière (2004) suggests that, today, it is possible for different individuals and groups to make something of the rights that are constitutive of the human community, those universal rights that are written in international documents. People in a variety of situations, including those without citizenship status or definite national identity, can put general rights of equality and freedom into practice. Rights on this view are not only "part of the configuration of the given" (303), that is to say, part of a given situation and inscribed within a particular place, they also depend on "experimental activation by those to whom they could but do not (yet) apply" (Ingram 2008: 412). Through its film selections, festival messages, and other programme materials, HRAFF is able to enact a level of experimentation with rights. As will be explained at the end of this chapter, such experimentation amounts to a form of what Rancière's calls "dissensus", a politico-aesthetic mode of activity that involves, among other things, blurring the boundary between who is able and not able to demonstrate political rights.

The Universal Declaration of Human Rights and audience address at the Human Rights Arts and Film Festival

The Human Rights Arts and Film Festival (HRAFF) sees itself, in the words of current Festival Director Ella McNeill, as having a responsibility to be informed about "human rights law and the Declaration" (Universal Declaration of Human Rights [UDHR]) (McNeill 2014). However, this is not because the choosing of films is directly tied to human rights policy or law, but rather because (1) the festival works within the legal, political and cultural field of human rights and (2) the festival responds to current issues that are informed by human rights agendas. In other words, while United Nations (UN) texts such as the UDHR are "kind of the backbone of (HRAFF's) decision making and curating and programming" (2014), McNeill says that at the level of selecting and exhibiting films, the festival aims to promote and explore various human rights issues and ideas rather than uphold international human rights dictates and decrees.

McNeill's comments suggest that documents like the Universal Declaration of Human Rights (UDHR) permeate the legal and cultural world of human rights within which festivals such as HRAFF exist. This situation can be seen as symptomatic of the establishment of

human rights as a dominant political language in the west, a process that, as discussed in the Introduction, the UDHR and other international human rights charters and organizations have played a key role in shaping. Devised in the context of the creation of the United Nations in 1945 and, in particular, the UN charter, signed in June 1945, Zebra F. Kabasakal Arat (2006) has suggested that the UDHR "defined the content of human rights and allowed the [United Nations] to introduce changes to the normative foundations of international politics" (417). Moreover, Arat argues that the UDHR and subsequent human rights documents and treaty bodies did not only help to introduce a global rights culture but also create "an international human rights regime" (417). To be sure, as Moyn suggests, texts such as the UDHR need to be historically contextualized in terms of a range of factors, including the language of natural rights presented in documents during the periods of revolution in the United States and France in the eighteenth century; such rights are generally considered the symbolic foundation and starting point of human rights in the west, even if these natural "rights of man" did not, of course, lead to the immediate end of slavery or other inequalities. Moreover, Moyn argues that, while human rights contained, particularly in the United States, different meanings for different people during the interwar years as well as during and immediately after World War II, it is not until the early 1970s that people in, mostly, western countries "for the first time in large numbers [...] started to use the language of human rights to express and act on their hopes for a better world" and when "social movements [first] adopted human rights as a slogan" (121). Whether one wants to locate the first manifestation of the dominance of human rights in the 1940s or the 1970s, the consensus is that, in the words of Moyn, "human rights struggles [have] snowballed [...] across the world" (121), and, what is more, this snowball effect has been substantially driven by the legal vocabulary of institutionalized human rights discourse. This is not only because documents such as the UDHR have been critical in the development of international human rights law, but also because they have continued to be, as Marco Odello and Sofia Cavandoli (2011) put it, "central in the promotion of political debates and philosophical discussions" regarding natural and universal rights (1).

Given the strong international presence of political human rights language, it is not surprising that human rights festivals like the Human Rights Arts and Film Festival (HRAFF) should be informed by documents such as the Universal Declaration of Human Rights (UDHR). Indeed, HRAFF has included information contained in the UDHR as part of its curatorial address to spectators. For instance, there are direct references made to the UDHR in some of the programming material for the festival. For example, in the 2011 programme booklet, Jarfar Panahi's short-film *The Accordion* (2010) is discussed in the following way:

Part of the "Art for the World Collection", this film is a reflection on the themes of tolerance, non-violence and respect for differences as inspired by Article 18 of the Universal Declaration on Human Rights: "Everyone has the right to freedom of thought, conscience and religion". It suggests that the future lies in solidarity over conflict.

In the 2008 programme booklet festival patron Byrony Nainby, then Senior Curator at the La Trobe Regional Gallery, suggests the following:

> It is 60 years since the UN in the aftermath of World War II adopted the Universal Declaration of Human Rights which declared that "No one shall be subjected to torture or to cruel, inhuman or degrading treatment or punishment." […] Yet today we seem no closer to achieving that goal. Appalling abuses including torture, slavery and imprisonment without trial are inflicted upon people around the world daily […] Against this background, artists and filmmakers work to present the world back to us in ways which cut through our defences, compelling us to reflect on our own place and power within society on a global and local level […] [HRAFF] provides opportunities for us to understand, participate in and respond to the political, social and cultural realities of the world and to reconsider our potential to challenge injustices.

Implicitly, too, the HRAFF draws on the language of the UDHR. For instance, as part of the festival statement for *Apropos – Human Rights in Film*, an arts programme that ran as part of the 2007 festival, the following comment is made: "The works in *Apropos* respond to a diverse range of human rights issues including freedom from discrimination, environmental issues, refugees, poverty, labour rights, indigenous issues, humanitarian conflict and freedom of expression". "Freedom from discrimination" echoes Article 7 of the UDHR – "All are equal before the law and are entitled without any discrimination to equal protection of the law. All are entitled to equal protection against any discrimination in violation of this Declaration and against any incitement to such discrimination" – while "freedom of expression" echoes Article 19 – "Everyone has the right to freedom of opinion and expression".

Of course, the concept of such rights does not begin with the UDHR and nor are notions of "freedom from discrimination" or "freedom of expression" only talked about, today, in the context of human rights. There has been "a huge array of doctrines and movements over the millennia" (Moyn 2010: 14) and many of these doctrines and movements have presented different and opposed notions of rights, entitlements and universalisms; in this sense, contemporary human rights practices should "count as only one among others in world history" (Moyn 2010: 13). Nonetheless, as already discussed, the ballooning of human rights discourse in the West has meant that all kinds of political and social issues are now ensconced within the lingua franca of international human rights dialogue; as a result, problems to do with "freedom of expression" and "freedom from discrimination" are increasingly codified within the international system of human rights law. Moreover, such freedoms are also continuously enshrined within the political culture of human rights. For example, in terms of "freedom of expression", Vanessa Pupavac (2012) has shown how human rights law-making and advocacy is the quintessential form in which free speech and other language rights issues are formulated and legitimized. Given this context, illustrating the domain of freedom through precepts such as "freedom of expression" and "freedom

from discrimination", and doing so not only in the context of a human rights festival but also as part of a list of items nominated "human rights issues", favours a particular interpretation, one that implicitly links the aforementioned freedoms with international human rights documents such as the UDHR.

These three examples illustrate how, at the Human Rights Arts and Film Festival (HRAFF), films, art programmes and the festival itself can be framed for spectators in terms of key human rights articles, such as those that make up the Universal Declaration of Human Rights (UDHR). One reason the festival conceptualizes itself and its screenings and events in terms of such articles is because, as discussed earlier, the festival feels that it has a responsibility to be informed about human rights documents such as the UDHR. This sense of responsibility stems out of the fact that (1) HRAFF exists within the broader legal, political and cultural field of human rights and (2) human rights have become a dominant political language in the West.

However, it is also reasonable to assume that another motivation for HRAFF to draw explicitly and implicitly on documents like the UDHR has to do with its interest in maintaining a strong relationship with audiences that are "active members of the human rights movement" while also attracting other audiences that are not so directly engaged with human rights issues (Muller 2012: 169). Drawing on HRAFF's 2009 Marketing Report, Claire Muller (2012) says that the festival conducts audience polls every year in order to identify the types of people who are attending. She says that while "HRAFF's priority has been to encourage and motivate those members of the community who already have an active interest in human rights issues", there are also other target audiences such as "the Young Trendy Alternative cohort" and "the Secure Professional cohort", the members of which may not always have a strong political background or a deep knowledge of human rights (169). McNeill has confirmed that while each year HRAFF's "marketing activities [...] [aim] to increase attendance of new demographic or psychographic profiles", with the intent of not simply growing the festival but also increasing the impact that the festival has on the general public, it also consistently aims to "look after [...] and be attractive [...] and remain relevant to [its] core audience", which is made up of people "already interested or involved in human rights or [...] already to some degree socially conscious [...] an activist crowd" (2014). Given the dominance, today, of human rights as a political language, and the fact that women's rights, Indigenous rights, children's rights, health rights and other kinds of rights have, in the words of Kenneth Cmiel (2014), "all, in one way or another, [become] part of the [human rights] discussion" (118), it makes sense to refer to the UDHR. As pointed out earlier, such texts, along with other materials produced by UN bodies and organs (such as the Human Rights Council), have produced conventional ways of talking about human rights that have entered public discussion. By framing the festival and its films and events in terms of such conventions, HRAFF tries to unify diverse audiences around a shared set of meanings that most, if not all, of its festival attendees recognize and, in some manner, identify with, even if the level of engagement with human rights among these attendees differs.

The unassigned place of human rights

It is clear from the examples discussed in the previous section that there are instances in which the HRAFF addresses audiences on the basis of the dominant institutional and legal language of human rights. Within this codified language there are assumptions of the universal right to freedom, which entails rights to all kinds of freedoms, and universal protection from inhuman treatment, which entails protection from a range of practices including discrimination and torture. Here it can be said that HRAFF follows the Human Rights Film Network (HRFN), which, as mentioned in the Introduction, supports a concept of human rights based on "international standards as embedded in the UDHR and other international law" as well as the common understanding of such law that it expresses essential rights that have universal applicability. As already discussed, a key factor that drives HRAFF towards attributing the language of the UDHR to the films and events in its programme – and to itself as a festival – is the fact that such language is part of the dominant discourse of human rights today in the west. HRAFF feels that it is its duty to be informed about such language. It also feels that such language can be used to bring together the different cohorts that it targets for each year's festival.

However, in the context of wanting to appeal to a wide range of people, HRAFF also shows spectators the different contexts within which human rights can be situated and, specifically through the selection of films, explores the different kinds of issues that can be associated with human rights. McNeill has said that in order to try to attract broader audiences to the festival, including people who, in their daily lives, are not engaged with human rights issues, and to have maximum impact in terms of spreading human rights within Australia, HRAFF adopts a fourfold approach (2014). First, it creatively re-imagines and re-frames human rights; second, it emphasizes art, film and storytelling; third, it devises "mass marketing activities" that brand human rights as "accessible", "cool" and interesting (even thought-provoking insofar as the trailers for the festival "challenge spectators in terms of what they think a human rights festival is"); and, fourth, it responds to topical events. Some of these approaches interrelate with other factors that shape the programming and curating of material, such as the content and quality of films that are submitted or acquired each year, as well as HRAFF's desire to expand as an art and film festival, which reflects the art and festival circuit discourse within which HRAFF also operates.

While there are a number of motivations that drive the programming of material, insofar as the aim is to widen HRAFF's demographic and cultural reach in the name of human rights, McNeill says that the goal is to facilitate spectators' personal connections with the stories presented on screen (or in art shows) and to make human rights accessible and relevant to spectators' lives (2014). The intent is not only to get spectators to engage with texts that they can read in the context of human rights, but also to re-contextualize human rights in order to make them more "engaging [...] for an audience who [might not have] realized they were interested in human rights" (McNeill 2014). Related to this intention to make human rights attractive to those who may not have

previously connected with human rights is the act of "being really creative in what [the festival] present[s]" in order to "talk about things that [people] might not [have] even ever considered to be a human right or their human right" (2014). Conscious of the fact that many Australian's "take for granted [their] human rights" (McNeill, 2014) – or in the words of Sari Braithwaite (2013), Programme Manager of the HRAFF in 2012 and 2013, perceive human rights as "simple and not worthy of investigation", simply a matter of "common sense" – McNeill says that one of the HRAFF's goals is to make Australians conscious of human rights issues that are pertinent to their own country. In order to achieve this, HRAFF focuses, for example, on particular, and often topical, themes that are relevant to Australians, such as mental illness, which was explored through documentaries, panel discussions and an exhibition in 2013. Alternatively, HRAFF may select individual films that respond to matters currently of interest for western democracies. Dana Ben-Ari's *Breastmilk* (2013), for instance, which is a documentary that tackles a range of subjects to do with how mothers from different ethnic and economic backgrounds respond to the politics of breastfeeding, screened in the 2014 programme. It was accompanied by a post-film forum focusing on recent medical and social debates in Australia about breastfeeding. McNeill says that the hope with such films and forums is that they will not only alert spectators to the fact that "breastfeeding is a human right" and that there are "social [and] body politics [issues] that come with something as simple and natural as breastfeeding", but also encourage spectators to reflect on what happens when the right to breastfeed is taken away from mothers and what such violations mean for human rights generally (2014).

In terms of wanting to make human rights relevant to Australian audiences, including those who might not have considered how human rights can impact the everyday life of people living in the western liberal-democratic world, the HRAFF does not only focus on specific and/or topical themes, but also explores the rights and issues that can be associated with human rights. Braithwaite (2013b) has said that:

> Human rights are often popularly imagined as these stale, solid ideas that are written down in law. The beauty of the festival is that we have the opportunity to explore the fact that these ideas are actually complicated, changing and often compromised by each other in interesting ways. We can use storytelling to put these ideas into a real life context [and] suddenly they become a lot more dynamic. We are constantly challenging these ideas of what our rights are and how we realise them. Film can be a great way of harnessing that conversation.

In other words, the festival is able to show audiences different ways in which human rights can be realized, as well as divergent notions of what constitutes human rights (and how these notions can change over time). It can also show audiences how different rights might relate to each other, including the ways that are not always in harmony and that may entail a particular right being modified or curtailed in some manner. One implication from

Braithwaite's comment is that the festival's way of representing human rights challenges the common perception that human rights expresses ideas (1) that are definitive and complete and (2) that have lost their force and effectiveness over time. Braithwaite suggests that this perception is tied to understanding human rights in legal terms, that is, what is "written down in law". However, it should be remembered, as discussed earlier in the chapter, that not only are all kinds of rights claims today articulated through the modern discourse of human rights, the legal vocabulary of institutionalized human rights language, represented by texts such as the Universal Declaration of Human Rights (UDHR), has played a major role in creating a new political environment in which both identity and cultural minority issues are central to the rights claims many people make around the world. As such, exploring the different ways individuals and groups realize human rights is consistent with the dominant practices of human rights today insofar as these practices involve a multitude of voices seeking political recognition. Moreover, the hope or ambition that so many people have today to have their specific human rights claims acknowledged is a process that, in part, owes its existence to the international system of human rights law; indeed, the act of seeking political recognition is often bound up with legal representation and/or support. Hence, Braithwaite's suggestion that HRAFF can challenge ideas about what human rights are and the manner in which they are actualized – or, to put it another way, create "conversations and debate" by allowing "human rights discourse [...] [to] be interrogated" through art and film (Braithwaite 2013) – needs to be qualified. Even when exploring the intricate and shifting meanings that can be attributed to human rights, the festival does not present a version of human rights that differs from what has been occurring within the dominant institutional framework of human rights law-making and legal representation. In terms of the festival's relationship to the broader, institutional human rights discourse, what HRAFF challenges is the perception that human rights are, today, unmovable and uninspired items of legal-speak.

As a result of wanting to draw an array of people to the festival, the language of human rights employed at the Human Rights Arts and Film Festival (HRAFF) contains an abundance of expressions, including expressions that have different meanings. By presenting such variety the festival not only hopes to disseminate information about human rights far and wide, but also presents different formulations of human rights in order to make them pertinent to people who may have never considered how rights issues are connected to their everyday lives. For example, in the case of the *Apropos – Human Rights in Film*, the various terms that are placed under "human rights issues" include not only the freedoms discussed earlier – "freedom from discrimination" and "freedom of expression" – but also "environmental issues, refugees, poverty, labour rights, indigenous issues, [and] humanitarian conflict". There are, in other words, a number of items included under the noun phrase "human rights issues". Moreover, not all of these items suggest the same kinds of rights issues. For instance, and as already mentioned, "freedom of expression" is a language rights issue; more broadly, it can be conceived of as an issue to do with the right, or not, of individuals and groups to represent their opinions through public channels of communication and media.

Other rights issues, such as labour rights, might involve "freedom of expression", and can also include "freedom of association", "freedom from forced labour", the right of individuals to have collective representation – often expressed through union membership – and a range of other rights connected to employment standards. Moreover, whereas "indigenous issues" are arguably tied to "group and national sovereignty rights associated with the decolonization process", "freedom of expression" issues are linked to "civil and political [...] rights associated with liberalism" (Douzinas 2001:183), although it would, of course, be possible for human rights claims to be made based on both indigenous and "freedom of expression" related issues.

Other programme booklets demonstrate the multifaceted approach that HRAFF adopts towards human rights. For example, in the 2011 festival, then Commissioner of the Victorian Equal Opportunities and Human Rights Commission, Helen Szoke, makes the following statement as part of "Festival Messages":

> In the last year, community concern about public safety, law and order, violence against women, and the protection and safety of families and children have focused attention on the importance of human rights for all Victorians.

> HRAFF plays a significant role in showcasing works that help continue this discussion and empower everyday people to know their rights and make a difference.

Unlike the human rights issues listed as part of *Apropos – Human Rights in Film*, the focus in the above festival message is on the relevance of human rights issues to members of communities living in the state of Victoria. In other words, human rights are situated within local contexts for audiences based in Melbourne and rural Victoria. Moreover, in the above statement, women's and family rights are presented as human rights issues, whereas these are not directly referred to in *Apropos – Human Rights in Film* (although they can, of course, be bound up with poverty issues, labour rights, "freedom of expression" issues and/or Indigenous rights).

In addition to festival messages and statements, film selections also play a role in multiplying the amount of ways human rights can be expressed. As Braithwaite suggests in the comment quoted earlier, for example, with every instance of human rights ideas being put into film form – that is to say, each time human rights ideas are expressed through the images, sounds and narratives that comprise the films shown at the festival – a dynamic and protean picture of human rights emerges. This is particularly the case at the Human Rights Arts and Film Festival (HRAFF), given that, each year, the features and shorts programming teams select a diverse range of films. Moreover, as a former features film programmer who worked at the festival in 2011 and 2012, I can say that festival film programmers are aware of the fact that it is possible to add to the range of meanings associated with human rights. In 2007, for instance, the programming team selected films that not only reflected, but also put into particular contexts, the different rights and issues connoted by the various terms placed under "human rights issues" in the festival statement for *Apropos – Human Rights in Film*.

For example, the festival showed the American documentary *A Walk to Beautiful* (2007), which addresses how mothers, living in poverty in rural Ethiopia, are mistreated after they suffer from childbirth complications. The festival also showed two films connected to labour rights issues: the Canadian Frontline documentary *Sex Slaves* (2005), which is about the global sex trafficking trade, and the American documentary *Mardi Gras: Made in China* (2005), which shows where the paraphernalia for the Mardi Gras parades in the United States is produced; namely, Chinese factories where employees, working under sweatshop-like conditions, manufacture beads and other items. There were also films on humanitarian crisis and conflict, such as *The Devil Came on Horseback* (2007), which surveys the ongoing, systematic, abuses occurring in the Darfur region of Sudan, and on Australian Indigenous issues, such as *Liyarn Ngarn* (2007), which "ponders what it means to be Aboriginal in contemporary Australia, and what it means to be a white person in the context of these issues" (Human Rights Arts and Film Festival Programme). By expressing the rights and issues mentioned in *Apropos* through these film selections, the festival could show, among other things, how rights are interconnected, that is, how poverty issues are linked to women's and family rights in *A Walk to Beautiful*, as well as how rights claims can be made by different groups and can have different focus dependent on context. For example, labour rights can be related to various kinds of employment issues for different peoples around the world, as expressed in *Sex Slaves* and *Mardi Gras: Made in China*, while Indigenous issues can be connected with national rights (often expressed through self-governance mechanisms such as self-determination), as depicted in *Liyarn Ngarn*.

The festival does not only programme films that represent a multitude of ways that human rights can be associated with particular group or individual struggles, or with specific situations of social conflict or crisis, it also programmes films that demonstrate the kinds of interplay that can happen between human rights and other abstract concepts. *Plug and Pray* (2010), one of the films that I acquisitioned for the 2011 programme, for example, was described by then Programming Manager Katie Mitchell as a coup for the festival. Exploring a range of ways that people and technology can interact, particularly in the context of recent developments in robotics research, *Plug and Pray* was selected because the film opens up ethical and existential questions about what it means to be human. It was decided by the programming team that including such a film in a human rights festival would mean that such questions could be related to human rights issues, suggesting human rights can also be about fundamental questions to do with what it means to be human.

Dissensus and the Human Rights Arts and Film Festival

As previously stated, exploring the different contexts within which human rights can be situated is consistent with the common practice that occurs within the dominant institutional framework of human rights law-making and legal representation. I would like to finish this

chapter by discussing how Jacques Rancière sees this practice as an example of "dissensus" and how this notion of "dissensus" can be related to the festival. As noted in the Introduction, Rancière is one thinker who believes that human rights, today, represent the rights of different individuals and groups. For Rancière, human rights are open predicates that can be enacted by all kinds of subjects in different circumstances and under different conditions. While, of course, it may not always be possible for people to meaningfully or effectively petition for the rights they are deprived of, even those who are not part of the political realm, including subjects who are not able to access and/or use formal channels of political communication within the state, may still be able to test and verify the political reach of human rights discourse: "today the citizens of states ruled by religious law or by the mere arbitrariness of their governments, and even the clandestine immigrants in the zones of transit of our countries or the populations in the camps of refugees, can invoke" human rights (Rancière 2004: 305). One reason this is the case is because, as discussed earlier, human rights has become a dominant political language. What this means is that there is no single, ideal subject who represents the only kind of person who can realize political predicates such as human rights. In other words, there are no "definite or permanent subjects" who are the only or proper bearers of human rights (Rancière 2004: 299). Subjects who have acquired the political rights of citizenship within a democratic nation-state, for example, are not the only subjects with the potential to enunciate human rights claims. For Rancière, this situation amounts to "dissensus" rather than consensus because, when those who have been traditionally excluded from being full citizens or playing legitimate political roles within the state can enact human rights claims, dispute is created about what human rights are exactly and whom they are applicable to.

It is vital to recognize that, for Rancière (2004), this activity of "dissensus" occurs with the context of the human rights regime. "The Rights of Man" – those written rights or inscriptions (302–303) expressed in documents such as the Universal Declaration of Human Rights (UDHR) (303) – do not only belong to those who exist within the sphere of citizenship, but to all individuals. For Rancière, the emergence of such documents, and their implementation by groups and individuals who occupy different social positions and/ or have different cultural backgrounds, not only opens up the possibility that "the capacity for politics" can belong to all (Corcoran 2010: 7), but also that political exchange between subjects is characterized by "dispute about what is given, about the frame within which we see something as given" (Rancière 304). As has been demonstrated in this chapter, through its programme material, including festival statements and film selections, the Human Rights Arts and Film Festival (HRAFF) is able to interact with attendees in a manner that engenders dispute about what human rights is, exactly, and who, or to what situations, it is applicable. In this sense, I would argue that the festival creates a form of "dissensus" because, through its curatorial address to attendees, the festival is able to question and explore the boundaries of human rights.

It is important to note that Rancière does not only use the concept of "dissensus" specifically in terms of human rights. It is a concept that he develops in the context of

exploring different aspects of politics and aesthetics throughout his writing. It is, therefore, a concept that has different dimensions to it. As said in the Introduction, it is not that the HRAFF enacts all the different dimensions of "dissensus", rather that it produces a form of "dissensus". The form of "dissensus" that HRAFF produces shows that, within the edifice of institutional human rights discourse, there is not a single way of presenting human rights. This argument is, in part, inspired by the work of Andy Lavender (2012), a scholar who specializes in theatre and performance. Lavender, who draws on "dissensus" among other key terms in the Rancière lexicon, shows how particular events and artefacts can involve degrees of "dissensus" for spectators. For example, speaking about a studio theatre production company in Chicago, who employ a number of techniques to create a fluidic, multiperspective experience for spectators, Lavender concludes that "the configurations" of space and movement (including audience movement) during performances "enable[s] some low-level effects of dissensus" (317). To discuss such theatre productions, Lavender draws more extensively, than this chapter has, on Rancière's notion of "dissensus". Lavender argues that such productions have a dissensual character to the degree that they reflect Rancière's (2009) claim, made in *The Emancipated Spectator*, that there are "scenes of dissensus capable of surfacing in any place and at any time" (48), which are able to disrupt and/or change the predisposed ways audiences perceive, emotionally engage with, and make sense of events and artefacts. In terms of the performances put on in Chicago that Lavender analyses, unlike the proper conduct of sitting down in one place watching a performance with a relatively fixed perspective, spectators have the "feeling of seeing things differently, of not having drama presented for the gaze, but rather textured into a space that itself", in comparison to the normal state of immobility that spectators experience, has become "a site of freer flow and negotiation" (317); in other words, a space where "divergent places of engagement" are possible (317). While this chapter has not, in any particular sense, explored the spatial dimensions of "dissensus", its argument is similar to Lavender's insofar as it has been claimed that HRAFF produces a form, or degree, of "dissensus". As has been discussed, HRAFF does this through its curatorial address to spectators.

Conclusion

It has been argued in this chapter that the Human Rights Arts and Film Festival (HRAFF) attracts different audience types to the festival by not only drawing on the language of institutional human rights discourse, but also, more broadly, enacting discursive practices associated with such discourse. It has been further suggested that this mode of address that HRAFF produces cultivates a form of "dissensus". As has been explained, "dissensus" is a concept that Jacques Rancière has developed to analyse a range of different activities, including practices to do with contemporary human rights. He believes that people (including non-western subjects) are living during a period where change has occurred to the way individual and groups think about, and exercise, rights. He says that the dominant

language of western human rights discourse has, in part, caused this change. HRAFF reflects this situation in the ways that have been discussed in this chapter.

References

Arat, Z. F. K. (2006), "Forging a global culture of human rights: Origins and prospects of the international bill of rights", *Human Rights Quarterly*, 28:2, pp. 416–437.

Ben-Ari, D. (2013), *Breastmilk,* USA: Aleph Pictures.

Bienstock, R. (2005), *Sex Slaves*, Canada: Associated Producers.

Braithwaite, S. (2013a), "Reframing the world", *RealTime,* http://www.realtimearts.net/article/114/11102. Accessed 5 March 2015.

———— (2013b), "Get with the program at HRAFF", *Broadsheet*, http://www.broadsheet.com.au/melbourne/arts-and-entertainment/article/get-program-hraff. Accessed 5 March 2015.

Brown, W. (1995), *States of Injury: Power and Freedom in Late Modernity*, Princeton: Princeton University Press.

Burres, B. (2012), "From local to global: The growing pains of the Human Rights Watch International Film Festival: An interview with Bruni Burres, festival director (1991–2008)", in D. Iordanova and L. Torchin (eds), *Film Festival Yearbook 4: Film Festivals and Activism*, St Andrews: St Andrews Film Studies, p. 202.

Cmiel, K. (2004), "The recent history of human rights", *The American Historical Review*, 109:1, pp. 117–135.

Corcoran, S. (2010), Editor's introduction in S. Corcoran (ed. and trans.), *Dissensus: On Politics and Aesthetics*, London: Continuum.

Dembour, M.-B. (2010), "What are human rights? Four schools of thought", *Human Rights Quarterly*, 32:1, pp. 1–20.

Douzinas, C. (2001), "Human rights, humanism and desire", *Angelaki: Journal of the Theoretical Humanities*, 6:3, pp. 183–206.

———— (2002), "The end(s) of human rights", *Melbourne University Law Review*, 26:2, pp. 445–465.

Grassilli, M. (2012), "Human rights film festivals: Global/local networks for advocacy", in D. Iordanova and L. Torchin (eds), *Film Festival Yearbook 4: Film Festivals and Activism*, St Andrews: St Andrews Film Studies.

Human Rights Film Network (n.d.), "Charter: Statement of principles and practices", http://www.humanrightsfilmnetwork.org/content/charter. Accessed 5 March 2015.

———— (2007), *Apropos - Human Rights in Art*, Melbourne, 27 November–15 December.

———— (2007), *Liyarn Ngarn*, Melbourne, 27 November–15 December.

Human Rights Arts and Film Festival Programme (2011), *The Accordion*, Melbourne, 12–22 May.

Ignatieff, M. (2007), *The Rights Revolution* (2nd ed.), Toronto: House of Anansi Press.

Ingram, J. D. (2008), "What is a 'right to have rights'? Three images of the politics of human rights", *The American Political Science Review*, 102:4, pp. 401–416.

Lavender, A. (2012), "Viewing and acting (and points in between): The trouble with spectating after Rancière", *Contemporary Theatre Review*, 22:3, pp. 307–326.

McNeill, E. (2014), interview with author, 30 June.

Mhando, M. (2007), *Liyarn Ngarn*, Australia: Australians for Native Title and Reconciliation.

Moyn, S. (2010), *The Last Utopia: Human Rights in History*, London: Harvard.

Muller, C. (2012), "Human Rights Film Festivals and Human Rights Education: The Human Rights Arts and Film Festival (HRAFF), Australia", in D. Iordanova and L. Torchin (eds), *Film Festival Yearbook 4: Film Festivals and Activism*, St Andrews: St Andrews Film Studies.

Nainby, B. (2008), "Festival patron statement of support", in *Human Rights and Arts Film Festival Programme*, Melbourne, 13–23 November.

Odello, M. and Cavandoli, S. (2011), "Introduction", in M. Odello and S. Cavandoli (eds), *Emerging Areas of Human Rights in the 21st Century: The Role of the Universal Declaration of Human Rights*, New York: Routledge.

Panahi, J. (2010), *The Accordion*, Iran: Art for the World.

Pupavac, V. (2012), *Language Rights: From Free Speech to Linguistic Governance*, Basingstoke: Palgrave Macmillan.

Rancière, J. (2004), "Who is the subject of the rights of man?", *The South Atlantic Quarterly*, 103:2&3, pp. 297–310.

—— (2009), *The Emancipated Spectator* (trans. Gregory Elliot), London: Verso.

Redmon, D. (2005), *Mardi Gras: Made in China*, USA: Carnivalesque Films.

Schanze, J. (2010), *Plug & Pray*, Germany: Mascha Film.

Smith, M. (2007), *A Walk to Beautiful*, USA: Engel Entertainment.

Stern, R. & Sundberg, A. (2007), *The Devil Came on Horseback*, USA: Break Thru Films.

Szoke, H. (2011), "Festival messages", *Human Rights and Arts Film Festival Programme*, Melbourne, 12–22 May.

United Nations (n.d.), "The universal declaration of human rights", http://www.un.org/en/documents/udhr/. Accessed 5 March 2015.

Section 3

National and Regional Perspectives

Chapter 7

Bristol Palestine Film Festival: Engaging the Inactive, the Aroused and the Aware

David Owen

Introduction

The Israel and Palestine conflict is arguably one of the most protracted, well known and yet perhaps least widely understood conflicts of the modern era. In any conflict there are not just two sides, but multiple sides and these multiple sides are explored in great depth in a variety of literature (see for example: Benny 2009; Harms 2012; Ross 2005). It is beyond the remit of this chapter to give an in-depth analysis of the conflict. My focus here is to set the scene for the aspects that are most relevant to the topics under discussion in this chapter; that is, the humanitarian situation in Palestine, its influence on Palestinian cinema and the reasons why this situation might motivate me to establish a Palestinian Film Festival. This should not be construed as bias, but simply attention to the matter under discussion.

The roots of the conflict lie in the period between the two major world wars. A now infamous letter from Arthur James Balfour (British Foreign Minister) to Lord Walter Rothschild (leader of the British Jewish community) in 1917 acts as a useful allegory. It promised the support of the British government for a national home for Jewish people in Palestine, providing that "nothing shall be done which may prejudice the civil and religious rights of existing non-Jewish communities in Palestine" (Harms 2012: ch. 3). 30 years on, and after several reports and commissions, the United Nations passed resolution 181 allocating 56 per cent of Palestine to the largely immigrant Jewish population which made up 30 per cent of the whole. The resolution was implemented with no intervention or peacekeeping plan, and sparked the beginnings of a civil war between Palestinian Arabs and Jews. In 1948, the conflict spread to the surrounding Arab nations who were defeated after a ten-month war, following which the 56 per cent allocated to Israel had expanded to 78 per cent leaving 22 per cent to the Palestinians (Harms 2012). Over the course of the war, approximately 700,000 Palestinians fled or were forced from their homes and are still unable to return today (Harms 2012). Since 1948, there have been a number of significant events in the ongoing conflict, including: the formation of the Palestine Liberation Organisation in 1964; the six-day war in 1967 in which a further 500,000 Palestinians were displaced and territorial gains doubled the area of land controlled by Israel; and two major Palestinian uprisings in 1987 and 2000 either side of the now defunct 1992 Oslo agreements (a declaration of principles between the PLO and the Israeli government) (Harms 2012; BBC 2015; Tessier 2009).

One does not need to be an expert in the conflict to know that there is something deeply wrong with the current situation. In 2014, the conflict between Gaza-based Palestinian militants and Israeli forces escalated, leaving 66 Israeli military and an estimated 500 Palestinian militants dead (BBC 2014). Alongside these military fatalities, the conflict left 1469 civilian fatalities, of which 1462 were Palestinian including 495 children (BBC 2014; OCHA 2015). From a purely humanitarian perspective, life in Occupied Palestine is increasingly unbearable. Gaza is home to 1.7 million people and is under an almost constant blockade by land and sea. The unemployment rate is currently among the highest in the world and rose to 44.5 per cent in the second quarter of 2014, up from 27.9 per cent in the same quarter of 2013 (UNRWA 2015). There is severe shortage of building materials, food, fuel and health supplies, and the region is now also among the most densely populated in world (BBC 2014b, 2014c). In the West Bank, Israeli checkpoints, Israeli-only roads, settlement cities and frequent military incursions restrict freedom of movement and quality of life (United Nations 2013). It is recognized by the United Nations that the current negative indicators for Palestine, such as Gross Domestic Product (GDP), employment, and health-care provision, are deeply affected by the Israeli occupation, and that sustainable improvements can only be meaningfully worked towards if the occupation were to end (United Nations 2014).

The influence of these circumstances on Palestinian cinema has been profound and is best summarized by Gertz and Khleifi (2008) who note four periods. The first period (1935–1948) is for all extensive purposes lost or destroyed; there is very little trace of the films made in this era except through the testimonies of those who were involved in making them. The second period (1948–1967) is dubbed the "epoch of silence" and is characterized by the absence of not just film-making, but also any cultural or historical narrative in the aftermath of the Nakba.[1] The third period (1968–1982) is notable for the increasing number of Palestinian films made by Palestinians in exile; many of the films made in this era are grouped by historians into two camps: either films that are of and about the revolution, or films made by Palestinian organizations. This phase is characterized by a greater investment in film-making from Palestinian organizations such as the Palestinian Liberation Operation (PLO). It is also an era in which there are significant increases in the volume of films made by non-Palestinians on the Palestinian struggle. Such films include: *The Fifth War* (Monica Maurer 1980) fronted by Vanessa Redgrave, and also the first fiction film funded entirely with Palestinian funds *Return to Haifa* (Kasem Hawal 1982). The current period, starting in 1980s to the present day, is characterized by both the growing volume of cinema and the creation of a number of internationally recognized films. The dispersed nature of Palestinian people means that many film-makers are now based outside Palestine, bringing a wealth of cultural experiences to Palestinian cinema and often although not exclusively drawing on Israeli, European and American training and funding. Key films from this include notable firsts such as the first feature film from the Gaza Strip *Curfew* (Rashid Masharawi 1994) and the first feature directed by a Palestinian Woman *Salt of this Sea* (Annemarie Jacir 2008); alongside Oscar nominations for films such as *Divine Intervention* (Elia Suleiman 2002) and *Omar* (Abu Hany-Assad 2014).

Many of these films assert a counter-narrative to what is seen as the dominant narrative; Gertz and Khleifi (2008: 1) describe this dominant narrative as Palestinian history told by the winning side. They begin to assert a new historical narrative, one of a displaced people. In doing so they attempt to invent, document and crystallize Palestinian history as leading from the past to the present and into the future, a history rooted in post-1948 trauma but one that is still very present today (Gertz and Khleifi 2008; Dabashi 2007).

I was first drawn to Palestinian cinema through an interest in the wider conflict with Israel. It was 1988 at the time of the first intifada and at eight years old I was beginning to show an interest in the news. I remember asking my parents what they were fighting over, and receiving a short and succinct reply: "religion". This rather incomplete answer led me to believe at an early age that the conflict was to do with arguments over beliefs, and stayed with me for much of my youth. My interest in the region eventually took me to the West Bank in 2007, travelling with my football team the Easton Cowboys (Simpson and McMahon 2012). It was on this trip that I was struck by the contrast between the perceptions I had formed of Palestine through watching the news, and the actual lived experience of being there. For me the news had left me with an impression of a place almost unliveable, and among the coverage of violence, I had no sense of the real people who lived there. It was a place of villains and victims. Having been there for a visit of just ten days, those superficial impressions were replaced with real people and their eccentricities both wonderful and mundane. To this day I am still connected to these people, and it is this connection that inspired me to use film as a means to facilitate that same connection for others who might not choose to travel to the region.

In 2011, the opportunity arose to establish the Bristol Palestine Film Festival. I was working in offices based at the Watershed (http://www.watershed.co.uk), a hub for cultural cinema and digital creativity based in the centre of the Bristol, and was given a small private donation to get a festival started. With no prior experience of the film industry or managing film festivals, I was very much jumping in at the deep end. As it turned out the festival ended up very similar to other activist film festivals, aiming to provide a forum for both artistic and cultural exchange, while focusing on bringing complex human experiences to a public forum. In this chapter, I reflect on two approaches I have used to help me deliver the film festival:

1. The use of audience segmentation models to better understand the motivations, knowledge and interests of the public that we were seeking to attract.
2. The use of systems thinking to curate a film programme that portrays the complexities of life in Palestine as a means to develop a deeper and more authentic connection between audiences and the subject matter on screen.

Drawing on evaluative data collected over the past three years, I explore how effective these two elements have been, particularly targeting non-activist groups (the "aroused" and "aware" as I refer to them in this chapter). I attempt to use this data to assess how effective

the approaches have been at creating efficacy between viewer and subject and at inspiring active responses to the worsening humanitarian situation in Palestinian.

Suffering and witnessing

The majority of the last fifty years of my life has been wasted photographing wars. What good have I done showing these people suffering?

(Don McCullin 2014, war photographer)

A familiar dogma surrounding human rights film-making and exhibition is the belief that in revealing human suffering, people will be inspired to take responsibility for the suffering they witness on screen and act accordingly (Torchin 2012). Entering into a conflict zone without the equipment and knowledge to help those most immediately in need requires a level of ethical and moral judgement about what one is seeking to achieve or gain from the act of documenting or witnessing suffering. Take for example, the film *My Name is Ahlam* (Rima Essa 2010), which I selected for the opening year of the Bristol Palestine Film festival. It tells the harrowing story of a Palestinian mother's fight to secure adequate health care for her five-year-old daughter who is suffering from Leukaemia, charting the daily challenge of navigating the Israeli checkpoints, the poor state of the hospitals in the West Bank and their problematic relationship with the occupation authorities. At any point in the filming, director Rima Essa could have intervened and arranged for funding for a bone-marrow transplant, or arranged for taxis to transport the child across the West Bank. The child eventually dies of her illness, and despite the close relationship between the director and the family, a decision is taken not to intervene. This decision is made not only because the mother would not accept help, but also because the director assumes that screening the film to audiences in Israel and the West can raise awareness and promote social changes that might, in turn, put additional pressure on governments to address such situations (Karpel 2010).

In the early days of the festival, I was working with a small group of committed activists. When I discussed film selection with this group, there was a preference for films made by other activists, particularly non-Palestinian directors, who were telling stories about specific individuals or communities living in the West Bank or Gaza. Several of these films tended to cover the "basic facts" of the dispute between Israel and Palestine, and were frequently narrated by western activists. I had several concerns about selecting these films for the festival. I sensed that films made by activists would first and foremost attract other activists to the festival. This is otherwise known as the homophily principle, the notion that we are likely to surround ourselves with people and information that we already agree with. The homophily principle is described by Kossinets and Watts (2009) as one of the more empirically proven social phenomena, and it has commonly been applied to understand how social groupings often form with similar attributes by education, income, gender, race and age. It has also been applied to understand how people organize by political attitudes

and beliefs, and more recently to understand behaviour on social networks such as Twitter and Facebook (Kossinets and Watts 2009). In relation to film selection at a film festival, one might therefore expect audiences to choose films that agree or support their political views or pre-existing knowledge of a subject. In order to attract a broader audience to the festival, I felt we had to look outside of ourselves, and let our target audience inform our decision-making. However, it soon became clear that if I wanted to attract this audience, I needed to better understand them. For example, what would motivate them to attend a screening, what would put them off, what their existing knowledge of Palestine was, and what they would be interested in finding out more about. To aid this process I developed a crude audience segmentation model.

Audience segmentation is a method of dividing the public into subgroups; it is used commonly in social marketing, public relations, arts, culture and heritage, marketing and campaigning (see for example: Arts Council 2015; Morris, Hargreeves and McIntyre 2013; Hine et al. 2014). Segmentation tools are often used as one aspect of increasingly sophisticated methodologies to better understand human behaviour (Barnet and Mahoney 2011). In the early days of the festival, I used the approach to build a model of the different audiences types we were seeking to attract to the festival, and to develop methods for marketing the festival to them (this is discussed below). As the festival developed over the years, I started

Figure 1: *5 Broken Cameras*, audience Q&A, BristolPFF 2012.

to apply the model to better understand how audiences might select and respond to films (this is discussed in the following two sections).

The model I developed consisted of five parts, which described attendants with various levels of knowledge about the issues surrounding Palestine:

1. *Active:* Frequently sign petitions, attend events and/or demonstrations, may have visited Palestine
2. *Informed and aware:* Tend not to be "active" but are well informed, and aware, of politics in Palestine and have a lot to add to the conversations
3. *Interested:* Have a tertiary awareness of the situation in Palestine, but have not prioritized looking deeper into the topic
4. *Unaware and uninterested:* Little or no interest or awareness of the topic
5. *Specialist interest:* May be interested in the event because of a specialist interest in film, documentary film-making, journalism, etc.

Using this model in discussions with the group helped us gain clarity and consensus on the people we were most interested in targeting. In our case, the *informed and aware, interested,* and *specialist interest.* We took the pragmatic decision that the active group would most likely attend the festival anyway, and we did not have the resources to consider the unaware and uninterested. Having made this commitment early on, I used the model to collect data from potential audiences and to inform decisions being taken. For instance, I designed a survey that classified respondents by self-perceived awareness of, and interest in, Palestine, and asked each respondent to select which logo from two would most likely attract them to the festival. One logo featured an abstract painting with swathes of reds, blacks and sandy orange. The other logo was of an olive tree and the Palestinian flag. Both logos could be said to be of equal quality and were designed by the same designer to two separate briefs. The results of the short survey [n=52] found that those with a self-professed knowledge of Palestine and the conflict with Israel were more likely to favour the second logo because it was a clearer expression of Palestinian identity and more representative of what they thought the over-riding message of the festival should be. This group typically felt the first logo was vague and had no clear statement or message about Palestine. A second group of people emerged who had some awareness of the topic (our target audience: the informed and aware, interested and specialist interest groups), and these favoured the first logo. This group reported that the first logo suggested they might learn something from the festival and that it would be more expansive. They made negative associations with the image of the Palestinian flag and previous experiences of activists who would "tell them what to think". Using the data collected from this survey I was able to persuade the group to choose the abstract logo on the basis that it was most likely to attract our target audience, as opposed to the logo with the Palestinian flag that may have been their personal favourite, but may also have dissuaded audiences from attending the festival.

Witnessing and responding

The act of witnessing does not necessarily imply that action will be taken, nor does it guide the witness as to what action should be taken. Hallahan (2000) suggests that inaction is a characteristic of large and complex societies, not as a result of apathy or lack of awareness, but because people juggle a variety of different activities and concerns in their daily lives. He highlights how people are selective about the issues with which they become involved, entering into deep relationships with only a few organizations and individuals, yet maintaining a range of secondary or tertiary commitments that are more superficial and purposefully limited in scope (Hallahan 2000). This model provides a helpful lens for thinking through the relationship between activist film festivals, audiences and activism. If audiences are already deeply committed to the issues that surround a particular film, what purpose does the film play in their lives? Does it "service" their ongoing commitment, providing a renewed emphasis or re-affirming the need to act? Or, in terms of audiences who only have a minor or superficial interest in the issues connected to a given film, how can activist film festivals help move such issues from being peripheral to tertiary and then primary? And then, where an issue is the primary concern of an audience member, how can activist film festivals help guide audiences with the knowledge and capacity to act responsibly?

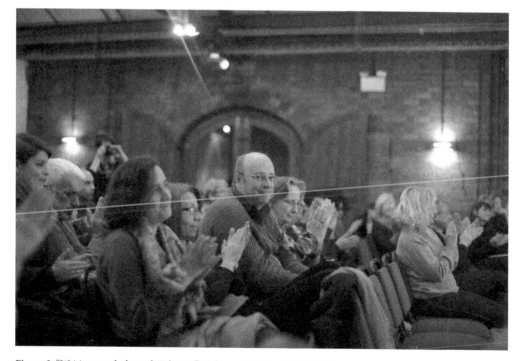

Figure 2: "Writing a path through Palestine", audience Q&A, BristolPFF 2012.

Problems vary significantly in the scale of complexity and seriousness; at one end of the spectrum are "difficulties", while at the other end are "messes". If something is difficult, we know roughly what the answer will look like, and the challenge is getting there; with a mess we cannot even be sure of or agree on what the answer might look like, or even what the problem might be (Reynolds and Holwell 2010). In contrast to difficulties, "messes" (a term coined by Russell Ackoff [Ackoff 1999]) are likely to have more interdependent factors and layers of complexity; they will be characterized by uncertainty with multiple, often conflicting perspectives about the problem, its solution and the pathway to that solution. Identifying from the outset whether you are dealing with a "difficulty" or a "mess" can drastically shape the approach you take to solving the problem.

I define the Israel/Palestine conflict as a mess. In perceiving the situation as a mess rather than a difficulty, I am therefore drawn to respond in ways that are most suited to dealing with messes. At the heart of my approach is a commitment to understanding the problem and its connectivity to other problems, accounting for power differentials across stakeholders, and making a commitment to a process of transformation rather than to a set of predefined outcomes or goals. Such an approach is loosely grounded in systems thinking. Systems approaches provide a way of thinking about problems and their potential solutions. As Ackoff (1999) states, the best thing to do with a problem is not to solve it, but to dissolve it, to redesign the entity that holds the problem so as to eliminate it. They provide a mechanism through which one can commit to holism and pluralism as a counter to reductionism and dogmatism, respectively. They provide insights into how to bring together people from various backgrounds and with different values, perspectives, knowledge and experiences, to generate meaningful, supported and feasible solutions in appreciation of the fact that no one has a monopoly on wisdom (Wals, Hoeven and Blanken 2009).

In order to engage the wider public in meaningful conversation about the Palestinian experience of the conflict with Israel, I was deeply connected with the idea that the festival would need to commit to being as pluralistic as it could. In my curatorial role, I placed a strong emphasis on selecting a range of films in the hope that each would attract a different audience, and that taken as a set, they would work together to create deeper insights into the Palestinian narrative. My ambition was not to foreground suffering, not to foreground the occupation, but to generate a wide-ranging curatorial programme. Several of the films I considered would stand alone for their artistic and creative merits, having toured major international film festivals such as Cannes Film Festival, Toronto International Film Festival or Berlin International Film Festival. My feeling was that viewers needed a window into the real and daily lives of Palestinian people. I felt that several of the films made by western activists struggled to give rise to any deep or authentic engagement with Palestinian society and its people, and instead showed them as powerless victims, unable to go about their daily lives. Previous programmes included films, animations and shorts exploring everything from "free running", cooking, woman's football and humour through to experiences of the occupation, health-care provision and the history of the conflict. Films selected include *Eid* (Saaheb Collective 2011), a short documentary that tells the true story of an enigmatic young Bedouin man called Eid who reconstructs intricate

models of jeeps, bulldozers and helicopters from the scraps he finds in his village. While in real life the Israeli army has demolished his home using these vehicles, the video focuses on Eid's creative processes, and what it means to him to reconstruct the vehicles as models. Another example, *Habibi* (Susan Youseff 2011) was a feature drama portraying a woman living in an increasingly conservative Muslim society, under siege in Gaza. A third example was *Free Running* (Azar and Shahin 2012), a short film that depicts the thoughts and dreams behind the first Gaza Parkcour Team. On this particular screening, I chose to move the screening in order to reach a group of young free runners from one of the most deprived areas in Bristol. At the end of the screening, the young men applauded. When I asked what they liked about

Figure 3: Audience member on cycle powered cinema watching a film about sustainable energy in West Bank, BristolPFF 2012.

the film, they noted the quality of the free running was very high, but also identified with the self-taught model that the Gazans had used to progress their practice. One boy observed that "they are like us, they don't have many facilities, or people to help train them, and so they have to use YouTube and the Internet to learn […]". Several audience members spoke of a desire to connect online with the Gaza Free Running group following the screening, and potentially a follow-up trip to the region. The audience reaction gave some indication that the primary reaction in the film was not one of what can we do to help these people, but of wanting to connect with these people around shared interests. The opportunity to follow up on this initial interest was limited by time and resource. A suitable course of action would be to arrange a Skype conference between the two parties, to see what emerged from those discussions. While the young people could have self-organized, my experience of working with young people has shown that some brokerage and facilitation is required, even if just to encourage and support young people to take leadership roles within a project.

Lessons from evaluation

In the first two years of the festival, I collected evaluative data to help me better understand who attended and what they gained from the festival. We had 210 responses to audience evaluation over two years, which represented a response rate of 30 per cent. Forms were handed to audiences as they left a film screening; people then completed the forms in the foyer and handed them to the box office. The demographics of those who completed the survey is summarized in Table 1. As detailed, the majority of the audience was white, female; however, there was a surprisingly even age range attending the festival.

The survey found that 30 per cent of those attending claimed to know lots about Palestine, 61 per cent claimed to know something, with the remaining 9 per cent claiming to know nothing at all [n=210] (Owen 2013). On reflection, I could have done more to ascertain levels of engagement and activism of audiences attending the festival, rather than just looking at self-reported knowledge. I could have explored, for example, about whether audiences were members of any solidarity groups, had visited the area, frequently read news reports, etc. The evidence I collected above did suggest that to some extent at least, the festival had been successful at targeting the audiences we intended to (*interested* and the *informed and aware*).

Gender	Female (62%)	Male (36%)	Other (2%)
Ethnicity	White (74%)	BME (22%)	Other (4%)
Age	11–25 (6%)	26–35 (30%)	36–45 (16%)
	46–55 (19%)	56–65 (15%)	66+ (9%)
	Prefer not to say (5%)		

Table 1: Demographics of festival attendees 2011–2012 (Owen 2011, 2012).

Activists working with me on the project also reported seeing many unfamiliar faces. In the first year, a woman attended every event at the festival because her granddad had served in Palestine during the British mandate. He had recently passed away and she had become interested in finding out more about his history. After the festival's second year, I received this response to the screening of *5 Broken Cameras* (Burnat and Davidi 2011):

> As an Architect with experience of designing sustainable housing it seemed to me that the Israeli settlements were anything but that and that a powerful critique could and should be made of them on those grounds as well. The only possibly sustainable settlements were the Palestine villages and farming practices. The Israeli "settlements" would seem to me no more than 3rd rate commuter villages. As such they are effectively obsolete already, although saying that might be not much comfort to the Palestinian villagers. They "only" need to wait for a few generations and the Israeli settlements will probably (hopefully) be ghost towns. Their (as our own) oil supplies will not be secure, and, for all I know, their water and electricity supplies are neither. Presumably the Palestinians occupy the high ground where the water must come from if not trucked in.

This level of engagement was one of my hopes for this festival. It was clear that the audience member above did not know much about the Palestinian experience of the conflict, that the Israeli settlements had been built on the land that was at a higher altitude and that Israeli authorities had done their best to claim the water supplies in the West Bank (Weizman 2012; Segal, Tartakover and Weizman 2003). However, hopefully for this audience member, this was just the start of the inquiry, a chance to pick up those details with time.

Interestingly over 80 per cent of audience members felt they learnt something from the event they attended, and almost all participants said they would continue to discuss the Israel/Palestine conflict afterwards. A selection of audience feedback taken from the evaluation reports (Owen 2011, 2012) is included below:

> I was relieved to meet people challenging the stereotypes and using new and unique ways of advocating for Palestine

> Palestinians have come alive to me and I greatly admire the speakers

> I was guilty of forgetting the issues there and have decided to actively reignite my understanding and awareness of what is happening in Palestine

> A great opportunity to engage with events so far away and to witness personal stories.

> It's a brilliant way to engage audiences/people in important issues & create dialogue around challenging subjects.

I received a couple of critical comments from audiences. One followed the screening of *No Laughing Matter* (Vanessa Rousselot 2010); the film charts the director's attempts to find

humour in the West Bank. While the film was well received by the majority of the audience, a Palestinian questioned the focus of the film and asked: "Is this all we have Palestinians have left now, our jokes [...]"? This provided a useful frame of reference for me. It led me to critique my curatorial work and seek greater depth to my film selection. Essentially, there are a great number of films made to debunk stereotypes and to humanize Palestinians. I realized that to some extent these films are also limited in what they can achieve creatively as a result of their starting position, that is, speaking to an audience that does not understand that Palestinians are layered and complex beings. In later years of the festival, it led to a shift away from works by international directors to focus on films made by Palestinians themselves.

I decided not to conduct an evaluation in the third year of the festival. However, the fourth season (December 2014) occurred at a time when I first began to engage with some of the literature on witnessing in human rights film festivals for this chapter. As a result, I found myself questioning what people do after witnessing the films, and whether the festival should do more to call people to action. As a result, I altered the questionnaire to ask audiences what they might do in response to the film they had just seen. A list of suggested actions was put forward and they were asked to indicate up to three responses that they might do as a result of the screening:

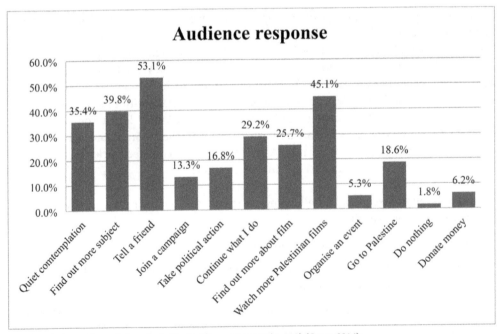

Graph 1: What audience feel motivated to do after a screening (n=113) (Owen 2014).

As shown, audience members report they are more likely to watch more Palestinian films (45%), find out more about the subject (40%) or quietly contemplate the film (35%), than travel to Palestine (19%), take political action (17%), join a campaign (13%) or organize an event

(5%). The most popular response, however, was telling a friend (53%), which indicates some form of mobilization and awareness raising albeit through immediate networks. The evaluative work could benefit from more analysis, for example, to explore whether there are significant differences by gender type or prior awareness of the topic. I could also develop it further with a follow-up survey or interviews with audiences. However, the results indicate a propensity towards continued learning and reflection rather than political action or acts of solidarity.

Conclusion

While a few projects such as "Film Matters?" (NPC 2014) are beginning to explore methodologies for evidencing the impact of film exhibition, beyond basic monitoring there is very little audience evaluation occurring in the film exhibition sector. The websites of key organizations supporting the sector such as the British Film Institute or the Independent Cinema Office provide very little guidance on evaluation beyond recording audience figures and demographics. As a result, very little is known about what people do in response to viewing films, let alone human rights films. Given the nature of these films and the ethical and moral dimensions that surround their making, it would seem to be of utmost importance that curators and film exhibitors understand what occurs in response to films.

My primary aim when I began the festival was to broaden the audiences who were prepared to engage with the Palestinian experience of the conflict with Israel and to provide those audiences with a pluralistic and deeply human connection with Palestinian people through cinema. The evidence collected from the evaluation shows that the festival has been successful in bringing new audiences into the festival and generating a wider understanding of Palestinian cultural, economic and political life through film. At the heart of my approach was the use of audience segmentation alongside a commitment to pluralism in programming. By selecting a diverse range of films that go beyond the villain or victim narratives, I feel I have been able to showcase an incredible range of films and film-making talents, including some incredible responses to life under occupation (such as the free running film), which have, in turn, developed a deeper connection between audiences in Bristol with the "actors" on-screen. I feel that I have shown that the portrayal of suffering is just one way in which activists can motivate others to respond, but there are many others. Using a variety of methods and films may have helped to broaden the scope of the festival, in particular attracting audiences with a broader range of experience and pre-existing knowledge of the subject.

I continue to question what people do with the experience of witnessing the films, and whether I could do more to call people to action. My approach has always been very hands off, to let people draw their own conclusions and to gravitate to the responses that fit for them. I feel that the festival should enable people to connect with the issue as they choose, as consumer, as activist, as learner. I appreciate that this raises a number of ethical questions regarding the screening of human rights films in particular. But I fear that asking each

audience member to act collectively, immediately or as suggested by the festival is somewhat counter-intuitive. My long-term aim is to build a lasting commitment between the festival attendees and the people of Palestine, one that is founded on mutual respect, empathy and exchange. The extent to which such relationships are possible through film alone is largely unknown to me; however, reflecting on my own experiences, the festival and particularly the films keep me connected to the issue and deepen my knowledge on a daily basis. Finally, the effect of the festival on public understanding of Israel and Israeli people needs further exploration both within the next instalment of this research and within the way the film festival is curated and managed. My personal commitment is to generating a pluralistic understanding of the culture and politics of both Palestine and Israel; I do not think this is possible within the current format, and for reasons outlined in the Introduction I began with Palestine.

Acknowledgement

Thanks to Emma Agusita, Associate Research Fellow, Faculty of Arts, Creative Industries and Education.

References

Ackoff, R. (1999), "On passing through 80", *Systemic Practice and Action Research*, New York, 12:4, pp. 425–430.

Arts Council (2015), "Arts audiences: What segment am I?", Arts Council, http://whatsegmentami.artscouncil.org.uk. Accessed 6 May 2015.

Azar and Shahin (2012), *Free Running*, Canada and Palestine: Al Jazeera, https://www.youtube.com/watch?v=T9ikCn3CWEA. Accessed 12 May 2015.

Barnett, C. and Mahony, N. (2011), *Segmenting Publics*, Bristol: NCCPE.

BBC (2014a), "Gaza crisis: Toll of operations in Gaza, BBC", http://www.bbc.co.uk/news/world-middle-east-28439404. Accessed 17 May 2015.

——— (2014b), "Life in the Gaza Strip, BBC", http://www.bbc.co.uk/news/world-middle-east-20415675. Accessed 17 May 2015.

——— (2014c), "Gaza shelling by Israel leads to deadliest day of conflict, BBC", http://www.bbc.co.uk/news/world-middle-east-28389282. Accessed 17 May 2015.

———(2015), "A history of the conflict, BBC", http://news.bbc.co.uk/1/shared/spl/hi/middle_east/03/v3_ip_timeline/html/default.stm. Accessed 24 May 2015.

Benny, M. (2009), *1948: A History of the First Arab-Israeli War*, New Haven, CT: Yale University Press.

Burnat and Davidi (2011), *5 Broken Cameras*, Palestine, Israel, France and Netherlands: Guy DVD Films.

Dabashi, H. (2007), *Dreams of a Nation: On Palestinian Cinema*, New York: Verso Books.

Essa, R. (2010), *My Name is Ahlam*, Palestine: Claudius Films.

Gertz, N. and Khleifi, G. (2008), *Palestinian Cinema: Landscape, Trauma and Memory (Traditions in World Cinema)*, Edinburgh: University Press.

Hallahan, K. (2000), 'Inactive publics: The forgotten publics in public relations', *Public Relations Review*, 26:4, pp. 499–515.

Hany-Assad, A. (2013), *Omar*, Palestine: ZBROS.

Harms, G. (2012), *The Palestine-Israel Conflict: A Basic Introduction* (3rd ed.), London: Pluto Press.

Hawal, K. (1982), *Return to Haifa*, Palestine: Popular Front for the Liberation of Palestine.

Hine, D., Reser, J., Morrison, M., Phillips, W., Nunn, P. and Cooksey R. (2014), 'Audience segmentation and climate change communication: Conceptual and methodological considerations', *Wiley Interdisciplinary Reviews: Climate Change*, 5:4, pp. 441–459.

Jacir, A. (2008), *Salt of this Sea*, Palestine, Belgium, France, Spain and Switzerland: Philistine Films.

Karpel, D. (2010), "No-one can help such Children, Haaretz", http://www.haaretz.com/weekend/magazine/no-one-can-help-such-children-1.304951. Accessed 12 May 2015.

Kossinets, G. and Watts, D. (2009), "Origins of homophily in an evolving social network", *AJS*, 115:2, pp. 405–450.

Masharawi, R. (1994), *Curfew*, Palestine: Rashid Masharawi.

McCullin, D. (2014), "Interview with iconic conflict photographer", http://petapixel.com/2014/01/29/incredible-must-see-interview-iconic-conflict-photographer-don-mccullin/. Accessed 12 May 2015.

Morris Hargreeves McIntyre (2013), 'National trust', http://mhminsight.com/articles/national-trust-962. Accessed 6 May 2015.

Nimr, S. and Maurer, M. (1980), *The Fifth War*, Palestine: Palestinian Cinema Institution.

NPC (2014), "Story of change for film – preliminary draft, Watershed", http://www.watershed.co.uk/sites/default/files/page/inline_file/2014-12-09/filmmattersworkshopnotes27.6.14.pdf. Accessed 12 May 2015.

OCHA (2015), "Fragmented lives: Humanitarian overview 2014, United Nations Office for the Coordination of Humanitarian Affairs occupied Palestinian territory", http://www.ochaopt.org/documents/annual_humanitarian_overview_2014_english_final.pdf. Accessed 17 May 2015.

Owen, D. (2011), "Evaluation of Bristol Palestine Film Festival, 2011", www.bristolpff.org.uk. Accessed 17 May 2015.

—— (2012), "Evaluation of Bristol Palestine Film Festival, 2012", www.bristolpff.org.uk. Accessed 17 May 2015.

—— (2014), "Evaluation of Bristol Palestine Film Festival, 2014", www.bristolpff.org.uk. Accessed 17 May 2015.

Reynolds, M. and Howell, S. (2010), *Systems Approaches to Managing Change: A Practical Guide*, New York, NY: Springer.

Ross, D. (2005), *The Missing Peace: The Inside Story of the Fight for Middle East Peace*, New York: Farrar, Straus & Giroux Inc.

Rousselot, V. (2010), *No Laughing Matter*, France and Palestine: éO Productions.

Saaheb Collective (2011), *Eid*, http://vimeo.com/27058855, Accessed 17 May 2015.

Segal, R., Tartakover, D., and Weizman, E. (2003) *A Civilian Occupation: The Politics of Israeli Architecture*, New York: Verso.

Simpson, W. and McMahon, M. (2012), *Freedom Through Football: The Story of the Easton Cowboys and Cowgirls,* Bristol: Tangent Books.

Suleiman, E. (2002), *Divine Intervention*, France, Morocco, Germany and Palestine: Pyramide Distribution.

Tessier, M. (2009), *A History of the Israeli-Palestinian Conflict: Second Edition,* Indiana Series in Middle East Studies, Bloomington: Indiana University Press.

Torchin, L. (2012), "Networked for advocacy: Film festivals and activism", in D. Iordanova and L. Torchin (eds), *Film Festivals Yearbook 4: Film Festivals and Activism*, St Andrews: St Andrews Film Studies.

United Nations (2013), "Occupied Palestine territory: Consolidated appeal, United Nations", https://docs.unocha.org/sites/dms/CAP/CAP_2013_oPt.pdf. Accessed 12 May 2015.

——— (2014), "The Palestine human development report, United Nations Development Programme", http://reliefweb.int/sites/reliefweb.int/files/resources/UNDP-papp-research-PHDR2015.pdf. Accessed 12 May 2015.

——— (2015), "International year of solidarity with the Palestinian people: Resolution 68/12, UN", http://www.un.org/en/events/palestineyear/. Accessed 12 May 2015.

UNRWA (2015), "Gaza situation report 78, United Nations Relief and Works Agency", http://www.unrwa.org/newsroom/emergency-reports/gaza-situation-report-78. Accessed 12 May 2015.

UN Watch (2007), "The United Nations and anti-semitism: 2004-2007 report card", *UN Watch*, http://www.unwatch.org/atf/cf/{6DEB65DA-BE5B-4CAE-8056-8BF0BEDF4D17}/UNW_THE_UN_AND_ANTI_SEMITISM_04_07_REPORT_CARD.PDF. Accessed 12 May 2015.

Wals, A., Hoeven, N. and Blanken, H. (2009), *The Acoustics of Social Learning: Designing Learning Processes That Contribute to a More Sustainable World*, the Netherlands: Wageningen Academic Publishers.

Weizman, E. (2012), *Forensic Architecture: Notes from Fields and Forums*, Berlin: Hatje Cantz.

Youseff, S. (2011), *Habibi Rasak Kharban*, the Netherlands, Palestine, USA and United Arab Emirates: Idioms Film.

Note

1 Nakba translates from Arabic into "Day of the Catastrophe". For Palestinians it marks the displacement that proceeded and followed the Israeli Declaration of Independence in 1948.

Chapter 8

Reframing the Margin: Regional Film Festivals in India, a Case Study of the Cinema of Resistance

Shweta Kishore

G ang violence and shadowy connections between mafia, police and local politicians have earned the eastern region of the state of Uttar Pradesh the cinematic title of "Chicago of the East" (Srivastava 2012). In combination with accelerating economic migration and frequent disease epidemics, a distressing story of social underdevelopment emerges from this Hindutva stronghold (Singh 2011).[1] 900 kilometres east of New Delhi and 200 kilometres from the nearest metropolitan city Patna, the town of Salempur, population 17,000, lies in this culturally distinct Bhojpuri-speaking region. Across the states of Bihar and Uttar Pradesh, approximately twenty million people speak Bhojpuri. In this linguistically distinct region, historical traditions of literature, theatre and folk musical forms now coexist uneasily with mass cultural forms, such as Bhojpuri cinema and 24-hour television channels Mahua TV and Hummra Music TV.

In 2005, Jan Sanskriti Manch (JSM) (People's Cultural Forum) launched the Cinema of Resistance (COR) series of film festivals in Gorakhpur, district headquarter for the eastern region of the state of Uttar Pradesh. In 2013 I travelled to the town of Salempur, host to its first ever film festival, the two-day Salempur edition of the COR. Typically at COR film festivals, the arthouse, classical and political cinema programme is accompanied by related events including panel discussions, displays of film posters, cinema publications and DVDs for purchase. In what Thomas Waugh (2012: 87) describes as a "congested" festival environment clustered largely in urban Indian centres, this festival series constitutes a unique exhibition model on multiple scales. Binding the love of cinema with site-specific constructions, JSM organizes up to a dozen festivals annually in regional, district and semi-rural towns across North India. A determined itinerary extends beyond the urban periphery and mounts an ambitious agenda of resistance towards the "box office-oriented" Hindi film economy (Ganti 2012: 2).

In this chapter based upon first-hand observation of the organizational practices, festival event, interviews with organizers and analysis of festival print materials, I contend that this festival series, along with offering cinephilic satisfaction, stakes what can be interpreted as a move in the Gramscian "war of position" where through its structures, processes and objects, the festival offers the possibility of alternate forms of social subjectification. The war of position is played out in the field of culture, a field where dominant economic and political systems aim to produce consent towards assigned forms of social organization. One of the consequences of this unequal distribution of power can be seen in the ways that the subaltern view of the world is shaped through their "subordinate and dominated position" where the world is seen in terms proposed by society's dominant groups (Crehan 2002: 116).

Waged through cultural instruments including "the analysis of the economy; labor struggles; literature and art; education; the reading of historical experience", in this war, culture is the field of political struggle (Aronowitz 2009: 9). Social re-organization through the creation of what Cox terms "alternative institutions and alternative intellectual resources within existing society" offers the possibilities of reorganizing the conditions of historical participation through institutions of civil society that include, "schools, religion, cinema and other artistic organisations" (1983: 165).

Thus I make three arguments, first, that in the context of the present study, COR creates a set of conditions with an objective to establish a critical relationship between cinema and the spectator, where films are not only presented as objects of consumption, scopophilia or narrative identification but also historicized and contextualized to permit numerous ways of viewing and interpretation. Next I argue that attention to the historical positioning of its regional and non-metropolitan audiences in relation to commercial and state cinema production and circulation regimes permits COR to create practices and events that counter these historically exclusionary processes. Finally, I contend that the philosophy and forms of audience relations authorized at this festival provoke consideration about how regional audiences may take active roles in viewing and creating cultural structures that offer genuine forms of cultural participation and expression of subjective and collective concerns.

Organized in three sections, the chapter begins by first tracing the history and philosophical underpinnings of the parent organization of the festival, the biographies of its key members and its objectives with relation to the festival series. In the next section I contextualize the festival against the historical cultural place of regional towns and audiences in the state and commercial cinema industry imaginary. At the same time I also provide an account of the present industrial systems in which mainstream cinema circulates as this is the primary form of cinema accessible to the audiences under consideration in this chapter. Finally, I present a first-hand account of the festival operations and practices where by addressing the cultural history of cinematic circulation, production and representation, COR produces a situated set of extremely localized and site-specific organizational methods and festival constructions.

Cinema of Resistance

As an institution, Cindy Wong (2011) argues, film festivals align themselves with particular interest groups, agendas and social agents. Festivals embody certain politics and create political configurations through the ways that they reinforce or challenge existing industrial or artistic hierarchies. The festival event – its structure, objects and its cultural positioning – represents the aspirations and agendas of its organizing agents. Where the programming is created in an institutional architecture, festival curators approach the programming through a double interplay, that of institutional cultural itineraries as well as personal cinematic taste. In order to understand these agendas, I outline the historical background,

and cultural-political principles of the parent institution Jan Sanskriti Manch, and festival founder, convenor and curator, Sanjay Joshi.

COR is a project of JSM, an organization founded by progressive artists and cultural activists including painter Ashok Bhowmick, playwright Gursharan Singh, writer Mahashweta Devi and musician/vocalist Bhupen Hazarika. The group came together in 1985 upon a common platform to promote the production and circulation of public cultural expression. By participating in political forms of action such as protest meetings and solidarity marches as well as cultural production, the organization continues to challenge what it views as contemporary models of cultural imperialism, the ever-expanding morphologies of corporate owned media and right-wing religious propaganda against social minority groups. One potent strategy forged to counter the convergence of corporate and media interests upon affluent urban populations, and the constriction of space for public expression leads to the organization's focus on regional and non-metropolitan towns.

The film wing of JSM organizes the COR series of festivals in association with its state-level units, local film clubs and interested individuals. In 2006, JSM launched the first Cinema of Resistance at Gorakhpur, a regional district headquarter where JSM found cultural and political solidarity with local journalists and cinephiles, academics and cultural activists. The political context of its origin depicts its aspiration to contest the dominance of right-wing cultural discourse in the city. According to festival founder Sanjay Joshi (2013),

> Gorakhpur is a strong hold of rightist politics and the local Member of Parliament controlled all the elections, municipal elections, university elections and state elections, so there was a kind of dictatorship. Any radical opposition had vanished by the 1990s and there seemed to be no other public opposition, so our festival succeeded in that context.

Sanjay Joshi's beliefs in cinematic activism are underpinned by a combination of radical left-wing politics and the appreciation of good cinema. He is inspired by the socially embedded cinema production and exhibition models made popular during the later phase of the Film Society Movement in West Bengal and Kerala. In contrast to the first phase of the Film Society Movement that originated during the late 1940s in Calcutta, the later phase, according to Rochona Majumdar (2011: 757) ushered a new political relationship between cinema and society. She writes,

> In a marked departure from the first phase of the movement when good cinema was largely understood as a sophisticated aesthetic product, the debates of the mid 1960s seemed to push the point that good cinema was one infused with a radical, leftist, even revolutionary, political sensibility. Its mark of distinction was to be able to register the contemporary social turmoil and the political anger it gave rise to in middle-class Indians.

In particular, Joshi cites the iconic Cochin-based Odessa Film Society, founded by film-maker John Abraham in 1984, as a political and operational model. Abraham, a former

student of legendary film director Ritwik Ghatak, named the group after the Odessa Steps sequence in Eisenstein's *Battleship Potemkin* (1925). Along with organizing screenings across the southern state of Kerala, the collective also raised funds for film production that continues to this day. Disavowing market systems of cultural production, members of the Odessa Collective, "In a now legendary journey through Kerala", writes Trisha Gupta (2012), "beat drums, sang and put up skits in village after village, asking people to donate money for the 'people's cinema'".

A documentary film-maker himself, Joshi trained at the Mass Communication Research Centre (MCRC), a New Delhi-based film school with a curricular focus on cinema history, cultural theory and social and political documentary cinema.[2] His interest in screening documentary cinema can be traced to the environment of the Mass Communication Research Centre whose faculty are the members of India's first women documentary film-making collective, the New Delhi-based Mediastorm, regarded for their radical feminist and political documentary films. Therefore, documentary cinema remains central to the festival programme and political documentary cinema produced by established and amateur film-makers is curated in the context of issues and local concerns current to each festival event. For instance, the sixth Gorakhpur COR (2011) was dedicated to the tenth anniversary of the International Women's Day and showcased Indian women's documentary cinema. Featuring the work of pioneering women film-makers, such as Deepa Dhanraj (*Something Like a War* [1990]) and Vasudha Joshi (*For Maya* [1997]), and emerging women film-makers including Faiza Khan (*Supermen of Malegaon* [2008]), the festival foregrounded the history of women's participation in cinema. In her inauguration speech, feminist and historian Uma Chakravarty contextualized the cinema relative to the gendered and exclusionary nature of mainstream cultural economies.

The organization of the festival is structured around two key principles. First, in producing the festival, Jan Sanskriti Manch stakes fierce claim to political and ideological independence. It has adopted a model of collective fundraising pioneered by the Odessa Film Society that attempts to free cultural production from the grip of market systems and/or state patronage. Aware of the material and philosophical tension between autonomy and dependence that stalks institutional financial relationships, JSM refuses all forms of institutional funding for its cultural initiatives. Instead it has developed innovative forms of crowd funding and volunteer-run festival organization models. At COR screenings, along with audience solicitations and donation boxes, DVDs and JSM publications are available for purchase. Large local organizing committees consisting of as many as 150 interested individuals are involved with fundraising at each location. These intimate and purposeful exchanges with the public and future audiences are viewed as form of social alliances that are likely to encourage deeper public investment in the effective functioning of the festival.

The second structural foundation of the Cinema of Resistance (COR) project relates to circulation. Critical of the historical modes of cultural circulation, JSM co-founder artist Ashok Bhowmick (2013) considers, for example, the mobile or travelling theatre and film performance as an instance of a hierarchical gaze that fixes individuals and groups in positions

assigned by the socially powerful. This culturally removed but socially authorized gaze of urban cultural producers, Bhowmick believes, reproduces and reinforces developmentalist understanding of regional publics. Conceptualized and produced in the city, he argues, the travelling cultural event merely replicates performances in regional settings without taking into consideration the historical experience, knowledge or social conditions of the regionally situated audiences. In response to the political analysis of historical cultural relations, the substantive aspects of the festival are founded upon the organizational dictum of "centralized politics and decentralized action", a belief that seeks to distribute control from an institutional core to regional partners (Bhowmick 2013). Each festival event operates as a collaboration between COR and local cultural actors to co-produce creative aspects such as festival theme, curation and operational elements consisting of festival management, publicity, audience building and fundraising. Numerous regional cultural and cinema groups including the Udaipur Film Society, Peoples Film Collective (Kolkata), Hirawal (Patna), Azamgarh Film Society and Sankalp (Ballia) have contributed to this process. A news report titled "Gondry in Gorakhpur" notes the local aspirations tied to the festival.

Allahabad and Patna have now joined a growing fray of cities and towns in their quest for novel recreation. Ankur Kumar, a cinematography student, and the convener of their forthcoming Allahabad gig, says, "Cinema was not a prevalent culture in our youth, except for the dreamland that Bollywood manages to create for us every time. The idea is to initiate discussion, to open our eyes to what is really happening around the world".

(Gupta 2011)

At the same time, the festival does not view the regional as a discreet set of conditions and ties regional concerns to larger issues and debates around cultural politics within the nation. Political commentator and author Arundhati Roy, radical independent film-makers Sanjay Kak, Anand Patwardhan and Surya Shankar Dash and Indian arthouse cinema legends M. S. Sathyu, Girish Kasaravalli, Saeed Mirza and Kundan Shah frequently participate in discussions with festival audiences on a number of issues relating to progressive cinema, censorship, political film practice and the significance of alternative media spaces.

History and cinemas: Industry, place and culture

Histories of circulation of minor and non-mainstream cinema offer an insight into the centre-periphery relations of cultural circulation within the Indian nation-state that Jan Sanskriti Manch seeks to address through its cultural initiatives. The circulation of documentary cinema produced and circulated through government institutions as well as the cinephile groups that emerged as part of the Film Society Movement, both bypassed the particular North Indian territories where JSM is active. Post-independence in 1947, documentary film was placed in an instrumental rubric as a form of audio-visual "state speech" where its

"significance" "was seen in terms in of its pedagogical potential" (Ganti 2004: 47). Produced by the central government production agency, the Films Division of India, an agenda of nation-building, included education and the building of civic rationality that required documentary cinema to travel beyond urban circuits to rural and regional constituencies. Plans for 224 Mobile Film Units, or a "cinema house on wheels", were mooted in 1945 by P. N. Thapar, Joint Secretary, Ministry of Information and Broadcasting, as a solution for the education of Indian adults, 90 per cent of whom resided in the villages and only 14 per cent of whom were literate (Anon. 1945).

Over the next four decades, a particular topography developed where regions beyond urban centres received cinema that aimed to produce behaviors and attitudes deemed appropriate in the developmentalist imaginary of the city-based bureaucrats and political leaders. Ministries of the Government of India and various government departments jointly selected film themes at the beginning of each financial year based upon national priorities that included films about "exemplary Indians", "citizenship and reform" and "themes of planned development" (Roy 2007: 47). In 1972, an audit of this vast filmic project reported foreordained conclusions; cinematic objects containing dissonant representation, mass audience address and didactic narratives, had rendered the film "in-credible" creating an indifferent regional spectator (Ghosh 1984: 65). Addressing an undifferentiated mass national audience, the report notes that the films dismissed regional cultural particularities, and suffered from "a lack of specificity". Circulation was obstructed by insufficient numbers of prints and language limitations. Although translated in thirteen languages, the films were not easily understood amongst India's many "dialect communities" (Roy 2007: 60).

Apart from the government structures of cinema production and circulation, a parallel Film Society Movement aspired to screen "better cinema" to its members and create a cinema culture alternative to the commercial fare of Bombay cinema. This movement occupies an important place in Indian cinema history for introducing arthouse and world cinema viewing cultures beyond the urban periphery. Inspired by the French cine clubs and salons, the movement originated in Calcutta in 1947 and following sporadic periods of growth, increased to 293 societies in 2013 (Federation of Film Societies). However, this movement bypassed large areas of North India including Uttar Pradesh, remained marginal players and hosted only eleven societies in comparison to 112 in Kerala alone (Federation of Film Societies).

In relation to commercial cinema cultures, the region under consideration was part of a thriving Bhojpuri language cinema, a cinema that continued to attract audiences from the early 1970s to the early 1990s (Ghosh 2010, web). However, popular anxiety appears to have taken over the current state and future prospects of this cinema. Historically, within the commercial sector, Bhojpuri cinema has occupied a marginal location in relation to the Bombay film industry even in Bhojpuri-speaking constituencies such as Salempur.[3] Widely considered a cinema of the "masses", its audiences include migrant labourers from Bihar and eastern Uttar Pradesh, construction workers, slum dwellers and rickshaw pullers, while aspirational and affluent audiences have stayed away. A critical study by Patna Women's

College attributes Bhojpuri cinema's low appeal amongst this audience group to poor production values and outdated gender portrayals (Krishner 2013). These ongoing debates about the textual qualities, the aesthetic, stylistic and narrative properties of this cinema can be interpreted as signs of a critical cinema culture. Nevertheless, the present anxiety arises due to the ever-growing proximity of an economic-cultural powerhouse, the contemporary commercial Hindi cinema or Bollywood. This cinema is understood to play a key role in the recent decline of the Bhojpuri cinematic idiom.

Anxiety has emerged around the collapse of cultural distinctiveness between the pan Indian Bollywood and regional Bhojpuri cinema. An editorial titled "Is the Bhojpuri film industry heading the right way" (2010) posted on the Bhojpuri cinema portal bhojpuriyacinema.com laments the popularity of Hindi cinema amongst Bhojpuri audiences and interprets this shift as a setback to the Bhojpuri industry. Historically, Bhojpuri productions release in single-screen theatres throughout the Hindi-speaking North Indian markets where theatre owners now report falling occupancy rates. They attribute this partially to the co-option of Bhojpuri aesthetics by Bollywood (Butalia 2012). The action figure masculine hero, for long a staple of Bhojpuri cinema, has transitioned into films such as *Dabangg* (Abhinav Kashyap 2010), a Hindi blockbuster that swept the Bhojpuri circuits where it released in 256 theatres.

Avijit Ghosh, author of *Cinema Bhojpuri* (2010), views this issue as central to the cultural politics of the contemporary Bhojpuri cinema industry. Initial optimism during the 1960s acclaimed cinema as a representative of regional identity. Ghosh writes: "These films were culturally located in the Bhojpuri-speaking area and the directors took pains to illustrate the region's customs, rituals and traditions in detail". At the same time, continues Ghosh, "Cinema was seen as a vehicle for social change that could 'help eradicate the social evils of the region'". As a potent form of knowledge, cinema embodied the possibility of cultural and social emancipation. But contemporary cinema appears to have taken a different trajectory. Another editorial titled, "Bhojpuri Cinema: 50 years and losing way", (bhojpuriyacinema. com 2011) cites imitative aesthetic tropes such as overseas shooting locations in Singapore and Bangkok and exaggerated action sequences as evidence of a contamination that threatens to rout Bhojpuri cinematic vernacular. It asks,

> Every Bhojpuri cinema director and producer promises high doses of action. My question is, can your film beat Dabangg, Ghajini and other Hindi blockbusters for action sequences? And now the dubbed versions of Western films such as Avatar and Matrix? Are action sequences the best measure of our films?
>
> (bhojpuriyacinema.com 2011, translated by author)

The re-organization of cultural space due to the decline of regional Bhojpuri cinema has occurred alongside the fast diminishing opportunities to participate in viewing cinema more broadly. In the non-metropolitan areas of eastern Uttar Pradesh, audiences are being excluded from the new exhibition and screening economies. The multiplex screen is the new home of the high investment, high turnover and quick-change Hindi film. Despite a minimal 700

multiplex screens out of 13,000 cinemas in the country, these account for nearly 50 per cent of the industry revenue (Bhushan 2008). Six national chains dominate, with international and national tie-ins with McDonalds, Pizza Hut and others. The screens are located in metropolitan and larger districts within air-conditioned shopping malls alongside food courts, nightclubs and entertainment facilities, where cinema forms part of a package of entertainment offerings (Pendakur 2012). There is consensus amongst cinema entrepreneurs that they need to woo the urban, "affluent and highly-aspirational consumers" (Ambwani 2011). Even with average ticket prices of INR 150 and weekend prices of up to INR 500, as compared to INR 30 at the single screen cinemas, the seductive multiplex family experience is marginalizing the older single screen theatre. In Gorakhpur alone, seven cinema halls closed down within a period of twenty years and in Salempur the oldest cinema hall, Maneka Talkies, shut down in 2012 to make way for a shopping mall. Gorakhpur-based journalist Manoj Singh (2013) believes the multiplex Hindi film release caters to an urban and diasporic audience who can afford the tickets and relate to the aspirational screen settings, lifestyles and consumer cultures.

Susan Sontag (1996: 60) in the *Decay of Cinema* venerates the sublime immersive experience of cinema, the experience of being "overwhelmed by the physical presence of the image". But here two other issues come into play; first, around access to the cinema screen which is mediated by economic and geographical factors, and second, the cinematic encounter itself including the possibilities for the spectator to suture him/herself into the process of making meaning. For the audiences under consideration in this chapter, the dominant Bollywood cinema offers assigned subject positions where regional cultural factors are co-opted within totalizing narratives. Ganti (2012: 285) argues that Bombay cinema aesthetics collapse social and cultural complexity by essentializing audiences in the taxonomy of "classes" and "masses". This, she continues, emerges from a combination of personal "intuition, regional stereotypes and developmentalist perspectives" about the influence of education, occupation and residence upon subjectivities and thus taste cultures. Included in the "masses" and further downgraded as audiences from the dark "interiors", are audiences from eastern UP including Salempur and Bihar, who according to Ganti, are believed to be "poorly educated, culturally conservative, economically marginalized, and socially backward" (291). The binary arrangement places provincial and rural audiences fundamentally in opposition to the urban "classes" on scales such as intelligence and intellectual curiosity. In the absence of scholarly research, this anecdotal understanding of spectator knowledge and experience operates as historical fact. Not surprisingly, regional audiences are placed within generalized ethnic and linguistic identity markers that work upon principles of literal identification. Simplistic associations based upon shared language, ethnicity and the presence of visual idioms such as local costume are employed to create registers of identification, through a form of "audio-visual ventriloquism".[4] And thus the "action" genre of Bollywood, consisting of films such as *Dabangg* that relies on little more than visceral identification with violence and slapstick, is widely distributed in this exhibition territory. In this equation there is little room for films that represent "the region in a proper light" or those that address cinematic desires anchored in the subjective knowledge contexts and experience of the spectator.

Re-locating place and reclaiming culture

Marijke de Valck (2007) draws upon Bruno Latour's Actor Network Theory (2005) to scrutinize transactions at film festivals and highlights two advantages of this application. One, the theory assumes "relational interdependence", and two, it includes both humans and non-human actors as objects of study (Latour 2005: 34). Interdependence draws together those considered marginal and separate to the event, such as film critics, agents that de Valck suggests co-constitute the festival. Non-human actors such as festival processes and structures open up space for the "practices of translation" and disclose vital conceptual frameworks that underpin the festival. In this section, utilizing the notion of agency of both human and non-human actors, I outline the ways in which this festival stakes claims in the cultural "war of position". Against the background of historically exclusionary cultural circulation and the ways in which contemporary cinema industries organize their symbolic and material forms, COR draws upon local knowledge, cultures and communities to calibrate its festivals and cultural itineraries. As outlined in the earlier sections of the chapter, I will specifically show this through three dimensions of the festival.

First, addressing the ways in which the specific audience constituencies have been marginalized from participating in meaningful and dialogic cinematic experiences, COR attempts to mobilize conditions where multiple and reflective forms of engagement with cinema become possible. I argue that not only assigned to consuming narratives or identification with screen characters, COR also frames the cinematic experience through relevant information, discussions and dialogue towards satisfying multiple desires and creating communities of critical spectators.

In his article about the 1955 Cannes Film Festival, Andre Bazin (2009) scrutinizes the physical topography of the Palais des Festivals and spatial arrangements for audience seating, describing it as a "hierarchy" that "enhances a sense of superiority" for certain groups. At Salempur, the festival geography and infrastructure also tell a story but unlike Bazin's description of the creation of difference through spatial organization, the Salempur COR focuses upon the basic objectives of gathering audiences and ensuring an equal festival experience for all. The venue, Bapu Inter College, a government secondary school is located on the outskirts of Salempur. Peeling paint, an overgrown yard and missing windows tell a story of neglect. Notwithstanding intermittent electricity, the school hall as the only local space with a capacity of 200 is nominated the festival venue. The shell-like hall requires a complete overhaul. Beginning with the assembly of physical infrastructure, the local festival team hires a diesel generator, procure tarpaulin and rent 200 plastic chairs to create a makeshift cinema theatre. Publicity takes the form of printed handbills, newspaper features and banners at street corners placed by the local organizing team. Bypassing the unequal access to the internet in the region as well as power supply breakdowns, the festival eschews electronic and social media publicity employed at other venues to instead run the campaign on print materials, hoardings and sign boards.

As evening falls, an hour before the opening, notwithstanding the 40-degree Celsius temperatures, audiences stream in and a roving tea seller does brisk business. Over the next two days, the festival creates an atmosphere of anticipation and cinema-related conversations are struck up between visitors. In an informal choreography before entering the cinema hall, visitors first view the cinema monograph and DVDs, and then move towards the poster exhibition, both areas strategically flank the entrance to the theatre. Posters of world cinema classics *Battleship Potemkin* (Sergei Eisenstein 1925), *The Battle of Algiers* (Gillo Pontecorvo 1966) and *Citizen Kane* (Orson Welles 1941) are placed alongside Indian arthouse classics *Do Bigha Zamin/Two Acres of Land* (Bimal Roy 1953), a move that aspires to re-contextualize and provoke thought about the relationship between the diverse kinds of cinemas. Juxtaposed and arranged in spatial proximity, the posters acquire the quality of a visual montage, images, forms and text colliding visually and conceptually to produce unique associational ideas of cinema histories, art and politics.

In my conversations with the visitors – students, aspiring actors, wedding videographers, shopkeepers and workers – I discover a variety of motivations. Some visit for a social outing, others out of boredom with Sunday television, but most arrive out of curiosity and a desire for "something new". Amit and Chandrashekhar travel 70 kilometres on a local train to participate. Ajay, stage actor, wants to see something different and learn about the world beyond. Few are familiar with the directors or the film titles. Still fewer have ever attended a film festival. So how do we understand this desire in relation to contemporary patterns of

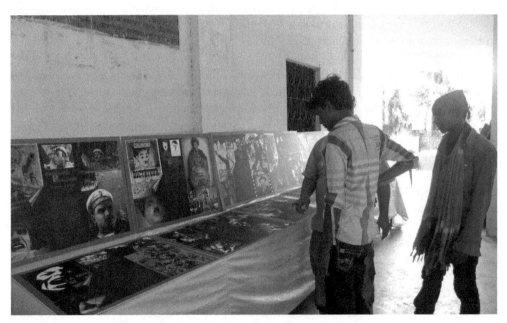

Figure 1: Outdoor film poster display.

cinema circulation? I see this as an expansion of a parallel circuit of exhibition that meets audiences whose cultural desires to connect with representations of lived realities exceed the mass cinema experience. Marginalized by the economics of commercial distribution and exhibition, combined with the predatory force of Bollywood, the turn towards a localized screen contains the potential for constructing an alternate viewing publics and cinema culture. The festival conditions – its banal location, focus on cinema history, no sponsorship and free entry – invite audiences to an alternative model of engagement with a localized screen positioned as a form of cultural experience instead of a commodity relationship.

The modes of framing film presentations through specific introductory information, opportunities for post screening discussions and panel discussions focused upon key themes play a significant function in forming relationships between spectators and meaning. Recognizing the condition that spectators arrive from a position of relatively little film festival experience and critical engagement with cinema, a range of practices are introduced to address this condition. Print materials related to the festival that include the festival brochure and festival posters, materials that Daniel Dayan (2000: 51) refers to as the "written festival" a kind of discourse production about the festival itself, play a key function in contextualizing each film as well as the festival. A detailed editorial, articles by film-makers and film critics, sketches and art by radical artists, interviews and commentaries about the broader relationship between cinema, society and politics are part of each festival brochure, available for purchase at a nominal charge of INR 20 to INR 50. The Salempur festival opens with a rousing speech by respected local journalist and Dalit activist Ashok Chowdhry who raises several personal issues that he faces when watching mainstream Bollywood cinema.

Figure 2: Re-purposed school hall functions as cinema theatre.

Figure 3: Spectators watching *Gari Lohadarga Mail/Train Lohadarga Mail.*

These relate, he says, to his feelings of alienation from the narratives and his inability to find political meaning or affective attachments in these narratives, a condition that he attributes to the marginal consideration for his cultural and geographic location within mainstream cinema economies, a relationship shared by the audience.

Each film screening is preceded by a brief introduction that provides facts about the director and motives behind its curation, but importantly in many of the introductions, Sanjay Joshi attempts to connect the film to the viewer's life worlds by pointing out shared symbolic or narrative aspects with the film. For instance, in the introduction to *Gari Lohadarga Mail/Train Lohadarga Mail* (Toppo 2005), Joshi draws parallels between the eponymous train at the centre of the documentary narrative and the local passenger train that connects nearby villages to the town. These introductions, he believes, offer a way for audiences to suture themselves with films that are often complex and do not follow chronological or causal narrative logic. Restricted to new audiences, according to Joshi these introductions are usually not required in repeat settings. Along with the provision of information, the focused introduction also summons legitimacy to the film-viewing experience; a responsibility to view the artistic expression with attentiveness that, an act that places the individual spectator in a direct situated relationship with the screen. But beyond intentionality, public presentation to an enquiring audience opens the films into a space of translation accomplished through a public dialogue rarely possible within the individualized multiplex settings and particularly with independent film-makers who are

Figure 4: Portable screening equipment, laptop and projector, and improvised seating arrangements.

themselves marginal in terms of media presence. Actors, suggests Latour (2005) instead of simply transporting facts, transform them. In the process of post-screening Q&A, the film opens out as a text mediated collectively through audience questions, comments, responses and the information provided by the director.

In this cultural-historical context of the region where market relations ironically restrict cinema access, these opportunities provided by the festival for critical spectator engagement with film beyond the credit roll and, in particular to conduct dialogue with the film-maker are an initial step towards a Latourian transformation of spectatorship processes. Critical modes of viewing where spectators evaluate and read screen images in subjective ways are visible in the post-screen discussions following the screening of local production *Saavdhan/ Caution* (2012). Directed by local theatre/film director Minhaz Sohagravi, *Saavdhan* is an HIV awareness film made according to conventional standards of informational film screened by the many NGOs and health organizations located in the region. Despite its laudatory social message, audiences scrutinize instead the representations of women and, critique the gender tropes deployed by director Sohagravi to portray the relationship between HIV infection and promiscuous behavior. An audience member asks, "why have you shown the woman as sexually irresponsible when both are equally promiscuous"? This movement between accepting a civic agenda constructed using particular language and social theorisations towards the active critique of its symbolic forms is highly significant in light of the circulation histories of message-oriented cinema in this region. The "war of position" played with instruments of culture requires these forms of seemingly benign images to be critically analysed and opened up to inquiry, an opportunity that becomes possible in the knowledge conditions created by the Cinema of Resistance (COR).

The second dimension addresses the historically exclusionary regimes of production and circulation. COR meets obligations towards building local cinema cultures by opening up spaces for the public performance of this cinema. At the same time, curation practices respond to the historical context, knowledge and concerns of site-specific audiences, in an effort to build affective festival publics.

In what appears to be a response to the concerns around declining audience interest in regional productions raised by local cultural groups and cinema critics such as bhojpuriyacinema.com, COR chooses to work with the minor independent section of cinema producers, those that are unlikely to find distribution and hence public performance. An extant industry of amateur cinema enthusiasts in the region produces bargain basement remakes of commercial Bombay blockbusters, released only on DVD. Filmed on semi-professional video cameras, starring actors from local theatre groups and edited in wedding video studios, these productions are financed by local businessmen turned film producers. But even with low production costs of between INR 200,000 and INR 300,000, these films like their theatrical Bhojpuri counterparts, remain a loss-making enterprise (Sengupta 2013). Imitative aesthetics attract few return viewers.

COR attempts to develop the extant desire to participate in cultural production towards sophisticated and durable forms of cinema. As Czach (2004) points out, no curation is free from politics and here an active agenda of encouraging vernacular cinematic idiom comes into being. In a programme of documentary, animation and world cinema classics, Salempur set amateur Bhojpuri productions, *Tohari Khatir/For you* (Singh and Vishwakarma 2007) and *Saavdhan/Caution*, are screened with introductions and post-screening Q&As.[5] As outlined in an earlier section, the first ever public screening of *Saavdhan* provokes a lively and constructive discussion about the film process, aesthetics and representation, an opportunity absent from the more private forms of circulation conventionally available to these film-makers.

In contrast to commercial cinema as well as historical state documentary cinema narratives, where non-metropolitan geographies and cultures are assigned fixed symbolic positions, the attention to local idioms is a crucial pivot upon which COR mobilizes publics. While site-specific contextualization enters into the festival through multiple entry points including organization and publicity, the film curation is the site of an active dialogue between the festival and its location. The Salempur-Barhaj Passenger train is a regional icon, historically a popular form of transport to the market town of Barhaj 60 kilometres east, on the River Ghaghra. The curation foregrounds this cultural-historic relationship and opens the festival with *Gari Lohadarga Mail/Train Lohadarga Mail*. The affective narrative reconstructs the musical vernacular of passengers on the Lohadarga Mail train in the eastern state of Assam, partially re-enacted during the last journey of this historic passenger train. In Salempur, the screening evokes memory and anxiety. In post-screening discussions with film director Biju Toppo, spectators share memories of train journeys and subsequently voice anxiety around the future of the Salempur-Barhaj passenger train in the current market economy. The screening of *Gaon Chodab Nahin/We Won't Leave our*

Village (Sasi 2009) is another instance of site-specific curation. Images of rural protest and tribal iconography are arranged to the lyrics of writer Meghnad, set to the composition of tribal leader Bhagwaan Maaji and performed by popular Bhojpuri singer Madhu Mansuri Hasmukh in this stirring video. A call against the anti-tribal industrial development policies of the Indian government, in Salempur, this video connects with histories of dispossession of tribal owners from their lands in the surrounding areas, where writes Apurva Kurup (2008: 98), "the tribes are the worst affected in the population since the state government's mining operations and hydro-electric power projects exploit natural resources in the resource-rich tribal areas, thus making the tribes outsiders in their own land". These curation practices, through co-constituting the festival with intimate knowledge of specific local issues and histories, also challenge what could be seen as the transplantation of an urban mode of cinema experience, the film festival, into a regional setting.

Finally, the multiple ways in which audiences and publics are invited to participate in this festival provoke consideration about how regional publics may take active roles in developing structures for the circulation of regional and alternative cinema. The practice of involving local cultural groups in curation and organization of the festival creates models for future cultural institutions and structures.

In terms of Peranson's (2009: 27) festival taxonomy, Salempur COR is an intimate "audience festival", where the audience and the cinematic programme, instead of industry and institutions, are the focus of the event, yet the organization practices extend the sphere of the festival from festival audiences to a wider public realm.[6] An ingenuous organizational model invites local cultural groups into the festival organizing committee and distributes production roles and creative decisions amongst the local representatives. These partnerships between local art/film societies and the core programming team of Jan Sanskriti Manch (JSM) work over a period of between three and four months to assemble each festival event. Established in 2009, Lok Tarang Foundation (LTF) is a Salempur-based cultural group that promotes regional performing and literary arts. In 2013, LTF participated in co-organizing the Salempur COR, an experience where they developed knowledge in a range of areas including festival curation, projection, publicity and festival management. Sharing insistence upon financial autonomy, the low-cost event is assembled on voluntary contributions of INR 15,000, gathered by the LTF following models developed by COR in other territories.

According to Latour (2005) anything that alters a given situation is an actor. Access to the laptop, a widely available technological object facilitates this clutch of new articulations between individuals, public and culture. The laptop enables the public mounting of cinema by voluntary regional groups such as LTF, and the transfer and circulation of DVDs and .mp4 files of films between interested groups and individuals, provoking the possibility for such groups to continue to organize public screenings. For instance in Kolkata following the first Kolkata People's Film Festival held in January 2014, the local organizing committee has expanded its screening programme to monthly screenings in Kolkata and surrounding areas of West Bengal, founded upon the experience of organizing the initial edition of the festival.

Conclusion

The construction of a public event can take multiple forms, which assign various forms of agency to its publics in roles such as spectator, participant or consumer. Against histories of inequitable distribution of cultural agency, the Cinema of Resistance engages in a war of position through forming alliances with regional actors in a bid to distribute the methods of cultural production, circulation and representation towards the construction of participatory public cultures. While creating opportunities for cinema literacy and durable cinema cultures, the festival is an attempt at the re-organization of cultural space by decentring market-based commodity relations in favour of cooperative structures of cinema exhibition. The principal stand against sponsorship restricts the festival in material ways of scale, operations and outreach; however, it grants autonomy to conceptualize the festival where COR is able to take independent positions on the screening of contentious political films, minor regional films and little known historical arthouse films. In its tenth year, the flagship Gorakhpur COR is testament of the success of this model, albeit one that builds intimately upon local support and community involvement for the success of its organization and publics.

References

Ambwani, M. (2011), "Auteur multiplexes providing luxury cinema experience becoming a big hit", *The Economic Times*, 24 December, *http://articles.economictimes.indiatimes.com/2011-12-24/news/30554741_1_big-cinemas-pvr-cinemas-luxury-cinema*. Accessed 12 November 2013.

Anon. (1945), "Film to educate India's masses: Government plans", *Times of India*, 15 October, p. 7.

Aronowitz, S. (2009), "Gramsci's concept of political organization", in J. Francese (ed.), *Perspectives on Gramsci: Politics, Culture and Social Theory*, Oxon: Routledge, pp. 7–20.

Bazin, A. (2009), "The festival viewed as a religious order", in R. Porton (ed.), *Dekalog III*, London: Wallflower, pp. 23–38.

bhojpuriyacinema.com (2010), Editorial, 28 October, http://www.bhojpuriyacinema.com. Accessed 20 November 2013.

—— (2011), "50 years old and losing its way", 10 February, http://www.bhojpuriyacinema.com. Accessed 20 November 2013.

Bhowmick, A. (2013), interview with author, New Delhi.

Bhushan, N. (2008), "Bollywood billions: Indian distribution and production change with the times", *Film Journal International*, 1 December, http://www.filmjournal.com/filmjournal/. Accessed 25 November 2013.

Butalia, N. (2012), "The last matinee of Bhojiwood", *DNA*, 12 February, http://www.dnaindia.com/entertainment/report-the-last-matinee-of-bhojiwood. Accessed 16 November 2013.

Cox, R. (1983), "Gramsci, hegemony and international relations: An essay in method", *Millennium: Journal of International Studies*, 12, pp. 162–175.

Crehan, K., (2002), *Gramsci, Culture and Anthropology*, California: University of California Press.

Czach, L. (2004), "Film festivals, programming, and the building of a national cinema", *The Moving Image*, 4, pp. 76–88.

Dayan, D. (1997), "In quest of a festival", *National Forum*, 77:4, p. 41.

Dhanraj, D. (1991), *Something Like a War*, UK: Channel 4.

Eisenstein, S. (1925), *Battleship Potemkin*, USSR: Goskino.

Faiza, K. (2011), *Supermen of Malegaon, Singapore: Mediacorp*, Japan: NHK, Korea: KBS.

Federation of the Film Societies of India (2012–2013), *Annual Report*, India: Madurai.

Ganti, T. (2004), *Bollywood: A Guidebook to Popular Hindi Cinema*, New York: Routledge.

—— (2012), *Producing Bollywood: Inside the Contemporary Hindi Film Industry*, Durham: Duke University Press.

Ghosh, A. (1984), "Media and rural women", in K. Bhasin and B. Aggarwal (eds), *Women and Media: Analysis Alternatives and Action*, New Delhi: Kali for Women, pp. 63–68.

Gupta, N. (2011), "Gondry in Gorakhpur: Best of world cinema in small towns", *The Sunday Guardian*, 4 December, http://www.sunday-guardian.com. Accessed 24 June 2014.

Gupta, T. (2012), "Godard's own country", *Caravan*, December, http://www.caravanmagazine.in. Accessed 26 June 2014.

Joshi, S. (2013), interview with author, New Delhi.

Joshi, V. (1997), *For Maya*, New Delhi: Vector Productions.

Kashyap, A. (2010), *Dabangg*, India: Arbaaz Khan Productions.

Krishner, F. (2013), "Why don't Bhojpuri flicks win awards?" *The Times of India*, 5 November, http://timesofindia.indiatimes.com/city/patna/Why-dont-Bhojpuri-flicks-win-awards/articleshow/25236188.cms. Accessed 12 November 2014.

Kumar, K. (1963), *Ganga Maiya Tohe Piyari Chadhaibo*, Bishwanath Prasad.

Kurup, A. (2008), "Tribal law in India: How decentralized administration is extinguishing tribal rights and why autonomous tribal governments are better", *Indigenous Law Journal*, 7, pp. 87–126.

Latour, B. (2005), *Reassembling the Social*, New York: Oxford University Press.

Majumdar, R. (2011), "Debating radical cinema: A history of the film society movement in India", *Modern Asian Studies*, 46:3, pp. 731–767.

Pamnani, N. (2011), *Main Tumahra Kavi Hoon/I am Your Poet*.

Pendakur, M. (2012), "Digital pleasure palaces: Bollywood seduces the global Indian at the multiplex", *Jump Cut*, 54, Fall, http://www.ejumpcut.org/archive/jc54.2012/PendakurIndia-Multiplex. Accessed 18 October 2013.

Pontecorvo, G (1967), *The Battle of Algiers*, Italy: Saadi Yacef and Antonio Musu.

Roy, B. (1953) *Do Bigha Zameen*, India: Bimal Roy.

Roy, S. (2007), *Beyond Belief: India and the Politics of Postcolonial Nationalism*, Durham: Duke University Press.

Sasi, K. P. (2009), *Gaon Chodab Nahin/We Won't Leave our Village*, Visual Search in association with Akhra, National Adivasi Alliance and others.

Sengupta, Y. (2013), "'Main bhi' producer: Small towns see rise in makers of feature films on DVDs", *DNA*, 29 September, http://www.dnaindia.com/lifestyle/report-main-bhi-producer-

small-towns-see-rise-in-makers-of-feature-films-on-dvds-1895374. Accessed 15 November 2013.

Singh, A., and Vishwakarma, B. (2007), *Tohari Khatir*, Salempur.

Singh, A. (2013), *Atash*, [no place].

Singh, M. (2011), "A migration story" (translated from Hindi), *Hindustan*, Gorakhpur, 16 September, p. 6.

—— (2013), interview with author, Gorakhpur.

Sohagravi, M. (2012), *Saavdhaan*, Salempur.

Sontag, S. (1996), "The decay of cinema", *The New York Times*, 25 February, pp. 60–61.

Srivastava, R. (2012), "Once upon a time in Gorakhpur", *The Times of India*, 18 January, http:// timesofindia.indiatimes.com/city/lucknow/Once-upon-a-time-in-Gorakhpur-/articleshow/ 11533376.cms. Accessed 15 November 2014.

Toppo, B. (2005), *Gari Lohadarga Mail/Train Lohadarga Mail*, Ranchi: Akhra.

de Valck, M. (2007), Film Festivals: From European Geopolitics to Global Cinephilia, Amsterdam: Amsterdam University Press.

Waugh, T. (2012), "Miffed! or Gasping for [Polluted?] Air", *BioScope: South Asian Screen Studies*, 3, 87–93.

Welles, O. (1941), Citizen Kane, USA: RKO Radio Pictures.

Wong, C. H. (2011), *Film Festivals: Culture, People, and Power on the Global Screen*, New Jersey: Rutgers University Press.

Notes

1 In eastern Uttar Pradesh, the district of Deoria (comprising Salempur) accounts for the largest number of economic emigrants to the Gulf states, nearly 25,000 (2008–2010) Hindutva is the political demand of the right-wing Bharatiya Janta Party (BJP) to reinvent India as a Hindu nation that goes against the secular Indian constitution. In 2013, both the parliamentary representatives and seven out of nine local assembly representatives from this region belonged to the BJP. Epidemics of Japanese Encephalitis occur annually in the eastern Uttar Pradesh regions during the monsoon season.

2 Mass Communication Research Centre was co-founded in 1982 by James Beveridge, close associate of John Grierson at National Film Board Of Canada between 1939 and 1944.

3 Bhojpuri annual revenues total INR 60 million and an annual production of approximately 70 films while the Bombay Film industry collects annual revenues of INR 110 billion with a production of nearly 200 films in Ernst and Young, and LA India Film Council (2013), *Roadmap for Single Window Clearance for Film Production in India,* India: Ernst and Young.

4 Stuart Hall proposes "linguistic ventriloquism" to describe the combination of popular journalistic language with the particularity of working class language to create a neutralized and standardized form of populist language in Hall, S. (1998), "Notes on Deconstructing the popular", in John Storey (ed.), *Cultural Theory and Popular Culture: A Reader* Athens: University of Georgia Press, pp. 448.

5 The programme included *Children of Heaven* (Majid Majidi 1998), *The Red Balloon* (Albert Lamorisse 1956), and *A Chairy Tale* (Norman Mclaren 1957). The programme differs widely, for instance in Varanasi, at the 3rd Cinema of Resistance (2014), eight experimental films by emerging local film-makers were screened.
6 According to Peranson, "audience" festivals are low budget, eschew corporate sponsorship and make minimal investment in film premieres or procuring films.

Chapter 9

"It's Not Just About the Films": Activist Film Festivals in Post-New Order Indonesia

Alexandra Crosby

ollowing the overthrow of General Suharto's New Order Regime in 1998, Indonesia began a process of *reformasi*, marked by political reform, democratization and increased regional autonomy. Since the upheaval of the late 1990s, most Indonesians have experienced a more open political-social environment in which local video production has flourished and the informal networks that catalyse the distribution of activist content have widened. The Jakarta International Film Festival (JiFFest) and the Indonesian Independent Film-Video Festival (FFVII), for example, while both facing uncertain futures, are globally connected events that provide opportunities for Indonesian audiences to see film and video content that commercial cinemas and television stations do not screen (Ratna 2007: 304). The biennial OK Video Festival (organized by the art collective ruangrupa) and ARKIPEL (organized by Forum Lenteng) are other Jakarta-based examples of important initiatives emerging since 1998 that circulate activist video content from Indonesia and elsewhere. On a regional level, the documentary festival, ChopShots (2012 and 2014), which was part of DocNet Southeast Asia project,[1] has established networks between film-makers and activists across South East Asia, work that is being continued by the Freedom Film Festival (FFF) through the Video Activist Forum.[2]

In this chapter, I argue that a film festival in Indonesia, as well as distributing activist content, can also be thought of as a form of activism in itself. As they circulate stories, festivals can also connect movements operating a range of scales in Indonesia: pro-democracy movements working at a national scale; community arts groups working at a household level and regional audiences in Malaysia and southern Thailand who can work with a common language. These connections provide opportunities for audiences to participate beyond spectatorship at multiple scales.

While I do bring attention to the end of the New Order (1998) to open the study, my aim is not to impose a post-authoritarian frame on activist film festivals in Indonesia. As Emma Baulch and Julian Millie argue in their explanation of how area studies and cultural studies intersect, "contemporary Indonesian media/politics cannot be seen as purely a product of Suharto's stepping down in 1998" (Baulch and Millie 2013: 232). Indeed, from my interviews and observations, festival organizers do not see themselves as working in an explicitly "post-authoritarian" space. Rather, they articulate that, while the context of their work is shaped by a traumatic national history that has deprived the development of film culture in many ways, they work now in a time of hope and opportunity as convergent media technologies, eager local audiences and a range of important political issues are giving rise to new forms of activism including a vibrant festival scene. They refer to the surge in independent video

production and the proliferation of film festivals as a driving force of Post-New Order *reformasi* as well as a result of it. After all, video activism

> played a prominent role in marking and making sense of these events, a key channel of the violence and the hope that energized a generation of activists, artists, film-makers and ordinary citizens, many finding their voice in the public sphere for the first time.
>
> (Teh and Berghuis 2015: 8)

While Indonesian cinema and popular culture in general have enjoyed renewed theoretical attention since the end of the New Order (Heryanto 2008; van Heeren 2012), and there have been a number of studies focused on the emergence of digital video technology in Indonesian art and journalism (Forum Lenteng 2009; Jurriëns 2015; EngageMedia 2009), with the exception of a few diligent Indonesian scholars (Ratna 2007; Jayasrana 2008), the specific role of film festivals in creating positive social change has received little attention.

In thinking about the film festivals discussed here as activist spaces, I consider them as sites of friction, where activists, films and the networks that connect them operate at multiple scales. Anna Tsing uses the metaphor of friction to explore how the sites that have come to be known as the "local" and the "global" are, in fact, made by each other in a "spatial, discursive, and metaphoric sense" (Tsing 2005), an idea that has been much overlooked in contemporary theories of the global. The global, she argues, is produced by the local (and vice versa) in a messy and unstable process she calls friction. The metaphor of friction provides an opportunity to counter the typical ways in which globalization is imagined, for example, as a clash of cultures or as a smooth and homogenous path of progress. To make sense of the nuances of friction, Tsing employs the idea that scale-making is a practice that needs to be considered alongside the emergence of activist movements and their effects beyond the confines of villages, provinces and nations. She refers to the making of scale as a creative process: "Scale is the spatial dimensionality necessary for a particular kind of view, whether up close of from a distance, microscopic or planetary" (Tsing 2005: 58). Tsing argues that scales, for instance the globalism proposed by human rights discourse or the nationalism of Indonesian *reformasi*, are not neutral ways of viewing the world; rather, they are brought into being through a kind of conjuring, where they are "claimed and contested in cultural and political projects" (58). Projects are "scale-making" when they "make us imagine locality, or the space of regions or nations, in order to see their success" (Tsing 2005: 57).

Considered in this sense, as scale-making projects, film festivals define solidarity by producing connections between a global human rights discourse, diverse audiences, film-makers and the subjects of their featured films. In Indonesia, activist film festivals resist the urge to utilize the ready-made formulations of "global" and "local". Like many other culturally diverse initiatives for human rights and social justice, street protests and online advocacy campaigns for instance, activist film festivals challenge an image of global activism

that is homogenous or centralized. As supported by Van Heeren's perception of Indonesian film festivals, different festivals in Indonesia "represent imaginations of different audiences" (2012: 13). By thinking about scale creatively, festival organizers create new forms of activism, new modes of storytelling and new definitions of solidarity.

By drawing on the idea of friction, I analyse how festivals and their programmers can translate local stories across scales of activism to settings of regional human rights solidarity and national democracy movements, among others. This translation is often driven by "friction", coming into being through specific engagements and encounters characterized by "the awkward, unequal, unstable and creative qualities of interconnection across difference" (Tsing 2005: 4). I argue that, as well as acting as important meeting points for film communities and activist groups from across South East Asia, film festivals in Indonesia can facilitate action around particular issues in contingent ways that are defined by both local needs and global conditions, rather than as a smooth global trajectory.

I focus on three film events in this chapter. As they are described it will become obvious that these events occur at multiple scales and that their stories are intertwined, and upon even closer examination, it will become clear how they are also scale-making forms of activism: (1) The urban South to South Film Festival and (2) its rural counterpart the Purbalingga Film Festival; (3) and the regional Freedom Film Festival. These events are not separate and concise sites of cultural production; rather, activists and organizations often work on multiple events simultaneously, branding, curating and campaigning at multiple scales. So too, the research has been conducted across and between these events.

The festivals and campaigns discussed have been researched through my own attendance at film festivals in Indonesia and Malaysia from 2002 to 2014. I have been involved in the events and organizations discussed in various capacities, including as an employee and a consultant, with EngageMedia from 2009 to 2012 and as a guest at the Freedom Film Festival in 2010. Much of the research for this chapter was undertaken for a Ph.D. thesis titled "Festivals in Java: Localising cultural activism and environmental politics, 2005–2010". During this time, I engaged in participant observation, conducted interviews with film-makers, organizers and audience members and undertook content analysis of communication material and associated media. My participation in the research included being part of the online subtitling community, working on the transcriptions of the Indonesian dialogue and the English subtitles.[3] The research was undertaken in both English and Indonesian. Throughout the research my focus was on the festivals themselves, rather than the films and the film-makers, although many of the festival organizers I spoke with are also film-makers. I have watched all the films discussed in this chapter multiple times.

Background

The relationship between film and political change has a rich history in Indonesia, which has been revisited with some intensity over the past few years with the release of the

documentaries *The Act of Killing* (2012) and *The Look of Silence* by Joshua Oppenheimer and an anonymous Indonesian team. One of the most comprehensive studies of Indonesian film comes from Sen and Hill in their (2010) anthology *Politics and Media in Twenty-first century Indonesia: Decade of Democracy*. In their chapter on cinema, they trace the New Order's control of most aspects of film culture. While the regime did throw the market open to foreign imports, reversing the previous government's ban on Hollywood films, it controlled the production of local film content with unreasonable vigour, focusing on ordering politics through the censorship of locally made films and the production of its own filmic propaganda (143).

For the next 30 years, there was little space for experimentation in cinema. The industry was small, censorship was pervasive and there was a tight monopoly on distribution (Seth and Hill 2010: 154). With the end of the New Order came a re-examination of the possibilities of video production and distribution in activist circles. Many new films were made that examined Indonesia's past such as those in *9808 Antologi 10 Tahun Reformasi Indonesia/9808 Anthology 10 years since Reformation in Indonesia* (Proyek Payung/Umbrella Project 2008), a collection of films made to commemorate the May 1998 uprising and the incidents that followed. Most of these projects were led by the film-makers themselves, were produced on low budgets and resulted in small-scale screenings often in informal spaces.

For clarification of this context, it is important to point to Van Heeren's observation that in Indonesia, "*film independent* should not be confused with the Euro-American meaning of 'independent' film, which stands for a movement which opposes the mainstream, mainly Hollywood, studio system" (van Heeren 2012: 53, original emphasis). In Indonesia, *film independent* refers to the way young people make their own films, drawing from the DIY and punk movements of the 1990s. Arguably more important than the films it produced, *film independent* gave rise to new communities of film-makers that could operate at different scales, opening up networks of distribution including independent film festivals. Jayasrana (2008) says that *film independent* helped activists develop skills in linking local stories (community films) to regional, national and even international media. This is a rough and rocky process, he says, characterized more by friction than the branding, marketing and distribution of mainstream film. "More often than not" he says "there is no strategy, just an organic process of testing, responding and planning".

However, despite the emergence of new forms of film activism, with its roots in *film independent*, mainstream media in Indonesia has remained in the control of a powerful elite. While the end of the New Order meant the loosening of government control, the majority of television, print and radio networks has continued to be owned by twelve media groups (Lym 2011), bringing a new set of challenges for independent media, and a renewed importance to film festivals that screen diverse content. By controlling these networks, such conglomerates continue to define the scales of mainstream media distribution. Activist film festivals play an important role in challenging these scales.

Challenging the status quo is not, however, the core motivation of most Indonesian film festivals that have emerged since the end of the new order. Lulu Ratna, a prolific film festival

organizer, and herself a film-maker, says that Indonesia currently has a dilemma of "quality versus quantity". An enormous population of young people with access to tools of production means film festivals are constantly emerging, but that they tend to be fairly unimaginative in terms of ticketing, distribution and framing discussion, following the mainstream models provided by popular culture. "Many commercial festivals are set up as entertainment events like a music or sport event, and many young people do not have a sense of the relationship between films and social change". She also says that Indonesian audiences are used to either extremely narrow or extremely wide scales of entertainment: Hollywood films or traditional culture such as *wayang* in the local community. For a film festival to have an effect on politics, the film-maker and the audience need to be learning from each other and willing to respond beyond spectatorship. "I think it is not so much about the 'event' of the festival as it is about the exchange of the ideas" (personal communications). She maintains that the various kinds of meetings that happen at film festivals, before and after films, over dinner and in public spaces, remain the most important aspect of the event (Ratna 2015).

Ratna says that these issues mean that tensions exist within the network of film festivals in Indonesia. She describes a core group of about twenty people who want film festivals to be about big political issues and to be forms of activism. Growing this relatively small group, she says, is a slow process about working with the right people at multiple scales, and prioritizing, in order to consolidate networks and activate audiences. She says that pragmatic concerns are ever present as all independent film festivals in Indonesia face significant obstacles, which is another reason to work together. There are few opportunities for continued funding, and there is a volatile political climate that causes uncertainty around censorship. There is also the issue of how festivals are understood by activists and film festivals. Film festivals, she says, are sometimes undervalued by activists, who tend to see them as part of broader campaign strategies. For example, EngageMedia, an Australian NGO based in Jakarta, sees film festival as part of what they call a "hybrid" distribution model common in Indonesia (Thajib et al. 2009).[4] EngageMedia "uses" film festivals as sites of distribution for activism. Sometimes these festivals take the form of a collection of screenings, and sometimes screenings contribute to the programme of broader activist festivals, or small local community (*kampung*) festivals that occur in neighbourhoods, often outdoors. According to EngageMedia, this is a reciprocal exchange as EngageMedia is also "used" by festivals. Their publishing portal at engagemedia.org provides festival organizers with free access to a diverse range of open licensed video content archived around particular themes. Yerry Borang of EngageMedia explains that this open distribution is an important part of the work they do since it is not the typical model of film festivals worldwide.

> Even if there is not a great internet connection, we try to make sure that content can be shared as easily as possible. And if there is a festival, like South to South Film Festival in Jakarta, or Freedom Film Festival in Kuala Lumpur, we work with organizers to open the distribution there.
>
> (personal communications)

While this is an opportunity for collaboration, it also shifts the focus away from the value of the films themselves to their "usefulness" to broader campaigns.

Campaigning across platforms in the ways encouraged by EngageMedia, can create new scales of activism, but can be at odds with the immediate goals of a film-maker. For instance, an activist film-maker who is selling a film to a festival to raise money for a campaign may not support the idea of free and open online distribution. In such a situation, the festival becomes a site of friction where barriers to seamless interaction are omnipresent. Activist festivals work through negotiations between actors, acting as mediators and in doing so creating new scales of activism.

Regents (Never) Lie and corruption in Indonesia

Examples of collaborative activism resulting from this notion of *film independent* can be found in the way particular films come to be included in activist festivals. In this section, I trace the trajectory of the film *Regents (Never) Lie*, a film about political corruption in Indonesia, from its production by the group the Cinema Lovers Community (CLC) of Purbalingga, Central Java, to its inclusion in the South-to-South Film Festival in Jakarta. The Central Java Corruption, Collusion and Nepotism Investigation and Eradication Committee (KP2KKN) recorded 102 corruption cases in 2011. This number increased to 215 in 2012 and further rose to 222 cases in 2013 (Suherdjoko 2014), an indication that the situation is not improving despite claims of transparency at all levels of politics.[5]

The CLC demands transparency and accountability in the democratic process by combining video evidence of campaign promises with the stories of people affected by those promises (Jayasrana 2008). The CLC Purbalingga was formed in 2006 by local film-maker Bowo Leksono when his attempt to establish a cinema in the district government office failed. Outdated laws from the New Order, which are used selectively to restrict who can produce and exhibit films, shut down the initiative (Ratna 2007: 306). Instead of pursuing this injustice, Leksono, Jayasrana and others organized an annual city-wide "guerrilla" film festival that focused on screening new local work, but also included workshops on documentary film-making, researching and creating video databases. Through this event the CLC built a broad network of young artists, activists and students and by 2012 had grown to around fifteen independent film production houses (Nikholas and Crosby 2012) and were well positioned to mount activist campaigns with the potential to work at multiple scales. In this case, the adoption of the festival form is a clear act of resistance, a tactical response to the restrictions imposed on cultural forms by the state.

To engage with the rising debate around local elections, in 2010 the Cinema Lovers Community (CLC) invited proposals for films that engaged with the topic of local government policies and, after a selection process, the production of *Regents (Never) Lie* began. A number of cameramen already covering the 2010 election campaign for mainstream media helped the CLC team to obtain footage showing the *then* candidate for

regent voicing a range of election promises. The CLC conducted research for one year after the election, which revealed that none of these promises had been kept, despite dramatic political rhetoric about economic development and prosperity. They produced a film contrasting these "broken promises" with the general lack of change for everyday people living in poverty. In their localized version of a film festival, the CLC organized discussions, sent thousands of text messages, posted on social media and blogged furiously, building a multiplatform campaign on corruption, rather than making a film that relied on a single narrative or staging a single festival event.

By December 2011, after the video had been in circulation just a few months, the Regent, Bupati Purbalingga Heru Sudjatmoko, warned Leksono with a personal text message:

> Thank you for this tendentious exposure. If they have good intentions, those who feel that I haven't fulfilled promises can communicate that to me. But if you have any other purposes, of course that's another story. And if that is the case, please, come forward.[6]

By the end of December 2012, although the film was not officially banned, police were intervening in community screenings, stating that CLC had not gained permission for public events, a common government tactic of public control in Indonesia. CLC also says that, since the launch of the film, they have been monitored closely by police (Jusuf 2014).

Regents (Never) Lie was screened at the South-to-South Film Festival in Jakarta in July 2012 to an enthusiastic audience. Festival directors stated that it was one of the strongest demonstrations they had seen of how technology can contribute to activism (Indrasafitri 2012). Pro-democracy activists across Indonesia quickly became interested in this campaign as a model for encouraging citizens to demand transparency from their politicians. Activists witnessing illegal logging and mining began to follow suit by either reaching out to film-makers willing to help, or by becoming film-makers themselves.

The Cinema Lovers Community (CLC) connected with other anti-corruption initiatives leading up to the April 2014 election in Indonesia to conduct live reporting distributed through social media. *Regents (Never) Lie* was screened in local coffee houses, universities, schools and makeshift open-air cinemas across Java (Nikholas and Crosby 2012). In this way narratives formed on multiple platforms, and campaigns developed with the film festival as a central platform for multiple modes of storytelling.

As part of the campaign, a website, korupedia.org – a conflation of *korupsi* (corruption) and Wikipedia – was developed to act as an online reference tool on corruption. Most controversially, it named the corruptors that had been convicted under one of Indonesia's many anti-corruption or anti-bribery laws put in place since the end of the New Order. These convictions are notoriously difficult for citizens to trace through mainstream media. The website was created by a coalition of prominent anti-corruption figures and NGOs, including the technology advocacy group AirPutih. AirPutih activists say that the site's primary aim is to educate people by providing more data and knowledge about corruption (personal communications). Each case is shown as a red dot on korupedia's map, with a high

concentration in central Java where political power is also concentrated. As politicians in Purbalingga and elsewhere are keen to keep their names off this site and out of documentary films screening to their constituents, this expanded form of an activist film festival against corruption acts to prevent corruption as well as expose it.

The Freedom Film Festival: Activism beyond national boundaries

Regents (Never) Lie demonstrates an expanded notion of activist film festivals in Indonesia that is capable of agitating at multiple scales, from the level of local politics to national anti-corruption campaigns. Sometimes the festivals that are most important to activism in Indonesia operate beyond national boundaries and make audiences imagine different types of locality in order to see their success.

One example is the Freedom Film Festival (FFF), which is organized from Kuala Lumpur in Malaysia, and has significant impact on the festival scene in Indonesia. FFF provides screening spaces for diverse content, opportunities for data to be exchanged (films are often shared on discs or uploaded to hard drives) and social spaces for film-makers and organizers who work together primarily online to meet face to face. FFF, established in 2003 by Malaysian media and human rights NGO, Komas, is Malaysia's most established annual human rights film festival. In Malaysia, where film censorship is strict and other forms of media are even more tightly controlled than those in Indonesia, FFF has been an important platform for the dissemination of stories about social justice and human rights and for films with themes not considered appropriate in mainstream channels, such as abortion, prostitution, transgender and homosexuality. The FFF programme also includes films from across the region, thus serving the important function of educating Malaysians about Indonesia, and opening discussions about social justice issues to large audiences.

FFF is a travelling film festival that takes place in multiple locations where Malay is a common language: Malaysia and Singapore, and Indonesia. FFF participated in the 2012 StoS Festival in Jakarta and in 2014, also partnered with EngageMedia, to organize a special screening of FFF films in Jakarta, with a programme of films from Cambodia, Thailand and Malaysia. While audience numbers were small due to major floods in Jakarta preventing much movement in the city, there was hope from both organizations that this was the beginning of a long-term collaboration.

Yerry Borang from EngageMedia says that the aim is not to generate large audiences or even about selecting the "right" films for the audience, but more about the potential of festivals working at multiple scales of activism. "It is important to have film festivals that can be flexible and take different shapes since Jakarta is such a challenging city to organise in. It is not like other cities" (personal communications). In Kuala Lumpur, Freedom Film Festival (FFF) is already well known – there are consistent venues and a committed audience

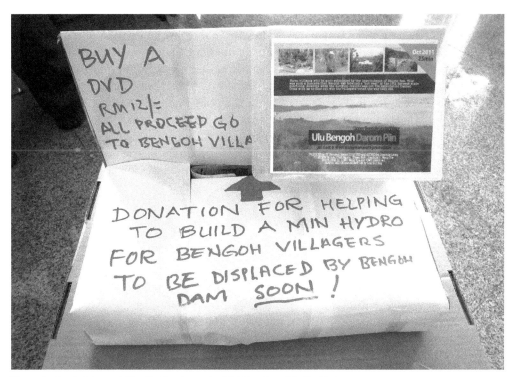

Figure 1: Fundraising and film distribution at the 2011 Freedom Film Festival.

that return each year ready to discuss social justice issues and follow-up on campaigns and stories from previous years. In Jakarta, a festival like this, with such an explicit agenda, is an unfamiliar idea. Yerry says it is very important that "Jakarta audiences identify with activist struggles in the region and the world". Through social media, the Jakarta screening widened and strengthened EngageMedia's support networks, bringing audiences together that were not previously connected, and in doing so, opened up discussions about regional solidarity that did not necessarily have Malaysia at their centre. In this way, a festival like FFF can occur across multiple platforms in different places. He says that at FFF Jakarta (2014), people stayed until very late discussing issues such as land grabbing, forced eviction and human rights violations. Audiences were surprised that these problems were occurring elsewhere as well as Jakarta. The programme included short activist films from Cambodia, Thailand and Malaysia, as well as video interviews with Indonesian migrant workers. As a result of programming films that go beyond national boundaries, Yerry says that audiences can understand that some of the problems they are facing in Jakarta are common to the entire region of South East Asia. He says that Jakarta audiences need inspiration and this comes in many forms. "The time is over", he says, "when you could just tell one story in one way and it

would change anything. Audiences in Jakarta need to see the successes of others. They need to know that they have allies, which is why our regional networks are so important". In this sense such film festivals work towards a regional humanitarian imaginary that can "reinvent itself as a communicative structure that is neither about our common humanity or about our own feelings for distant others" (Chouliaraki 2013: 203). This imaginary is essential for the creation of space that can acknowledge the politicization of humanitarianism and go beyond its impossibility. When Jakarta audiences view stories that are simultaneously distant and familiar, scale is brought into being. Films and film festivals become "scale-making" as video stories extend into dynamic campaigns that operate across the borders created by nations and languages, allowing activists and audiences are able to imagine the possibility of transnational activism.

Southern Peace Media

A striking example of the productive nature of such spaces can be seen in the circulation of films from the province of Narathiwat, in southern Thailand, through Freedom Film Festival (FFF) and EngageMedia. The language in this area is Malay based and subtitling is relatively easy for Malay and Indonesian speakers. The group Southern Peace Media has been working to build international support for victims of violence in the region. Separatist violence has occurred for decades: since 2004, the conflict has pitted variously armed and organized ethnic Malays – nearly all Muslims – against the predominantly Buddhist Thai state and its security forces, resulting in more than 5000 deaths. In July 2005, Thaksin Shinawatra, the *then* prime minister, declared an emergency decree, assuming wide-ranging emergency powers to deal with the conflict. The military was granted an extraordinary increase in executive powers to combat the unrest (Zawacki 2012). Desperate to tell their stories, the Thai activists formed relationships with activists in Malaysia and Indonesia and eventually also a partnership with EngageMedia. In this context, film festivals such as FFF have played an important role in telling stories about human rights abuses when language has been a major obstacle to their circulation.

Film-makers from Southern Peace Media attended FFF in 2011 and screened their films (in Thai with Malay subtitles). Since most of the audience could speak both Malay and English, they were also able to discuss the films. Before forming these networks, activists had been unable to get their testimonies of violence out to an international audience that could help them create a human rights campaign. They had conducted all their interviews in the Thai national language (although this is not their first language) so that they could be understood on a national scale. By working with regional allies, using online subtitling technologies, and having a multilingual forum at FFF, they began to strategize more carefully about working across the region, recording video testimonies in Malay and Thai that enabled their communication with Malay-, English- and Thai-speaking audiences.

Conclusion

I have argued here that film festivals in Indonesia play an essential role generating scales of activism. The examples given in this chapter are networked, hybrid forms of activism, that make change as they reconfigure production and distribution. The festivals discussed, as well as others such as Festival Film Dokumenter Yogyakarta and Q Film Festival, open new spaces for the discussion of important issues such as political corruption and regional solidarity. These initiatives are important in the ways they build communities, networks, projects and campaigns across scales rather than in their production or distribution of concise, tangible and finished films.

The Cinema Lovers Community in Purbalingga demonstrates the way a seemingly small initiative dealing with local politics can connect with more powerful national pro-democracy campaigns when activists are able to imagine a film festival as a scale-making project. In this example, the possibilities of campaigning across multiple platforms (festivals, websites and local media) in combination with the ways corruption is understood differently in different contexts (the regent was forced to consider his "broken promises" in the context of a history of corruption on a national scale) produced a new way for the local community to imagine what film activism does. In the example of Freedom Film Festival (FFF), a regional initiative is reproduced at a more local scale, shifting the bounds of human rights discourse, and circulating the important story of human rights abuses in southern Thailand by altering the flow of its translation and augmenting its audience.

Those involved in these experiments express hope for the future of activist film festivals in Indonesia. New human rights-focused film festivals are emerging in Indonesia, such as the Freedom of Expression Film Festival, which will run in 2016, and others such as the Anti-Corruption Film Festival (ACFFest),[7] which has been running since 2013, continue, and many more are in planning stages. Activist led initiatives such as COFFIE (Coordination for Film Festival in Indonesia). Badan Perfilman Indonesia/BPI (Indonesian Film Council) continue to form, supporting all kinds of film issues across Indonesia, pooling resources to create networks and opening up discussions on the possibilities of media activism. In the words of Dimas Jayasrana, who claims to have dedicated his life to activist film festivals, "there is no career path. And there is no format I can follow. We are making it happen in new ways every day".

Acknowledgements

The author would like to gratefully acknowledge the generous assistance of Dimas Jayasrana, Lulu Ratna, Ferdi Thajib and Yerry Niko Borang in the writing of this paper. To Ariani Darmawan, thank you for introducing me to Indonesian film. Also thanks to Tanya Notley and Juan Francisco Salazar who were co-researchers into the online subtitling of activist video in South East Asia.

References

Agustin, U., et al. (2008), *9808 Antologi 10 Tahun Reformasi Indonesia/9808 Anthology 10 years since Reformation in Indonesia,* Indonesia: Proyek Payung/Umbrella Project, 115 mins, https://9808films.wordpress.com/directors-statement/.

Baulch, E. and Millie, J. (2013), "Introduction: Studying Indonesian media worlds at the intersection of area and cultural studies", *International Journal of Cultural Studies,* 16:3, pp. 227–240.

Chouliaraki, L. (2013), *The Ironic Spectator: Solidarity in the Age of Post-Humanitarianism,* Cambridge: John Wiley & Sons.

Crosby, A. (2013), "Remixing environmentalism in Blora, Central Java 2005–2010", *International Journal of Cultural Studies,* 16:3, pp. 257–269.

Crosby, A. and Notley, T. (2014), "Using video and online subtitling to communicate across languages from West Papua", *The Australian Journal of Anthropology,* 25:2, pp. 138–154.

EngageMedia (2009), *Videochronic; Video Activism and Video Distribution in Indonesia,* Collingwood: EngageMedia.

Forum Lenteng (2009), *Videobase: Video-Sosial-Historia,* Jakarta: Pusat Informasi Data Penelitian dan Pengembangan Forum Lenteng.

Heryanto, A. (ed.) (2008), *Popular Culture in Indonesia: Fluid Identities in Post-Authoritarian Politics,* New York: Routledge.

Indrasafitri, D. (2012), "SToS 2012: Movies, meetings and more", *The Jakarta Post,* 25 February, www.thejakartapost.com/. Accessed 13 November 2015.

Jayasrana, D. (2008), "Fragmen Sejarah Film Indonesia", *A Fragmented History: Short Films in Indonesia,* http://www.clermont-filmfest.com/00_templates/page.php?lang=2&m=72&id_actu=494&id_rub=&mois. Accessed 13 November 2015.

Jurriëns, E. (2011), "A call for media ecology", *Indonesia and the Malay World,* 39:114, pp. 197–219.

——— (2015), "Video art communities in Indonesia", in B. Hatley (ed.), *Performing Contemporary Indonesia: Celebrating Identity, Constructing Community,* Lieden: BRILL, pp. 98–118.

Jusuf, W. (2014), "CLC Purbalingga: Edukasi Film, Edukasi Politik", 13 April, http://cinemapoetica.com/clc-purbalingga-edukasi-film-edukasi-politik/. Accessed 13 November 2015.

Lym, M. (2011), *@crossroads: Democratization and Corporatization of Media in Indonesia,* Participatory Media Lab, Arizona State University and Ford Foundation.

Nikholas, Y. and Crosby, A. (2012), "No room for broken promises in an online Indonesia", *Global Information Society Watch 2012,* Johannesburg: Association for Progressive Communications.

Notley, T. and Crosby, A. (2014), "Transmedia activism: Exploring possibilities in West Papua", in D. Polsen, A. M. Cook, J. T. Velakovsky and A. Brackin (eds), *Transmedia Practice: A Collective Approach,* Oxford: Inter-disciplinary Press, pp. 77–89.

Nuraini, J. (2006), "Whatever I want: Media and youth in Indonesia before and after 1998", *Inter-Asia Cultural Studies,* 7:1, p. 142.

Oppenheimer, J. (2012), *The Act of Killing,* Denmark: Final Cut for Real.

Ratna, L. (2007), "Indonesian short films after Reformasi 1998", *Inter-Asia Cultural Studies,* 8.2, pp. 304–307.

———(2015), "Program Festival Film: Antara Penemuan dan Pertemuan", *Cinemapoetica* http://
cinemapoetica.com/program-festival-film-antara-penemuan-dan-pertemuan/ Accessed
13 February 2016.

Sen, K. and Hill, D. (2006), *Media, Culture and Politics in Indonesia*, Jakarta: Equinox Publishing.
——— (2010), *Politics and Media in Twenty-first century Indonesia: Decade of Democracy*,
London: Routledge.

Suherdjoko (2014), "Corruption cases on the rise, abuse of political power", *The Jakarta Post*,
8 January, http://www.thejakartapost.com/news/2014/01/08/corruption-cases-rise-abuse-
political-power.html. Accessed 13 November 2015.

Teh, D. and Berghuis, T. J. (2015), "The act of video: Reflections on video vortex# 7 and
contemporary video practices in Indonesia", *Theory, Culture & Society*, published online 18
August 2015, doi:10.1177/0263276415598560.

Thajib, F., Nuraini J., Lowenthal, A. and Crosby, A. (2009), *Videochronic: Video Activism and
Video Distribution in Indonesia*, Australia: EngageMedia.

Torchin, L. (2012), *Creating the Witness, Documenting Geneocide on Film, Video and the Internet*,
Minneapolis: University of Minnesota Press.

Tsing, A. L. (2005), *Friction: An Ethnography of Global Connection*. Princeton: Princeton
University Press.

van Heeren, K. (2012), *Contemporary Indonesian Film: Spirits of Reform and Ghosts from the
Past*, Lieden: Brill.

Zawacki, B. (2012), "Politically inconvenient, legally correct: A non-international armed conflict
in southern Thailand", *Journal of Conflict and Security Law*, 18: 1, pp. 151–179.

Notes

1 Available at www.docnetsoutheastasia.net.
2 Available at http://freedomfilmfest.komas.org/sea-video-activist-forum/.
3 For a detailed discussion of how open source online subtitling works, see Crosby and Notley
 (2014).
4 EngageMedia is an open source online video sharing platform and works with activists
 in the Asia Pacific to make and distribute videos around environmental and social justice
 issues. http://engagemedia.org/.
5 Indonesia ranked 107th in Transparency International's Corruption Perception Index, which
 ranks countries based on how corrupt their public sector is perceived to be (https://www.
 transparency.org/cpi2014/results).
6 My translation. Terima kasih atas ekspose nya yang tendensius. Kalau anda mau beritikad
 baik, saya rasa mereka yang merasa belum terpenuhi atas "janji" saya, bisa dikomunikasikan
 ke saya. Tapi kalau anda punya maksud lain, tentu lain lagi ceritanya. Dan kalau memang
 begitu, ya monggo saja.
7 Available at http://acffest.org/site/.

Section 4

Identity Politics

Chapter 10

imagineNATIVE Film + Media Arts Festival: Collaborative Criticism through Curatorship

Davinia Thornley

Introduction

Held in Toronto each October, imagineNATIVE Film + Media Arts Festival celebrates the latest film and media works by Indigenous peoples. imagineNATIVE is regarded as one of the world's most important Indigenous film festivals; according to the 2013 imagineNATIVE statistical records, it has become the largest, with 15,558 attendees on record (imagineNative 2013). The Festival's programming, cultural and social events and *Industry Series* (workshops and panels) attract and connect film-makers, media artists, programmers, buyers and industry professionals from around the globe (14th Annual 2013: 8). Based on my attendance at the festival, and speaking as a non-Indigenous person, I use this chapter to demonstrate how the imagineNATIVE film festival acts as a working laboratory for collaborative criticism.

I define collaborative criticism as receptive to the goals and philosophies of Indigenous media. This kind of criticism takes up esteemed Maori director Merata Mita's invitation, a quarter-century ago, for majority audiences to watch Indigenous films in ways that allow for "an experience beyond the self" (Mita 1995: 54). Traditional criticism emphasizes cinematic objectivity, narrative coherency, technical excellence and realism, while the critic is expected to be both omniscient and distant in their evaluation. In contrast, collaborative criticism is immersive, relational and ongoing, requiring a level of commitment and even discomfort from critics as they accept and foreground *not knowing*.[1] I will detail the role of not knowing in this type of criticism shortly, showing how it provides a space that privileges Indigenous ways. Likewise, a collaborative ethos is created at imagineNATIVE that allows for different kinds of viewing, inviting further conversations between film-makers and audiences, Indigenous and non-Indigenous.

I suggest that the Festival employs cross-cultural collaborative criticism through curatorship, which I define as follows. It is possible to see film festival attendance – particularly at activist festivals such as imagineNATIVE – as a way to undertake this specific type of criticism, a "lived" enactment of the principles above. One of the core themes of this edited volume is the idea of "the spectator [being] called forth as an active participant" (see Introduction, this volume). Indeed, Leshu Torchin recognizes that "festival screenings are only one component of the festival practices that contribute to its definition as activist, as advocating for social justice and change, and seeking to engage a community" (Iordanova 2012: 1–12). To show this process of curatorship occurring, I will look not only at the choices of films, but also the discussions following the screenings, the sites and framing (physical, ideological and virtual) of various festival events and the interpellation of spectators undertaken by festival personnel. Spectators

are, therefore, called upon *to act as* activist-critics through the curation of their cinephilia, as outlined further in the next subsection ("Curation as a collaborative critical space").

Collaborative curatorship and criticism engage with Fourth Cinema themes championed by Barry Barclay (Ngati Apa and Pakeha) (2003),[2] an esteemed director, activist and writer, recently deceased. These themes have since been taken up and expanded by other theorists working in the field of Indigenous media and critique. Discussing Indigenous peoples in much of North America and the Pacific, David Pearson states that, despite small numbers, these groups have become a potent force. Ongoing negotiations for material reparation and political autonomy destabilize state sovereignty, while increasingly global recognition of their position as "First Nations" provides a prominent position in public iconography – particularly in relation to the recasting of foundational myths for majority groups in post-settler states (2001: 1–2).[3] Fourth Cinema is one such nexus where all these concerns come together: film is recognized as a place where "material reparation" is made, "political autonomy" is fought for as "state sovereignty" is simultaneously challenged, and through that challenge, the very myths undergirding settler nationhood are dismantled.

Coined by Barclay, the term Fourth Cinema refers to gains made by Indigenous peoples in independence, media control and political representation throughout the1960s and 1970s, particularly the long march to the 2007 United Nations Declaration on the Rights of Indigenous Peoples. The "Fourth" also designates a separate, but not lower designation (as the numerical order might suggest) for films made by and addressing Indigenous peoples and their concerns. Distinct from, but capable of incorporating mainstream (First) and arthouse/documentary (Second) formats and themes, Fourth Cinema is also set apart from Third Cinema, originating in neocolonial Latin America, Asia and Africa. It differs from all three in its relation to the nation state and its cinematic productions, seeing them as "invader cinemas" (Barclay 2003; Bennett 2006). Rather, as Barclay and Mita, among others, have already recognized, Indigenous film-making and theory draw on, but are by no means defined (or subsumed) by any of these other models.

My chapter gestures to Fourth Cinema's remit but also expands it somewhat: specifically by foregrounding curatorship at the imagineNATIVE Festival as a way for the Festival's audiences – both Indigenous and non-Indigenous – to think in a collaborative, critical way about the Indigenous films that they watch. It also asks them to understand such a worldview *from that perspective*, and – ultimately – to recognize the extent to which this understanding can only ever be an ongoing web of dialogue and exploration.

imagineNATIVE: Curation as a collaborative critical space

Collaborative criticism is regenerative as Indigenous productions are regenerative. Unlike traditional criticism, collaborative criticism does not try to "put things in boxes", like butterflies being pinned to a board. Houston Wood has a telling subsection in his book *Native Features: Indigenous Films from Around the World*, titled "White Shamanism and the Abuse

of Indigenous Films". Here, he outlines the complications surrounding majority audiences' viewing of Indigenous practices and beliefs; he also quotes Lofty Bardayal Nadjamerrek who states, "[f]ilming is like being speared" (2008: 71). Criticism should not contribute to the mistrust that has built up between majority and minority/Indigenous audiences since the cinematic medium was invented. Instead it should judge the work according to the epistemic frameworks of the culture sharing the story, not the culture watching – *as far as is possible* (I will expand on the limits of such a position towards the end of this piece). imagineNATIVE makes this kind of viewing possible.

Collaborative criticism is proactive in the widest sense: deconstructionist work has little place here, but it is also not obsequious or uncritical. Reciprocity is required; learning must take place on both sides, but more heavily weighted for non-Indigenous audiences. The cultural and sociological specificity of what it means to be Indigenous cannot be assumed by a non-Indigenous critic or audience member, even while motivated by empathy; the capacity to fully inhabit the world portrayed by the film is not possible. imagineNATIVE film-makers and activists often alluded to the damage done by hasty conclusions that non-Indigenous audiences may comprehend an Indigenous worldview. Shallow acceptance ("I know just how you must feel") signals the end of communication because it closes down possible future channels of exchange and understanding.

On the other hand, if a critic simply avoids any judgment in favour of an unquestioning acceptance, she "treat[s] the film with an indulgence which [sic] would be patronizing" (Calder 1989). It is one thing to label a film difficult to understand from your cultural viewpoint and leave it at that, the judgment standing alone to speak for itself. It is entirely another, and much more challenging task to (1) label a film difficult to understand from your own standpoint, (2) demonstrate that you are aware this is a culturally specific perspective and then (3) go on to do the hard work of still justifying why your appraisal of the film was negative.[4] In this way, cross-cultural interaction occurs when critics are forced to not only confront the differences between themselves and others, but also to acknowledge and live with those differences – possibly even beginning to question their own position and value systems so that the work of watching alters the critic/viewer as well (Thornley 2006: 67–75). Such an approach at least begins an examination of specific critical standards and how they can both illuminate and simultaneously constrain audience readings.

Mita also suggests that because communication from the screen is absorbed in a single sitting, the oral tradition is present but with a heightened visual aspect (1995: 39). Given that the critic and/or audience member is not of that culture, it must follow that they will be unable – in just that one sitting – to absorb the cultural messages embedded in such densely layered works. It is a given that they will never understand them all. That does not mean, however, that it is enough to simply stop their exploration at the gate of their own world, or that they should rest easy, as Mary Catherine Bateson recognizes,

Those who try to limit artists to confirming existing ways of seeing may also limit their own capacity to learn. The rejection of the unfamiliar in the arts is often a blend of

imposed tests of reality and propriety. If observers say, from their limited point of view, "It isn't really like that, the work is false, slums are terrible places where life is nasty, brutish, and short" [...] they are introducing something intended as a reality test. Art that is reality-tested this way is not allowed to reveal new realities or to foster in the observer the capacity to discover and construct new realities elsewhere.

(1995: 225)

Not knowing is never an excuse for ignorance or simplistic dismissal. Instead, it requires courage and a constant reaching-out from the critic. Most essentially, it requires tact and graciousness: the ability to know when you have seen enough; when you have done enough research and asked enough questions; when you should listen, rather than keep talking and when you should relinquish the role of "omniscient judge".[5] Bateson asks: how quickly are we able to move from courtesy to mutual recognition? She understands that it is extremely difficult to learn easily or at any depth from those towards whom you feel condescension, and suggests that the basic challenge we face today in an interconnected world is to "disconnect the notion of difference from the notion of superiority" (1995: 233). Perhaps the most radical position of all is not even in acknowledging difference and embracing what it has to offer, but simply to know you will, in fact, never know – and to accept *that* as exactly the means, and the ends, of your critique. At imagineNATIVE, therefore, the goal is not simply to encourage a cross-cultural encounter between Indigenous and non-Indigenous ways of knowing, but also to ask non-Indigenous people to practise self-reflexivity in terms of the *limits* of their understanding of what they watch.

imagineNATIVE films

imagineNATIVE's positioning of its audience begins long before they set foot in the TIFF Bell Lightbox complex, the festival's primary base and also home of the prestigious Toronto International Film Festival (TIFF), arguably one of the top film festivals in the world open to the public. Audiences for imagineNATIVE have always been split fairly evenly between Indigenous and non-Indigenous attendees; in 2013 the percentages were 46 to 54, with 67% female, 31% male and 2% transgender respondents in festival surveys. The festival's staff, or "Legion of Super Administrators" in the festival booklet, make it very clear that theirs is an international festival, drawing Indigenous content from across the globe and prompting an internationally collaborative conversation. Interestingly, 10% of the attendees also travelled from outside of Canada, a 9% increase from 2012 (imagineNative 2013). Marcia Nickerson, Chair of the Board of Directors, writes:

As you all know, this year the nation's consciousness was elevated around a number of issues faced by Indigenous peoples in this country, thanks to *Idle No More*.[6] This grassroots

movement – coupled with increased visibility of Indigenous-made media art works – has created an unprecedented portal into diverse complex Indigenous perspectives from around the globe.

(14th Annual 2013: 20)

Films from such far-flung regions as Norway, Taiwan and Chile are featured. The Sami people are represented, as well as the Ghurkas (*Who will be a Ghurkha?* tells of the brutal process of enrolment for young Nepalese men into the British Army, and won the Festival's Best Documentary award). The opening film in 2013 was an Australian genre piece, from one of the country's leading Aboriginal film-makers, Ivan Sen (*Mystery Road*), while the closing night screening featured the latest offering, *Uvanga*, from the Arnait Video Production Collective, a women's group from what is now the Indigenous territory of Nunavut in northern Canada. The group was founded in 1991 and focuses on Inuit women and their stories, histories and concerns. At both the opening and closing events, the directors and key cast members were present for Question and Answer sessions with the audience. These discussions were stimulating for both groups, lasting for almost an hour after each screening and addressing a number of issues regarding Indigenous politics and cultural mores. Further information is provided in the next section regarding the role of these and other discussions in promoting a collaborative critical sensibility throughout the Festival.

In 2013 imagineNATIVE's International Spotlight on the Maori Nation (Aotearoa/New Zealand) included five feature films (two of which are in the top fifteen domestic box office hits list), two short film programmes, a Radio New Zealand drama series called *Skin Writing* and the North American premiere of *In Pursuit of Venus*, an art installation by one of the country's top media artists, Lisa Reihana. The introduction for this spotlight reads, "Ours is an Indigenous experience that unites us and speaks volumes about who we are as global citizens" (14th Annual 2013: 36). In all, there are more than 50 Indigenous nations represented. Such a breadth of programming assumes audience members who are simultaneously aware of the diversity and similarities between Indigenous nations, all of who have experienced the effects of colonization and exploitation by more dominant powers.

The Festival's primary implied audience, therefore, is Indigenous peoples from across the world, promoting the possibilities of cultural exchange. Presenting the work of Indigenous film-makers and media artists takes precedence according to Ryle, Festival Director. Indeed, my decision to attend and research imagineNATIVE was solidified at a screening held in Wellington, Aotearoa New Zealand, a year earlier. The event, presented by the New Zealand Film School, New Zealand Film Commission (NZFC), and Te Paepae Ataata,[7] showed a selection of international Indigenous short films and featured a Question and Answer session with Ryle and Nickerson as First Nation guests from imagineNATIVE. This exchange laid the groundwork for the Maori International Spotlight mentioned above.

At the same time, Festival programmers are aware that while their Toronto audience consists largely of educated, urbanized cinephiles, non-Indigenous viewers from this group

Figure 1: The 2013 Toronto imagineNATIVE Film + Media Arts Festival poster, featuring Sky Woman. Design by beehivedesign.com. Illustration by Richard Pace.

may have differing levels of understanding about Indigenous issues. Some will be highly knowledgeable, whereas others may have chosen an imagineNATIVE film simply as an alternative to something else screening at TIFF beforehand, or at another theatre in the city. As with any engaged conversation, but particularly when holding a *collaborative* critical conversation, imagineNATIVE aims to be inclusive, but not at the expense of "dumbing down" Indigenous content or concerns in order to make them palatable for a wider audience. Rather, it was clear, from attending several films and panels that non-Indigenous audiences were expected to meet the Indigenous challenges presented onscreen through respectful listening, ongoing discussions and even further research, if necessary.

Film discussions

Being in *relationship* is the first step in any collaborative criticism: there has to be some kind of commitment on the part of the critic/audience member to engage with the films shown. This engagement does not mimic the reserved "box checking" or awarding of points by the traditional artistic criticism that I mentioned earlier. Such criticism assumes both objectivity and confrontation, while collaborative criticism is a discussion rather than a pronouncement, dialogic rather than divisive. Many majority critics and academics may struggle with related strategies, such as employing respectful listening – and especially with *not knowing*.[8] This requires a new kind of learning for people accustomed to a way of seeing and understanding the world through individually acquisitory – rather than co-created, communal – knowledge (Bateson 1995: 213).

While traditional criticism does not so much engage with films as pass judgment on them, during my Festival-going experience there was precious little of this occurring at imagineNATIVE. Rather, discussions before and after the films were lively and wide-ranging; many of them were concretely focused on political awareness and immediate action. For example, waiting in the rush line for a series of documentary shorts titled *Meeting Points* (which included a Zacharias Kunuk piece about the recent Inuit – Cree reconciliation to celebrate 200 years of peace following historical conflict between the two groups), I saw two women watching YouTube on one woman's cell phone. They were sharing footage of the New Brunswick clash, still ongoing as I write, between Elsipogtog and Mi'kmaq First Nations protesters and Royal Canadian Mounted Police (RCMP) over shale gas fracking exploration on their land. Indeed, Dina Iordanova recognizes that in activist festivals, "the discussion is as important as the film screening and undoubtedly constitutes an inherent part of the festival structure" (2012: 16). Such discussion is not limited to the circumscribed time set aside in the Festival programme (and tied chronologically to the film itself), but extends into the hallways and streets outside the venue also.

Collaborative criticism requires of film critics that they incorporate Indigenous understandings and experiences into their critiques. One way to do this is to acknowledge the lengthy historical and cultural thematic lineage in most Indigenous cinematic story-

telling. As Joanne DiNova recognizes, "It is crucial for any indigenist approach, indeed for any non-racist approach, to account for the antiquity of Aboriginal thought and to assert the antiquity of that intellectualism against more assimilative and dominant forms of inquiry" (2005: 174). During post-film discussions, several audience members drew comparisons between events experienced by the characters on screen (e.g. residential school attendance; "stolen generations" experiences; racism; domestic and sexual abuse of Aboriginal women; language loss/revitalization and cultural rituals; among others) and their own communities' experiences. In the following paragraph, I outline a specific conversation, which expanded into an exchange that can be seen as both critical and collaborative.

After I offered a comment in one such discussion, an audience member introduced himself to me as Robert Soldat. We struck up an acquaintance over the next few days of the festival and continued emailing after it finished. When I asked him why he had decided to attend, he sent me the following response and gave me his permission to use it here:

> I'm a native from the Dene Nation and my grandfather, Jimmy Soldat, was a noted Chief from that area. My reason for checking out the festival was a personal one[,] which basically is to learn from the experiences of other Residential School participants. I suppose it's a selfish one but that's all it was! Most of the experiences shown weren't foreign to me, just reminders! Some are just better or worse than other experiences, depending where you are located in Canada.

As a non-Indigenous person I can only guess at such an experience, but I felt privileged Soldat chose to share even this brief feedback with me. Our interaction is just one example of the kind of relationship that can develop at an activist festival such as imagineNATIVE; one where Indigenous and non-Indigenous can dialogue after the Festival has officially closed, electronically continuing these important discussions that need to persist – both at national (Canadian) and global levels.

This multi-layered verbal register, where Indigenous artists and audiences talked first and foremost among themselves, while still graciously acknowledging the presence of other interested groups, highlights the role of curation as an important subset of collaborative critique. Collaborative curation understands that non-Indigenous audiences have to learn to sit with *not always knowing*. It is a type of understanding that accepts a cyclical way of looking at the world, and is comfortable with the "repeats" and silences that come out of the oral tradition. In order to fully embrace the ethos of imagineNATIVE, there also has to be an acknowledgement that they may never fully "understand" or be able to discretely categorize such films (or, indeed, such experiences) into a western model. This is as it should be. Truly collaborative criticism, facilitated by the curatorship of imagineNATIVE, requires first the ability to recognize the innate difference of the work or worldview under consideration and, secondly, the willingness to engage with both – in spite of and, indeed, *because* of – these differences.

Special events: Sites and framing

Along with co-production, D.I.Y. distribution and professional development panels, I also sat in on an Oxford-style debate on the continued importance (or unimportance) of identity-based art production and distribution, a Producers' Masterclass and a discussion around "Indigenous Media Art in Aotearoa New Zealand". Throughout all of these events, a primary ideological thread developed regarding the importance of trans-Indigenous networks, foregrounding a spectatorship that could function outside of (and, often, in spite of) national bureaucracies and borders. Francesco Di Chiara and Valentina Re have suggested that the present role of film festivals is the creation of a set of networks formulating new international production and distribution pathways (also described by Thomas Elsaesser in his 2005 book); this had the effect of shifting the film historian community's view towards a transnational approach (Di Chiara and Re 2011). But imagineNATIVE participants were not simply transnational networkers.

Panel members at imagineNATIVE went one step further by creating their own models, weighing them by very different criteria than those put forward by Di Chiara, Re or Elsaesser. As Barclay recognized in designating Fourth Cinema as a separate category from First, Second and Third Cinemas, Indigenous networks operate *outside* national boundaries. Therefore, the panel members worked to "throw the established rules out the window to brainstorm fresh, new and uniquely Indigenous possibilities for joint ventures between Indigenous nations in Canada, Aotearoa (New Zealand), and Australia", just as collaborative criticism has done with traditional understandings of critique (14th Annual 2013: 91). Across the different panels, debates and commissioned events, production and distribution channels were reworked to better fit the needs of Indigenous spectators. As Torchin acknowledges, forums such as imagineNATIVE are at their best when they fulfil their role of allowing Indigenous film-makers and industry personnel to participate in a "renewal of commitment, where one sheds the yoke of cynicism by watching empowering stories and mingling with equally committed people" (Iordanova 2012: 6). The following provide "lived examples" or applied branches of collaborative criticism – because they are all concerned with returning agency to Indigenous groups and, in so doing, righting the long-out-of-alignment balance between film-makers and critics.

A primary concern was changing the dynamic of the cinematic industry model to more equitably represent and respond to Indigenous spectators. Anne Lajla Utsi (from the International Sami Film Centre or ISFC) stressed the importance of preserving the Sami language in all of their initiatives, which include Development, Training, and Production Grants. While the Centre headquarters are in Norway, the ISFC supports Indigenous Sami populations spread across the four countries they inhabit: Norway, Sweden, Finland and Russia – an apt example of the need to work around sometimes inhospitable (in both senses of the word) national borders and boundaries.

Quinton Hita, participant in the Art in Aotearoa panel, stated that community-based film-making is about "going back to our people". Hita suggested a domestic Maori

distribution model, following a Maori-orientated philosophy, which could then serve as a global spectatorship template for other Indigenous peoples. He discussed how *marae* (local community meeting areas) could function as a first "point of call" for films that only afterwards would show in mainstream theatres. A speaker from the Adam Beach Film Institute in Canada then discussed a related but methodologically different spectator experience: taking the theatre concept to Indigenous communities by employing streaming and Blu-Ray technologies on huge screens, providing healthy concessions, and having celebrities attend. In this way, a complete entertainment package is physically delivered to communities that are often geographically isolated.[9]

Continuing the collaborative conversation

Houston Wood (see above) argues two further points that became salient when non-Indigenous audiences watch Indigenous films: the appropriation that often accompanies such viewing and the fact that, often, there is little or no appropriate cultural context surrounding the presentation of these films (particularly when viewers watch in non-theatrical spaces). As he writes,

> Throughout history, of course, people have frequently borrowed ideas, tools, and practices from other cultures without permission, training or much understanding. In general, these borrowings cause few problems. Troubles do arise, however, when those who appropriate are members of groups with a disproportionate degree of power over those from whom they borrow.

> (Wood 2008: 77)

imagineNATIVE does important work in both areas: first, by providing a gateway for both Indigenous and non-Indigenous viewers and practitioners to enter into respectful conversations about these films and the worlds that they highlight. Secondly, at least for the time that film-makers spend at imagineNATIVE, they are able to practice a form of visual sovereignty onscreen, one that was heralded by Mita (1995) and discussed at the start of this chapter.

Ultimately, however, collaborative criticism contains within itself the seeds of its own undoing. It is only ever able to approach a dialogue with Indigenous peoples' work and this is a dialogue that is, by necessity, ongoing and tenuous. It may well be that Indigenous film-makers and theorists will reject such an approach as still not enough (not culturally located enough, not political enough, "too little too late"). Be that as it may, it is inescapable that majority audiences will still continue to watch[10] Indigenous media in the form of films seen in the theatre, at festivals like imagineNATIVE and on the Web. Again for this reason, and by necessity, collaborative criticism speaks first to non-Indigenous peoples (some of whom may be encountering such films for the first time or with only a basic understanding

of Indigenous realities), so that they can educate themselves in order to be more "in relationship" with what they watch.

References

14th Annual imagineNative Film + Media Arts Festival (2013), *Where Artists Are Heroes,* Festival Programme, imagineNative Film + Media Arts Festival, Toronto, Canada, 16–20 October.

Barclay, B. (2003), "Celebrating fourth cinema", *Illusions,* 35, pp. 7–11.

Bateson, M. C. (1995), *Peripheral Visions: Learning along the Way,* New York: Harper Perennial.

Bell, A. (2014), *Relating Indigenous and Settler Identities: Beyond Domination,* Basingstoke: Palgrave Macmillan.

Bennett, K. (2006), "Fourth cinema and the politics of staring", *Illusions,* 38, pp. 19–23.

Calder, P. (1989), "Mauri: Confusing but magnificent", *New Zealand Herald,* 29 September.

Di Chiara, F. and Re, V. (2011), "Film festival/film history: The impact of film festivals on cinema historiography, *Il Cinema Ritrovato* and Beyond", *Revue d'Études Cinematographiques (Journal of Film Studies),* 21:2&3, pp. 131–203.

DiNova, J. R. (2005), *Spiraling Webs of Relation: Movements Towards an Indigenist Criticism,* New York: Routledge.

imagineNative Film + Media Arts Festival, (2013), "imagineNative smashes attendance and impact records at the 14th annual festival", http://imaginenative.org/ home/node/3204. Accessed 24 June 2014.

Iordanova, D. and Torchin, L. (eds) (2012), *Film Festivals and Activism,* St Andrews: St Andrews Film Studies.

Mita, M. (1995), "The soul and the image", in J. Dennis and J. Bieringa (eds), *Film in Aotearoa New Zealand,* Wellington: Victoria University Press, pp. 36–54.

Pearson, D. (2001), *The Politics of Ethnicity in Settler Societies: States of Unease,* Basingstoke: Palgrave Macmillan.

Thornley, D. (2006), "Indivisible: Maori-Pakeha hybridity in Aotearoa New Zealand cinema", *International Journal of the Humanities,* 3:6, pp. 67–75.

Womack, C. (1999), *Red on Red: Native American Literary Separatism,* Minneapolis: University of Minnesota Press.

Wood, H. (2008), *Native Features,* New York: Continuum.

Notes

1 Readers who are interested in a full accounting of the differences between traditional and collaborative criticism will find one in my 2014 book, *Cinema, Cross-Cultural Collaboration, and Criticism,* Basingstoke: Palgrave Macmillan.

2 These are tribal affiliations. Pakeha refers to those from the dominant majority (descendants of European settlers, usually English), while Ngati is a prefix for specific Maori groups, such as Ngati Apa or Ngati Porou.

3 For further examinations of both the global and local signification of Indigenous groups, see Brendan Hokowhitu and Vijay Devadas' Introduction in their 2014 book, *The Fourth Eye: Maori Media in Aotearoa New Zealand*, Minneapolis: University of Minnesota Press, as well as Hokowhitu's chapter within on "Theorizing indigenous media".

4 Similar arguments – all of which expand on and complicate traditional literary perspectives and, indeeed, even more recent cultural and critical theory – can be found in Joanne DiNova, Craig Womack and Avril Bell's work, for example.

5 Hokowhitu and Devadas have an intriguing section in their Introduction (see p. xxxvii) addressing a very similar concept of non- or antisynthesis.

6 From the *Idle No More* website: "*Idle No More* calls on all people to join in a peaceful revolution, to honour Indigenous sovereignty, and to protect the land and water", http://www.idlenomore.ca/vision.

7 From *Te Paepae Ataata* website:

> *Te Paepae Ataata* is New Zealand's only national, Maori film development organization. Based in Auckland, *Te Paepae Ataata* aims to identify and develop Maori writers for feature films that will eventually receive significant industry funding and be released to the public. *Te Paepae Ataata* is a Maori cinema development initiative. A *paepae* [respected panel] of Maori practitioners and experts will use professional and cultural considerations to support the growth of Maori films [*ataata*].
>
> (http://www.paepae.co.nz/about-us/)

8 Readers may appreciate the fact that this struggle played out in the peer reviewing of this chapter, where the reviewer baulked at many of my suggestions for an epistemic shift on the part of the viewer, so that they might respectfully engage with indigenous artworks (particularly in regards to Mita's conception of an "experience beyond the self"). Instead the reviewer's comments for revision and clarification continued to fall back on established western theoretical frameworks, scholars and worldviews.

9 Natural resource companies, Canadian governmental entities and other organizations such as Telefilm provide funding, treating their involvement with the Institute as a charitable contribution under the "Aboriginal language envelope".

10 And in many cases – with all the negative ramifications attached to such a term – even consume.

Chapter 11

Disability Film Festivals: Biological Identity(ies) and Heterotopia

Ana Cristina Bohrer Gilbert

D isability film festivals configure spaces where political activism and social concerns predominate (Iordanova 2009). Their emergence is intertwined with the affirmation of international disability political movements in the 1960s–1970s, mainly in the United Kingdom and the United States, and the strengthening of discourses of difference as a politics of identity that offered an alternative to discourses of normalization (Goodley, Hughes and Davis 2012). The proclamation of 1981 by the United Nations as The International Year of Disabled Persons and the formulation of the World Programme of Action Concerning Disabled Persons (United Nations 1982) led to discourses of inclusion focused on participation and equalization of opportunities for people with disabilities.

Disability film festivals proliferated in several countries. The North American festival SUPERFEST started as a pioneer in 1970, a small event presented by Culture!Disability!Talent!, a non-profit organization, and inspired many others in different countries with different formats, such as We Care Film Fest in India, ReelAbilities in New York, The Other Festival in Australia, Wie Wir Leben in Germany, Assim Vivemos in Brazil, among others.[1] Focused on a subject such as disability, the emphasis is less on the geographic territory of film production than on the territory of biological identity, summarized by the homogenizing category disability that assembles a collection of bioscapes (Burri and Dumit 2007) in contemporary biopolitics.[2]

The main purpose of this kind of festival is to bring disability to light. On the one hand, this is done by stimulating film-makers, writers or producers with disabilities (but not limited to) to present their work and by showcasing films that depict people with physical, emotional, cognitive or sensorial disability in their lives (Mitchell and Snyder 2008). On the other hand, the festivals emphasize accessibility to cultural events for people with disabilities, which means to value them as an audience and to give importance to their particular needs by removing barriers through the use of audio description, closed captioning, sign language, braille booklets and adapted access for wheelchair users.

Disability festivals aim to be spaces that challenge values, concepts and myths based on pre-established and reductive normative frames that result in an ontological invalidation (Hughes 2012:17). They provide depathologizing contexts, actively influencing the process of forging new identities distant from biomedical and social categories of sameness, important elements of a "politics of atypicality" (Snyder and Mitchell 2008: 14). More than destigmatizing individuals with atypical bodies through awareness or knowledge on specific conditions, what is at stake is to discuss a politics of multiplicity that escapes from the dichotomy able-disabled (Snyder and Mitchell 2008). By exposing the audience to bodies

that evoke feelings of discomfort, confusion and disorder, the festivals invite spectators to develop new attitudes towards people with disabilities and different perspectives of looking at them, questioning the practices of exclusion of a certain group or culture.

In this chapter, drawing on Michel Foucault's notion of heterotopia (1986), I examine the political role of disability film festivals focusing on Brazil's International Disability Film Festival Assim Vivemos (The Way We Live) as a case study. Heterotopia is a term derived from the Greek *heteros* (other) and *topos* (place)[3] that refers to spaces of an alternative order related to some kind of ontological difference, which can be considered as deviation either in behavioural or physical terms, such as disability, and also to an epistemological difference that questions how individuals of a certain kind relate to themselves. I argue that the Brazilian festival intends to be an *other* space that can be defined as heterotopic to exhibit different realities about individuals with disabilities and to demarcate new understandings of the human body. In doing so, it exerts an influence on viewers' perception and conduct through the screening of films, as well as through formative strategies (debates with various professionals) and institutional images and discourses that contribute to form an audience in political and ethical terms regarding disability. To discuss this influence, I use another term by Foucault (2003) – governmentality – in its broad meaning of governing others' conduct. According to Foucault, governmentality involves rationalities (or ways of thinking) and technologies (or tools for intervening) and, especially in our time, is not restricted to modes of exercise of power by the state but includes forms of self-governing that rely upon expertise and membership of heterogeneous communities. Governmentality also has an intrinsic discursive character responsible for defining and representing the aspects of reality involved in government (Miller and Rose 2008).

For this purpose, I focus on the discourses of the sponsors and of the curators contained in the festival's institutional material (programme booklets) distributed in each of its six editions in search of evidence of consistent, ambiguous or even contradictory messages concerning the festival's aim. I am considering discourse not only as the expression itself (sentences, propositions or speech acts) but also as a group of *statements*, that is, historical rules that define the conditions that make any expression discursively meaningful for a particular area (Foucault 2013). In this sense, discourses constitute social practices that refer to a subject who speaks to someone about something in a specific space/time. I privilege such discursive material, considered at first as less important than the visuality and the actual interaction of bodies within the festival, because they contain an underlying mode of thinking that defines the festival and shapes the perspective of disability assumed by it, which ultimately orients the selection of films and themes for debates. Also, discourses have an implicit persuasive component whose function is to engage the audience to achieve some result or response from it (Austin 1975), in this case, a critical stance with respect to disability. This persuasive component of discourse, I argue, is a form of governmentality. In pursuing this line of analysis, I considered the sponsors' and the curators' written texts as a *corpus* and, subsequently to an exhaustive reading of the material, applied procedures of isotopic analysis (Greimas 1987), which takes into consideration categories of identical

or compatible meaning that are present in a text and indicate a direction for interpreting it (Eco 1979). The following discussion articulates the identified categories to a theoretical framework, rather scarce in relation to disability festivals, and is illustrated by some examples extracted from the booklets. The use of semiotics refers not only to my interest in the processes of meaning making and representation of disability, but also emphasizes the presence of shared cultural codes orienting the discourses that make them meaningful to the spectators. As I am concerned with more than the explicit content of the discourses, my analysis is framed by Carlo Ginzburg's (2013) epistemological model that concentrates on modes of apprehension of reality based on clues, details, absences, silences; that is, on evidence that is imperceptible to most people.

By analysing the aspects of signification and statements in the discourses included in the booklets, it is possible to better understand the political role the festival assumes and the influence it exerts on viewers' conduct.

Disability film festivals as heterotopia

Foucault (1986) refers to heterotopia as counter-spaces or sites outside ordinary sites that exist in every culture but, different from unreal spaces like utopias,[4] are localized and real. He asserts that heterotopia is an enacted utopia with a relational mirror-like quality of reflecting, contesting, distorting or inverting real spaces. He suggests that it involves a disruption in time and/or space, and in some cases, a juxtaposition of various (real or imaginary) spaces and temporalities, which alters our perception of the ordinary space we inhabit. To illustrate his assertion, he alludes to examples as diverse as children's games, spaces for rites of passage, festivals, cinema, theatre, brothels, museums, libraries, cemeteries and ships where displacement of space is often associated with accumulation of time or ephemerality. Although heterotopias change across history, their function entails the creation of either *spaces of illusion* that expose how real spaces are more illusory, or *spaces of compensation*, more perfect and organized than their counterpart. Foucault also refers to disruptive features concerning permeability as access is regulated by rules or rites.

Peter Johnson (2006) reinforces the disruptive aspect of heterotopias, considering them as disturbing spaces which dislocate people's comfort zone and defy what they know about themselves. In addition, Johnson argues that even though Foucault considers heterotopia as a practised utopia, the idea is not connected to any kind of promise or forms of resistance or liberation generally associated with utopias. Rather, heterotopia differs from, disrupts and transforms utopia, offering an opportunity not for the subversion but for the problematization of power relations present in practices and thoughts.[5] Heterotopia destabilizes our customary life and illuminates new ways of thinking about aspects of reality by providing literal or figurative spaces for the emergence of different possibilities (Johnson 2006). These spaces provoke repulsion and fascination and become powerful receptacles for the imaginary and the creation of new narratives (Genocchio 1995).

Disability film festivals are spaces that can be understood in light of Foucault's notion of heterotopia.[6] They configure spaces of ontological and epistemological difference that make explicit an alternative order regarding the human body in terms of both physical accessibility and cultural imaginary, thus influencing viewers' attitudes towards disability. Foucault uses the idea of a mirror to evoke the spatial disruption that characterizes heterotopia and the consequent strangeness that comes with it: the mirror is a place where I see myself but I am not there. In the case of a disability film festival, the screen is a kind of mirror which confronts the audience with bodies that provoke a sense of misrecognition, since they do not correspond to a certain standard, that may unsettle viewers' understandings of human beings and, consequently, of themselves.

To achieve new points of view, those festivals engage in the production of new discourses of truth (Foucault 1990) to define people with disabilities through which spectators (with and without disability) can think of themselves and understand who they are and their capacity of agency in a different way, reshaping not only their identities, but also how they conduct and recognize themselves as subjects. A new and more inclusive sense of citizenship emerges (Ginsburg and Rapp 2013), strengthened by a "visual activism" that asks the audience to "look at" people with disabilities rather than "don't stare" (Garland-Thomson 2009: 193). Social networks are created and validated as a result of the strengthening of these new subjectivities, providing a sense of belonging, altering power relations and questioning the cultural environment for non-normative bodies (Mitchell and Snyder 2008).

However, Foucault's (1986) definition of heterotopic spaces as sites outside of all sites and at the same time within society, and Johnson's (2006) reaffirmation of heterotopia as a disturbing space, clearly point to the existence of tensions between the heterotopic space of the festival and other social spaces. These tense relationships concern not only the obvious aspect of physical adequacy for people with special needs but also, more importantly, discussions over normality, or over an "integrated and fully-functioning body" (Shildrick 2002: 50) as an implicit standard. The normal body, with its qualities of cohesiveness, harmony and beauty, configures what Haraway (1997) defines as an "unmarked category" (23), a category that is unquestionable and universal. The unmarked body conveys the idea of a utopian body in the sense that even susceptible to disease and death, it is not inherently unruly and is considered as a desirable and appropriate reference to non-normative bodies. Its ordered and invulnerable corporeality is taken for granted (Garland-Thomson 1997) and contrasts with the marked differences of fragmentation, leakage and disruption of non-normative bodies, considered as deviant (Lindemann 2009).

Narratives of disability

Historically, disability was depicted in medical narratives as an undesirable imperfection and bodies considered as abnormal were treated as loci of intervention, that is, bodies to be eliminated, cured or rehabilitated. They were characteristic of a biological determinist

model originating in the nineteenth century. At that time, the emergence of western scientific medicine, with its disciplinary practices and classificatory and normative systems, replaced superstitions and religious beliefs about disability (Goodley, Hughes and Davis 2012). Definitions of normality and deviation arose in connection with new laws for the enumeration and classification of people and their habits which were then used to justify interventions into vital aspects of the individuals (Rose 2007). It was at that point that the polarity disabled/able-bodied (ableism) emerged, establishing only one body as an acknowledged standard (Campbell 2012).

The medicalized discourse was questioned by the social model of disability that emerged in the 1970s in the United Kingdom and produced narratives of overcoming. As part of a political movement whose main slogan was "nothing about us without us" (Goodley, Hughes and Davis 2012: 329), this second model established a difference between impairment and disability, the former referring to limiting (pre-social) biological characteristics and the latter to something culturally and socially constructed, responsible for the exclusion of individuals with defined biological realities. However, this social model has been extensively criticized since the late 1980s for reaffirming Cartesian dualisms and considering disability as a "disembodied social phenomenon", or a depersonalized issue, even with the acknowledgement of its relevance and influence in the process of understanding and including disability in society (Goodley, Hughes and Davis 2012). The dissociation between pre-social somatic differences (impairments) and disability as a social construction implicitly conveys the idea that people with disabilities are *like everyone else*, which sounds like equality but disguises a tendency to normalization that does not take into consideration the materiality of variant bodies.

A third model resulting from the intersection of various disciplines, mainly in North America and Canada, developed reflections on both previous models, questioning biological determinism and social constructivism (Goodley, Hughes and Davis 2012). Aligned with the social sciences and their criticism of dichotomous positions (nature/culture, self/society, same/other, human/non-human, body/mind), this theoretical approach, conceptualized as critical disability studies, discusses inclusion as a social issue and advocates for a non-dissociation between the materiality of different corporealities and their being in the world.

This model also challenges narratives of overcoming. *Heroic narratives* focus on overcoming adversity (in many cases used as a synonym of disability) in an effort to resemble unmarked bodies. (McGrath 2012). By contrast, the narratives produced in this new context, which I call embodied narratives, focus on the inclusion of the embodied experiences of an individual as important elements for the constitution of the self. This new narrative pattern does not provoke a radical rupture with the biomedical domain since somatic realities and diagnostic categories are indubitably present. Rather, it reflects a rearrangement of power relations between people with disabilities (previously considered only as patients, not agents) and the biomedical domain, no longer hegemonic, which results in the individuals' effective participation in decisions concerning interventions on their bodies (Rabinow 1992).

Disability film festivals, like the Brazilian festival, are examples of such new rearrangement; narratives of disability that are produced by these festivals and circulate in their spaces have changed with time, reflecting political, theoretical, rhetorical and practical positions adopted by disability communities in different historical periods. Those narratives refer to spatial practices that arrange and choreograph non-normative bodies, and organize and connect places where they circulate. They allude to the contrast between adequate physical access at the festivals' venues – such as wheelchair ramps, lifts, disabled toilets, signs, sounds, yellow rubber guide strips used on flooring, spaces for wheelchairs in the darkroom – and the lack of such conditions in other spaces. But also they refer to a mode of thinking, a choreo(bio) politics,[7] or biopolitical practices of movement, that questions a particular way of managing human bodies centred in the perspective of an autonomous, abled, productive, rational and self-moving subject, an emblematic representation of modernity.

For the remainder of the chapter, I turn to the empirical material – the discourses of the sponsors and the curators in the Assim Vivemos's booklets – to examine how the Brazilian festival as a heterotopic space discursively destabilizes (or not) the utopia of a universal normal body, characteristic of the modern subject. To do so, I focus on the explicit and implicit content of the discourses and on the narratives of disability they disseminate to engage the viewers in new perspectives of disability.

Discourses on disability

The Assim Vivemos festival began in 2003 as a pioneer of the genre in Brazil. Curated and produced by Lara Pozzobon and Gustavo Acioli, it is sponsored by Bank of Brazil Cultural Centre (CCBB), the cultural institution of the Brazilian government controlled Bank of Brazil, whose sponsorship is obtained at every edition via an application process for the bank's annual cultural grants programme. The idea for the event came from the curators' participation as film-makers (with a short film on blindness) in the 2001 edition of the German festival Wie wir leben (The Way We Live) promoted by the non-governmental organization ABM (*Arbeitsgemeinschaft Behinderung und Medien*/Disability and Media Association).

The first edition in 2003 was supported by ABM and comprised a selection of fictional and documentary films screened in three editions of the German festival and included some Brazilian productions. In subsequent editions, the festival became independent, with its own rules, application procedures for film-makers and awards for the best films, and received authorization from ABM to keep the same name as the German festival (personal communication). The launch of the festival in Brazil was concurrent with the establishment of Brazilian public policies in 1999 and 2002 concerning social integration and health care for people with disabilities. The festival is biennial and takes place in Rio de Janeiro, Brasília and São Paulo. In 2010 and 2012, the festival secured cultural grants from the Ministry of Culture and *Petrobras*, a semi-public multinational energy company, for itinerant editions

in four other cities in the southeast and south of Brazil (reproducing the same programmes of the 2009 and 2011 editions). Being an international event with the screening of films from different countries, the festival provides a window to ways of understanding and representing disability in different societies, bringing geographically distant experiences closer to the Brazilian audience. The programme booklets contain information about the films (directors, country and year of production, plot summary, cast members) and include two texts (in Portuguese and English), one by the sponsors and another by the curators, introducing the festival, its purpose and understanding of disability. Now I discuss the themes identified by the isotopic categories in the semiotic analysis and bring some excerpts from the booklets to exemplify these themes.

The booklet of the first edition is particularly important for the analysis since it establishes a discursive frame for a festival whose subject – disability – was not widely discussed in Brazil at that time. The first theme that emerges refers to a "new awareness" regarding people with disabilities, which at the implicit level means a redefinition of disability. By describing the festival's purpose, the discourses of both the sponsors and the curators set the boundaries of an *other* (heterotopic) space that contrasts in terms of accessibility with other spaces outside the festival, and intends to challenge practices of looking and understandings of disability. Both discourses defend a new way of looking at disability changing from "stigma and social exclusion to integration" in alignment with international movements, and declare their commitment to a flexible attitude to change "paradigms in the concepts of normality, difference and ability".[8]

The festival's explicit aim to promote a consistent and permanent change in dealing with disability reveals an implicit ideal to spread that alternative order to other social spaces. To achieve that, the curators and the sponsors intend to exert an influence upon the audience in the sense of indicating perspectives and forging opinions and understandings. This influence can be understood as a form of governmentality, or a play of power, which is neither positive nor negative in itself, that affects how viewers look at people with disabilities and that come into effect through persuasive discursive strategies. These strategies are based on general notions they share with the spectators – a collective and social approach intertwined with an individualized and subjective one – to engage them in the same commitment. Language plays an important and active role as an intellectual technology, being used to translate modes of thinking into action in order to stimulate self-regulating aspects in individuals for political purposes (Miller and Rose 2008: 31). The following sentences are examples of that: "The world turns in this direction" [toward inclusion]. "There's no reason to resist".[9]

The collective and social approach adopted in the discourse of the sponsor explicitly rejects the stereotyped cultural (discursive) locations at the edge of society in which people with disabilities often find themselves placed, exemplified by expressions such as "victims of fate", "excluded from society" or "deserving of compassion". By contrast, the text affirms that "limitations are inherent in human beings". The implicit definition of disability as limitations shared with human beings in general echoes the social model of disability. The assertion is framed by a set of fundamental and indisputable political values that define democracy,

coherently aligned with the status of the sponsors as institutions connected to the Brazilian democratic government. The aspect of persuasion is based on elements of a utopic ideal for a better life blended with disability rights and democratic egalitarian values that define individuals as citizens belonging to a society, as stated in the sentence " [...] that Brazilians may get closer to the future they deserve".[10]

The individualized and subjective approach alludes to the curators' experience in the German festival as essential to the perception of something previously understood as distant and different but also human. This discursive approach highlights a need for sharing personal experiences with a wider audience ("[...] aiming to share our experience with the greatest possible number of people") and makes use of a confessional tone as a persuasive discursive strategy to bring the spectators closer and to engage them in a new critical stance with reference to disability ("we firmly believe that nothing replaces being face-to-face, exchanging ideas, sharing experiences").[11]

Both discourses reproduce what they call an international tendency in film production on disability that changes the focus from disability itself, defined in one of the booklets as "characteristics and conditions pointed out like obstacles and imperfections", to aspects relating to all human beings, that is, to what unites them as species, described in the same text in terms of "limitations and possibilities of us all". At the implicit level of the discourses, what can be observed is a movement towards the category of human nature replacing the category of norm. Even though the festival intends to value diversity by reshaping how individuals understand themselves as subjects (Foucault 1998b) outside a normality frame, or as atypicals (Mitchell and Snyder 2012), it refers to individuals with disabilities focusing not on their difference – biological marks (physical or intellectual), embodied experiences, special needs – but on their shared human abstract aspects – subjectivity, autonomy, human rights and citizenship.[12] As pointed out by Mitchell and Snyder (2008) and reaffirmed by Ginsburg (2012), processes of identity production in disability festivals involve tension and a certain degree of incoherency since they have to deal with a homogenizing identity category under which various identities, with different claims but shared stigma, struggle to refuse generalized capacities and expectations. The same applies to the Brazilian festival. However, focusing on commonalities between typical and atypical bodies risks making human variability elusive, hidden by a collective identity that serves as a cohesive and unifying image to reduce the idea of fragmentation, disruption and multiplicity that is associated to bodies with disabilities (Shildrick 2002).

Elements of narratives of overcoming or heroic narratives are used to describe the trajectories of individuals with disability, particularly in the discourse of the sponsors. Those narratives reinforce able-bodied entities (equivalent to the hero) as an ultimate goal, strengthening subjectivities constructed around the autonomous subject and invalidating what differs from it (McGrath 2012). The coexistence in the texts of an explicit desire to break with worn-out ideas of normality, reinforced at every edition, with narratives of overcoming, understood as natural, creates and communicates ambiguous messages to the viewers.

Although at the explicit level the festival presents itself as engaged in a new perspective of disability that would destabilize the utopia of a universal normal body, it implicitly reinforces what it intends to question by making use of narratives of overcoming. The following sentence exemplifies this point: "disability indeed imposes obstacles, however, all of them, without exception, can and should be overcome".[13] In the perspective of overcoming, the materiality of the body remains in the background and the tendency is to minimize biological differences, experiences of embodiment and particular needs, at the risk of reducing them to invisibility. On the one hand, the recurrence of overcoming as a narrative pattern apparently reinforces the agency of people with disabilities, and on the other, it positions them closer to normality (mistaking egalitarian values for sameness), and therefore less disruptive and disquieting, which ultimately serves as an appeasement to the viewers.

Conclusions

Disability film festivals are events where activism intends to provoke social change related to a politics of identity (Mitchell and Snyder 2012). Thus more than depicting realities of people with disabilities, what those festivals aim to accomplish is to engage the audience in new perspectives on the subject. As heterotopic spaces, disability festivals offer an alternative way of thinking of non-normative bodies that disrupts the utopia of the normal body as an unquestionable and universal category. Far from stimulating a humanitarian gaze (Tascón 2015), disability festivals privilege a form of gaze that intends to bring the spectator closer to the film (or to the subject depicted in it) by conveying a perception of disability not as a distant *other* but as a subject that concerns us all and, consequently, demands political and ethical positions. In their political role, festivals are possible spaces for the construction and strengthening of new subjectivities, disarticulating the binary logic that establishes what type of body is proper and, by contrast, improper. Nonetheless, this is not an untroubled task, and in some cases, contradictory or ambiguous messages reflect the difficulty of questioning deeply ingrained values, concepts and discursive images.

The Brazilian festival configures a relational space capable of assembling multiple discourses (biomedical, educational, political, filmic, cultural and so forth) that amalgamate to discuss disability. In doing so, the festival exerts a kind of governmentality, orienting viewers' conduct in relation to disability through the discourses that inform visual practices. The festival potentially makes conditions of difference visible that can generate new perspectives to the accepted understandings of disability. Also it can destabilize convictions by displaying the human as much more than merely a collection of common abstract aspects. However, the discrepancy between the two levels of the discourses of the sponsors and the curators results in ambiguous messages that might weaken the festival's political aim.

The *Assim Vivemos* festival, as other disability film festivals, offers the opportunity for the construction of different visual and discursive images of disability. To put it in Haraway's (1997) metaphorical terms, the festival invites us to envisage neither reflected nor refracted

images of the same (the normal body), but diffracted images generated by some interference (disabilities) that result in new, multiple and irreversible patterns.

References

ABM-Medien (2003), http://www.abm-medien.de. Accessed 30 March 2015.

Assim Vivemos 1ª Mostra Internacional de Filmes sobre Deficiência (2003), Festival held at Centro Cultural do Banco do Brasil, Rio de Janeiro, August [Festival booklet #1].

Assim Vivemos 2º Festival Internacional de Filmes sobre Deficiência (2005), Festival held at Centro Cultural do Banco do Brasil, Rio de Janeiro, August [Festival booklet #2].

Assim Vivemos 3º Festival Internacional de Filmes sobre Deficiência (2007), Festival held at Centro Cultural do Banco do Brasil, Rio de Janeiro, August [Festival booklet #3].

Assim Vivemos 4º Festival Internacional de Filmes sobre Deficiência (2009), Festival held at Centro Cultural do Banco do Brasil, Rio de Janeiro, August [Festival booklet #4].

Assim Vivemos 5º Festival Internacional de Filmes sobre Deficiência (2011), Festival held at Centro Cultural do Banco do Brasil, Rio de Janeiro, August [Festival booklet #5].

Assim Vivemos 6º Festival *Internacional de Filmes sobre Deficiência* (2013), Festival held at Centro Cultural do Banco do Brasil, Rio de Janeiro, August–September [Festival booklet #6].

Assim Vivemos Festival Internacional de Filmes sobre Deficiência (2013), 'Apresentação', http://www.assimvivemos.com.br/2013/pt/apresentacao/. Accessed 14 July 2013.

Austin, J. L. (1975), *How to Do Things with Words*, Oxford: Oxford University Press.

Brotherhood (2014), "About we care film fest", http://wecarefilmfest.net/about-we-care-filmfest.html. Accessed 27 March 2015.

Burri, R. V. and Dumit, J. (eds) (2007), *Biomedicine as Culture: Instrumental Practices, Technoscientific Knowledge, and New Modes of Life*, New York: Routledge.

Campbell, F. K. (2012), "Stalking ableism: using disability to expose 'abled' narcissism", in D. Goodley, B. Hughes and L. Davis (eds), *Disability and Social Theory: New Developments and Directions*, New York: Palgrave Macmillan, pp. 212–232.

Culture! Disability! Talent! SUPERFEST International Disability Film Festival (2005), "Frequently asked questions", http://www.culturedisabilitytalent.org/superfest/sffaq.html. Accessed 25 March 2015.

Eco, U. (1979), *The Role of The Reader: Explorations in the Semiotics of Texts*, Bloomington: Indiana University Press.

Fiuca, B. T. (2012), "Disability and health-related festivals. Table 5", in D. Iordanova and L. Torchin (eds), *Film Festival Yearbook 4: Film Festivals and Activism*, St. Andrews: St. Andrews Film Studies, pp. 299–300.

Foucault, M. (1986), "Of other spaces: Heterotopias" (trans. Jay Miskowiec), *Diacritics*, 16:1, pp. 22–27.

—— (1998a), *The History of Sexuality, Vol 1: The Will to Knowledge* (trans. R. Hurley), London: Penguin Books.

—— (1998b), *The History of Sexuality, Vol 2: The Use of Pleasure* (trans. R. Hurley), London: Penguin Books.

—— (2003), "Governmentality", in P. Rabinow and N. Rose (eds), *The Essential Foucault: Selection from Essential Works of Foucault, 1954–1984*, New York: The New Press, pp. 229–245.

—— (2013), *The Archeology of Knowledge* (trans. A. M. Sheridan Smith), London and New York: Routledge.

Garland-Thomson, R. (1997), *Extraordinary Bodies: Figuring Physical Disability in American Culture and Literature*, New York: Columbia University Press.

—— (2009), *Staring: How We Look*, Oxford: Oxford University Press.

Genocchio, B. (1995), "Discourse, discontinuity, difference: The question of 'other' spaces", in S. Watson and K. Gibson (eds), *Postmodern Cities & Spaces*, Oxford and Cambridge: Blackwell, pp. 35–46.

Ginsburg, F. (2012), "Disability in the digital age", in H. A. Horst and D. Miller (eds), *Digital Anthropology*, London: Berg, pp. 101–126.

Ginsburg, F. and Rapp, R. (2013), "Disability worlds", *Annual Review of Anthropology*, 42, pp. 4.1–4.16.

Ginzburg, C. (2013), *Clues, Myths, and the Historical Method*, Baltimore: The Johns Hopkins University Press.

Goodley, D., Hughes, B. and Davis, L. (eds) (2012), "Conclusion: disability and social theory", in *Disability and Social Theory: New Developments and Directions*, New York: Palgrave Macmillan, pp. 308–317.

Greimas, A. J. (1987), *On Meaning: Selected Writings in Semiotic Theory*, Minneapolis: University of Minnesota Press.

Haraway, D. J. (1997), *Modest_Witness@SecondMillenium. FemaleMan©_Meets_OncoMouse™, Feminism and Technoscience*, New York: Routledge.

Hughes, B. (2012), "Civilising modernity and the ontological invalidation of disabled people", in D. Goodley, B. Hughes and L. Davis (eds), *Disability and Social Theory: New Developments and Directions*, New York: Palgrave Macmillan, pp. 17–32.

Iordanova, D. (2009), "The film festival circuit", in D. Iordanova and L. Torchin (eds), *Film Festival Yearbook 4: Film Festivals and Activism*, St. Andrews: St. Andrews Film Studies, pp. 23–39.

Johnson, P. (2006), "Unravelling Foucault's 'different spaces'", *History of the Human Sciences*, 19:4, pp. 75–90.

Lepecki, A. (2013), "Choreopolice and choreopolitics: Or, the task of the dancer", *TDR: The Drama Review*, 57:4, pp. 13–27.

Lindemann, K. (2010), "Cleaning up my (father's) mess: Narrative containments of 'leaky' masculinities", *Qualitative Inquiry*, 16, pp. 29–38.

McGrath, E. (2012), "Dancing with disability: An intersubjective approach", in D. Goodley, B. Hughes and L. Davis (eds), *Disability and Social Theory: New Developments and Directions*, New York: Palgrave Macmillan, pp. 143–158.

Miller, P. and Rose, N. (2008), *Governing the Present: Administering Economic, Social and Personal Life*, Cambridge: Polity Press.

Mitchell, D. and Snyder, S. (2012), "Permutations of the species: Independent disability cinema and the critique of national normativity", in D. Iordanova and L. Torchin (eds), *Film Festival Yearbook 4: Film Festivals and Activism*, St. Andrews: St. Andrews Film Studies, pp. 81–93.

Rabinow, P. (1992), "Artificiality and enlightenment: From sociobiology to biosociality", in J. Crary and S. Kwinter (eds), *Incorporations*, New York: Zone Books, pp. 234–52.

ReelAbilities: NY Disabilities Film Festival (n.d.), "About us", http://www.reelabilities.org/about-us#our-mission. Accessed 25 March 2015.

Rose, N. (2007), *The Politics of Life Itself: Biomedicine, Power, and Subjectivity in the Twenty-First Century*, Princeton: Princeton University Press.

Shildrick, M. (2002), *Embodying the Monster: Encounters with the Vulnerable Self*, London: Sage.

Snyder, S. L. and Mitchel, D. T. (2008), "'How do we get all these disabilities in here?': Disability film festivals and the politics of atypicality", *Canadian Journal of Film Studies – Revue Canadienne D'Études Cinématographiques*, 17:1, pp. 11–29.

Tascón, S. (2015), *Human Rights Film Festivals: Activism in Context*, Basingstoke: Palgrave Macmillan.

The Other Film Festival (2014), "What is The Other Film Festival?", http://otherfilmfestival.com. Accessed 27 March 2015.

United Nations (1982), "World programme of action concerning disabled persons", http://www.un.org/disabilities/default.asp?id=23#10. Accessed 7 February 2014.

Zielinski, G. (2012), "On the production of heterotopia, and other spaces, in and around lesbian and gay festivals", *eJump Cut* 54, http://www.ejumpcut.org/archive/jc54.2012/gerZelinskiFestivals/. Accessed December 2012.

Notes

1 For a list of disability and health-related festivals, see Fiuca (2012).

2 Medicine has long been highly influential in shaping subjectivities. The power over life that developed since the eighteenth century marked a political interest on vital elements of human beings thus becoming a biopolitics. This power, named by Foucault (1998) as biopower, was concerned with intervention and control over vital processes of the population, as well as the optimization and performance of bodies. In the twenty-first century, contemporary biopolitics is concerned not only with health and illness as opposing poles but also with the possibilities of control and management of vital capacities at the molecular level. Throughout the twentieth century, medicine, or biomedicine, intertwined with the life sciences applying their methods to clinical practice for new developments in prediction, diagnosis and treatment, for example, in genetics or assisted reproduction. Those circumstances changed how we understand ourselves in our bodies (Rose 2007). A significant characteristic of our century regarding biomedical subjectification is described by Rabinow (1992) as biosociality. This phenomenon describes groups of individuals around a common biological condition defined by biomedicine – bioscapes – that establish new relations with medical authorities and knowledge.

3 Heterotopia is originally a medical term denoting a tissue or an organ developed in an unusual position without configuring a disease (Johnson 2006).

4 Foucault (1986) presents utopia as an unreal space that reflects a perfect form of society or its untidy counterpart.

5 I am following Foucault's (1998) definition of power as something that exists when exercised by some on others (both recognized as free subjects who act) not only as a means of control but also of improvement.

6 Zielinski (2013) develops a similar argument in relation to lesbian and gay film festivals.

7 I adapted this expression from *choreopolitics* by André Lepecki (2013), a scholar working in the fields of dance and performance studies, that develops the idea of moving politically, or moving "towards freedom" (20), as the endless task of the dancer.

8 Quotations and themes from booklet #1. The same themes appear in booklets #2, 3 and 4.

9 The theme of governmentality appears in all booklets, even though it is more explicit in the first four editions. Quotations from booklet #1.

10 Quotations from booklets #1 and 4. The theme of a collective and social approach used as a persuasive discursive component appears in all editions as a reference to a common humanity and a democratic society.

11 Quotations from booklets #1 and 4. From the 2011 edition onward the experiential discourse of the curators is diluted, becoming closer to the sponsors'.

12 Quotations from booklet #3. The theme of human nature appears in booklets #3 and 4.

13 Quotation from booklet #4. Overcoming appears in booklets #1, 2, 3 and 4.

Chapter 12

"Would You Like Politics with That?" Queer Film Festival Audiences as Political Consumers

Stuart Richards

Introduction

> Queer cinema seeks to confront and discomfort not so much the straight audience, but the ideologically complacent lesbian and gay audience. This queer attitude of confrontation is quite different from the community-building attitude of films, which seek to unify the audience by giving us a common history, despite our differences.
>
> (Collins cited in Berry 1993: 39)

Queer cinema has come a long way from the confrontational New Queer Cinema movement of the early 1990s. No longer do we have this dichotomy of discomfort and community-building cinema as highlighted by Collins above. We now have films with the potential to achieve both convictions. From grass-roots screenings organized by community activists to commercially minded organizations, the queer film festival has always been an integral player in the development of queer film. Beginning as underground radical and experimental film festivals that directly challenged dominant ideologies of sexuality and gender identity, queer film festivals have grown to be elite film institutions with an influential position in the dissemination of queer images (Stryker 1996). These festivals provide spaces for the lesbian, gay, bisexual, transgender and queer (LGBTQ) community to access films otherwise unavailable. However, in order for the festivals to achieve their social missions, they must achieve financial sustainability in order to meet their social mission, which is to ultimately provide "audiences with opportunities to enjoy commercially unviable films projected in a communal space" (Peranson 2008: 23). The central question here, however, is whether these films challenge ideologically complacent LGBTQ audiences within this commodified environment.

This commodification is evident in approaches to the identity-based branding of the gay and lesbian movement (Warner 1999; Chasin 2001; Duggan, 2003; Sender 2004). This chapter addresses this tension and makes the case that queer film festival audiences are political consumers, in that they are consumers partaking in a leisure activity that is also an ideologically progressive activity. Here, I am defining ideologically progressive films as ones that challenge homonormative politics. Lisa Duggan (2013) asserts that homonormativity is a product of neo-liberalism and involves assimilationist politics rather than confrontational tactics. To examine the representation of homonormativity in the queer film festival, films programmed in the San Francisco Frameline International LGBTQ Film Festival (hereafter Frameline) will be examined according to three key themes evident in homonormative

politics: depoliticized films anchored in a consumerist framework, recreation of the nuclear family within an LGBTQ context and a hierarchy of sexual identities. Thematic readings of films programmed on the queer film festival circuit will be used as evidence to support the claim that queer film festival audiences engage with both socially empowering *and* conservative cinema.

Kate Soper (2008) outlines the possibility for alternative hedonism in consumer culture:

> An anti-consumerist ethic and politics should therefore appeal not only to altruistic compassion and environmental concern but also to the more self-regarding gratifications of consuming differently: to a new erotics of consumption or hedonist "imaginary".
>
> (571)

In my analysis of queer film audiences, I intend to co-opt Soper's approach to outline the possibility for the politically empowering consumption of cinema. Here we are seeing the hedonistic aspect of film spectatorship coupled with queer politics. I posit that we can apply this alternative hedonism to a spectatorship that is synonymous of political consumption of an anti-homonormative aesthetic. The role of the films within this environment must not be understated, which unfortunately happens all too often in film festival studies. This chapter will offer an analysis of popular contemporary films on the film festival circuit through the rubric of homonormativity. I will examine films that either critique or reinforce the uneven power structures within the LGBTQ community. Ultimately, I argue that there is the possibility for a middle ground between pleasurable consumption and political engagement.

The aim of this chapter is to present a method to analyse the political engagement (and potential limits of) that plays out in the films of the queer film festival. Highlighting key themes of homonormative cinema will offer insight into how a redefined political consumption can occur within the queer film festival audiences; one that leads to political action rather than compliance. In one of the founding academic musings on the queer film festival, Richard Fung states that when one "programs a festival, one also programs the audience and the community" (1998: 82). Analysing festival programmes is imperative to understanding how the festival audience challenges homonormativity. Is there the potential to be a socially and politically engaged spectator at the queer film festival or is it just all about watching pretty boys with six packs? This chapter argues that the potential for a politically active spectator relies on, first and foremost, the films programmed in the queer film festival programme. This is not to say that supplemental events are not important. Panel discussions and event parties all have immense power to shape an attendee's experience. Additional events have the power to shift an individual into action. My concern in this chapter, however, is to shift a discussion on film festivals to the content of the films themselves. The queer film festival is a fantastic case study to analyse this direction, as they are not always presented as being explicitly political. The queer film festival is an event that is often presented as a light-hearted leisure activity, as opposed to engaging in direct political activity, such as a political protest.

The growth of the queer film festival and homonormativity

The status of queer film festivals has undoubtedly grown. Beginning in 1977, the San Francisco Frameline International LGBTQ Film Festival was the first of its kind. The festival has become an influential player in the queer film festival circuit (Stryker 1996). The film festival is a field-configuring event (Rüling 2009), as many industry professionals, from directors to distributors and other queer film festival programmers often attend the event. This development of Frameline has been propelled by the increased professionalism of the queer film festival, from being a grass-roots radical organization to an elite cultural event. The 2014 festival's opening night gala with the HBO-produced documentary *Case Against 8* (Cotner and White 2014) is a far cry from the festival's early days of experimental projections in a community centre. Queer film festivals are now found worldwide. In her historical account on the development of the queer film festival, Rhyne (2007) establishes four key periods. Frameline played an influential role in the formation of early queer film festival culture in the first wave. Rhyne characterizes the second period by "newly defined relationships between gay and lesbian film festivals, and the commercial industry" (4). Major North American and western European festivals began to form significant relationships with the corporate sector. We also see the birth of many new festivals, such as Melbourne in 1991 and Sydney in 1993, who adopted the queer label comparatively earlier than their international counterparts due to the activist nature of the programmers at the helm (Searle 1997). In the third wave, Rhyne notes that the expansion of queer film festivals did not take off in East Asia till the late 1990s/late 2000s, which saw many organizations having issues with local authorities, such as Seoul (1998), Bangkok (1998) and Jakarta (2001). While the festival in Hong Kong began in 1989, its long hiatus did not end until this wave in 1999. The final wave sees the development of alternative digital distribution networks, such as pay per view television and online delivery channels, such as Frameline Voices (Richards 2013).

Queer film festivals have a social purpose to serve the queer community while still remaining financially viable. As Loist and Zielinski argue in their historical account, "the formation of the queer film festivals owes much to the activist media practices and theories of (positive) representation of earlier social movements" (2012: 58). There is a limited but a gradually expanding array of scholarly literature written on the queer film festival. It is widely assumed among scholars that the queer film festival is a space for films that are by/for/about the queer community as "part of a concerted political project to seize the means of self-representation in the face of widespread cultural invisibility and stereotyping" (Pidduck 2003: 267). While invisibility might not be an issue for major queer film festivals in western Europe, North America or Australia, it is a primary driver for many festivals in the Asia Pacific region, such as the Q! Film Festival in Jakarta, and in eastern Europe and Russia, such as the Side-by-Side Film Festival in St. Petersburg. It is for this reason then that a textual analysis of films programmed is imperative when analysing these festivals. In all these different festivals, is there a specific kind of image of homosexuality evident?

Most scholarship on the queer film festival concerns itself with queer cinema's journey into the mainstream and how this can result in a homogenized array of films programmed. Eric O. Clarke (1999) highlights the risk of niche marketing, with the queer film festival becoming homogenized due to the dominance of conventional films. As a result, a homosexual phantom normalcy has the potential to dissipate any semblance of diversity (1999). B. Ruby Rich emphasizes the role of pleasure in these spaces:

> Audiences don't want disruption. They don't want "difference." Instead they hunger for sameness, replication, reflection. What do queers want on their night on the town? To feel good. To feel breezy and cheesy and commercial and acceptable and stylish and desirable. A six-pack and Jeffrey (Christopher Ashley 1995). A six-pack and Bound (Wachowskis 1996). They just wanna have fun (sic). And if the occasion is serious, then it had better be predictable: the AIDS quilt or lesbian adoption rights.
>
> (Rich 1999: 83)

While highlighting the importance of pleasure, B. Ruby Rich makes a sweeping generalization on queer film festival audiences, and ignores the complexity of spectatorship and diversity of queer film festivals worldwide. Pleasure and a disruption of dominant ideologies need not be mutually exclusive.

Like many other community arts organizations, the queer film festival has traversed the arduous journey from being an informal event to a professional organization. The queer film festival must attract corporate sponsorship and include films that will sell tickets in order to include less profitable work. A growing dependence on sponsorship is a key theme in Joshua Gamson's invaluable work, a scholar who has engaged with a discussion of the construction of sexual identities in New York queer film festival programming, where the funding environment has dramatically changed (Gamson 1996). The power of the organization to affect the collective identity is clear in his comparison of both NewFest and MIX, with a bias being evident for the latter. While the experimental MIX New York, the New York Queer Experimental Film Festival, states that they make art for themselves and their community, not for museums or any other commercial interests, NewFest has a more commercial approach to festival management. If we recall Fung's claim that the film festival also programmes the audience, it becomes clearer here, then, the power of the queer film festival to programme the collective identity of the audience is a politically active one. In his article, Gamson sees NewFest as being isolated from the queer community it seeks to embody and organize. MIX, on the other hand, provides a space in which "gay consciousness" could be freely created outside the constraints of commercial media and the aesthetic approaches they require. Gamson's analysis is based upon the claim that "Collective identities [...] are continually filtered and reproduced through organizational bodies" (235). While these festivals:

> Take actions on behalf of "communities," they do so also as organisations largely autonomous from those populations. As such, they must negotiate and move within

particular institutional environments and are dependent on a variety of parties for support and legitimacy.

(235)

Nowadays there is less reliance on grants and more corporate interest from sponsors. The ideological implications of this are profound. While the experimental MIX New York has moved away from gay and lesbian labels with "an organizational shift to garner connections to the elite art world while expanding racially" (258), the more commercial New Festival has adopted an increasingly multicultural approach towards queer identity affirmation. While MIX New York does offer a more fluid collective identity, Gamson concludes that both had become to "resemble one another, both structurally [...] and ideologically" (256) as both adopt curatorial approaches that reflect the changing organizational field. Gamson pessimistically questions whether this organizational path has turned the film festival patrons from engaging in political activities to a consumer. Here, I maintain that there is the potential to be both. In order for the festival to continue to exist, Gamson argues that it must create equilibrium between its relationships to "the community" and its relationship to sponsors creating a "double bind within these socially formed spaces" (236).

As this cumulative success of queer cinema over the past few decades has seen queer film festivals needing to engage with corporate sponsorship more so than government assistance, the contemporary western queer film festival is now in a balancing act. The audience member is both a customer and a politically active subject. This is because Frameline, and other leading queer film festivals, must be socially legitimate *and* engage with market forces to function at the level in which they are currently at. The queer film festival is now competing in a neo-liberal terrain. For Duggan, neo-liberalism is a kind of non-politics "presented not as a particular set of interests and political interventions" but a promotion of "universally desirable forms of economic expansion" (Duggan 2002: 177). The logic goes that marketization of queer cinema is purely apolitical; financial gain as corporate sponsorship is not a philanthropic act. The neo-liberal cultural economy sees an upward distribution of power that caters to economic interests. Not all members of the LGBTQ communities equally receive the benefits of this commercialization and this has resulted in a distinct fracturing of the LGBTQ community:

In developed capitalist countries, while commercial scenes are more accessible to even lower income LGBTs, growing economic inequality has meant increasingly divergent realities in LGBT people's lives. Alienation has mounted among some LGBT people from the overconsumption increasingly characteristic of many aspects of the commercial gay scene, which inevitably marginalises many LGBT people.

(Drucker 2011: 6)

The disintegration of the LGBTQ community is directly tied to capitalism in Kevin Floyd's work (2009). Floyd borrows the concept of reification from Marxist scholar György Lukács

(1923), where social relationships are expressed through commodified objects. Floyd sees sexual categories as examples of reification, where particular identities are objects attainable through possessing socially desirable commodities. This is evident at many major Pride Parades, such as those in San Francisco or New York, which are profitable events on the social calendar for many brands. Queer participants at this event are indeed the commodified objects. One only has to attend pride marches in major US cities to see this. Cute, young employees of major brands like Apple, AT&T and Yahoo (who in 2015 touted t-shirts with "yahoo" being read backwards as "oohay") now outnumber politically progressive contingents in the march. As such, conventional (which I find to be inherently conservative) representations of gender and sexuality are central to the process of capitalist accumulation. It is this intersection between identity and capital where this neo-liberal fracturing of the LGBTQ community occurs and is a fundamental component of contemporary homonormative politics. The connection between the increasing visibility of the gay community and commodity culture has been discussed at length (D'Emilio 1983; Chasin 2001; Sender 2004). Ultimately, these social identities are formed upon the basis of consumption.

This commodification of the LGBTQ communities is the key ingredient of homonormativity. Born out of heteronormativity and neo-liberalism, a homonormative critique is an extension of Warner's work on heteronormativity (1993) by looking at the uneven power relations within the LGBTQ community. Lisa Duggan asserts that homonormativity is a product of neo-liberalism and involves assimilationist politics rather than confrontation. According to Duggan, homonormativity:

> Does not contest dominant heteronormative assumptions and institutions, but upholds and sustains them, while promising the possibility of a demobilized gay and lesbian constituency and a privatized, depoliticized gay culture anchored in domesticity and consumption.
>
> (Duggan 2003: 65)

In a neo-liberal-fuelled political economy, homonormativity sees the dominance of assimilationist tactics rather than disrupting the status quo. This is a superficial distancing from progressive politics that would aim to identify and disrupt heteronormative ideals. Warner (1999) co-opts the terms "stigmaphile" and "stigmaphobe" from sociologist Erving Goffman, whereby a stigmaphile space is where we find commonality with those who suffer from stigma and the stigmaphobe space being the world of the mainstream, where conformity is ensured through fear of stigma:

> Like most stigmatized groups, gays and lesbians were always tempted to believe that the way to overcome stigma was to win acceptance by the dominant culture, rather than to change the self-understanding of that culture.
>
> (50)

This is a depoliticization and privatization of the gay rights movement. As such, assimilationist tactics do not seek to contest pre-existing neo-liberal power dynamics in society and enforce a "narrow, formal, non-redistributive form of 'equality' politics" (Duggan 2003: 44).

Homonormative cinema

The foundations of this chapter are twofold. First is the notion that film festivals programme the audience and, second, is the prevalence of homonormativity in contemporary LGBTQ social movements. With this in mind, it is imperative now to consider the representation of homonormativity in popular queer films programmed on the film festival circuit, as these films, in turn, have the power to programme queer film festival audiences. My aim here is to elucidate the position that audiences don't necessarily demand conventional cinema. There is a significant amount of contemporary popular cinema on the queer film festival circuit that dismantles homonormative politics. The tensions between the stigmaphile and stigmaphobe positions have become actualized in queer film festival programmes, which is a result of neo-liberalizing trends in contemporary LGBTQ media. Through this process of normalization, difference is tolerated and ignored. This purification reconfigures gays and lesbians as desexualized normative citizens situated within domestic settings (Warner 1999). This is a reconfiguration into the ideal neo-liberal citizen, a "self-regulating homosexual subject who chooses stable co-habiting relationships" (Richardson 2005: 522). In order to achieve this equality and sameness, it is the responsibility of the sexual Other to "adopt disciplined sexual practices through the internalisation of new norms of identity and sexual practices associated with a certain (heteronormative) lifestyle, with various rights granted through demonstrating a specific form of 'domestic' sexual coupledom" (521). The gay market recreates the boundaries of sexual norms by privileging this "ideal image of the gay consumer as (an) affluent, white, male, thirty-something, gender-conforming and sexually discreet" individual (Sender 2003: 335). Homonormativity is thus born out of a post-political, neo-liberalist rhetoric, in that there can be an internalization of societal norms. There is very little scholarly literature on the manifestation of homonormativity in contemporary LGBTQ cinema that is primarily distributed through queer film festivals, in that many of these films do not receive distribution outside of the queer film festival circuit. As such, this study looks at the materialization of the political divide between cinema as a tool for queer social empowerment and a product for consumption. My analysis of Frameline's programming emerges from this uneasy relationship in contemporary LGBTQ cinema. To aid my interrogation, I will highlight three key characteristics of homonormativity present in LGBTQ cinema. These three categories will allow us to consider the potential for the queer film festival audience to be political consumers.

1. **Politicization.** Some films adopt dominant ideologies while others are consciously disruptive. Some films foreground social issues while others do not. As outlined above,

a key characteristic of homonormativity is a "depoliticized gay culture anchored in domesticity and consumption" (Duggan 2003: 65). No genre of queer film demonstrates depoliticized narratives like the spate of gay male romantic comedies, which tend to display a clear lack of engagement with contemporary politics. Films are products of, and, I argue, have the power to influence, their ideological environments, in that they are "manufactured within a given system of economic relations, and involve labour (i. e. money) to produce [...] a commodity, possessing exchange value [...] governed by the laws of the market" (Comolli and Narboni 1971: 29). They are ideological products of their system. This filmic "reality" has the potential to be nothing more than a reproduction of the dominant way of seeing. While a theoretical analysis of this realist aesthetic is beyond the scope of this chapter, I remain interested in how these films reproduce the way we *experience* the world, and how dominant cultural principles define this aesthetic. As such, we can see how dominant ideologies of masculinity, race and so forth have influenced the privileging form of gay masculinity that is represented in so many films programmed in the queer film festival. Homonormativity shows gay culture that does not disrupt dominant social norms. As such, this depoliticized film is a key trope of homonormative cinema.

While LGBTQ characters in contemporary queer cinema need not be overtly political in order for the film to be deemed "politicized", we often find the gay male character that exists purely for commercial pursuits. All queer film festivals usually have a number of gay male romantic comedies in their programme. This emphasis on the masculine, waxed, oiled up, muscled body is the draw card to this film as exemplified by the stills chosen to promote these films. This is masculinity being positioned as a desirable commodifiable identity (Rahman 2004). The protagonists in many of Casper Andreas' films, for instance, represent the epitome of the privileged gay male image that Sender describes. Men in *Going Down in La La Land* (2011), *Violet Tendences* (2010), *The Big Gay Musical* (2009), *A Four Letter Word* (2007) and *Slutty Summer* (2004) are conventionally masculine, ultimately desiring monogamy, sexually conservative, white and so on. Sender's research into LGBTQ-oriented advertising found a certain level of legitimacy given to a certain "brand" of gayness over other sexual identities. This realist aesthetic presents a skewed representation of gay masculinity. By valuing whiteness, muscularity and youthfulness, films such as these support a dominant ideology of what masculine beauty is. While gay male narratives need not necessarily entail cultural resistance against heteronormativity, this hyper-masculinity "re-idealizes heterosexual norms *without* calling them into question" (Butler 1993: 231, original emphasis). This idealization of masculinity is an appropriation and reinforcement of patriarchal discourse. This is a "branded" masculinity wherein "profit can be produced by generating insecurity about one's body and one's consumer choices and then providing consumers with the correct answer or product" (Alexander 2003: 551). This ideological view of male beauty is not natural but a cultural falsehood that has been heavily influenced by a heteronormative preference for a certain type of masculinity. By foregrounding the aesthetic of, presumably, desirable male bodies,

these films are failing to engage the intersectional and historical dimensions of queer identities. For the audience, this ultimately creates a form of apolitical spectatorship.

In contrast to the above films that are emblematic of homonormativity, there is the possibility for films to directly engage in politics. Being cheaper to produce, short films allow for a digital democracy. Documentaries are often driven by an overt political agenda. Many films reject the need to conform to a conventional film style, such as *Xenia* (Koutras 2014). Koutras' film is a road movie where Greek-Albanian brothers Dany and Odysseas leave Athens for Thessaloniki to locate their supposedly wealthy estranged father. According to Comolli and Narboni (1971), progressive cinema appears to reproduce dominant ideologies but uses formal cinematic systems and conventions to evaluate particular political manifestations. On the surface, *Xenia* appears to be like many other gay-themed European arthouse films, such as *Rückenwind/Light Gradient* (Krüger 2009), *Donne-moi la main/Give Me Your Hand* (Vincent 2008) – all are road movies with an emphasis on attractive male leads and wide shots of the landscape. The film, however, uses this conventional narrative to present two young men displaced by the financial crisis and their status as illegal immigrants. The title itself translates to "hospitality", referring to both an ancient Greek custom and the contemporary debate over immigrants in Greece. When played within the context of the queer film festival, *Xenia* is a film that offers the audience the pleasure of watching a film that straddles reality and camp, while being exposed to immigration politics of the European Union.

2. **Challenging domesticity.** Homonormativity is the imitation of heteronormative archetypes. A significant manifestation of this is the attempted recreation of the nuclear family with little challenge to dominant ideologies within familial politics, unlike queer time and spaces, as theorized by Halberstam, which develops "in opposition to the institutions of family, heterosexuality, and reproduction" (Halberstam 2005: 1). By having an emphasis on normalized, private domestic settings, homonormative narratives are not contesting pre-existing representations of gender and sexuality. By "domesticated", I refer to characters that primarily engage in heteronormative-based activities that concentrate on domestic labour, family, reproduction and so on. These characters realign what constitutes as sexual normativity. Does the domestic gay couple actively queer an environment traditionally thought of as a space for the nuclear family, or are we seeing deviance being domesticated? Domestic spaces in contemporary western homes are mostly considered the de facto province of heterosexual coupledom. Writing on the role gay men play in lifestyle television, Gorman-Murray writes:

> [...] The image of the "domestic" gay man presents a *paradox*. While gay domesticity challenges and subverts the normative heterosexuality of the home, this association also provides a way to regulate and sanitize a dissident sexuality, linking gay masculinity with ideals of domestic family life acceptable to mainstream Australia.

The image of the domestic gay man both *queers* ideas of home and *domesticates* a "deviant" sexuality.

(2006: 233, original emphasis)

Popular queer film titles such as *The Green* (Williford 2011), *Shelter* (Markowitz 2007) and *Breakfast with Scot* (Lynd 2007) are all examples of these films that present gay and lesbian characters within traditional domestic spaces. While we do have domesticated couples queering a traditionally heterosexual environment, there is still an element of normalcy to them. The privatization of sexuality problematizes the seemingly empowering queer domestic couple. Presenting queer families in a primarily domestic setting has the power to challenge dominant ideologies of the family. Films, such as *Shelter* and *Breakfast with Scot,* fail to disrupt any existing norms.

Queer films can challenge the homonormative privileging of domesticity and the nuclear family with narratives that deconstruct the familial household setting. A film like *Margarita, with a Straw* (Bose and Maniyar 2014) sees a protagonist explore their identity once they leave the confines of the family home. Laila Kapoor is a wheelchair-bound woman with Cerebral Palsy at Delhi University. Her supportive family offer her the independence to travel abroad and mix with her able-bodied peers at New York University, where, during an Occupy Wall Street protest, she meets Khanum, a Bangladeshi-American with visual impairment. While her mother is with her at the beginning of the trip, Laila is eventually alone with her new girlfriend, where the two live together and assist each with daily tasks. Once back home in India, Laila comes out to her mother and has a newfound confidence that was absent at the beginning of the film. This is a "coming of age" narrative, in that in order for the central character to progress, they must leave their comfort zone. For Laila, that is the family home in Delhi. Expressions of queer desire in the public sphere, such as those between Laila and Khanum in New York, are imperative to dismantling a homonormative influence on contemporary gay and lesbian narratives. Queer desire is not relegated to the private space of the home.

Ultimately, a film, such as *Margarita, with a Straw,* demonstrates the potential for queer domesticity. Queer families do not try to emulate any heteronormative ideals but explore different forms of living arrangements. They are made on their own terms. Laila makes her own choices with her living arrangements. There is a difference between Laila's confidence in her new domestic setting and those that uphold heteronormative ideals, such as the conclusion to the films *Shelter* or *Breakfast with Scot.* The relationships between the adults in the latter films centre on raising children with wealth playing a significant role in these two conservative representations. In a heteronormative society, queer couples have limited choices when it falls to becoming parents and ultimately, personal wealth creates more opportunities. As such, these homes represent wealth and heteronormative ideals. Laila's own domestic setting with Khanum, however, centres on her growing independence. *Margarita, with a Straw* ends

with Laila on a date with herself, relishing her confidence and freedom. This film offers the possibility for domesticity to represent something beyond conventional ideals.

3. **Challenging hierarchies of identity.** The final category for homonormative cinema is the recreation of previous hegemonic relations within the queer community. This is an internalization of heteronormativity when contemporary lesbian and gay cinema sees a privileging of whiteness and being gender appropriate (Knegt 2008). Cinema with LGBTQ-related content can abandon progressive ideals in favour of a mainstream brand of identity politics or critique and challenge pre-existing views on sexuality and gender, such as the privileging of the gay male figure in category one. Since homonormativity sees a realignment of the stigmaphile and stigmaphobe positions, privilege is given to certain members of the LGBTQ community based on wealth, status, gender identity, race and so forth. Do certain films mimic patriarchal norms favoured by a heteronormative society? This incorporation heteronormativity into the LGBTQ community sees the movement of certain identities out of a stigmaphile space, where there is commonality in oppression, and into the stigmaphobe space of the mainstream.

 While there will always be the few films that occupy this stigmaphobe space, a distinct trend is evident in queer film festival programming, whereby quite a significant quantity of films openly challenge this hierarchy of identities that we are seeing in the normalization of gay and lesbian culture. Frameline 35 in 2011, for instance, opened with *Gun Hill Road* (Green 2011), a film that explores the relationship between a young transgender woman and her father. The Melbourne Queer Film Festival (MQFF) in 2012 opened with *Cloudburst* (Fitzgerald 2011), a road movie with Olympia Dukakis and Brenda Fricker as an elderly lesbian couple travelling to Canada to get married. MQFF in 2010 closed the festival with *Elvis and Madonna* (Laffitte 2010), which depicts a relationship between a trans woman and a butch lesbian. These programming decisions challenge pre-existing dominant norms and are providing voices for identities traditionally marginalized in the gay mainstream media. Quite often queer film festivals will open with a fairly standard gay feature, as that is the safest option for obtaining a sell-out session. Opening or closing with a transgender narrative is a significantly innovative move to dismantle a homonormative divide between identities at the queer film festival. Transgender voices are traditionally marginalized and desexualized within the queer film festival (Williams 2011). Queer film festivals frame "transness as something other to, or in-between, 'girl' o 'boy'" (Williams 2011: 176). A cisgender narrative, for instance, are primarily labelled as "gay" or "lesbian", while trans-themed films between two transgender characters of the same gender would be labelled as just "trans" and separated from any sexuality. This is a result of the transition from the disruptive to the normalizing politics that Duggan (2003) identifies in her critique of contemporary lesbian and gay identity politics. The inclusion of transgender voices further disrupts the homonormalization of sex and identity evident in popular LGBTQ cinema. The queer film festival programmer has the power to disrupt these power relations by positioning films with marginalized identities in significant programme sessions.

Conclusion

While it is clear that the programming of LGBTQ film festivals can directly affect the constituency of their audiences, it would be imprudent to make any grand statement identifying exactly what effect would necessarily occur. My aim in this chapter is to highlight the potential for contemporary queer audiences to be both consumers and be spectators of ideologically progressive films. Films that challenge these three representational themes of homonormativity have the power to alter potentially complacent film festival audiences.

There are conservative elements evident in the contemporary queer film festival. At surface level, the queer film festival is structured according to a risk-averse strategy that privileges the ideal gay consumer. The pink dollar economy affords greater licence to those deemed fit by a neo-liberal cultural environment. This can be seen in Frameline's programming through their selection of films that adhere to a homonormative ideology. Casper Andreas' films are examples of many gay male romantic comedies that use formal cinematic codes to reproduce a homonormative dominance of whiteness, masculinity, class and so on. Films such as *The Green*, *Shelter* and *Breakfast with Scot* anchor the sexuality of the characters in a private, domestic setting. While some films uphold dominant gender expressions and hierarchies of shame, there are many films that directly challenge a homonormative hierarchy of identity. The queer film festival is no longer just a non-profit organization that relies on others' good will. Many queer film festivals have an increasingly complex economic outlook to increase their financial sustainability. Programming the occasional conservative film that represents and attracts the pink dollar's ideal gay male consumer allows for this financial sustainability. This independence allows for the queer film festival to programme a significant amount of films that distinctly challenge the three homonormative themes identified in this research. Political minded documentaries, such as *East Bloc Love* or experimental films such as *Maggots and Men* (Cronenwett 2009) – a re-visioning of the Kronstadt Uprising featuring an entire trans male cast – help the queer film festival achieve its social mission of providing a space for empowering cinema.

A paradox arises here, however. While this sustainability does allow freedom to programme challenging work, the festivals then in turn become dependent on commercial entities that support the festival – sponsors, gay male romantic comedies and so on. Queer film festival programmes offer a complex interplay between conventional media practices and attempts to rupture dominant norms. At the time of writing, the most recent Frameline festival – 2014's Frameline 38 – demonstrated numerous moments where these conservative elements became undone. On the night of Pink Saturday, the ultimate culmination of San Francisco's Pride festivities, Frameline screened German comedy *Feuchtgebiete/Wetlands* (Wnendt 2013), a film about an adolescent woman's sexual and bodily misadventures. While the same sex activity in the film is quite minimal, Helen breaks several taboos in how she relates to her own body. In this sense, the film is very queer while not neatly fitting into an L, G, B or T label. Another highlight of Frameline 38 was documentary *Out in the Night* (Doroshwalther 2014), which detailed the legal battle faced by four African American lesbians who fought

off the advances of an aggressive admirer. Highlighting the misogynistic, homophobic and racist elements of the contemporary American criminal justice system and media reporting of the incident, the film is an important call to arms for the need for intersectional social movement politics. There is definite room for socially progressive films on the contemporary queer film festival circuit. *Out in the Night* is perfect example of a film that constructs the audience members as political consumers. The three themes of homonormativity identified in this chapter allow for a structured analysis of the queer film festival's programming. By identifying *how* films directly challenge dominant societal ideologies, we can begin to identify how the queer film festival attendee can be a politically engaged one. I posit that it is through the consumption of films that challenge homonormative themes, queer film festival audiences are able to engage in a form of political consumption.

References

Abrahams, A. (2011), *The Grove,* USA: Open Eye Pictures.

Alexander, S. M. (2003), "Stylish hard bodies: Branded masculinity in Men's Health magazine", *Sociological Perspectives*, 46:4, pp. 535–554.

Andreas, C. (2004), *Slutty Summer,* USA: Embrem.

—— (2007), *A Four Letter Word,* USA: Embrem.

—— (2009), *The Big Gay Musical,* USA: Embrem.

—— (2010), *Violet Tendencies,* USA: Breaking Glass Pictures.

—— (2011), *Going Down in La La Land*, USA: Embrem.

Artz, L. and Murphy, B. O. (2000), *Cultural Hegemony*, New York: Sage.

Bernstein, M. and Reimann, R. (2001), *Queer Families, Queer Politics: Challenging Culture and the State*, New York: Columbia University Press.

Berry, C. (1993), "Looks a little queer to me", *Metro Magazine: Media & Magazine*, 95, Spring, pp. 38–40.

Binnie, J. (2013), "Neoliberalism, class, gender and lesbian, gay, bisexual, transgender and queer politics in Poland", *International Journal of Politics, Culture, and Society*, October, pp. 241–257.

Bose, S. and Maniyar, N. (2015), *Margarita, with a Straw,* India: Viacom 18 Motion Pictures.

Butler, J. (1993), *Bodies that Matter: On the Discursive Limits of Sex*, New York: Taylor & Francis.

Calciano, J. C. (2011), *eCupid,* USA: TLA.

Cantu, B. (2011), *Stadt Land Fluss/Harvest,* Germany: TLA.

Chasin, A. (2001), *Selling Out: The Gay and Lesbian Movement Goes to Market*, New York: Palgrave.

Comolli, J.-L. and Narboni, P. (1971), "Cinema/Ideology/Criticism", *Screen*, 12:1, pp. 27–38.

Cotner, B. and White, R. (2014), *Case Against 8,* USA: HBO.

Cronenwett, C. (2009), *Maggots and Men,* USA: The Film Collaborative.

D'Emilio, J. (1983), "Capitalism and gay identity", in A. Snitow, C. Stansel and S. Thompson (eds), *Lesbian and Gay Studies Reader,* New York: Routledge.

Doroshwalther, B. (2014), *Out in the Night,* USA: Sundance Institute.

Drucker, P. (2011), "The fracturing of LGBT identities under neoliberal capitalism", *Historical Materialism*, 19:4, pp. 3–32.

Duggan, L. (2002), "The new homonormativity: The sexual politics of neoliberalism", in R. Castronovo and D. D. Nelson (eds), *Materializing Democracy*, Durham: Duke University Press, pp. 175–194.

—— (2003), *The Twilight of Equality: Neoliberalism, Cultural Politics, and the Attack on the Democracy*, Boston: Beacon Press.

—— (2011), "Forward", M. d. M. C. Varela, N. Dhawan and A. Engel (eds), *Hegemony and Heteronormativity: Revisiting the Political in Queer Politics*, Surrey, England; Burlington, USA: Ashgate, pp. xxv–xxvii.

Fitzgerald, T. (2011), *Cloudburst*, USA: Sidney Kimmel Entertainment.

Floyd, K. (2009), *The Reification of Desire: Towards a Queer Marxism*, Minneapolis and London: University of Minnesota Press.

Fockele, J. and Smolowitz, M. (2011), *Still Around*, US: Outcast Films.

Fox, M. (2011), *This is What Love in Action Looks Like*, USA: TLA.

Fung, R. (1998), "Programming the public", *GLQ: A Journal of Lesbian and Gay Studies* 5:1, pp. 89–93.

Gamson, J. (1996), "The organizational shaping of collective identity: The case of lesbian and gay film festivals in New York", *Sociological Forum*, 11:2, pp. 231–261.

Gorman-Murray, A. (2006), "Queering home or domesticating deviance? Interrogating gay domesticity through lifestyle television", *International Journal of Cultural Studies*, 9:2, pp. 227–247.

Green, R. E. (2011), *Gun Hill Road*, USA: Motion Film Group.

Halberstam, J. J. (2005), *In a Queer Time and Place: Transgender Bodies, Subcultural Lives*, New York: NYU Press.

Jackson, M. (2011), *Without*, USA: m-Appeal.

Knegt, P. (2008), *Forging a Gay Mainstream: Negotiating Gay Cinema in the American Hegemony*, MA dissertation, Montreal: Concordia University Press.

Koutras, P. (2014), *Xenia*, Greece, France and Belgium: Feelgood Entertainment.

Krüger, J. (2009), *Rückenwind/Light Gradient*, Germany: Strand Releasing.

Laffitte, M. (2010), *Elvis and Madonna*, Brazil: Breaking Glass Pictures.

Lynd, L. (2007), *Breakfast with Scot*, Canada: Regent Releasing.

Lukács, G. (1971), "Reification and the consciousness of the proletariat", *History and Class Consciousness: Studies in Marxist Dialectics* (trans. Rodney Livingstone), London: MIT Press.

Loist, S. and Zielinski, G. (2012), "On the development of queer film festivals and their media activism", in D. Iordanova and L. Torchin (eds), *Film Festivals & Activism*, St Andrews: St Andrews Film Studies, pp. 49–62.

Markowitz, J. (2007), *Shelter*, USA: here! Films.

Mucha, L. (2011), *East Bloc Love*, Australia.

Olnek, M. (2011), *Codependent Lesbian Space Alien Seeks Same*, USA: n Space Aliens LLC.

O'Clarke, E. (1999), "Queer publicity at the limits of inclusion", *GLQ*, 5:1, pp. 84–89.

Peranson, M. (2008), "First you get the power, then you get the money: Two models of film festivals", in R. Porton (ed.), *Dekalog 3: On Film Festivals*, London and New York: Wallflower, pp. 23–37.

Pidduck, J. (2003), *New Queer Cinema: A Critical Reader,* Edinburgh: Edinburgh University Press.

Rahman, M. (2004), "Is straight the new queer? David Beckham and the dialectics of celebrity", *M/C (media/culture),* 7:5, http://journal.media-culture.org.au/0411/15-rahman.php. Accessed 1 March 2015.

Rhyne, R. (2007), *Pink Dollars: Gay and Lesbian Film Festivals and the Economy of Visibility,* Ph.D. thesis, New York: New York University.

Rich, B. R. (1999), "Collision, catastrophe, celebration: The relationship between gay and lesbian film festivals and their public", *GLQ: A Journal of Lesbian and Gay Studies,* pp. 79–84.

Richards, S. (2013), "Frameline's digital activism", in *Global Networks-Global Divides: Bridging New and Traditional Communication Challenges,* Fremantle: Australian and New Zealand Communication Association.

Richardson, D. (2005), "Desiring sameness? The rise of a neoliberal politics of normalisation", *Antipode,* 37:3, pp. 515–535.

Rüling, C. (2009), "Festivals as field-configuring events: The Annecy International Animated Film Festival and Market", *Film Festival Yearbook* 1, St Andrews: St Andrews Film Studies, pp. 49–66.

Searle, S. (1997), *Queer-ing the Screen: Sexuality and Australian Film and Television,* St. Kilda, Victoria: Australian Teachers of Media in association with Australian Film Institute Research and Information Centre and Deakin University of Visual, Performing and Media Arts.

Seigal, M. (1997), "Spilling out onto Castro street", *Jump Cut* 41, May, pp. 131–136.

Sender, K. (2003), "Sex sells: Sex, taste, and class in commercial gay and lesbian media", *GLQ: A Journal of Lesbian and Gay Studies,* 9:3, pp. 331–365.

Sender, K. (2004), *Business, Not Politics,* New York and Chichester: Columbia University Press.

Stone, A. L. (2009), "Diversity, dissent, and decision making: The challenge to LGBT Politics", *GLQ: A Journal of Lesbian and Gay Studies,* 16:3, pp. 465–472.

Stryker, S. (1996), "San Francisco international lesbian and gay film festival", in J. Olson (ed.), *The Ultimate Guide to Lesbian and Gay Film and Video,* San Francisco: Serpent's Tail, pp. 364–370.

Vincent, P.-V. (2008), *Donne-moi la main/Give Me Your Hand,* France and Germany: Strand Releasing.

Ward, E. J. (2008), *Respectably Queer: Diversity Culture in LGBT Activist Organizations,* Nashville: Vanderbilt University Press.

Warner, M. (1993), *The Fear of a Queer Planet,* Minneapolis: University of Minnesota Press.

—— (1999), *The Trouble with Normal: Sex, Politics and the Ethics of Queer Life,* New York: Free Press.

Weeks, J. (2001), *Same Sex Intimacies: Families of Choice and other Life Experiments,* New York and London: Routledge.

Wnendt, D. (2013), *Feuchtgebiete/Wetlands,* Germany: 20th Century Fox Entertainment.

Williams, J. (2011), *Trans Cinema, Trans Viewers,* Ph.D. Thesis, Melbourne: The University of Melbourne.

Williford, S. (2010), *The Green,* USA: Wolfe Video.

Notes on Contributors

Daan Bronkhorst is staff writer at the Dutch section of Amnesty International who has been involved in the Amnesty International Film Festival/Movies that Matter Foundation from its incipience in the mid-1990s. He published books on the history, arts and philosophy of human rights, and is preparing a Ph.D. on human rights defenders.

Alexandra Crosby is a lecturer in the Faculty of Design, Architecture and Building at the University of Technology Sydney. Her research focuses on how media, technology and creative practices form culturally specific forms of activism. Her Ph.D. (2013) was titled "Festivals in Java: Localising cultural activism and environmental politics, 2005–2010". She is currently developing and using interdisciplinary research methods, such as hybrid forms of mapping and experimental futuring to understand political complexity and emerging forms of environmentalism. She has used these to map urban food production and knowledge share networks as they appear in Australia and Indonesia.

Tomás F. Crowder-Taraborrelli received his doctorate in Spanish and Portuguese at the University of Irvine, California. He is an associate producer for ITVS and POV, from the Public Broadcasting Service in the United States. He is on the editorial board of the journal *Latin American Perspectives*, of which he is co-editor of the film section. He is co-editor of *Film and Genocide* (University of Wisconsin Press, 2012) and *El documental político en Argentina, Chile y Uruguay* (LOM Ediciones, 2015). Currently, he is a visiting Professor of Latin American Studies at Soka University of America, California.

Lyell Davies is a documentary video-maker and Professor of Film and Media at The City University of New York. His documentaries have been aired on public television in the United States and screened at film festivals internationally, and he has facilitated participatory media-making projects engaging youth, recent immigrants, the homeless and workers. His scholarly research focuses on media and social change, media justice and documentary film-making. He earned his Ph.D. in Visual and Cultural Studies from the University of Rochester.

Ana Cristina Bohrer Gilbert is a postdoctoral fellow in the Advanced Programme of Contemporary Culture at the Federal University of Rio de Janeiro (PACC-UFRJ) and a

research fellow in the Centre for Medical Genetics at Fernandes Figueira Institute/ Oswaldo Cruz Foundation. She is also a psychotherapist and works in private practice. Her academic background is in psychology and she has been working at the intersection of Humanities, Social Sciences and Public Health since her graduation. Her research interests include cultural studies, disability film festivals, Down syndrome and technologies of the self.

Matthea de Jong works in the field of media, art and social impact. For many years, she worked as a programme coordinator for the Movies that Matter Festival and programme manager of a workshop and grant programme to support human rights film screenings worldwide. This programme also includes the coordination of the Human Rights Film Network. She holds a Master in Cultural Anthropology.

Shweta Kishore recently completed her doctoral thesis entitled "Practicing independence: Indian documentary film and filmmakers" from Monash University, Melbourne. She has published on the ethics and practice of Indian documentary cinema in *Third Text, Studies in Documentary Film* and *Senses of Cinema*. Kishore is a lecturer at RMIT Vietnam in the Centre for Communication and Design.

David Owen is a freelance consultant, researcher and project producer with expertise in public engagement, partnership development and organizational change. In 2011 as a side project, he founded the Bristol Palestine Film Festival, which engages 800 members of the public and showcases a range of compelling and thought-provoking films and artistic works by established and emerging artists. You can find out more about his work and interests here: www.gurukula.co.

Stuart Richards completed his doctoral thesis in the School of Culture and Communication at the University of Melbourne. He currently teaches in the fields of Media, Screen and Cultural Studies at The University of Melbourne and RMIT. His book *The Queer Film Festival: Popcorn & Politics* is forthcoming from Palgrave Macmillan. His research interests focus on queer media, film festivals, the creative industries and Indiewood cinema. He is on the selection panel for the Melbourne Queer Film Festival and is a committee member for *Senses of Cinema*.

Sonia Tascón has been an academic in the fields of cultural studies, sociology, human rights, media and film for fifteen years. She has also been involved in human rights activism for most of her adult life, mostly through an association with Amnesty International. She turned to the scholarship of human rights film festivals after she coordinated the establishment of the first human rights film festival in Perth, Western Australia in 2007; in 2015 her research in this area was published by Palgrave Macmillan in a book entitled *Human Rights Film*

Festivals: Activism in Context. She currently holds the position of Lecturer in the School of Social Sciences in the University of the Sunshine Coast, in Queensland, Australia.

Davinia Thornley is a senior lecturer in the Department of Media, Film and Communication at Otago University in Aotearoa, New Zealand. Her research on film, indigenous issues and nationality appears in *The European Journal of Cultural Studies, The Journal of International Communication, Palgrave Communications, Studies in Australasian Cinema, National Identities, Film Criticism, Quarterly Journal of Film and Video* and several edited collections. Her 2014 book *Cinema, Cross-Cultural Collaboration, and Criticism: Filming on an Uneven Field* investigates film collaborations between indigenous/minority and majority groups in New Zealand, Australia and Canada.

Svetla Turnin is a co-founder and Executive Director of Cinema Politica, a non-profit exhibition network for independent political documentary with 90 global chapters. She co-edited and published *Screening Truth to Power: A Reader on Documentary Activism* (2014), and recently wrote "Beyond the female gaze and towards a documentary gender equality", a *POV Magazine* article on women in documentary. Svetla has curated documentary programmes and workshops, as well as sat on several juries at numerous festivals such as Festival du Nouveau Cinema (Montreal), Visible Evidence (New Delhi), Sofia International Film Festival (Sofia), RIDM and Docudays UA International Human Rights Documentary Film Festival (Kiev).

Kristi M. Wilson is an Associate Professor of Rhetoric and Humanities at Soka University of America. Her research and teaching interests include classics, film studies, gender studies, cultural studies and rhetoric. Dr Wilson is the co-editor of Italian Neorealism and Global Cinema (2007), Film and Genocide (2011) and Political Documentary Cinema in Latin America (2014), and author of numerous publications in such journals as *Screen, Yearbook of Comparative and General Literature, Signs, and Literature/Film Quarterly*. She also serves on the editorial board and is a film review editor at Latin American Perspectives (SAGE Publications).

Tyson Wils is a Lecturer and tutor in the School of Media and Communication at RMIT University, Melbourne, Australia. In 2012 and 2013, he worked as a Features Film Programmer and Guest Education Speaker at the Human Rights Arts and Film Festival. He has also worked as a Project Officer at The David Unaipon College of Indigenous Education and Research in Adelaide, Australia. He has published on a range of areas in cinema studies, including activist film festivals, classic film theory and landscape and nature in film.

Ezra Winton is Assistant Professor of Film Studies at Concordia University and holds a Ph.D. in Communication Studies from Carleton University. His research interests include

film festivals, Indigenous cinema, alternative media and documentary film, institutions and culture. Ezra is a co-founder and Director of Programming of Cinema Politica, the world's largest grassroots documentary screening network. Recent publications include *Challenge for Change: Activist Documentary at the National Film Board of Canada* (2010) and *Screening Truth to Power: A Reader on Documentary Activism* (2014). He is currently working on a monograph that looks at Alanis Obomsawin's classic documentary *Kanehsatake: 270 Years of Resistance*.